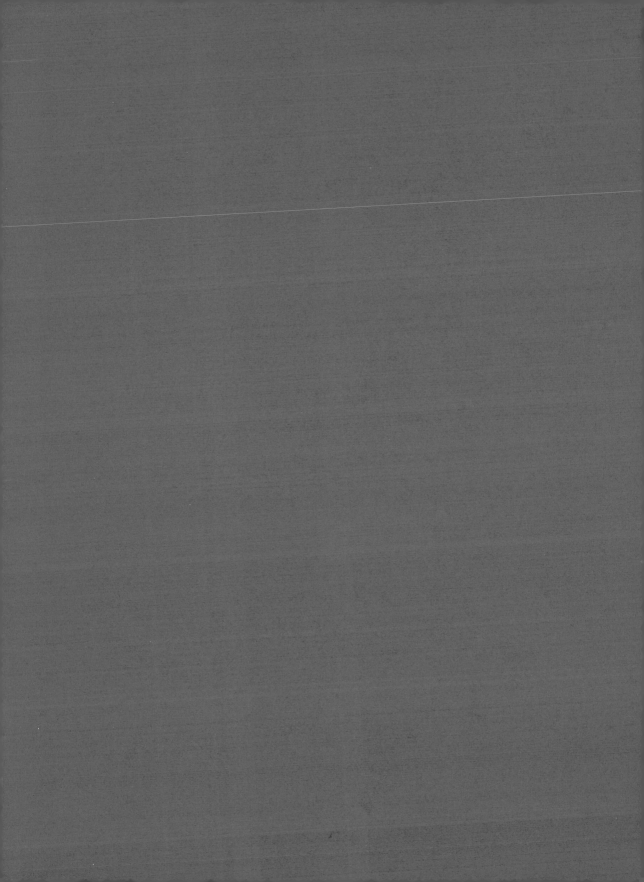

CRAFTING THE NEWS FOR ELECTRONIC MEDIA

CRAFTING THE NEWS FOR ELECTRONIC MEDIA

WRITING, REPORTING AND PRODUCING

CARL HAUSMAN

New York University

WADSWORTH PUBLISHING COMPANY
Belmont, California
A Division of Wadsworth, Inc.

Communications Editor: Kris Clerkin
Editorial Assistant: Patricia Birkle
Production Editor: Vicki Friedberg
Managing Designer: Kaelin Chappell
Print Buyer: Randy Hurst
Art Editor: Nancy Spellman
Permissions Editor: Robert M. Kauser
Text and Cover Designer: Joe di Chiarro
Copy Editor: Jennifer Gordon
Technical Illustrator: Diphrent Strokes, Columbus, Ohio
Compositor: G & S Typesetters, Austin, Texas
Printer: R. R. Donnelley & Sons, Crawfordsville, Indiana

1 2 3 4 5 6 7 8 9 10—96 95 94 93 92

Library of Congress Cataloging-in-Publication Data
Hausman, Carl, 1953–
 Crafting the news for electronic media: writing,
reporting, and producing / Carl Hausman.
 p. cm.
 Includes bibliographical references (p.) and
index.
 ISBN 0-534-14358-X
 1. Broadcast journalism. 2. Television
broadcasting of news. 3. Radio authorship.
4. Television authorship. I. Title.
PN4784.B75H38 1992
070.1'9—dc20 91-27381

CONTENTS

PREFACE

This is a book about news. Strictly speaking, it is not about writing, production, announcing, history, ethics or ratings, although those and other topics are covered in detail.

Instead, this text treats news as a *process*. It is meant to be read from cover to cover in one semester. During that semester, I hope the book will show that learning about news is a process-oriented task, and that the text will:

- Help readers understand the *nature* of news and develop news judgment.
- Offer some insight into how broadcast news is gathered, evaluated, written and produced.
- Present practical, hands-on instruction on writing, announcing and producing.
- Investigate the realities of broadcast journalism, including a warts-and-all look at the business of broadcast news and an examination of the medium's social impact and ethical quandaries.

During my career as both a print and broadcast journalist and later as a journalism educator, I've noticed that many journalism students have come away from broadcast journalism classes with vastly different impressions of what the course was supposed to be about. Some assumed that the course was all about writing, others that it was concerned entirely with production, and still others believed it dealt only with on-air performance.

That may have been the fault of the text, the teacher or their own individual biases, but we *know* that's not what broadcast journalism is about: Broadcast journalism is about *news*.

I hope that the readers of this book will learn that newswriting is not an intricate parlor game played with a hopelessly cumbersome set of rules. While that might be the impression given by certain texts (one of which opens cold with more than 60 pages of style guidelines), I believe that newswriting is an intuitive skill that comes naturally once one understands the news *process*.

Likewise, I believe that news announcing is not some mutation of a modeling-school curriculum. Good announcers understand news first, and then they become good announcers. You cannot reverse the process, and you cannot teach the skill of communicating with an audience by offering a list of rote mechanics and advice on clothing and haircuts. (Although I do address those topics, I try to put them into perspective.)

The point is that even though broadcast journalism is a skills course, it is difficult to teach those skills in isolation from the real-world considerations of news judgment, news sources, newsroom operations, gathering the facts needed to write a news story, basic writing techniques, intermediate and advanced techniques, radio and TV news production skills, announcing skills, ethics, laws, and the other issues relating to broadcast news and the society. Those are the subjects and the order of the chapters in this book.

Although the chapters flow in sequence, I have structured the work so that most chapters or groups of related chapters can stand alone. This entails some cross-referencing, but where items are cross-referenced it is done as unobtrusively as possible.

Instructors who wish to immediately begin lab work on writing can start with Chapter 4, newsgathering, or Chapter 5, basic writing skills. Chapter 5 can be studied separately to allow students to begin work on the typewriter or VDT without delay. The news judgment chapter (Chapter 1) can then be picked up when appropriate. The instructor's manual also provides

additional exercises and raw materials for writing assignments.

However, don't be misled by the fact that the word *writing* is not in the title of the first three chapters. They and the end-of-chapter exercises do deal with the most fundamental aspects of writing: gathering information, weighing it, evaluating it and turning it into a news story.

In the opening of this preface I stated that the book is about news, but the subject is broader than that: more precisely, it is about *communication*. The underlying philosophy of this book is that tools and techniques are means to an end, and that end is conveying an accurate, responsible and ethical message to the audience.

I've used that approach in my previous works, including texts on news judgment, radio production, television production, broadcast operations and public relations. I'd like to think that this approach has worked to some degree in those disciplines and will succeed in this work as well.

ACKNOWLEDGMENTS

I would like to thank Mike Ludlum of New York University and Carl Ginsburg of CBS and the staff at Wadsworth, especially my editor, Kris Clerkin. I would also like to acknowledge the valuable suggestions of the following reviewers of the manuscript: David Bradbury, Wright State University; E. Scott Bryce, Saint Cloud State University; Pat Cranston, University of Washington; John Clogston, Michigan State University; Donna Gough, East Central University; James Hoyt, University of Wisconsin at Madison; Ron Jacobson, Fordham University; Peter Pringle, University of Tennessee at Chattanooga; and Robert Stewart, Ohio University.

CRAFTING THE NEWS FOR ELECTRONIC MEDIA

1

WHAT IS NEWS?

A little smoke was billowing from the front and the back of the three-floor apartment building. The smoke—not the fluffy white stuff associated with bonfires, but greasy, black, superheated gas—spread like a lightning-quick cancer. In the back of the building, the common staircase linking all three floors sucked up the smoke and fumes like a huge chimney. Survivors would later say they heard the gases rise with a roar like a freight train.

From the street, you couldn't see any actual fire because the flames were licking up *inside* the walls, infiltrating the skeleton of the 70-year-old building.

At 8:11 p.m., the first alarm came in to the Central District firehouse's "tapper" room. A tapper was an old-fashioned type of alarm that would tap out a series of dots and dashes to indicate the location of the alarm box that had been pulled. Firebox 531, for example, would send a signal to the station, tapping five times . . . three times . . . and then once. Today, fire reports come through the city's computerized 911 dispatch unit and are relayed by radio; the tapper room is now officially known as the watch room, but traditions in the firehouse die hard and nobody calls it that.

The firefighter in the tapper room announced the location over the station's loudspeaker, and a pumper, a ladder unit and the rescue van roared from Central District.

■ ■ ■

The TV newsroom is usually a noisy place. Even though computer printers have replaced the old-fashioned clacking teletype, the printers' *zrrrt . . . zrrrt . . . zrrrt* add to the general hubbub of a large room that holds anywhere from ten to 40 people at a time—some typing, many talking on the phone and most arguing with one another.

Tonight, a cluster of five people stand by a plastic chart where stories for tonight's newscast—the lineup—have been scrawled in grease pencil. The news director, who is in overall control of the department, is making a convincing if strident argument that a story about a murder investigation should go first. A senior reporter, who has just finished a three-part series on abuse of the elderly, contends with equal vigor that the newscast should lead with part one of her story.

But suddenly things become very quiet. The police and fire scanner—which typically provides a steady babble of conversation about broken windows, license plate numbers and barking dogs—goes silent. And so does the newsroom. When garrulous public safety officials clear the air and halt their chatter, everyone in the newsroom knows that something big is happening.

Now, the commands come in terse, clipped tones: The dispatcher asks for "another alarm," meaning another fire unit will be sent to the scene. Then another. And another.

■ ■ ■

Reporters from the city's TV stations, radio stations and the local daily newspaper arrive on the scene at about the same time as the third fire unit. They face the problem of how to get the news without getting in the way of the emergency personnel. Most elect to find the highest ranking official at the scene coordinating the logistics. In this case, it's the man in the white hat—the district chief. The district chief fields questions when he can shift his attention away from directing the fire-fighting operation.

TV reporter: *Is anyone still in there?*
Chief: *Yeah, yeah. I think so, anyway.*
Radio reporter: *How many?*
Chief: *The owner of the building says 12 people live here. We've accounted for five. There are four old*

people who live on the first floor, and he says they don't go out much.
Radio reporter: *Can you get them out?*
Chief: *Maybe, if you'll get the hell out of my way. (To nearby firefighters attaching their hoses to a hydrant): Put Captain Larsen on the nozzle. Look in the first two rooms on the right as you go in. The first two rooms on the right!*

Captain Larsen is in charge of the Central District Rescue Squad. It is he and his firefighters who will crawl into the maw of the fire and search for victims. They travel on their bellies; the air near the floor is relatively cool—150 degrees Fahrenheit—but if they stood erect their protective masks might melt and the squad would be incinerated from the waist up.

Captain Larsen's firefighters crawl ahead, pushing the nozzle forward, wetting down the path of entry and groping for the first doorway. Although they carry powerful flashlights, the beams only illuminate a 6-inch cone of smoke. By touch rather than sight, they locate the door—which is locked. The firefighters rise to their knees and crack the door open with axes.

As they enter the first room, the firefighters are already exhausted. In addition to fighting against the pressure of the water coming from the nozzle—something like trying to push a rocket back on its launching pad—each member of the squad is encumbered by a coat, boots, hat and respirator, which weigh a total of 45 pounds. Fighting off the fatigue, Larsen's squad begins spraying the room and searching under beds and in closets, places where frightened and disoriented fire victims typically hide.

Because of the thick smoke, the firefighters are disoriented, too. One realizes that he is standing in an overflowing bathtub. Another finds that what he thinks is a wall is really the door of a refrigerator.

Outside, fire crews are scrambling to set up ladders. They want to carve holes in the roof to allow the superheated gases to escape, and they

need to have access to the windows to search for and extricate survivors. Lieutenant Masters is in charge of a ladder company. He's short-handed as it is—he's even conscripted a civilian to help him raise a ladder—but he stops what he's doing to run over to the district chief when he sees an ominous sign.

"*Chief*," Masters implores, tugging on the chief's sleeve, "Look at the smoke coming out of the back. It's real black, and it's swirling."

The district chief knows what that means. He orders all firefighters inside the building to evacuate.

And they almost made it.

■ ■ ■

When a burning structure is tightly sealed, as it is on this cold December night, the fire sometimes uses up all available oxygen. If a path to the outside is made, the oxygen rushes in underneath the superheated gases in a "back-draft." A backdraft is dangerous because the route firefighters are using for entry and exit becomes the direction in which the fire spreads.

In this case, the rushing air causes a powerful backdraft because the ceiling has not yet been fully vented, and the oxygen creates a "flashover"—a deadly effect in which everything inside a room or hallway reaches its ignition point but can't burn due to lack of oxygen. But when oxygen does arrive, as it did at 8:37, everything inside explodes.

The flashover killed three firefighters. One resident died: an elderly man who, moments after the flashover, leaped from the third floor to escape the flames. No residents were still inside the bottom rooms when the fire scene flashed over.

■ ■ ■

Here is what will happen with the information gathered by reporters at the fire scene:

■ Ellen, a local TV reporter, will do a live report at 11 p.m. (There is no question as to what the lead story is now.) She will open live, her image relayed back to the station's anchor desk by the satellite news vehicle's (SNV) microwave link. On her camera operator's cue, she recounts the grim affair for the camera:

Three firefighters and an elderly man are dead, victims of a fire this evening at 111 Delaware Street. The firefighters were trapped inside the burning building, and the elderly man jumped to his death from a third-floor window.

The newscast director will then switch to Ellen's prerecorded "package" (prepared TV news piece), which was hastily assembled prior to airtime. The package documented the events immediately after her arrival on the scene, including a shot of the elderly man leaping from the window and interviews of firefighters and residents of the building.

Next, the newscast switches back live to Ellen, who notes that the names of the deceased are not yet available pending notification of their relatives. She then conducts a live interview with the city fire chief. The chief does not know how it happened that the men were killed; he bristles when asked if they were sent into an inherently unsafe situation; any fire, he maintains, is an inherently unsafe situation.

Ellen asks about the cause of the fire. "Can arson be ruled out?" The chief says it can't— a standard answer, since it's difficult for arson to be immediately ruled out under any circumstances, except for a fire caused by a lightning strike in front of witnesses. But the chief volunteers a little more information. The fire, he says, looks suspicious.

Why? Fires don't start in two places at once, as this one apparently did. Secondly, the fire in the front porch appears to have started in the middle of the room. Fires usually start in electrical wiring, or in stoves, or

in a couch (which is generally placed against a wall) where someone has dropped a cigarette. Fires rarely start in the middle of a room unless someone has piled flammable material there and then lighted it.

■ Bob, a radio reporter, has been filing frequent updates throughout the evening. Bob's first "roser," *radio on-scene report*, was a dramatic narration broadcast live.

> . . . the building just burst into flames. It practically exploded. I can feel the wave of heat on my face, and you can probably hear the roar in the background. Firefighters are making a rush for the front of the building right now, trying to beat back flames that just started funneling out of the front door. There are three firemen inside . . . inside that hallway that's just turned into an inferno.

Seconds later, he breaks in with another roser.

> On the third floor there's someone hanging from the window. I can see smoke and flames behind him. There's no ladder, no net, nowhere for him to go . . . He's falling, he's falling, he's falling. [SOUNDS OF HEAVY BREATHING AND FOOT-STEPS AS BOB RUNS TO THE SCENE.] He's hit the pavement about 20 feet in front of where I'm standing. He appears to be an elderly man, wearing pajamas . . .

Bob has collected two cassettes' worth of "actuality," a radio term for interview material. He also has quite a bit of "wild sound," the sound of the firefighters at work, the sirens of the incoming units and so forth. Bob feeds some of this prerecorded material back to the station via a portable cellular phone and a high-quality audiocassette recorder.

A reporter back at the station tapes the material and writes, edits and shapes additional reports. The reporter at the station also anchors the 10-minute newscast at 11 p.m. (which features both a live on-scene re-

port from Bob and some taped interviews) and prepares extensive scripts, recordings, and instructions for the morning news announcer, who will arrive at work at 5 a.m. Bob also returns to the station to help with preparation of material for the morning news.

The next morning . . .

■ All the city's first-shift radio and television reporters are at work before the sun rises, as usual. The newswriters update the story, adding the victims' names, facts not available last night because it took several hours for relatives to be notified. Also, fire investigators and city detectives, who have been on duty all night investigating the apparent arson, have some information about suspects and motives.

Police are often tight-lipped about giving out such details (too much public information can tip off the suspect), but they do acknowledge that revenge may have been a motive. That's all they will say.

The anchors of the morning TV news program write this new information around Ellen's packages, which were filed last night. The packages have left out details of the number dead, the names of the dead and the probable cause—for a good reason. Ellen knew that new facts would be surfacing overnight, and she "protected" her package, omitting details that would age quickly and spoil the whole piece.

■ By 10 a.m., the radio reporters are winding down their coverage. The brunt of their work is done for the day, because radio's period of biggest listenership, the morning "drive time," has passed. Only the city's largest radio stations will continue their full-speed coverage of the story.

But the TV crews are just beginning to move into high gear. Their morning reports— 5-minute inserts into the network news/ entertainment show—command relatively

small viewerships. The noon programs have a larger audience, and the hour-long 6 p.m. news reports have a larger audience still.

At 10 a.m., the TV journalists are planning their coverage, lining up interviews, assigning various angles of the story to different reporters and—most importantly— dogging the police department for any information on the revenge motive.

The story is available through various news services across the country, but it does not receive equal attention in all local markets. Roughly speaking, journalists will regard the relative importance of the story in terms of how far it is from their hometown.

The city where the fire took place has a tremendous amount of coverage. TV stations in nearby cities, which have picked up the story from a variety of satellite video news feeds and print wire services (a wire service is a type of news network that provides printed copy and other services to member stations and newspapers), plan to give the event major play, but it will not be the day's main story for most of them.

Radio news outlets have made generous use of the story; it has made the overnight and early-morning network radio newscasts, and the radio news services (the audio divisions of the wire services) have "moved" the story—sent it electronically to their affiliates.

In New York City, the heads of the major network TV news divisions are screening footage of the fire provided by their local affiliates; they are attempting to decide whether to use the story at all. It's an important story, and the video is compelling, but in the limited time available for the network news, it faces a great deal of competition: The president is holding a summit meeting with the leader of the Soviet Union, a major bill may come up for a vote in Congress today, and seven U.S. military advisors have died in an ambush in a country strongly allied to the United States.

At 10:30 a.m., the producers of one network newscast begin debating the fire story. It's a cold-blooded affair, comparing whether the deaths of four people here are more important than the deaths of seven people there. News decisions involving the magnitude of a story based on the number of deaths can be, as John Chancellor of NBC News points out, a "cold, impersonal process," but it is "the mathematics of the news business." When only two people die in a tragedy, he notes, it is a small story nationally; if it were 22, it would be a major story.[1]

But the fire is a huge story locally. And at 3 p.m., the story becomes even bigger. Police arrest a man and charge him with arson. The ṛ̣ ? He wanted to exact revenge against a ℓ̣ lover who had spurned him. The irony was that she no longer lived in the building.

The local evening newscasts run several stories about the arson. One station carries these elements of the story:

- The general lead, read by the principal anchor: Four people died in what officials charge was an act of misguided vengeance.

- A package about the man arrested and the events leading up to his arrest.

- A package about the fire, focusing on why, precisely, it was so deadly, and why it was possible that experienced firefighters could be caught by the flashover.

- A feature about the three firefighters who lost their lives, including tributes from those who knew them and a discussion by the fire chief of how all firefighters live with the threat of sudden death.

- A report on the elderly man who died in the fire.

[1] John Chancellor and Walter R. Mears, *The News Business* (New York: Harper & Row, 1983), p. 5.

■ A package about the inherent danger of this particular type of building, a common structure in the working-class neighborhoods of the city. Questions are raised about the city safety codes, which, the reporter implies, may not be strict enough.

The story makes the network TV newscasts but only as a 15-second piece read by the anchor, with some footage of the fire (about 7 seconds' worth) shown over the anchor's picture while the anchor continues to "voice over" the story. The brief script:

> What police called a senseless act of revenge was made even more tragic by a startling revelation . . . Police in the city of Metropolis today charged a man with arson in connection with a fire last night that killed four people, including three firefighters. Police say the man set the blaze as an act of revenge against a former girlfriend . . . but they say *she had moved out of the building two weeks ago.*

■ ■ ■

Such are the workings of a broadcast news story.[2] We would all agree that the story is *news,* but *why* is it news? And why do news items have varying importance to different audiences? Several factors contribute to "making news," and in this chapter we will lay the groundwork for understanding just what news is. Using the example of the fire story and other cases, we will explore: *how journalists recognize news, the various types of news* and *how journalists determine the relative importance of news stories.*

[2] Although this story is hypothetical and designed to illustrate aspects of the broadcast news process, it is based on true experiences drawn from several fires.

Ηow Journalists Recognize News

In order to recognize news, we first have to know what it is—and the definition of news is largely formulated by the people who report the news. If that reasoning sounds circular, it is. Journalists, by and large, recognize this.

Michael Short, Boston bureau chief of The Associated Press, once remarked that the best definitions of news were jokes, such as "news is what the editor thinks is news" or "news is the same thing happening to different people."[3]

There is an element of truth in both of those definitions. In reference to the first joke, remember that a news item does not *become* a news item on a particular medium until someone in charge decides to air it or print it. If the above-described fire had occurred on the same day as a massive stock market crash, it likely would not have made the network newscasts. Producers of national news programs naturally choose as news items they believe to be of the greatest interest and importance to their mass audience; the fire story would be bumped from the lineup to make way for expanded coverage of the stock market crash, an economic issue that has direct and immediate implications for everyone everywhere in the nation. The fire, then, would not be news outside of the immediate area if it occurred at about the same time as a national economic crisis.

Is news, as the second joke asserts, the same thing happening to different people? Well, yes. Fatal fires occur with dismaying regularity at various locales. So do famines, auto accidents, wars, treaties, droughts, floods, hirings, firings and so on. Very few occurrences are new in the world, and news organizations are not only

[3] Interview, Dec. 9, 1987.

aware of this fact *but are structured around it.* Experienced journalists have specific routines for handling the daily menu of the same things that are happening to different people. While the cast of characters may change, there are certain to be discrete and repetitive developments in government, public safety, education, consumer affairs and dozens of other areas.

As a result of the routines, consumers of news are conditioned to expect standardized elements in their news coverage. The technique of covering the fire story is similar at all stations in the country. The reporter asks typical questions that mirror what the reporter believes the viewer or listener wants to know.

If you drove by a major fire and observed the conflagration in progress, it is likely that you would want to know: (1) Is anyone dead, injured or still in danger? If so, who? (2) How extensive is the fire, and is it being brought under control? (3) What started it?

In addition, it is probable that you would take in the sights and sounds of the fire. Our innate curiosity (some would describe this characteristic in negative terms: "morbid curiosity" or "nosiness") has been the motive behind great achievements in journalism, literature and the arts. We should not arbitrarily be ashamed of our natural inquisitiveness.

What we have just described—the sequence of questions you would want answered if you came across a major fire—is the same process a journalist would use in providing you with the information you desire. He or she would not only ask, as a matter of routine, the three basic questions above but would use pictures and/or audio to complement the recounting of events.

The choice of questions is not always so obvious. In less intuitive situations, more advanced news judgment is required, a concept to be discussed shortly. Let's return now to our attempt to nail down that elusive definition of news.

Scholarly literature has a broad array of definitions. In their book *Understanding Mass Communications,* Melvin DeFleur and Everette Dennis informally define news as "a view of reality gathered quickly under difficult circumstances."[4] That is a reasonable point: News is not a comprehensive record of every event that happens on a given day, but a highly selective and sometimes imprecise version of important events, a version gathered on the fly and prepared under the merciless rule of the clock.

University of Oregon journalism professor Ken Metzler offers another definition. News, he contends, is "prompt, 'bottom-line' recounting of factual information about events, situations and ideas (including opinions and interpretations) calculated to interest an audience and help people cope with themselves and their environment."[5]

That definition lends itself well to the example of the fire story. When the broadcast journalists reported live from the scene, they were delivering prompt information about an important event—an event of singular importance to local viewers. But should the story be bumped from the network newscast because of a stock market crash, another element of Metzler's definition would be brought into play: The story would interest a smaller audience *on a national scale* than would the stock market piece because it directly deals with more people's "environments."

The stock market affects all of us, even those of us who don't own stocks, because the market's behavior is a strong influence on employment creation and stability and interest rates,

[4]Melvin L. DeFleur and Everette E. Dennis, *Understanding Mass Communications,* 3rd ed. (Boston: Houghton Mifflin, 1987), p. 312.
[5]Ken Metzler, *Newsgathering,* 2nd ed. (Englewood Cliffs, N.J.: Prentice-Hall, 1986), p. 23.

just to name two factors. So anyone interested in working, applying for a loan or earning money on savings—which includes just about everyone—has a direct, personal interest in the story.

NEWS JUDGMENT

Having come up with a working definition of what journalists recognize as news, we're ready to evaluate *news judgment*, the quality that allows a journalist to gauge the importance of a story. At its root, news judgment is a matter of recognizing news *as news*; at a more advanced level, news judgment entails balancing the relative importance of stories.

Journalists are confronted with a myriad of story opportunities each day. Some stories clearly are news; some are not. Many fall into a maddeningly broad gray area. Because broadcast journalists have only a limited amount of time in which to present their stories, the menu will be narrowed to stories that are of some importance to the audience or, at the very least, are calculated to attract the audience's attention. But the nature of this selection process means that certain stories must be excluded. Which stories make the cut? That is a matter of news judgment.

Also, stories must typically be presented in relative order of importance. The lead story in a radio or television newscast assumes much more significance than the seventh story presented (unless that seventh story is a breaking news item injected as it happens). Which story goes first? Second? Third? That is one more aspect of news judgment.

Finally, time must be used wisely. Some television news stories merit 2 minutes. They are of major importance, have many aspects that should be covered and possibly are too complex to be boiled down to 15 seconds. But other items—the ribbon cutting at the zoo, for instance—merit only 10 or 15 seconds of coverage. We intuitively know that in a local newscast a major fire within our coverage area merits at least 2 minutes, whereas the zoo story—if it's not bumped from the lineup—rates about 15 seconds. But how about a fire versus a bank robbery? Or an exposé of fraudulent car repair shops versus a story on what to do if it's April 14 and you haven't finished your taxes?

FACTORS IN NEWS JUDGMENT

Many observers of news and news practitioners have developed categories that purport to represent the fundamental aspects of news judgment. However, there is no universal agreement, and one set of categories is probably as good as another. For the purposes of this exploration, we'll use five factors: *timeliness, magnitude, unusual aspects of the story, direct or indirect identification* and *drama*.[6]

Timeliness Most of us are interested in recent developments; hence the common expression, "Did you hear the latest?" Sometimes this interest in timely stories is a function of curiosity, while other times there is a direct need to know up-to-date information.

Our interest in the fire story was piqued because it was happening *now*, right this minute. We wanted to know all the details about a story of this importance—and we wanted them now, not tomorrow.

Timeliness in news is on rare occasions a matter of life or death for news consumers. On October 17, 1989, San Franciscans turned to their portable radios for information on what to do and what not to do in the wake of that city's killer

[6]These categories are from Carl Hausman, *The Decision-Making Process in Journalism* (Chicago: Nelson-Hall, 1990), passim.

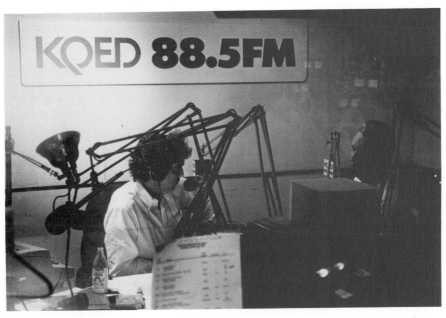

Figure 1.1 *Kevin Pursglove, host of KQED-FM's "Forum" program, interviews Lt. Gov. Leo McCarthy following the Oct. 17, 1989, San Francisco earthquake. (Photo courtesy KQED-FM, San Francisco.)*

quake. Radio, still the best emergency communications system we have, figuratively saved the day and may literally have saved lives. KQED used auxiliary power and a novel ad hoc power and networking arrangement to inform listeners about the ongoing fire in the Marina district, the collapse of various highway structures and relevant emergency procedures. Lieutenant Governor Leo McCarthy visited the emergency-powered studio to discuss state aid procedures for earthquake victims (Figure 1.1).

Magnitude The size and scope of an event has a direct impact on its newsworthiness. If many people are affected, a huge amount of territory is destroyed and a large sum of money is spent, you've got a story. The fire that led this chapter involved the loss of four lives; even though in the impersonal mathematics of the news business four lives might not guarantee newsworthiness on a network newscast, it *is* a compelling factor nonetheless. If 40 people died, the event would make the national news. If 400 perished, it would be one of the biggest stories of the year.

Unusual Aspects of the Story The "man bites dog" bromide still holds true in news. News is generated when something out of the ordinary happens. The event might not be anything earthshaking; it may even be downright silly. An example that comes to mind is a seasonal story given prominent national play over a period of years involving the ill-fated romance of a wild moose and a dairy cow.

Unusual aspects elevate a story in importance when they are coupled with a deadly serious side, too, such as the death of three fire-

fighters. While firefighting is a hazardous job, it is still rare for three firefighters to die in one blaze. The same is true for plane crashes; it is the atypical aspect of a plane crash—and not necessarily its magnitude—that draws news coverage. Three people killed in a plane crash will receive wider media attention than three people killed in an auto wreck because there is an uncommonness associated with vehicles dropping from the sky.

Direct or Indirect Identification A story about a fire in a downtown landmark is likely to interest listeners or viewers to a greater degree than a fire of similar import in a remote area. If it happened in a building that thousands of people drive by each day, the event gains in news value because people identify with the scene of the event and can, to an extent, picture the story in their heads.

The same theory applies to stories about famous people. We don't know them per se, but we know about them. We have some indirect, vicarious identification with them. Hence a story about comedian Richard Pryor's heart attack will receive wider coverage than will your dentist's cardiac woes.

To reinforce the theme of our chapter-opening example, we identify with fire stories strongly, on both a direct and an indirect level. Viewers in the local area know where the neighborhood is, and probably know the street, too. Hence the stronger appeal of the story to a local audience as opposed to a national audience: We identify more with events that are geographically close. There is also a large measure of indirect identification in that most of us have had some experience with a housefire—either having seen one or experienced one.

Another facet of identification is *impact*. The fire story might not touch us directly but, as alluded to above, it has an indirect impact. Further, as residents of the city, we have a pre-

sumed right to know why three of our municipal employees died in a fire.

Drama A drama is essentially a story, and newscasters are storytellers. At their root, stories are about conflict. It may be conflict of men and women against one of our oldest adversaries—fire. In other circumstances, the drama might center around the conflict of two people vying for a political office, or police attempting to stanch the drug trade.

Conflict by itself is not drama. Conflict can be stationary, but drama must *move*. Dramatic stories always are propelled toward a resolution of the conflict. For example:

> Candidate Smith has a conflict with candidate Jones. The conflict is secondary to the effect on the resolution: Who will win in November?

> Humans have a conflict with nature—four mountain climbers must be rescued from an avalanche. The conflict is clear: Can they be reached before they starve or freeze to death?

Good storytellers remember that the resolution is the key to the story, even if that resolution is not immediate. For example: The mayor and the city manager have a shouting match in public. So what? That's not really the story. *What's going to happen to the city manager?* Now *that's* the story.

Types of News

Journalists commonly use the terms *hard news, soft news* and *investigative reporting* as descriptors of the work they produce. In truth, there are no precise borders among these categories, and other categorical labels can be perfectly accurate. But a familiarity with these three basic areas does provide at least a common ground

for understanding the categories and subcategories of news.

HARD NEWS

Hard news is generally thought of as breaking news—that is, a timely story of great import. A fire is hard news. So is a city council meeting, a resignation of a politician, an arrest of a local clergyman.

Hard news is timely, although hard news does not necessarily have to be breaking at the moment it is reported in order to qualify as hard. But current, important occurrences are always hard news, and in some cases, when the time factor is of great importance (and the story is unfolding before our eyes or ears), we term such coverage "on the spot" or "spot" coverage.

The availability of live-news technologies has greatly enhanced the ability of broadcasters and cablecasters to deliver spot news. For example, in our fire story, crews from all over the city were on the air, live, throughout the story's development. In real life, journalists *do* race to fires, knowing that the very nature of breaking news rewards the reporter who gets on the scene first. And, racing to the scene of a fire *is* a gamble, because sometimes such stories don't pan out (a lot of smoke but no real fire, perhaps) and the efforts of many people have been diverted from other stories.

Bob Campbell, news director at television station WTHR in Indianapolis, faced exactly that decision on February 9, 1988, when a fire broke out in a downtown building. His decision? Send out the crews. "It's standard operating procedure," Campbell said. "If it turns out not to be news, at least we've gone through the exercise."[7]

[7]Interview, July 9, 1990.

But the story turned out to be frighteningly newsworthy. Fourteen firefighters were injured, and the story evolved throughout the day. Different aspects, different *angles*, assumed prominence as events unfolded. (More on that story follows later in this chapter.)

SOFT NEWS

A *soft* news story exists under many guises. In some shops, "soft" is synonymous with "human interest," meaning a story that has an appeal to basic human emotions but is not a timely item of impact.

But sometimes there's a thin line between hard and soft news, and on occasion soft news becomes hard news or vice versa. Here's an example: The coronation of a new Dairy Princess would, if it made the news at all, be an extremely soft story (in all but the smallest markets). It's soft because it's lacking in the values of timeliness and magnitude. It's not a breaking story that will have an impact on many listeners or viewers. (All right, it might be happening as we speak, but who cares?) The story's main appeal is human interest—young woman makes good, flashes pretty smile, extols the value of dairy products and so on.

But suppose the Dairy Princess disposes of a rival for a local farmer's affections by strangling her in the parking lot of a motel? (This actually happened in Marathon County, Wis.) The situation assumes a new perspective. A killing is most definitely hard news. It involves magnitude—the loss of a life—and when it breaks, it is timely and undoubtedly unusual.

Because of its unusual quality, though, the story will linger long after the immediate incident is reported. It will again assume proportions of a soft story and—reflecting the gruesome fascination we have with bizarre irony—will be treated in some cases as a *humorous* story. Vari-

ous national media, in fact, dubbed it the "moo-moo" murder.[8]

Some organizations call soft news "back-of-the-book" news; that term is used on many magazine-type shows. Note the direct allusion to the print media. Indeed, CBS News' "60 Minutes" is patterned after a magazine, with a selection of contrasting stories. Hard stories go up front, the way they usually do in a printed news-magazine, with the soft, feature material in the back of the "book."

Interestingly, "60 Minutes" in general and Mike Wallace in particular have garnered accolades for treatment of soft, back-of-the-book stories. Wallace, a keen observer of the arts (he once had the lead in a Broadway play) brings a deft touch to his interviews with personalities from the worlds of theater and classical music. When the memorable moments of the long-running show are chronicled, it is often the exchanges from the back of the book that are best remembered.

"Soft" does not mean unimportant. Wallace's back-of-the-book interviews may be light and witty, but they touch on some serious issues. For example, Wallace once illuminated a social condition worth serious consideration when interviewing Leonard Bernstein:

Wallace: Serge Koussevitzky, the man who led the Boston Symphony years ago, . . . was Bernstein's idol, and Kousse adored the young Lenny, nurtured him, saw his infinite possibilities. But Koussevitzky worried that one thing would stand in Bernstein's way.

Bernstein: It's the name, the *nom.* He said, "It will be open for you all the gates from the world, but it will nothing happen [if] you will not change it the *nom.*" And then he proposed the *nom* that I should change it to, which was "Leonard S. Berns." I lost a

night's sleep over it and came back and told him I had decided to make it as Leonard Bernstein, or not at all.[9]

Wallace's peer with the urbane feature, Morley Safer, is adept at illuminating the dark corners of the artistic temperament, which is exactly what he did during an interview with ballet luminary Rudolf Nureyev.

Safer: Do you regret that you haven't gotten married and had children and raised—
Nureyev: No!
Safer: —small Nureyevs, perhaps?
Nureyev: No, no. Suppose they were not as good as me? What would I do with those imbeciles?[10]

So never conclude that the soft story is necessarily less important than the hard, breaking story. Well-done soft news shows us meaningful and searching reflections of our society and ourselves.

■■■■■■
INVESTIGATIVE JOURNALISM

Investigative stories tend to be more hard than soft, but often straddle that line of demarcation because they are not necessarily timely. An investigative piece often is put together from information the reporter digs up purely on a hunch or idea, using his or her enterprise to construct the piece—hence the old-fashioned term "enterpriser."

An investigative enterpriser may be fashioned from things we see every day but take for granted. This was the case when WJXT-TV (Jacksonville, Fla.) Assistant News Director Nancy Shafran connected the similarities among the all-

[8]For verification, see *Newsweek* (July 9, 1990): 7.

[9]Transcript from Don Hewitt, *Minute by Minute* (New York: Random House, 1985), p. 145.
[10]Hewitt, p. 91.

too-common police reports on fatal traffic accidents. "Every few days the police would call us with another traffic fatality and give us the routine information," she said. "But when we [she and then–News Director Mel Martin] began to look more closely, there were some things the police reports did *not* reveal. For example, the official report would say, 'Car A hit Car B.' But the people in Car B didn't die because Car A hit them; they died because Car B hit a telephone pole."[11]

Digging more deeply, she discovered that everyday objects we pay little attention to— guardrails, telephone poles, even mailboxes— claim thousands of lives each year because they are poorly placed, creating deadly booby traps on the highways. WJXT brought in an outside consultant on highway safety and produced an award-winning investigative piece titled "The Deadly Drive Home." The story alleged that at least one-fifth to one-fourth of Florida's traffic deaths were linked to roadside booby traps.

This illustrates an important point: Investigative stories do not have to involve shocking revelations about presidents and senators. Like "The Deadly Drive Home," they can shed light on important situations a block away or right down the road.

Many stories are developed in this manner; reporters working on investigative pieces often follow up on something that seems normal, but somehow, for some reason, doesn't "smell" right.

For example, let's return to the fire story. Was there anything in the account that made your antennae tingle? What about the fact that the fire crews were so shorthanded that a civilian had to be enlisted to help raise a ladder? Taken by itself, that's not really a story. But suppose you have heard persistent complaints from

firefighters about budget cuts and understaffed trucks. Maybe you've got the beginnings of a story. You must proceed cautiously and meticulously, but there's a chance that the rumblings are real and that lives were lost because the fire department is understaffed or poorly managed. And if that is the case, why is it happening and who is at fault?

Or suppose you discover that the building had never been officially licensed as a rooming house, and thus had not been forced to conform to city fire codes? You're holding the thread of a news story: Is this common? Are there many other uninspected rooming houses in the city, possibly placing other people at risk? Who is responsible for enforcing licensing regulations, and why were those regulations not applied to this building?

The Relative Importance of News Stories

We have examined the factors that make a story newsworthy. Now, let's briefly explore a remaining factor in news judgment: the ability to weigh the importance of one story against another.

LEAD STORIES

One of the broadcast journalist's most difficult tasks is to determine which story runs first during the newscast (lead stories and story order within a broadcast are addressed at some length in Chapter 9). Running a story as a lead elevates it in importance. At the same time, the lead story is very important to the success of the newscast. After all, it is the hook that convinces the listener or viewer to stay tuned.

Sometimes, lead stories emerge naturally from the milieu of the day's events. Barring another catastrophe, the deaths of the firefighters

[11]Interview, June 7, 1988.

is the only sensible opening story *because it is the most important.* But in other cases, a story might be elevated to lead status because it is *exclusive* to one station. If yours is the only TV station with a live remote truck at the scene of the search for an escaped prisoner, that story will most likely lead the newscast because you beat the competition.

And sometimes the decision on the lead is a toss-up, or, more precisely, it is the producer's best guess as to which story will interest the most viewers or listeners and/or reflect most favorably on the station's news efforts.

STORY ORDER WITHIN A NEWSCAST

Other than in the case of the lead story, broadcast news does not necessarily involve presentation of all the stories in descending order of importance. Often, stories are grouped by similarity of content. If there were three plane crashes in different parts of the state, those stories would almost certainly be presented back to back at some point during the newscast, usually with transitions between the stories—"The same type of jet experienced landing-gear difficulties in Cleveland, when . . ." Sometimes stories are grouped by region: The international stories would be bundled together, as well as the state news items and so on.

HOW IMPORTANCE CHANGES WITH THE AGE OF A STORY

A final aspect of news judgment about a story's relative importance concerns its *age.* Generally speaking, a hard news story's newsworthiness declines with its age. Soft news is relatively timeless, but since soft news is often based on reaction to current trends or events, it has a limited shelf life, too.

Although it may seem obvious that new news is better than old news, don't forget that a news story is *not* a static event. It changes with time,

and while most stories decline in news value, some assume additional importance as new angles are developed or new events unfold.

WTHR-TV's coverage of the Indianapolis fire evolved through several stages in a matter of hours. As mentioned earlier, first a decision was made to commit a live crew to the event—a gamble because no one knew if this would become a major fire.

In fact, the fire itself would turn out to be of relatively small proportion, but at first it warranted coverage because of the factor of *direct or indirect identification.* Bob Campbell, WTHR's news director, phrased this concept in more specific terms: "Because this was a historic landmark in downtown Indianapolis, we knew there would be high interest in it from people who could just see it out their skyscraper window."[12]

The fire, in the Murat Shrine Building, turned out to be fairly routine. Until a floor collapsed, trapping six firefighters.

Now, the story met all the criteria cited on pages 8–10: timeliness, magnitude, unusual aspects of the story, direct or indirect identification, and drama. It was happening *now:* Live pictures were on the air less than half an hour from the time the fire started. It was *big:* Six lives were at stake. As Campbell noted, it furnished *direct or indirect identification.* And it overflowed with *drama:* firefighters trapped in a burning structure, families anxiously waiting outside the building, crews working frantically to free the firefighters.

WTHR, which later won an award for spot news reporting from the Society of Professional Journalists for its coverage of the event, kept the story fresh. That evening, the station presented a detailed recap of the fire and the floor collapse, the rescue, a history of the building and

[12]Quoted by Bill Swilsow, "Journalism's Best: The Winners of the 1988 SDX Awards Tell How They Did It," *The Quill* (June 1989): 41.

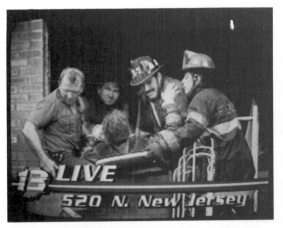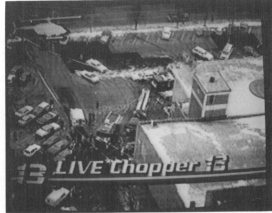

Figure 1.2 *The drama of live news. This fire was fairly routine—until a floor collapsed, trapping several firefighters. WTHR-TV in Indianapolis covered the story in depth, winning an award for spot news coverage. (Photos courtesy Bob Campbell, news director, WTHR-TV.)*

follow-ups of the condition of the firefighters (all were saved but one was seriously injured). Some scenes from the story are shown in Figure 1.2.

The situation was tense, fluid, unpredictable, and combined the routine with the unexpected. And that, of course, is the nature of the business of news.

SUMMARY

1. The definition of news is elusive, but it can be thought of as prompt, bottom-line information about an event that has a direct impact on a listener, viewer or reader. A joking but reasonably accurate definition of news might also be "news is what the editor thinks is news." That is, news does not become news until the person who controls a news medium puts it on the air or in print.

2. To an extent, news is a matter of routine: It involves obtaining answers to questions about which we are naturally, intuitively curious. In this aspect, it is not a mysterious process.

3. The ability to recognize what is news and what isn't is called *news judgment*. This is largely an acquired skill. Journalists learn the factors that make a story news: among them are timeliness, magnitude, unusual aspects of the story, direct or indirect identification, and drama.

4. While there are many ways in which news can be categorized, three useful primary categories are *hard news, soft news* and *investigative reporting*. There is some overlap among these categories, and other types of news may be considered subcategories.

5. A lead story in a broadcast assumes greater importance by its status as the first story used. But the rest of the story order may be determined by other factors, including the natural grouping of stories into related clusters, such as international news or a series of aircraft accidents.

6. News stories are not static events frozen in time. They can change from minute to minute, and the very nature of news involves staying on top of new developments, follow-ups on what has happened previously and freshening a story's angle.

EXERCISES

This chapter made several references to fire stories. While the purpose of this book is not to train you in covering fires, they are typical major local news stories and occur with unfortunate regularity in all markets.

So here is a chance to apply what you've learned about news judgment to coverage of a fire. The following text is an interview you have conducted with a local fire official. Like many such interviews, it is accomplished under time constraints; simply put, the fire official has other things to do.

Interview with Deputy Fire Chief Paul O'Rourke

Q: Chief, I'm recording this interview for my newscast in 5 minutes, so I've gotta do this quickly. I understand there was a major fire overnight?

A: Yes, that's right. Four-alarmer.

Q: Any fatalities?

A: Two people died . . . two kids. Andrew and Wyatt.

Q: Andrew and Wyatt what?

A: Andrew and Wyatt Davison.

Q: Address?

A: 211 West Valley View Avenue, Riverside.

Q: So what happened . . . could you sum it up for me?

A: We got the call at 3:35, sent in fire apparatus. Father and mother were out of the house, told us kids trapped inside. We called in additional units. The rescue squad tried to get into the house but they just couldn't do it. The heat and flames were too intense.

Q: The bodies of the boys were recovered?

A: Yep, found under the beds . . . what was left of the beds.

Q: What were the ages of the boys?

A: Andrew 4, Wyatt 3.

Q: What are the names of the mother and father?

A: Alex and Kirsten.

Q: Anyone else live at the house? Anybody in the house?

A: No.

Q: How long did it take to put the fire out?

A: It took almost an hour to knock the fire down . . . and we almost lost some men when

the roof caved in. One fell through to the floor below. We had to run a ladder up to the window and pull him out. He broke his leg.

Q: What's his name? The fireman who broke his leg?

A: Martello. Lieutenant Paul Martello.

Q: When did that happen?

A: When did what happen?

Q: When the roof caved in?

A: About 4:30.

Q: So then what happened?

A: We just kept pouring water on it. The house is destroyed . . . burned right down to the foundations. It's still smoldering.

Q: Any other firefighters injured?

A: Well, a couple were treated for smoke inhalation. The usual kind of thing. They were released after a few minutes at the hospital. I don't really know how many or who they were.

Q: So the parents were all right? They had to watch the house burn down with the kids inside?

A: Yeah, they both had to be restrained from going back into the house. But they were uninjured, far as I know.

Q: Any idea what started the fire?

A: The father reported hearing an explosion downstairs, so it could be a gas leak. Looked like it, too—the foundation walls were blown outward. But you didn't get that from me, right? Call the fire prevention office, they're investigating. Listen, I gotta go. Call me back later.

1. Identify, in descending order of importance, the five most significant factors you can glean from this interview. Make each factor one complete sentence of reasonable length; try to keep each factor (sentence) focused on one specific idea. Don't worry about style or format (that will come later). Simply write the five complete sentences.

2. Tell as much of the story as you can in 75 words or less. Do not attempt to write the story in broadcast style. Instead, write it as if you were telling a friend, over the phone, what happened last night at 211 West Valley View Avenue, Riverside. Be certain to include the major points you identified in exercise 1. Remember, though, you are scripting an imaginary *conversation*, not a news article.

3. Your instructor will ask you and other members of the class to read the stories aloud. Critique the stories using the following two criteria:

 a. Does it sound like a natural conversation? Is this the way a friend would really speak to you over the phone when relaying a story about a tragic fire nearby?

 b. Does it cover all the points in those 75 words?

2

SOURCES
OF NEWS

Newcomers to journalism often feel overwhelmed by the sheer volume of information that comes their way. How is it possible for a handful of people to keep tabs on the workings of the city, state, nation and world?

Physicians often feel the same way on their first night of emergency room duty. How can a few doctors and nurses keep track of all those illnesses and injuries, and how can they identify and treat the people who immediately need help?

While training and experience play a role in both scenarios, an important factor in the daily job of making order out of chaos is *routine*. Emergency rooms have established protocols for handling medical problems, which is why they can (usually) handle whatever comes their way.

Newsrooms function similarly. Established routines allow journalists to keep a handle on all the sources of news that they encounter. This chapter will focus on the ways in which events are channeled into the broadcast newsroom, which is something like an emergency room of current events. Specifically, this chapter will examine: *the standardized routines that make gathering news from various sources a manageable task; the ways in which stories recur and allow journalists to anticipate them; the regular sources of news that provide information to a news department* (including wire services, networks and satellite news feeds, and public relations agencies); *news that emanates from events* (such as press conferences, public spectacles and emergencies); and *the sources of news known as beats.*

The News Routine

Remember the reference to news being the same things happening to different people? From the journalist's point of view, that quip reflects a fundamental truth. In fact, if it didn't, we would

be hard-pressed to come up with a coherent strategy for covering the news.

News departments plan for the expected and, as far as possible, for the *unexpected*. Stations in California and other shaky territories, for example, have contingencies for covering earthquakes. Many of those stations, incidentally, have modified their plans based on their recent experience.

Stations in the snowbelt have standard procedures for covering major storms (often including contingency plans for transporting staffers to work). News organizations in floodplains typically give considerable thought to what will happen if the river rises.

RECURRING STORIES

The news department also expects the *expected*. The city council meets regularly, as do a host of other government agencies. Police don't arrest criminals on schedule, but they do make their arrest records available, and most reporters have a specific check-in time where they call or visit police agencies to find out who has been charged with what.

Dozens of other newsmaking organizations schedule their announcements and conferences well in advance. The local labor department typically releases monthly unemployment figures—always of interest in depressed areas of the country. Although the weather changes from day to day, we have routinized the collection of weather data, and the news department receives forecasts, maps and other information on a regular basis.

National and international events generally are not planned per se, but broadcast journalists do receive summaries of such events on a rigidly adhered-to schedule. (The mechanisms involved will be explained shortly.)

Mail arrives at a TV or radio station by the bushel, and each day's bagful contains a number of items that may prove newsworthy. News

also comes from the sky, with audio and video feeds coming to the station via satellite on a predetermined schedule.

HOW A REPORTER ANTICIPATES THE DAY'S NEWS

So, to a limited extent, we know most of what will happen during a given day, or at least we know where, when and how we will receive information about the events for which we cannot plan.

For instance, when a reporter begins a typical shift, he or she reads the *daybook*, a list of the day's upcoming events fed by a wire service.

In addition, reporters can pull from the station's *futures file*, a collection of notes and documents filed by date of planned events. For example, a state senator's office might send a press release (a document directed to the news media) notifying the station of the senator's planned appearance at the county grange hall to discuss a program of disaster relief for area farmers. That press release would probably carry the text or general description of what the senator is going to say, a tactic designed to assist reporters in covering the event.

Reporters also have preplanned stories on which to follow up. Our reporter might, for example, have scheduled an appointment to visit the local hospital today for a story about rehabilitation of head injury patients.

A clear picture of the day begins to emerge, even from these modest descriptions. Now, let's observe the station's news day unfold a bit further. In addition to the daybook, futures file and stories generated by individual reporters, the station's news director (the head of the news department) or assignment editor (usually one of the next people in the hierarchy) will assign reporters to cover various events. That is an intricate task, but news directors have enough experience to know how long the events will take, how long it takes to get from place to place, and

how much time the reporter will need to write and produce the story.

There are some other news sources that aid in the planning effort: for example, the results of the police calls. Every news department has a list of telephone numbers of law enforcement agencies, which are called on a regular schedule (if staffing permits, these agencies may be visited personally). In addition to producing the raw material for news, the police logs also provide information about events yet to happen, such as when an arraignment is likely to take place.

Another resource is yesterday's news and today's newspaper. (Since most morning newspapers are put to bed between midnight and 3 a.m., yesterday's broadcast news and the morning newspaper might be identical, depending on how late the broadcast news shift worked the previous evening.) Several follow-ups might be generated from a careful inspection of loose ends in old stories. An example might be an investigation into why the fire department was so short-handed that it had to ask a civilian to help raise a ladder during the recent fatal fire.

Now the news director or assignment editor knits this information into a schedule for the reporters on duty today. Sometimes the schedules and assignments are typed out, often they are written with marker on a plastic placard, and increasingly they are entered into the station's computer system. A reporter's assignment sheet might look like that shown in Figure 2.1.

Our tidy schedule might, of course, disintegrate if a major story breaks. While the plight of local dairy farmers deserves attention, all bets are off if a downtown bank is robbed or the mayor has a heart attack.

While the news is a product made fresh every day, each day's work does not start from ground zero. Note, too, that a news department does not have to gather every tidbit entirely through its own efforts. In fact it is impossible for *any* news organization to be in all places at all times.

Because of this, news departments rely on various services to provide news and information.

News Services

The daybook is an example of a news service. It is one of the many news and feature items provided by a *wire service*. Also in the category of news services are *networks, independent satellite news-feed services* and *freelancers*.

WIRE SERVICES

The term *wire service* is a holdover from the days when news was fed by wire, and it's still commonly used even though most modern wire service transmission comes via satellite. The wire service provides local stations with reliable and timely coverage of regional, national and international events.

There are two major wire services furnishing general news in the United States, The Associated Press (AP) and United Press International (UPI). The Associated Press is the larger of the two wire services, and the elder; it was founded in 1848, when it became apparent to a group of newspapers that they could save time and money by sharing news from an incoming telegraph wire. AP hit its stride during the Civil War when the country was hungry for news. And, as a side effect of war coverage, AP changed existing standards for news reporting.

In pre–Civil War America, objectivity was not a tenet of the news business. Much if not most reporting was openly partisan. But because AP had members on both sides of the Mason–Dixon line, its reporting became, of necessity, *objective*—meaning that the service provided fact that was not filtered through a layer of political bias and advocacy. We take this principle of objectivity for granted today, even though there is

Figure 2.1 An example of a list of assignments given a reporter.

11:00 a.m.	Cover strikers' march at Eldridge Co. Have live feed for noon cast. If you can, feed back some prerecorded stuff about 11:30 and lead into it during your live noon spot. Be careful . . . it got rough last time. Stay near the police.
1:00 p.m.	Interview Dr. Myers at Head Injury Treatment Center, Memorial Hospital. Need two-parter for Health and Healing series; can you have by Thursday?
2:45 p.m.	State Sen. Curcio at county grange. He's going to talk about state disaster relief for dairy farmers. There's been so much rain that they can't get their tractors into the fields and so they can't harvest the feed. Grange is at intersection of Routes 122A and 16—at least 30 mins. from downtown.

considerable debate about the precise definition of the term.

AP provides news primarily to its *members*. That's a distinction AP is careful to point out, because the organization is owned by the news organizations that use it. It's a *cooperative*, meaning its members are entitled to use what is on the wire and AP is entitled to news produced by its members. (The ostensible distinction is that other types of services simply sell news and information outright, but because AP does sell its services and other news organizations share information, the precise differentiation is growing fuzzy.) At recent count, AP has more than 5,700

members among radio and television stations, and serves roughly 1,400 daily newspapers. According to the Associated Press, the service reaches more than 1 billion people in 108 countries every day.

AP's major United States competitor is UPI, which stands for United Press International. UPI is smaller than AP, younger and less financially secure. The organization underwent a series of ownership and structural changes in the 1980s, but despite its history of financial problems it remains viable, well-respected and scrappy. UPI prides itself on speed. In fact, it reported the end of World War I four days before any other news organization—primarily because it reported the event four days before it actually happened; but that's another story, one that UPI is still trying to live down. Other than that miscue (and do not be misled—AP and every other news organization have made whoppers, too), UPI enjoys a well-deserved reputation as a competitive underdog in the wire service business; the service is especially well-liked by broadcasters.

UPI was the first wire to offer broadcasters a separate service. The broadcast service started in 1935, when the organization was still called the United Press. The United Press (UP) was founded by Edward Wyllis Scripps, who was disenchanted with AP; the International News Service (INS) was the brainchild of William Randolph Hearst. In 1958 the two merged operations and acronyms, and became UPI.

There are other news services in operation, such as the British-based Reuters, and many syndicates and public relations organizations supply news and information in a manner virtually identical to the wire services. But AP and UPI provide the vast majority of wire service copy to American news outlets, so a more detailed examination of their operations is helpful.

How a Wire Service Works Wire services' operations sometimes seem mysterious to the end users, who see and utilize the incoming in-

formation but may not have a full understanding of where that information comes from, how and when it is delivered, and what the various codes attached to the stories mean. Broadcast news people can and do survive by just "ripping and reading" what comes off the teletype (actually, the teletype has given way to the dot matrix printer, and now many stations feed the wire service directly into the computer system), but a better understanding of the wires is useful.

Many reporters never learn the full scope of services offered by the wire. At least from my personal experience, it seems that news staffers are rarely given a complete rundown of what comes across the wire, and when. The fact is that the wire services provide excellent documentation of their services. For some reason, that documentation seems to wind up filed away in the station manager's office, out of sight of the people who really need to know about the wide array of news, features and other services offered.

Broadcast Wires The fundamental structure of wire services begins with the differentiation between print and broadcast wires. AP and UPI offer separate services for print and broadcast outlets. The newspaper wires, called "A wires," move stories written primarily for use by newspapers. ("Move," like "wire service," is a verbal throwback to the days when stories moved over the wires in Morse code; while technology in the news business changes rapidly, the vocabulary doesn't.) The broadcast wires of AP and UPI furnish stories already written in *broadcast style,* ready to be read aloud over the air.

Broadcast style is better demonstrated than explained. You can intuitively deduct the difference between print style and broadcast style by comparing the A-wire version of an AP story (Figure 2.2) with the broadcast wire version (Figure 2.3).

We will be examining broadcast style at length in upcoming chapters, but this is the appropriate

Figure 2.2 *A-wire version of an AP story.*

ALBANY, N.Y. (AP)_Gov. Mario Cuomo's plans to increase travel outside New York, and his attacks on Bush administration policies, shouldn't be viewed as an embryonic presidential campaign, a top aide said Friday.

"The governor has no plans and is not making plans to run for president," said Anne Crowley, press secretary to the New York Democrat. "Nor does he plan to make plans."

The Los Angeles Times reported Friday that Cuomo would use a stepped up travel schedule to challenge President Bush on what Cuomo called the president's "fundamental lack of direction."

Cuomo told the newspaper that he would speak "wherever they will give me a platform." He didn't say he would run for president but said that Democrats "do have to get the process started soon" for selecting a 1992 candidate.

At a brief appearance Friday in New York City with an official of the Russian Republic, the governor was asked, "how does this (appearance) dovetail with your presidential ambitions?"

"Only in the mind of the confused," Cuomo responded.

Earlier, Crowley said the governor "travels around the country all the time" and would continue to attack federal policies that concern him as a governor.

In the past two years, records show, Cuomo has made as much or more money from speeches, often in other states, as he is paid to be governor, $130,000 a year.

Several months ago, Cuomo said he would step up his travel schedule once a new state budget was adopted. It is now more than three weeks overdue.

Despite that setback, such diverse political figures as former U.S. Sen. George McGovern, the Democrats' 1972 candidate for president, and former President Nixon have said Cuomo would be the strongest Democratic challenger.

For months, prospective candidates have been reluctant to take on Bush, who is riding a wave of popularity from the Gulf War. Only former Sen. Paul Tsongas of Massachusetts has scheduled an announcement of candidacy.

AP-NY-04-26-91 1727EDT

Figure 2.3 Broadcast wire version of story shown in Figure 2.2.

Here's the latest New York state news from The Associated Press:

(Los Angeles_Cuomo Tour_new)

It's the strongest indication to date that Governor Mario Cuomo is considering a bid for the Democratic presidential nomination next year.

Cuomo told the Los Angeles Times he's preparing a national tour to attack the Bush administration's domestic policies. He faults President Bush for what he calls "a fundamental lack of direction." And the New York governor says he'll travel to wherever he can get a platform.

Although Cuomo has not said whether he will definitely run_he says the Democrats have to get the process started soon and field some candidates for the nomination.

For months_prospective Democratic candidates have been reluctant to tackle the extraordinarily popular Republican president.

Only former Massachusetts Senator Paul Tsongas has said he will be a Democratic primary candidate.

Cuomo's comments were published in today's L-A Times.

place for a brief introduction to the differences between writing for the ear as opposed to writing for the eye. As you have already gleaned from your examination of the wire service copy, broadcast style is shorter, more conversational and much more verbally lean than newspaper style.

Why the difference? Aside from the obvious difference that it is meant to be read out loud, broadcast news has to be *heard*. That is, it must be comprehensible and clear to the listener or viewer *the first time it is heard,* because a listener/ viewer does not have the opportunity to review the previous sentence or paragraph. Also, broadcast copy must be comfortable prose that mim-

ics everyday speech. Building on this approach, a writer for the broadcast wires—indeed, the writer of any broadcast copy—will follow the guidelines described below.

The biggest difference between writing that is to be read on the printed page and writing that is to be read out loud is that *out-loud writing follows normal speech patterns.* If you were to tour any broadcast news center—be it a wire service, television/cable station or radio station—you would see writers talking to their typewriters. What they're doing is not an overreaction to job stress: They are saying each sentence out loud as they write it to be certain that it *sounds* natural. Writers who talk to the typewriter also are hunt-

ing for hidden tongue twisters, such as "Sixty-six separate businesses sold stock options . . ."

In addition, broadcast writing is shorter than newspaper writing, in terms of both sentence length and story length. Twenty or 25 words is about the top limit for a sentence that can be comfortably read aloud, without forcing the newscaster to gasp for air. Most broadcast stories don't exceed a minute in length (radio stories are usually much shorter than a minute).

The time limit naturally invokes a limit on the amount of copy that can be written; at a typical reading rate the maximum number of words in a 1-minute story will be about 150. Some newscasters read as many as 200 words per minute. Most wire service copy has about ten words on a line, so about 15 lines of copy will fill 1 minute. About eight lines will comprise 30 seconds' worth of airtime.

Just by observing the physical constraints, you can see that broadcast writers must tell the story quickly and compactly. (Most standard typewriters produce about ten words per line, too, but script formats at different stations affect the length of the line and most news department typewriters use a large-size typeface; so the only way you'll be sure of your calculations is to time yourself. That's why those people talking to the typewriter often have a stopwatch in their hands.) Counting lines is a good way to *approximate* time but it has its limitations. I generally do not advise heavy reliance on this practice, but mention it here because line counting is used by many journalists.

Another guideline for broadcast copy is that *attribution* is put before the statement. *Attribution* simply means the source of the information. For example, in broadcast copy we would usually write:

Senator Norris said there is an alarming lack of concern about the issue.

A newspaper reporter would be more inclined to phrase it this way:

"There is what I perceive to be a shocking and alarming lack of concern about this issue," Senator Wayne B. Norris said.

Tying into this practice, direct quotes are not generally used in broadcast copy. Quotes from newsmakers are paraphrased, unless—obviously—the quotes are recorded on audio- or videotape and played back during the newscast.

There are two basic reasons why we paraphrase. First, paraphrasing makes the story more compact. Using direct and complete quotes from politicians, for example, would eat up a great deal of the newscast's allotted time for local news and might threaten to consume the weather and sports segments, too.

Second, there is no convenient way for a broadcast writer to indicate a direct quote. We can't have announcers constantly saying "quote" and "unquote" to indicate where the quotation marks are. The only time broadcasters routinely use an indication of a direct quote is when the quote itself is so outrageous that we want no ambiguity about the source of the words, or want to make it plain that we are not putting idiotic words into his or her mouth. For example, it would be proper broadcast style to write:

Senator Smith said, and this is a direct quote, All the staffers involved in the scandal should be lined up against a wall and shot. . . . end quote.

To sum up so far, the major difference between copy on the A wire (newspaper) and the broadcast wire is that broadcast copy is conversational, shorter than newspaper copy, puts attribution first and paraphrases quotes. More detail on broadcast newswriting follows in the appropriate chapters, but the above principles are the keystones to understanding the differentiation among wires.

Another point we should clear up before moving on involves the terminology of the wires themselves. The print wire is called the A wire but the broadcast wire is generally not called

the B wire; that's because "B wire" originally meant another type of newspaper wire that fed stories that were not very important. So the broadcast wire is called just that, or it is called the radio wire.

It is possible that if you pursue a career solely in broadcast news you may never encounter an A wire, but large-market broadcast news operations do subscribe to the A's. The A wire provides significantly more detail than the broadcast wire. At major-market stations most wire copy is rewritten anyway, so it does not matter very much if it comes across in print or broadcast style.

You may encounter other wire services. Major cities have local wires, which serve not only as sources of news itself but as calendars of events happening that day. The daybooks produced by the local wires are invaluable in planning coverage. Some stations utilize wire services provided by public relations firms (public relations agencies are discussed later in this chapter).

How the Wires Operate In most cases, your first and primary contact with wire services will be through AP or UPI broadcast wire. Specific operations vary, but both wires function in roughly the same fashion. Here are seven key points of their operations:

1. Both AP and UPI have powerful sorting programs that can customize service for their users; thus a station can choose in advance what it wants to receive and how much material it will get in various categories. Until a few years ago, sorting news was not much of a problem. We drove nails into the wall of the teletype room, wrote labels like NATIONAL, SPORTS or WEATHER above them, and stuck the ripped-up copy on the nails. But within the past five years or so the amount of copy available has multiplied, and the nail-sorting system has become cumbersome, although many stations still use it.

 In order to expedite the sorting process, wire services print some apparent gibberish at the top of the story. It's not crucial to be able to translate the code, but it might interest you to know a little about the symbols, so I have included an example in Appendix A.

2. Wire services will print out, in plain English, the "alert level" of an important story. (Remember, most of the coding standards discussed above are for computer sorting; when an important story breaks, the wire services want the humans to know about it, too.)

 The most important alert level of a story is *FLASH*. This is an extremely rare designation and is reserved for the most critical of stories. I have personally witnessed only two flashes move across the wire: NIXON RESIGNS and PRESIDENT REAGAN SHOT.

 Next in priority is *BULLETIN*. A bulletin is breaking news on an important story.

 URGENT, the next level of priority, is not as urgent as, say, an urgent phone call. The word describes a breaking story, but one that is of some general importance.

3. Wire services send various *content advisories* to subscribers. While these advisories are not news per se, they can be very important. The granddaddy of advisories is the no-nonsense command *KILL*, which means "under no circumstances use the story that was just moved, kill it, it is no longer to be aired." Kills are filed after the truthfulness of a story has been called into question or it has simply proved to be wrong. Take a kill advisory seriously, because if you air the story after it has been killed, it is possible that your station, instead of the wire service, could be sued for damages caused by the error.

 A *CONTENT ADVISORY* alerts stations that the story that follows may, for some reason, be objectionable. Advisories on content often are made about stories with graphic descriptions of violence or sex. Sometimes, they reflect a rather stuffy concern with the delicacies of public taste. UPI, for example, once fed an advisory on a report of an im-

pending toilet paper shortage. (The advisory was probably prompted by the reporter's closing remark that this is an issue likely to "touch every American.")

Sometimes, a story is *EMBARGOED,* meaning that it must be held for release until a specified time. Embargoes are often placed on the text of a speech. A speech is released in advance to allow reporters to file their stories more quickly. It is considered very bad form to break an embargo, and good manners are only one reason for this attitude. Sometimes, you see, speeches embargoed for later release are not given. On one exceedingly rare but obviously mortifying occasion, the person slated to give a major speech was killed before he could deliver it—but the text of the speech had already been reported by some news organizations.

4. Wire services use other types of advisories as well. They advise about future programs, schedules for upcoming feeds, and, most importantly, offer details on updates and reorganization of the news copy.

A new lead on a fast-breaking story, for example, is usually indicated by an advisory message. In the case of an updated report on a traffic accident, UPI clued in its subscribers to what was new in the latest version of the story. UPI puts these update advisories before the slug. Here is how it looks:

```
(complete writethru _ 66 kids on
bus; adding details, quotes)
16 kids killed in school bus
accident
ALTON, Texas (UPI) _ A crowded
school bus collided with a
tractor-trailer rig Thursday and
plunged into....
```

"ALTON, Texas" is the "dateline," the place from where the story originates.

5. The broadcast wires contain *pronouncers,* phonetic spellings of unfamiliar words, places

and names. The "prono-guide" is moved in the early morning, and contains listings of expected tongue-tiers to come. UPI's very helpful guide lists the word and an identification:

```
AL FATAH (AHL-FAH'-TAH), ARAB
GUERILLA GROUP, P-L-O BRANCH
```

Pronouncers are also written directly into the news copy, in parentheses immediately following the unfamiliar word.

6. AP and UPI have state bureaus that take over wires for a scheduled part of each hour and feed what's called the "state split." A schedule is fed in advance so you will know when to expect the state split.

7. In recent years, both AP and UPI have diversified the types and numbers of services they offer. Custom-tailored services too numerous to describe here meet the needs of stations with various formats and news appetites.

Of particular interest to radio reporters are the audio services offered by the wire services. A vast array of radio material is fed by satellite to local stations. UPI feeds— among other material—5-minute hourly newscasts, a 1-minute hourly headline service, 14 2-minute sportscasts per day (2½ minutes on weekends), 13 business reports, three reports per day from investigative reporter Jack Anderson, weekly public affairs panel discussions and 19 hourly news feeds. The news feeds contain reports from staff journalists as well as brief taped interviews with newsmakers. UPI depicts its schedule on an easy-to-scan "clockface," which is often posted in news and radio control rooms (Figure 2.4).

The news feeds offer cuts that can be incorporated into a local newscast, and are billboarded in hardcopy by the audio producers. An example of a billboard is shown in Figure 2.5.

Billboards come from many news services and private publicity agencies. While billboards

UPI RADIO NETWORK

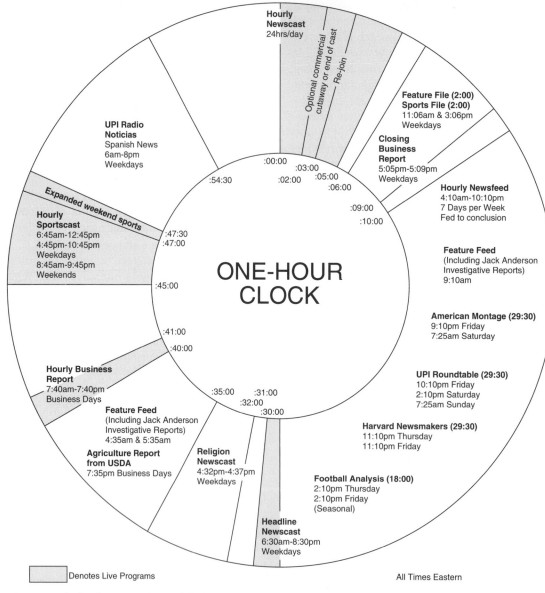

Figure 2.4 *A visual representation of the feeds from UPI audio. The clockface is a handy tool for broadcasters, who learn to think in terms of parts of the hour. Note how much easier this clockface is to quickly comprehend than is a list of coming events. (Reprinted by permission of UPI.)*

Figure 2.5 Example of a billboard.

```
_FOLLOWING CUTS FED AT 6:10 E-S-T:

11  :49 V NY_(ECONOMY)_(MARK ROBINSON) TOP ECONOMISTS ARE
WARNING THAT DESPITE ENCOURAGING ECONOMIC INDICATORS,
RECESSION MAY STILL BE LOOMING.

12  :56 V-A WA_(ENVIRONMENT)_(MARY SANCHEZ WITH NATIONAL
SCIENCE FOUNDATION RESEARCHER MORGAN STANLEY) RECORD
RAINFALL IN THE NORTHWEST MAY BE DUE TO POLLUTION, SAYS A
LEADING GOVERNMENT RESEARCHER.

13  :12 A NY_(POLITICS)_(POLITICAL ANALYST JOHN LEWIS) THE
CAMPAIGN SEASON BEGINS EARLIER EACH ELECTION, AND THAT'S BAD
NEWS FOR THE VOTERS (NEVER SEEMS TO END).
```

vary in detail, almost all have a cut number (the first number preceding all other information), which is simply an arbitrary indicator. Next comes the dateline (which indicates where the story originates), the time of the cut and an indicator of whether the cut is a voicer (V), a voice-actuality (V-A) or an actuality (A).

The subject and the reporter's name are generally written out. If the cut is an actuality or voice-actuality, the name of the newsmaker being interviewed is specified too. Next is a sentence or phrase that can be used to lead into the cut. In the case of an actuality, the outcue is specified. Look at cut #13 in Figure 2.5: The last words political analyst John Lewis will say on the cut are "never seems to end." (Details about voicers, actualities and voice-actualities will be presented in Chapters 5 and 6.)

NETWORKS

Television and radio networks also provide their affiliates with news that otherwise would be impossible for the affiliates to gather independently. Radio and TV networks, including NBC, ABC and CBS, provide audio and video news to their affiliates. NBC, for example, provides six video news feeds to affiliates each day.

If you are wondering why NBC is categorized as a "network" while AP is called a "wire service," you are raising a valid question for which there is no clear answer. AP's audio feed is a *network* in the same sense of the word as the division of NBC that provides an audio feed. And as we will see shortly, stations that have no affiliation other than geographical proximity are taking advantage of new technology to create informal, ad hoc arrangements, which, for lack of a better term, are networks as well.

"Networking" has become vastly more simple since the 1970s and early '80s. Creating a network was once a very big deal. Expensive transmission lines had to be purchased or rented, and installation of the hardware was tedious and complex. But today, network feeds are usually transmitted by satellite, and the process of networking has become almost as simple as placing or receiving a phone call.

Here's how it works: Communications satellites (Figure 2.6) are "parked" in orbit over the earth's equator. They are figuratively parked because their orbit is exactly synchronous with the earth's rotation. This is called a *geostationary*

Figure 2.6 *The satellite (obviously not drawn to scale here) orbits more than 22,000 miles above the earth in a geostationary orbit. The transponder on board the satellite picks up the signal from the uplink and retransmits it to the downlink. The satellite's "footprint" can cover about one-third of the earth's surface.*

orbit. Since the orbiting satellite is in the same position relative to the earth, anyone who wants to transmit a signal can do so by pointing a relatively inexpensive satellite dish in the direction of the orbiting "bird." All one needs to do is rent time from the owner of the satellite.

Using coordinates to aim the dish at the satellite, the person doing the transmitting simply points and shoots. The satellite uses a *transponder* to receive the signal coming from the earth and beam it back down to the planet.

That beam—by the time it reaches the earth—is quite large, sometimes as big as a third of the earth's surface. Anyone with a receiving dish lo-cated within the area where the signal falls, known as the satellite's footprint, can pick up the signal.

Networks such as NBC, CBS and ABC, as well as PBS and other radio networks like Mutual, use satellite technology for most of their network connections. In addition, a new entrepreneurial type of news business is taking advantage of satellite technology.

Independent Satellite News-Feed Services As one example, a firm called Conus Communications feeds news footage, packages, live reports and produced news programs to, at last count,

140 stations around the globe. CNN Television in Atlanta, in addition to its familiar cable news programs, also provides daily satellite feeds, called CNN Newsource, as well as printed rundowns and scripts. Such services are becoming common tools of the trade even in medium markets. WPBN Television in Traverse City, Michigan, receives 20 feeds per day: six from NBC, nine from CNN and five from Conus. WPBN News Director Judy Horan points out that, ". . . in some instances, we're getting better service from outside organizations [meaning, not network-affiliated]. . . . They all give something a little bit different."[1]

TV stations often opt for a large menu because the wide array of choices allows them to pick and choose video that best suits their particular format. CNN, for example, often offers very short items, useful in the environs of a cramped newscast.

Big news-feed menus are expensive. KPRC-TV in Houston subscribes to the NBC feed (Skycom), a California-based feature service called NIWS, a separate medical-news service operated by NIWS (Group W News Services) and a sports highlight satellite feed. The bill, estimates News Director Paul Paolicelli, comes to about *$300,000 per year.*[2]

But for stations engaged in the deadly serious business of providing more and better pictures in hopes of garnering more and better ratings numbers, the price may be worth it. TV stations want and need breaking coverage— and not all newspeople arrive at the scene at the same time. So stations now have the option to pick and choose from the video and audio bartered and sold through the satellite services, searching for the most complete, up-to-date and compelling raw material for their newscasts.

[1] Quoted by Rob Puglisi, "Satellite News Feeds: Many New Sources," *Communicator* (November 1988): 10.
[2] Puglisi, p. 17.

FREELANCERS

Although not a news service in the same sense as wire or satellite feeds, some of the day's news comes from *freelancers,* independent contractors who provide radio or television scripts, audio, video or all three.

Although some do thrive in the business, broadcasting has never been particularly receptive to the concept of freelancers. In part, this is because the equipment traditionally was so expensive that broadcasters could not freelance in the same way as did magazine writers. But there are a good number of freelancers, particularly camera operators, who make it their business to be where the regular crews are not.

For a news director, the advantage of using a freelancer is that the person is paid per piece; that is, a report is purchased as a product, and the station is not obligated to buy any more pieces or to pay the reporter's medical plan, vacation time and so forth. But bargains carry a price. Freelancers do not depend on one station for their entire salary, and in rare cases may provide shoddy or even phony footage. Do *not* interpret this as an indictment of freelance journalists, because it is not meant as such; indeed, that is how I make part of my living. But it is an inevitable reality that a news director will not know freelancers or be able to control them as well as staffers.

Some news organizations have found themselves waist-deep in ethical hot water because of the use of freelancers; CBS News was in an awkward situation recently when the authenticity of a tape showing a disaster in Afghanistan was challenged. And the situation is becoming more confused by the proliferation of home videocameras; they produce pictures that are, while not of high technical quality, perfectly usable in a TV newscast. But again, using this type of footage requires faith in an unknown supplier.

Furnished News

The same caveat applies to "news" generated by people in public relations. No blanket condemnation of PR is intended here, but it stands to reason that a document or audiovisual piece produced by a business or organization probably won't be a model of objectivity.

Furnished news sources require some special handling. Let's quickly summarize the nature of furnished news, looking at: *press releases, the role of public relations agencies and their clients, video and audio press services,* and finally, *how to evaluate the newsworthiness of something furnished to you.*

PRESS RELEASES

A "press release," which is more commonly called a news release by public relations practitioners, is defined as a document issued by an institution, and sometimes an individual, for use by the news media. Press releases are written in newspaper style (often by ex-newspaper writers) in such a way that a newspaper could, if it wanted, insert the item verbatim. Many newspapers do precisely that. Although this practice is arguably an abdication of newspapers' roles as arbiters of the news, it does reflect the fact that many publications are not able or willing to independently rewrite every story, or check out every press release that comes through the mail.

Radio and television news departments generally do not use press releases verbatim—not out of an inherently higher moral stance than newspapers, but because press releases are written in the wrong style for reading out loud. Sometimes press releases are given a once-over rewrite, or they may be used as springboards for gathering stories, as a starting point rather than an end product.

But more often than not, press releases are simply thrown away. There are just too many of them to fit into a newscast, or they may be of dubious origin, or they may have no real news or feature value. Others, however, are legitimate news items.

PUBLIC RELATIONS AGENCIES AND THEIR CLIENTS

Not every press release is the result of someone trying to get a free plug for a product, service or organization. However, there is nothing *wrong* with soliciting a free plug for a product, service or organization that is newsworthy. A press release announcing the opening of a new division for a local factory is news; but of course so is a press release announcing the closing of a division. A press release from a local university featuring comments from an economics professor about the city's current tax problem seems like legitimate news, and so does the unfortunately all-too-regular press release announcing the university's tuition hike for next year.

We've just used examples of good news and bad news in press releases, which raises the question of why anyone would issue a press release that reflects unfavorably on an organization. The question can be answered more fully by examining the nature of public relations agencies.

Note that although the word *agency* is used as a matter of convenience and convention, not every group hires an outside agency. Many if not most organizations have an in-house department or staffer to take care of the PR function; a good example is the office called "public relations," "communications" or "news bureau" found in almost all colleges and universities. But for the sake of simplicity we will use *agent* and *agency* to refer to any PR-generating person or group of people.

This raises another question: What is public relations? You might think that this discussion seems overly academic, or is an excursion into hair-splitting, but the definition of PR is hotly

debated within the industry. It is such an umbrellalike term that almost anyone can claim it as a profession, including the folks who hand out free sausage samples in the supermarket. Since journalists are heavily involved with PR, it is important to know exactly what we are talking about.

PR serves a number of functions. In the book *Positive Public Relations,* I and co-author Philip Benoit defined public relations by describing the functions it fulfills.[3] Those functions include the effort to:

■ *Promote good will.* Good will is vitally important to organizations that depend on support from the community, such as charities and foundations, and organizations that rely on the public at large for funding.

■ *Release information to the public.* In general, we feel that the public has a right to know about certain events. Government has an obvious obligation to release information on its workings. Major economic forces in a community have a similar but less clear-cut obligation, which is why their public relations agents release bad news with the good. This does not necessarily stem from a noble spirit. Quite often, it's a matter of defusing a situation by releasing negative information before the news media find it out for themselves, which helps explain why an organization would pay a staff member or PR agency to spread bad news about itself.

■ *Directly promote a product or service.* An entrepreneur opening a new business will certainly send out press releases to the local media. Someone marketing a product nationwide will attempt to gain coverage in the

many "new product" sections in national magazines. (Radio and TV are hard to crack with new product news, though.) Chambers of commerce for tourist areas will invariably send out notices of upcoming festivals.

■ *Counteract negative publicity.* In theory, public relations people understand what makes a positive or negative impact on the public and are often counted on to provide "damage control." Put less politely, the role of PR is often as much to keep a person or an organization *out* of the news as *in* the news.

These descriptions only skim the surface of public relations, and I included just those particularly relevant to broadcasters. If possible, take some courses in public relations or learn the PR business some other way because *PR will always be a major source of news, and the more you understand about PR the better able you'll be to deal with PR products and practitioners.* The PR person can be your best ally (when you need an expert for a talk show) or your worst enemy (when you are trying to find out why a certain corporation keeps losing money but all you get is a major-league stonewall), but the practitioner of PR will always be involved, to some extent, in the news business.

In some cases, the PR person will be the appointed spokesperson for the institution. This, in itself, can be a problem because it often limits you to dealing with a mouthpiece when you want access to the real newsmaker.

VIDEO AND AUDIO SERVICES

The proliferation of mass media technologies has blurred the distinction between news and public relations. Not long ago, only broadcast stations and networks could afford the cameras, recorders and studios to produce air-quality programs. But equipment became relatively inexpensive and user-friendly, which opened the

[3]From Carl Hausman and Philip Benoit, *Positive Public Relations,* 2nd. ed. (Blue Ridge Summit, Pa.: McGraw/ Liberty Hall Press, 1990), pp. 1–4.

door for organizations to produce their own radio and television for distribution to commercial and public stations. As a result, many organizations could produce what looks and sounds like news.

For example, I once operated a radio and television news service for a large university. In that capacity, I produced radio and television spots in *exactly* the same manner as I had previously produced news for commercial radio and television. The pieces were short, fit neatly into newscasts and as a result were used by some stations throughout the Northeast.

Was I producing "news"? Well, yes, in a self-fulfilling sense; since the pieces wound up on newscasts they obviously became news by that very act. But while I never knowingly misrepresented any fact or implication, and the stories themselves were more or less objective, I was hardly a detached observer. (I was paid by the university, and I would not have remained on the payroll had I dedicated myself to producing exposés about my employer.)

That is the dilemma facing you, the electronic journalist, when you take something that is offered for free. Just as there is no free lunch, there is no absolutely free, unencumbered audio or video PR piece. Somebody must gain from the transaction, or it would never be made: In the case of my news service, the university gained positive exposure from pieces that showed faculty members speaking knowledgeably about current events.

In some cases, the payback may be more subtle. A beverage firm once circulated footage of a major road race. The video also showed thirsty runners lapping up the producer's product at the finish line.

Video news releases (known as VNRs) promote many products and services. Clients (the people who pay for the production and distribution of the VNRs) range from pharmaceutical companies to industry groups promoting the major food groups. The VNR is typically down-

linked via satellite and offered free to any station that cares to pick it up.

And apparently, quite a few stations do care to take advantage of that service. A study conducted by Nielsen Market Research and reported in the *Communicator*, the trade publication of the Radio-Television News Directors Association, showed that 78 percent of local TV news directors who responded were using at least one edited video news release in their newscast on a weekly basis.[4]

There is a difference between the video news release and what is commonly called syndicated news programming. Essentially, VNRs are free, but syndicated programming is not. Syndicated news segments are sold to the station as a product, a product that will ostensibly boost news ratings. Examples of syndicated news features are the ubiquitous food-advice segments used in newscasts, syndicated movie reviews and the growing number of medical pieces.

Local news departments buy syndicated material because it's professional, audience-grabbing radio or television, usually featuring high-quality talent. You have probably either seen or heard medical features by Dr. Dean Edell or Dr. Red Duke, physicians who are not only scientifically knowledgeable but also warmly communicative. Also, syndicators stay in business by providing programming that is difficult to produce locally because of staffing, economic or geographic factors. Travel features are an example of this specific need.

There is less of an ethical dilemma involved with syndicated programming since there is little difference between buying from a syndicator and buying from a network. Given the current methods of distribution, it's difficult to define a demarcation between a syndicator and a network.

[4]"78% of All TV Newsrooms Use VNRs on a Weekly Basis, Medialink Claims," *Communicator* (May 1990): 12.

However, some journalists are uneasy about making the syndicated talent "look local" or "sound local," which is undoubtedly the goal of many syndicators and their local clients. Advances in radio automation in particular enable localized buffers to be inserted, thus making the program appear as if it were generated in town. Television stations often use their local medical reporter and the syndicated doctor piped in via satellite in a tandem operation. This practice makes it difficult for the viewer to discern that one of the medical reporters is in the local studio while the other one is beamed in from outer space.

■■■■■■
EVALUATING FURNISHED NEWS

Since much news is furnished in one way or another, it is difficult to make overarching recommendations on how to treat such information. In fact, as we've seen from the foregoing discussion, it is even difficult to distinguish between news that is furnished and news that is gathered.

But you will probably find it intuitively simple to separate the wheat from the chaff—or in this case—the news from the fluff. To enhance your intuitive skills, Chapter 4, "Newsgathering Techniques," offers detailed advice on judging the truth, newsworthiness and built-in biases of the various news and imitation-news that come your way.

To briefly summarize what has been discussed in this section, please remember these points:

■ Some of the news furnished to you comes from people who want advertising but don't want to pay for it.

■ There is nothing inherently unethical about what people who want free exposure are doing, unless they lie or mislead. (Indeed, radio and TV news departments engage in promotions and public relations, too.)

■ Sometimes, even outright attempts at free publicity are newsworthy, so don't reject PR-generated news out of hand.

■ Retain your journalistic skepticism when you use furnished news. Try to get other sides of the issue and check out as many facts as possible before running the piece.

■ In your career, you will meet many superbly capable PR agents, many of whom were highly skilled reporters before they accepted positions in public relations—a field that generally pays better and offers shorter and more regular hours than does journalism. Often, these people will be of enormous help to you.

And that can be a problem. Because journalists are so busy, we sometimes are tempted to use what is served up to us on a platter. This can be a particularly seductive habit once we get to know and trust the server. *Do be cautious about becoming too regular in your use of a good PR source.*

Events

It's a good idea to exercise similar skepticism in coverage of events. We won't delve heavily into the techniques of event coverage here, since that topic is addressed in other appropriate sections of the book, but we will take a very brief look at *news conferences, public spectacles,* and *disasters and emergencies* in terms of their role as news sources.

■■■■■■
NEWS CONFERENCES

A news conference serves a number of purposes, some less obvious than others. First, it is a convenient forum for a newsmaker to disseminate information to a number of journalists. That purpose is obvious.

Not so obvious is the fact that a news conference is a public relations vehicle. A person speaking at a news conference may seem to gain in stature over a person doing a one-to-one interview.

It is also worth mentioning that a news conference may be used to *control* the flow of news as well as to start it. After all, the conference convener starts and stops the affair and—if he or she is sufficiently skillful—has the ability to avoid certain questions and questioners. This gives the appearance of facing up to all the issues when in fact a news conference offers more opportunity to duck probing questions than a person-to-person interview with no set time limit.

A news conference is also a method of distributing news in a fair manner, one that does not alienate competing reporters. A person or organization in the public eye must control what information is released and when it is released. Giving an exclusive story to one reporter may antagonize other members of the news media. A news conference solves the problem by establishing a set time for release of the information.

Formal news conferences are announced a day or so in advance, except for those dealing with breaking stories; then, the lead time can be reduced to a matter of minutes. Sometimes, informal news conferences materialize wherever reporters and newsmakers happen to congregate. An example of this is the familiar question-and-answer session held on the courthouse steps after a verdict is handed down.

News conferences do pose problems for journalists, not the least of which are the strict time limitations. A hastily called news conference is difficult to accommodate into a busy schedule, and if you miss the event, you cannot ask that it be restaged. Secondly, news conferences can be inefficient because the reporters are jockeying for camera- or mic-time; an uncharitable view of the situation is that reporters are often more concerned with getting their own question asked than with getting answers to the right questions.

Stations do not like using sections of a news conference showing a reporter from *another* news organization asking the big question. (Some newspapers developed a novel solution to this situation when printing pictures of the news conference: Their staffers in the photo lab airbrush out the "mic-flags"—the little placards on the microphone with the station call letters.)

PUBLIC SPECTACLES

Groundbreakings, openings, campaign rallies and other formal occasions can provide good audio and video. Or, they can be a complete waste of time. Unfortunately, there is no reliable way to gauge this other than your experience with the organization and your gut-level estimation of the interest the event holds for your listeners or viewers. But you can probably rule out groundbreakings and "check-passings" without agonizing too much over the decision.

Groundbreakings—ceremonies where people with ornamental shovels turn the first dirt—have become so trite that many news organizations just refuse to cover them; ditto for what are often called check-passings, occasions where someone turns over a contribution to an organization or an individual.

Campaign events present some of the same problems (and raise some legal and ethical questions addressed in Chapter 12). Mostly, though, they are just plain dull—often rote regurgitations of the same speech given at the last ten events. Moreover, they are sometimes nothing more than a ploy to attract radio, TV and newspaper coverage. At this point, they become what historian Daniel J. Boorstin termed "pseudo-events," happenings staged for the media that have a shaky grounding in reality.

Here is an example of that special twilight zone of a real-but-not-quite-real event: I once covered a political rally in a *totally empty* hall—empty, that is, except for a couple of reporters and the candidate and his staff. The TV camera,

if focused on the dais, would show a beaming candidate standing next to (what else?) a flag. As I recall, there was recorded music playing in the background. Unable to resist the irony, I asked the cameraman to pan the empty hall—at which point, a campaign worker accused me of taking a cheap shot at the candidate.

There was some merit to that objection. I had not made it a practice to report attendance figures for other candidates' events, or to document that each event in everyone's campaign was, in some way, manufactured. But on the other hand, I was distinctly queasy about airing a piece that would give the impression that an event occurred when *nothing* really happened.

DISASTERS AND EMERGENCIES

It is a sad fact that a reporter's job involves documenting other people's suffering. Fires, auto wrecks, mudslides, riots and other calamities all are obvious and legitimate news items. Having said that, it is important to recognize that disasters and emergencies pose unique problems as news sources.

For example, you really must stay out of the way. Interfering with an emergency rescue worker could cost a victim's life.

In addition, you must be concerned with the privacy and dignity of victims. However, you also must get a story. Much is made by media critics of broadcasters' propensities for shoving a mic at people who are watching their house burn down and asking them how it feels. Yes, there's a good point to that criticism, but if you don't question these people, you may miss important elements of the story. Surely, there is a middle ground; people can be approached gently, and overly distraught people can simply be left alone.

Another factor in reporting disasters is that you must protect yourself and co-workers. It is disheartening to observe that many of the broadcast industry trade publications now carry ad-vertisements touting body armor for news photographers. With increasing regularity, crowds are turning their hostility against the press.

Camerapeople are much more vulnerable than other journalists because they have one eye in the viewfinder, and they cannot swivel their heads to detect danger. Also, the camera has an incendiary effect in certain situations; and, from personal observation, it brings out not only the worst in people but quite simply *the worst people*. If you feel threatened by a crowd, drift over toward the police or just get away from the scene.

Beats in Broadcast News

We wrap up this chapter by returning to the notion that a great deal of the day's news surfaces as a matter of routine. The journalists who gather that news often do so as part of their daily "beats"—areas of regular and specialized coverage.

Although beats in broadcasting are not as pervasive as they are in newspapers (which have proportionally larger staffs and may have a reporter specifically assigned to county government, education and so on), broadcast journalists do develop various formal and informal beats. In larger markets, broadcast journalists are routinely assigned to specific beats, and in network operations, reporters often are attached solely to one location, such as the White House or Congress. Smaller-market journalists often cover many beats.

The routine of beat-based newsgathering varies from station to station, but here are some of the basic operational details.

GOVERNMENT

Government bodies schedule meetings at regular intervals, making them predictable sources of news (although many local government agen-

cies cut back their schedules during the summer). The most immediate dilemma facing a reporter on the government beat is not what to cover but what to skip. No station can afford to send a reporter to a meeting of every commission, licensing agency and elected body.

This is a situation in which you must rely on the experienced people in the news department and on your sources in government. Those sources can often alert you to important meetings and issues. For example, a county official once told me that the airport commission was going to consider extending a runway to accommodate larger jets. Given certain conditions in that particular city, including noise factors and the location of the airport near a residential area, this was the start of a fairly important story. The source's tip was invaluable because I did not know that the item was even being considered or that it was on the agenda for the airport commission. In fact, until that point I did not know there *was* an airport commission.

LAW ENFORCEMENT

Police and courts are a valuable news source; some of the techniques of gathering news from this beat are explored in Chapter 4. At this point, remember that while the law enforcement beats supply a great deal of news, they also pose particular challenges for the journalist. For instance, you must be very accurate in reporting such events as arrests and charges. (It may appear redundant to warn in a journalism textbook that you must be very accurate, but we are operating within the bounds of reality here, and do recognize that a reporter cannot expend an equal amount of detail-work on every story. So I am advising you to summon your highest energy level for fact-checking on law enforcement stories.) You are headed for trouble, *real* trouble, if you misidentify an arrestee or the crime for which he or she is charged.

Committing such a blunder is *much* easier than you might imagine. For example, in a drug bust there are usually a few arrestees who were not caught with the "goods" and are charged with lesser crimes, such as "being a disorderly person." Never report that all 15 people taken into custody in a drug raid are facing drug charges unless you have verified that with police. Several "disorderly persons" may file suits against you.

On the subject of verifying stories with police, remember that police can make mistakes, too. There is a growing trend among thinking criminals to "steal" identities. They may pick a name, address and telephone number out of the phone book, memorize that information and give it to the booking officer. The information seems plausible and it cross-checks—but it's wrong. Career criminals, who make it a habit not to carry identification, sometimes use false identities (they may even "steal" an innocent person's place of employment if they can find it out) and hope to slip through the judicial cracks before their real name is uncovered.

Because this is a relatively new phenomenon, the legal issues surrounding it are in limbo, but you will be on safer ground if you clearly attribute the name and the charge to the police. Heavy use of the phrases "police charged" and "police said" is a hedge against legal trouble, although it is not foolproof and should not be abused.

The situation boils down to what Mark Twain advised: When in doubt, tell the truth. Tell what "police said," if that is indeed how you obtained the information, and do not intimate that you witnessed something you really did not see. Let the public know the source of your information, and you will serve them and protect yourself.

Another point about the law enforcement beat is that you should invest some time into learning the workings of your local judicial system. Gaining an understanding of your law en-

forcement sources will pay off immeasurably in the long run. You'll know when and why a case is handled by the detective bureau, for example, or when and where certain cases are arraigned or tried.

Pay particular attention to the courts. The court systems in most communities are baffling, primarily because they are often an absolute mess. There are too many cases, too little staff, and inordinate and frustrating delays.

To make matters more difficult, it becomes apparent to anyone who has witnessed a trial that courtroom operations are not oriented toward the convenience of the press or the public; schedules are changed at the last minute, judges arrive late, and the language used in the proceedings is often a mumbled verbal shorthand that makes no sense whatsoever to the uninitiated. So ask a friendly clerk, lawyer or bailiff to walk you through the system and tell you what goes on where and when. You'll have a head start on covering legal stories.

Courtroom proceedings and the attendant publicity they engender cause peculiar problems when using the legal system as a source of news. Regulations about courtroom access vary among jurisdictions, so you may or may not be allowed to record inside a court chamber, or you may be allowed to record only certain parts of the proceedings.

You'll also have problems regarding access to the attorneys during the trial. In general, defense attorneys are more apt to talk to reporters while a trial is in session than is a government prosecutor. This presents you with a problem, because it certainly is not good journalism to let a defense attorney's courthouse-step statements dominate your coverage. You are obligated to balance the defense attorney's comments, should he or she make any, with material from other sources, such as the testimony itself.

Oddly, some prosecuting attorneys are positively garrulous *before* a trial, at the time when an indictment is handed up. Here, you are faced with the dilemma that the defendant—despite the impression the prosecuting attorney would like to make—is still innocent.

A final point: While it is often possible to elicit statements from jurors after a trial, you *cannot* attempt to question a juror during a trial. Doing so could result in a mistrial.

There are many other facets to coverage of a trial that we will be discussing at various points throughout this text.

EDUCATION

As a broad and thoroughly unproven generalization, I would say that most young, beginning journalists greatly underestimate the public's interest in education. Why? Because young reporters usually do not have children of school age. But listeners and viewers old enough to have children in school take a close, sometimes highly partisan interest in the workings of the school system and the school board. After all, don't forget that we're talking about an institution that (1) sequesters their children for about seven hours during weekdays, (2) will have a profound impact on their children's future and (3) absorbs a whopping amount of a property owner's tax money.

Higher education is also an important beat, often because colleges and universities employ a variety of experts on newsworthy topics, and major universities have a profound impact on the character and economy of a community.

OTHER BEATS

The list of possible beats is as long as the roll of subjects about which to report. Reporters in some broadcast news departments cover—either on a full-time or part-time basis—politics, medicine, law and consumer affairs. But although specialists do thrive in broadcast jour-

nalism, most radio and TV reporters are, by nature and temperament, generalists.

Some of broadcasting's critics view this as a negative characteristic. They may maintain that education reporting is of higher quality in newspapers because the paper has a full-time education writer. It is hard to argue with the contention that the full-time education writer will know more about the field than will the broadcaster who covers education as only part of his or her job. However, a case can also be made that a generalist sees connections, interactions and correlations that a specialist may miss.

SUMMARY

1. The sheer amount of news may at first seem overwhelming, but journalists have developed standardized routines of gathering news and have learned to regularly mine sources to make the job more manageable.

2. In fact, many stories recur on a regular basis, so that reporters can anticipate much of the day's news.

3. A news department has access to sources that provide news from places where the department's staffers cannot be. Among those sources are wire services, networks, satellite news-feed services and freelancers' services.

4. Some news is furnished to the news department by people or organizations that have something to gain by its use. While furnished news is not necessarily misleading or deceptive, a journalist must remember that it is not objective in the same sense as news provided simply for the sake of providing news.

5. Types of furnished news sources include press releases and video and audio services.

6. News often comes from events, such as press conferences, public spectacles, and disasters and public emergencies. It is important to remember that an event such as a press conference or a campaign rally is often staged to gain publicity. When covering disasters and emergencies, reporters are well-advised to carefully respect the privacy and dignity of victims and stay out of the way of emergency personnel. Also, keep an eye out for your safety and the safety of the crew.

7. There are many beats in broadcast journalism; they include government, law enforcement, education and other specialties.

EXERCISES

1. Here is a press release that came in the mail this morning.

FOR IMMEDIATE RELEASE
METROPOLIS PRODUCTS POSTS SMALL LOSS IN THIRD QUARTER

Sales and earnings for the quarter ending September 30 were down compared to the same period last year, according to Vice President for Sales Louis Martin. However, the profits will rise when $10 million worth of new government contracts take effect January 1 of next year.

Martin said the firm reported earnings of $2.1 million on sales of $22.3 million, down from earnings of $3.5 million on sales of $41.1 million for the same period a year ago.

The organization's downturn stems from an overall weakness in the economy, Martin said. He noted, though, that following a planned layoff of 20 production workers the firm's earnings are expected to improve.

Metropolis Products manufactures ceramics used in the aerospace industry. It is the nation's second-largest producer of specialty ceramics, and produces the highest-quality products in the industry.

Are you prepared to simply rewrite this press release in broadcast style and use it on the air, or are there areas that trouble you? In a brief paper, critically analyze the release and describe how you would handle the story. For starters, describe what facts in the release you would use and which ones you would want verified. Also, if you were to follow up on this story, what *additional* questions would you ask? And how would you rank the relative importance of elements within the story? Is anything of importance buried in the release?

2. Here is a hint regarding exercise 1 that serves as a springboard for this exercise. An experienced newswriter might be willing to accept the press release's claim that Metropolis Products is the world's second-largest producer of specialty ceramics, although he or she might want to attribute that piece of information to the company spokesperson. But "highest quality"? Who says the product is the highest quality? And what, exactly, does "highest quality" mean?

You can instinctively tell that one claim is dangerous while the other is reasonably safe. Even if the firm were not the second-largest manufacturer of the product, no great harm has been done if you repeat that fact. But proclaiming that the firm makes the best products is an egregious error; you have no way of knowing that, and you're giving a free plug to the firm.

Make a list of ten statements you might receive from any source—a press release, a source at city hall or whatever—that you would use without challenging them. Write the statements out as complete sentences. Now, invent ten sentences you *would* challenge, investigate further, or at the very least directly and clearly attribute to the source. Use this model:

Safe: An official with the tax department informs you that next week is the deadline for filing appeals of the latest round of property valuations.

Unsafe: A clerk at city hall informs you that the mayor will not run for re-election.

3. Remember the incident described in this chapter concerning taking video of an empty hall during a campaign rally? Use that scenario as a discussion question in class or the topic for a brief paper; your instructor will determine the format. Do you think such an action is correct? Why or why not?

3

HOW A NEWS DEPARTMENT OPERATES

S pecifics vary, but the organizations that gather news, edit it and present it to the general public usually follow the same basic working principles. What happens in the radio or TV newsroom is very much the same regardless of where it's done.

The primary difference is simply the number of people dedicated to specific jobs. In larger operations, there are more people to handle concomitantly specialized tasks. In small markets, there's less specialization; fewer people perform a broader range of duties.

It is not practical to explore the intricacies of how each and every newsroom operates. Rather than detail the rote *mechanics* of news department operations, we will concentrate on the *functions: who the people are and what they do, the general breakdown of news operations,* and how this combination of people and duties might contribute to *a typical newscast and news day.*

The People of Broadcast News

If you read through "Help Wanted—News" ads in trade publications such as *Broadcasting* or the bulletin of the Radio-Television News Directors Association, you'll frequently come across the term "team player." Sometimes, the ad-writers are more blunt and specify "no prima donnas need apply."

There is a popular conception that broadcast journalists are blindly self-centered egotists who value personal gain above all else. In all honesty, some people do fit that description, but it is virtually impossible to survive in broadcast news without being that type of person known as a team player.

Most of the work in the broadcast newsroom cannot be done by one person. A news director needs reliable reporters whom he or she can trust to carry out assignments in all parts of the city under very little supervision. Conversely,

reporters require knowledgeable supervisors to gauge realistic time frames for production of stories, to provide guidance on professional skills, and to intercede with top management in order to procure a reasonable operating budget for the news department.

A producer, the man or woman in charge of putting together a newscast or other piece, needs to rely on tape from photographers, copy from writers, a properly adjusted camera tuned up by the engineering department, a competent on-air reporter to ask the right questions, and a knowledgeable, sensible person to arrange transportation and logistics.

THE BROADCAST JOURNALIST

As applied to broadcasting, the term *journalist* covers a great deal of territory. Journalists produce, journalists manage, journalists perform on-air, but the overriding job of any employee billed as a journalist is to gather and report news.

Who are the people who perform these tasks? Let's examine their *typical backgrounds*, the *standard duties* they perform and the *conditions under which they work.*

Typical Background Most broadcast journalists are college-educated, although in many organizations a degree is not specified as an entry-level requirement. We tend to see the pool of entry-level personnel containing an increasing number of college graduates, most with bachelor's degrees and many with master's degrees. Older broadcast journalists sometimes do not have much if any college background. The ranks of college dropouts include such journalistic luminaries as Walter Cronkite. You might be surprised to know that Peter Jennings never graduated from high school.

Experience and ability, not academic training, have traditionally been the coin of the realm in the news business. Experience is always a major factor in securing a job; many surveys show that those in a position to hire would—all other factors being equal—favor an applicant with experience but no degree over a job-seeker with a degree but no experience.

This is not meant to demean the value of a college degree. In fact, many personnel departments limit their candidate pools to degreed applicants purely as a matter of convenience. While the arbitrary cutoff may screen out otherwise qualified people, it narrows the field and simplifies the hiring process. You will, therefore, see "bachelor's degree required" on many advertisements.

But, operating on the assumption that experience is important to work in the field, where does one obtain that experience? Good question; it raises the Catch-22 of not being able to get a job without experience and not being able to get experience without a job.

Although that lament has some validity, it is plainly evident that many people *are* working in broadcast news, and they all managed to start *somewhere.* An examination of their professional backgrounds will turn up one or more typical starting point. For example, many gained their first experience in extremely low-level, low-paying jobs in tiny markets, often in positions unrelated or only partially related to news. Many a big-city TV anchor got his or her start as a small-town radio disc jockey/news announcer/jack-of-all trades. Dan Rather is a good example; he began his career in a small-market radio station and worked his way up through local and national radio and TV.

Some broadcasters started in medium or large markets in support or clerical positions, where they typed memos, made photocopies, ripped copy off wire machines, or even acted as the proverbial coffee and donut "gofer." Natalie Jacobson of WCVB-TV in Boston, widely regarded as one of the nation's top local anchors, began as a secretary at a Boston station and worked her way up to an on-air position.

Many broadcast journalists have gotten a foot in the door through internships. An internship, an unpaid position for which a student generally receives academic credit, is valuable both from the standpoint of proving one's reliability and making contacts.[1]

These are not the only avenues to a broadcast news position, of course. Some reporters cross over from print. Others started in different fields and parlayed their specialty into a journalism job. Experts in the business world, for example, may turn in their briefcases and pinstripes for a business reporting position. Other specialists, such as lawyers and doctors, frequently gain lateral entry into the business.

However, the typical broadcast journalist is a generalist—a "utility player" who has come up through the ranks, worked at a few stations in various positions of increasing responsibility; this journalist is able to handle stories on crime, education and medicine all in one day. Versatility and general knowledge are qualities highly prized by news executives who hire journalists.

In short, the broadcast journalist generally has an interest in and knowledge of a wide assortment of areas. You're severely handicapped without the type of knowledge that falls in the category of "the liberal arts." It's difficult or impossible to put events into perspective without some knowledge of economics, literature and (especially) history. That's why a news director at one medium-market televison station doesn't begin his interview with questions about experience and degrees. Instead, he asks the applicant for the name of the second president of the United States. Those who don't pass this first hurdle don't get a chance to parade their other credentials.

[1] I would advise anyone considering an internship to ascertain in advance whether the job involves actual journalism duties or whether it is a source of free labor to an employer who wants unpaid gofers.

Standard Duties While a range of personnel, including graphic artists and publicity managers, are involved in the news process, the people we usually term "broadcast journalists" are those who produce, gather, write, and report the news and those who supervise news operations. We'll deal with the duties of the news director, assignment editor, studio and field producers, photographers and editors shortly. First, though, let's examine the work of *general assignment reporters*, the people who comprise the infantry of the radio and television news department.

It is the general assignment reporter that we most often think of as a broadcast journalist, and it is from the ranks of general assignment reporters that anchors and network correspondents are promoted. (The term *correspondent* is typically applied only to network reporters assigned to a particular location; however, the duties of a correspondent and reporter are the same.)

As the name implies, a general assignment reporter is usually assigned a wide range of stories by news management. However, general assignment reporters are also expected to dig up their own news, find new and updated angles on current stories, and relate national stories to regional issues by finding a local angle on the day's news.

In both radio and TV, the prime responsibility and the ultimate qualification of the general assignment reporter is his or her ability to *write*. Writing takes up a good share of almost any broadcast journalist's day, and it is imperative that the reporter know the conventions of broadcast newswriting and be able to compose clear sentences that are both pleasing to the ear and logically constructed.

In addition, writing duties involve what's known as writing to tape, meaning:

- Composing a story that gracefully leads into and out of the audio- or videotape segment.

- Understanding how to write the story so that it does not duplicate what's on the tape. In other words, *not* writing, "Mayor Sennett says that the City Council's action is a disgrace," and then rolling a tape of Mayor Sennett saying, word for word, "The City Council's action is a disgrace." In television, this also means *not* writing copy to be read over visuals (voice-over copy) that tells the viewers what they can plainly see for themselves.

- Understanding how to write the story so *it does not stray too far from what's on tape.* For example, a general assignment reporter writing for television would not write an extended dissertation about details of an arson investigation to be read over dramatic shots of the fire. The script and the video don't mesh; better to show the arson investigator sifting through the ashes. (We'll show an actual example of this in Chapter 9 on news production.)

- Understanding the technical end of the writing process. Assembling video scenes in a package is every bit as much a writing chore as pounding out the voice-over copy on the typewriter or word processor. The general assignment reporter for radio needs a thorough understanding of the basic structure of radio voicers, actualities and voice-actualities. The television journalist needs a working knowledge of the structure of packages and the production of video for anchor-read voice overs.

Before news is written, it must be gathered, a topic addressed in Chapter 4. For now, simply note that the broadcast reporter must be thoroughly conversant with the techniques of interviewing, sorting out newsworthy events from the not-so-newsworthy and generally "making the rounds" of local newsmakers.

In addition to writing copy, general assignment reporters also do their own on-mic and on-camera announcing and a generous share of ad-libbing. Broadcast journalists who work primarily as producers do not appear on-air, but instead concentrate on content and form. All contribute to the overall mix that produces a newscast.

Working Conditions If you take nothing else away from this chapter, please remember that beginning broadcast journalists often work long, grueling hours for low pay. Many veteran broadcast journalists work long, grueling hours for low pay, too. Some broadcast journalists make quite comfortable salaries. And they earn them, because they, too, work long, grueling hours. (We'll discuss salary ranges in Chapter 14.)

Broadcast journalists in small markets, particularly radio journalists, often have shockingly low incomes. That is a sad fact brought about by the exigencies of a supply-and-demand economy. Medium-market broadcasters (medium markets are mid-size cities like Rochester, N.Y., or Omaha, Neb.) usually earn decent livings, although the lower-ranked news employees in medium-market news operations, particularly radio, still do not earn what might be expected for people with their education and skills.

Major markets—New York, Los Angeles, Chicago, Philadelphia and the like—pay on- and off-air news personnel quite well in general, with TV reporters and anchors frequently earning five-figure and sometimes six-figure salaries.

In short, this is not a good business to enter with the expectation of becoming rich. Some broadcast journalists *do* become rich. And some soldiers become generals. But these are exceptions, not the rule.

What is given in this case is that a career in broadcast news involves long and irregular hours. Radio airs its top-rated newscasts in the early, *early* morning, so a successful career in radio news will generally elevate you to a shift that begins around 4:30 or 5 a.m.

Many television reporters, particularly those who appear on-air during newscasts, work a shift that begins at 2 p.m. and ends around midnight. Even with a generous amount of time allotted for lunch (or is it supper?), the workday can be an all-consuming one. One successful and very well-known local anchor of my acquaintance opted out of the business for specifically that reason. He noted that many thought him crazy to leave a job that offered high recognition and a comfortable salary, but privately he contended that only a crazy person would voluntarily spend the rest of his professional life working from 2 until midnight.

It should be noted, too, that a job in broadcast news involves working holidays and weekends. The news does not stop for holidays, and while senior reporters and news management generally have Christmas and Thanksgiving off, junior employees usually do not enjoy that luxury.

There's also the matter of pressure and your ability to deal with it. Broadcast news is run by a tyrannical taskmaster: the clock. The game is called Beat the Clock, but it's not a fair contest because the clock cannot lose. If airtime is 6 p.m. and you are not ready, there is no debate, no excuse and no compromise.

The long hours and pressure make broadcast news an occupation ideally suited for physically vigorous and constitutionally sturdy people. Walter Cronkite, the dean of modern TV newscasting, is renowned for his seemingly inhuman durability; that quality, in fact, has become his trademark. It should come as no surprise that in his free time during his career, Cronkite pursued active and competitive sports, including auto racing.

Cronkite's successor at the anchor chair, Dan Rather, frequently credits his success not to his ability to outthink the competition, but simply to outwork them. That is exactly how Rather manufactured one of the first in his series of big breaks: He reported for days, virtually nonstop, on floodwaters ravaging his native Texas.

The news business at any level requires stamina and dependability. Dependability is regarded not so much as an asset but as a *given;* it is fully expected that broadcast journalists will be at their stations every working day, on time, *always*. While it is a relatively routine matter in some occupations to call in at the last moment to take a personal day or a sick day, in the broadcast business absences from work are very much frowned upon.

In some cases an absence, even a legitimate absence based on illness, can be calamitous. Suppose you are the morning anchor at a small radio station with only one other newsperson on staff. You usually wake up at 4:15 to get to work by 5 a.m. You awake at 4:15 not feeling well.

Whom do you call? The person scheduled to work from 2 to 10 p.m.? Do you really expect him or her to work a 17-hour day? Or do you call the station manager, hoping that he or she will somehow be able to summon a replacement to gather, write and deliver the first newscast at 6 a.m.? The most obvious solution is that you go to work regardless of how you feel—a fact of working life in most of broadcast news.

To be fair, working life in the business is not by any means a living hell. The negative aspects of the job are mentioned only to counterbalance the positive aspects, about which you probably already know a great deal. For example, broadcast journalists receive enormous public recognition, far more recognition than their counterparts in print. There is a great deal of status connected to any reporting job, a type of status that not only elevates you in the eyes of the public but gives you license, irrespective of your age and experience, to stride up to any politician or businessperson, ask pointed questions *and expect an answer.*

While newsrooms aren't known for their luxury, they are typically clean, air-conditioned and well-heated. (A cynic might contend that broadcast stations are air-conditioned primarily

to protect the equipment, but in either event you reap the benefits.) And although the work is pressurized, it is also fascinating. Most people don't have the opportunity to meet with a senator, ride in a police car or see the circus roughnecks put up the big top. You will.

As mentioned earlier, *journalist* is a word that covers broad territory. Let's quickly run down some of the other jobs in the news department: We will examine the jobs of the *news director, studio and field producer, assignment editors, photographers, sports reporters, weather reporters* and *writers.*

NEWS DIRECTOR

The *news director* is in charge of the news department. All news employees, including reporters, producers and photographers, report to him or her.

News directors' responsibilities fall into two major categories: They are obviously expected to be journalists, but at the same time they are charged with the management-oriented task of keeping the station's news efforts competitive with rival broadcasters. This may entail making decisions about areas not specifically related to journalism, including set design, presentation of graphics and news promotion (literally, the advertising of the news product).

In large news departments, the news director may be somewhat removed from the day-to-day news function. Much of a major-market news director's day is spent negotiating contracts, fighting for departmental budgets, and attending to the other details that fall upon an executive administering a department with more than a hundred employees.

Note, though, that in small markets the news director is an active reporter; in small-market radio, the news director may, in fact, be the *only* reporter on staff.

STUDIO AND FIELD PRODUCERS

The concept of producing the news has various meanings. Usually, the *news producer* at a television station has overall responsibility for a newscast. The producer decides, typically with the consultation and approval of the news director, what stories will be covered and how they will be presented within the newscast.

There are not too many "news producer" jobs in radio, except at the network level. Generally, a radio reporter does his or her own production, deciding what stories to use and mechanically assembling them.

A newscast producer often has an integral role in the *execution*, as well as in the planning, of the newscast. A crewperson known as the director will actually call the shots, instructing the camera operators and rolling the tapes, but the producer will make the decisions regarding content. If a major story breaks during a newscast, the producer not only decides how much coverage to devote to that story but what else must be trimmed in order to make the newscast elements fit into their allotted time schedules.

Good producers are known for their news judgment and ability to keep the ship from running aground during rapidly changing seas. These qualities are what separate top-notch producers from what are known as mere story stackers.

A *field producer* is a journalist assigned to guide coverage of a story taped out of studio. The field producer may line up interviews, instruct the photographer on the proper shots to take, and brief the on-air reporter about the details of the event being covered. During live coverage, the field producer is the liaison between the local anchors, the studio control room and the remote satellite news vehicle.

Not all broadcast news operations utilize field producers. The position is common in network and large-market television, but it is not

Figure 3.1 *Assignment Manager Tetyna A. Husar prepares reporters' assignments at WPVI-TV, Philadelphia. The computer has become the tool of choice for assignment editing and scheduling at most large stations.*

so typical in smaller TV markets and is virtually non-existent in most local radio operations.

ASSIGNMENT EDITOR

Assignment editors (also known as *assignment managers*) manage the comings and goings of newsroom personnel. They usually determine which reporter will cover which story and how much time is needed. This decision is based not only on the reporter's individual skills and familiarity with the story at hand, but on simple logistics as well. Is the reporter going to be across town and have to fight rush hour traffic to make the press conference? If so, somebody else must be assigned the story.

In general, the assigment editor is the person who keeps all the balls in the air. He or she maintains a schedule of who is doing what and where they're doing it, makes sure that the work is being performed on time, and makes last-minute changes when stories begin to break (Figure 3.1). As the news director's deputy, the assignment editor also keeps track of events planned for the coming week and month and allocates resources as necessary.

PHOTOGRAPHERS

These are the men and women in charge of getting the picture and making it look good. *Photographers*, or as they are often known, *videographers*, operate a portable camera and videocassette recorder (Figure 3.2). Increasingly, the camera and record deck are in the same unit, called a *camcorder*. The microphone is mounted on the

Figure 3.2 *The portable news camera brings reporters to the action. Here Frank Herzog, sports anchor for WJLA-TV in Washington, D.C., reports from the Washington Redskins' training camp at Dickinson College in Carlisle, Pa.*

camera or camcorder, but usually during field-work the reporter uses a separate mic that is plugged into the record deck.

News photographers are journalists in every sense of the word. They, too, gather and report stories, but they do their work exclusively through the lens of the camera. And although the reporter or field producer calls the shots, it is important to remember that the photographer is generally an experienced news professional whose suggestions and ideas can add immeasurably to the quality of the story.

Incidentally, this is a position offering increasing opportunity to women. The job of news photographer was once considered a man's domain, ostensibly because the equipment of a decade ago was much heavier than today, but now a specific gender is no longer a qualification.

What *is* a qualification is the ability to think and move quickly. Steady nerves and steady hands are essential. Good vision never hurts;

it's easier to use the viewfinder if you don't wear glasses—since a rubber eyepiece cups up against your eye—but many photographers do have spectacles.

SPORTS REPORTERS

Modern sports reporting has evolved significantly from the days when a sports segment was nothing more than a quick recitation of scores and a montage of game highlights. Serious themes recur in sports; the *sports journalist* must intelligently report stories involving drug abuse, allegations of recruitment violations, and personal tragedies stemming from the deaths and injuries that inevitably result from risky sports such as auto racing, horse racing, football and boxing.

And then . . . there are those scores and highlights. Although sports reporting can be

and often is an enjoyable job, the gathering of scores and highlight tape is one of the most stressful tasks in broadcast journalism. A TV sports anchor preparing for the 11 p.m. report must keep track of scores and highlights literally until the instant he or she goes on the air. Many of the events are still in progress, a situation particularly daunting for East Coast sports reporters tracking West Coast games.

The video highlights arrive from a variety of sources: staff members covering local events, cable channels and satellite feeds. Staffers, often interns, view the highlights and the beamed-down highlight package (which might start at about 10:30 p.m. Eastern time) and frantically search for the best plays of the day. Some stations have arrangements with cable companies whereby the local sports reporter can use highlights from the cablecast *but only after the game is over*, a factor that heightens the stress as airtime and the end of the game approach within moments of each other.

When the report finally airs, the sports anchors may have to ad-lib the voice overs and are often fed score updates while tape packages are run. And heaven forbid that the anchor should not have the big play or the latest score; to sports fans, that is unpardonable. As John Dennis, sports anchor for WHDH Television, Boston, notes, there's one question that haunts him after every day's forage in the jungle of sports in a sports town: "Did I miss anything?"[2]

Radio sports reporters typically handle play-by-play of local events, a special skill and one far beyond the scope of this book.[3] It is also not uncommon for radio sports reporters to moderate sports call-in shows.

▬▬▬▬
WEATHER REPORTERS

Weather reporters literally deal with matters of life and death. Although most days involve only the standard fare of rain, snow, sun and the relative proportions of each, some days involve the ravages of tornadoes, blizzards and floods.

As such, the duties of a weather reporter, or any reporter for that matter, involve an understanding of whence emergency information will come in the event of a natural disaster. Radio journalists are particularly sensitive to this, because it is they who often reach the victims of weather-related disasters. Electricity is usually among the first services disrupted, and there are very few homes with battery-powered television sets.

"One of the most important things you'll be covering is local weather," points out Scot Witt, a radio news veteran who built two radio newsrooms from the ground up and helped with the format and design of KKAR, an all-news station in Omaha. Witt advises:

> Get to know your local emergency government/civil defense director and personnel at the local National Weather Service office. Find out what system they use to alert the public and how you get your station into that system. . . . The time to develop the contact to provide you with accurate and timely information is before the warning sirens scream. You have an obligation as a professional broadcast journalist to get that information out quickly, and more important, accurately, to the people who need it.[4]

[2] Quoted in "It's a Tough Town for Sports Anchors to Stay Afloat," *Boston Globe*, 8 July 1990:27.

[3] For further information on sports play-by-play, see relevant sections of Lewis O'Donnell, Carl Hausman and Philip Benoit, *Announcing: Broadcast Communicating Today* (Belmont, Calif.: Wadsworth, 1987).

[4] "Just Add Thought and Stir: Thoughts on Starting a Radio News Operation," *Communicator* (March 1989): 18, 19.

WRITERS

Very large radio and TV stations have staffers who do nothing but write copy. However, virtually all on-air reporters write, too, and even the marquee names who simply read other people's copy only reached that status because they proved themselves able *writers/reporters* earlier in their careers.

Please don't labor under the misconception that someone aspiring to an on-air position need not know how to write well. That's just not the case. And even the big names in the business (again, people who have gotten where they are in part because of their writing ability) often continue to write their own copy simply because it's easier for them to read. David Brinkley, for example, always wrote or rewrote his own copy when he was an anchor for NBC. He did so not as a badge of honor—out of any need to prove he was a real journalist, something that obviously did not need proving—but because he had difficulty reading other people's writing on the air.

The News Department and the Station

News operations are only a part of the radio or television station; they are one of many departments. While that observation might seem obvious, frictions often develop between news and other departments because the respective divisions do not have a complete understanding of how everyone's duties mesh in a cohesive organization.

Here, then, is a brief primer on news operations in radio and television and how the news department interacts with the station; in particular, we're talking about how news affects the bottom line.

THE RADIO STATION: PERSONNEL AND OPERATIONS

Radio stations are run by a general manager, often called the station manager (in some cases there may be a distinction between those titles), who supervises heads of various departments, including sales and programming.

In general, a subordinate executive known as the program director is responsible for everything that goes out over the air. The news director usually but not always reports to the program director.

The program director, or PD, is typically someone who has risen through the ranks of on-air staff announcing—a radio veteran who knows the details of the local market, the right music format to fill a profitable niche in that market, and the complexities of maintaining a cohesive "sound" that sets the station apart from the competition on the crowded dial.

The PD and the station manager (the station manager often has a sales background) may know relatively little about news, other than that it is an expensive way to fill airtime, costing much more per minute than playing a cut of music.

What most PDs and station managers *do* know about news is that it is expected to make money or break even, or at least not create too much of a deficit. But what really matters most to them is that the news not cause listeners to tune out.

"Tuneout" is a dreaded and self-explanatory concept in radio programming; anything that might prompt the listener to change stations is a sure ratings-killer. News can sometimes contribute to tuneout (called "turnover" in the ratings reports) if the general news presentation is at odds with the station's programming strategy. A station featuring irreverent banter among the disc jockeys probably will not please its audience with a long block of news presented in a

stiff, formal manner. Therefore, many of these stations include the newsperson in the banter, or, with increasing regularity, make the newsperson the butt of the banter. While that may sound innocent enough, it is a situation deeply troubling to many radio reporters, especially those who appear on so-called zoo stations.

This is not to imply that radio news as a whole has become a contaminated commodity; indeed, that perception would be entirely false. Stations in markets of all sizes continue to offer news programming that is a genuine service to the community. But radio is no longer a mass entertainer. In most cases, it is a format better suited to reaching narrow audience segments. And since news is a part of that audience-building effort, the approach to news will inevitably have to be in sync with the station's overall sound.

THE TELEVISION STATION: PERSONNEL AND OPERATIONS

News occupies a slightly different place in the television hierarchy. Usually, the news director reports directly to the station manager. Since most commercial television programming is basically the same, without the narrow and specialized formats that characterize radio, TV news is generally *not* regarded as a programming function to reinforce the station's choice of material for airplay.

It might even be safe to say that the reverse is true: *TV news sets the trend for the station's image.* Mentally compare two network-affiliated television stations in your hometown. What, in your mind, differentiates the two? The prime-time programming? The game shows? Probably not. Most of us would be hard-pressed to make any clear differentiation along the lines of, "Channel 2 has more police shows than Channel 5, but the game shows on Channel 5 have better prizes." But we often *do* remember the local an-

chors and are even aware of the programming strategies of the local news departments. I lived in one area, for example, where one station clearly represented itself as being more attuned to news of the outlying regions. The other stations certainly didn't imply that regional news was not important, but they tended to focus more clearly on events in the metro area.

NEWS AND PROFITS

The essential point is not that radio news is a poor cousin to television news. Radio news, in many ways, is more versatile and more critical to the community's needs than television. Think about the last major storm in your area: When the power went out, did you pick up a battery-powered TV? Which medium helps you skirt the traffic jams on your way to work or school? If there's a big fire down the block, which medium is likely to offer details of the event at 10:30 a.m.?

No, radio news is alive and well in many stations in many markets. But it does not thrive equally among all stations in the market, and it simply cannot produce, on an industry-wide basis, the same profits as TV news.

Having said that, let's note that few stations, radio or television, can or will continue to subsidize very unprofitable news operations over the long haul. This frequently places the broadcast journalist in the uncomfortable position of being part of a news organization that is also expected to be a profit center.

Pressure to attract a news audience is certainly evident during those periods when local ratings are being intensely scrutinized. The sudden increase of lurid stories (sex, violence, new sightings of Elvis and so forth) during the so-called ratings sweeps has become so commonplace that few broadcast executives even bother to deny that it happens.

Other economic factors come into play, including the role of advertising. Small stations are particularly vulnerable to advertiser pressure. The station's financial footing might be tenuous at best, and the loss or addition of a major advertiser's account could have a critical effect on the health of the overall organization. In light of this factor, it is not unheard-of that the news director might be asked by management to cover the opening of a new grocery store, a store that by happy coincidence will be buying tens of thousands of dollars' worth of advertising on the station. (Store openings are not usually newsworthy events, but you may be asked to cover more than your share.)

There is no easy answer to this dilemma. Resistance is a good option and a recommended one, but it is a harsh reality that resistant journalists can be replaced with employees who are more pliable should management decide to do so. You may encounter this situation quite early in your career (in fact, you are more likely to encounter it at your first job at a small station than during subsequent employment in larger markets), and it is one that you may be better-prepared to handle with some forethought.

A Typical News Day

Recognizing that the people and positions involved in broadcast news vary from market to market, and that the operations of radio and TV news differ significantly, we can still paint a broad panorama of how a typical station operates—focusing on one journalist's newsgathering for a newscast and how that journalist depends on work that has been done previously and that sets the scene for work to be done later.

We've seen several examples of station operations in Chapters 1 and 2, but we've yet to observe the specifics of gathering, writing and presentation in sequential order. Let's take a part of the broadcast day and show how it's structured and how it relates to duties performed by other personnel during other time periods.

For the sake of this example, we'll set the scene at a medium-market radio station. The city itself has a population of 300,000 people, while the metropolitan area served by the station (the suburbs and a few outlying small towns in nearby counties) totals almost a million.

Hypothetical station WXXX has ten full-time employees in the news department and two part-timers. The station's format is known as adult contemporary, a mix of the easier strains of currently popular rock (no heavy metal here) and a few oldies. The station has a strong commitment to news and unabashedly bills itself as the city's news leader.

THE START OF THE NEWS DAY

Pam, the morning anchor, is first in the door. She arrives a little before 5 a.m. There is no overnight newsperson, but the all-night disc jockey spends a lot of time on the phone with other insomniacs, so he can often fill her in on major overnight developments.

Pam's first task, after gulping down another cup of coffee, is to check the wire. Just six months ago, this meant sorting through reams of paper spewed out by the station's Associated Press printer, looking for the weather forecast, state news and any national story that might be localized. But now AP is tied into the newsroom's new computer system. Updated stories are fed directly into her "queue," a line of stories available to her at a keystroke.

There's also a lineup of local stories in this morning's queue, mostly material left over from last night's coverage of local meetings and a couple of crime stories. The computer system

automatically kills stories—erases them from the queue—when they reach a certain age.

After checking through the wires and local stories, Pam works the phones. She has a list of 15 local and area police and fire agencies. "Anything happen overnight?" she asks—15 times. This morning, four items are, in her view, newsworthy:

1. A fire in which a building was destroyed but no one injured
2. An auto accident involving serious injuries
3. The escape of a criminal from a local jail
4. A major brawl at a local nightclub in which ten people were arrested and five injured

She takes notes and writes up each story using the word processor in the computer system. Her system's software counts the number of words and automatically calculates about how much time each story will take to read. The computer is programmed to do this for each staff member, based on that staffer's typical reading rate. Her computer workstation is tied into other computers in the newsroom.

To digress a bit in order to stress an important point, let's note that the interlinking of computers can be a curse as well as a blessing. Most computer stations have personal workstation areas that contain information such as correspondence and notes. Although passwords and other security measures supposedly protect your work from prying eyes, don't put too much faith in the sanctity of workstation security.

Paul Puccio, technical supervisor of WBZ-TV in Boston, puts it more succinctly: "Don't ever," he warns, "put anything in the computer you wouldn't want your mother or your news director to see."[5] Paul Smirnoff of Fox Network News in New York wholeheartedly concurs: "Nothing is private in a computer. . . . I never think my stuff is safe. I've been raided. I even found a news director whose password was FOX."[6]

Having said that, let's return to WXXX's morning news operation. After working on her computer-processed stories, Pam scans the morning paper to see if she's missed any major events. And it looks as though she has. The paper has a major story about the pending indictment of the mayor's son on drug charges. The paper attributes the story to an unidentified source at the city courthouse.

It is never a good idea to simply rewrite a story from the newspaper and use it as your own. Many radio stations do this, but at some risk: If the paper is wrong, you are wrong too. And newspapers are not inclined to look favorably on radio stations that regularly appropriate their stories; they may take legal action against—or at least publicly embarrass—the station, its management and you by pointing out that your morning newscast is coming directly out of the newspaper.

However, this particular story cannot be ignored, nor can it simply be rewritten as though it were gathered by the station's news department. So Pam does what she considers the right thing: She rewrites the story and credits it to the newspaper. A little of this is all right—in fact, she has no real option in this case—but if it's overdone, listeners get the idea that all your stories come from the newspaper.

As a general rule, once you've checked out a newspaper story with your own sources, or undertaken an additional interview to flesh out

[5] Remarks made during panel on "Newsroom Computers: Security and the Future," Radio-Television News Directors Association convention, Kansas City, Mo., September 15, 1989. Quoted by Compuserve Journalists Forum System Operator Jim Cameron.

[6] "Newsroom Computers: Security and the Future."

the story, or have done *something* to advance the story and make it yours and not the newspaper's, it is all right to use it.

Now, Pam prints out her stories and chooses the story order for the 6:05 a.m. local newscast (the local news follows the network radio newscast, which is fed on the hour). Sometimes, the decision is easy. If a major story eclipses the others, the decision about which story to lead with is clear-cut. When there are five stories of equal importance, she may just shuffle the leads from newscast to newscast.

Today, no local story is of overriding importance, but she chooses to lead with the escape from the local jail. The escapee is not particularly dangerous (he's charged with burglary and has no history of violence), but the story has a hint of drama to it and, more importantly, is an *ongoing* story. Police are searching for the escapee as the story is airing.

Pam knows that broadcast news is more effective when it is written in the present tense. She can write the lead to the jail escape story in the present tense,

> Police are searching for an escaped criminal who jumped from a second-story window at the county jail early this morning.

making it a natural opening for the newscast.

The second story? A report filed by the late-night street reporter on the city council meeting, which lasted until almost 11 o'clock, contains some very good actualities. Radio is a "show" medium as well as a "tell" medium, so she elects to use the story near the top, even though it's not as current as some other items.

Next comes the brawl story. She chooses it because it occurred at a well-known local establishment. Many of her listeners can identify with the item. Unfortunately, it's a weak radio story because she has no sound—no actuality, no wild sound of the melee, nothing. She could

have recorded the remarks of the desk sergeant who read her the report, assuming that he gave her permission to do so, but he was only relaying information off the sheet filed by the officers at the scene. The desk sergeant didn't see the incident himself, so a recording of his voice would be a very weak actuality, indeed. Maybe later one of the reporters will be able to track down someone who witnessed the event and get some tape.

THE REST OF THE NEWS DAY—AND THE DAYS AHEAD

That is how the first newscast of the day, usually the one with the second-biggest audience (the 7:05 a.m. newscast has slightly higher ratings) is put together at WXXX. The remainder of the day will involve Pam, who works until 2 a.m., gathering news and rewriting some old stories, and the news director, who arrives at 8 a.m., reviewing Pam's copy and making assignments for the day.

Marty, the news director, already knows much of what will be happening during the day. As we've mentioned earlier, a good deal of the news is generated from the futures file—that collection of notices about upcoming meetings of government agencies, groundbreakings, political rallies and so on.

Marty works out the schedule for who covers what. As reporters arrive in the newsroom for their respective shifts, they'll know where they're going and when. In addition, each reporter, whether based in the studio or on the street, will be responsible for coming up with his or her own story ideas.

What kind of stories? Perhaps a follow-up to an event that took place days or weeks ago. Possibly an interesting feature on health or fitness. Many news departments are continually on the lookout for investigative pieces that deal with issues of direct concern to the public. (In Chap-

ter 6 we'll see how one enterprising Chicago radio reporter broke a major story on airline security.)

In the next chapter, we'll explore step one in writing a news story—gathering the facts. Chapter 5 introduces more fundamentals of basic newswriting. Chapter 6 looks at some of the more advanced newswriting techniques and lays the groundwork for the following sections, which deal with integrating writing and production, and construction of the newscast.

SUMMARY

1. News department functions are nearly identical in all newsrooms. What varies is how specific each job is. In large markets, specialists tend to work in tightly defined roles. In smaller markets, fewer staffers handle a wider variety of duties.

2. Broadcast news is a team effort. Everyone contributes to the final product, and everyone's contribution is important.

3. Most broadcast journalists entering the field today are college-educated. While not always a prerequisite, a college degree is helpful in this competitive environment.

4. Arguably the most helpful attribute for a journalist is experience. Usually, broadcast journalists obtain experience by taking just about any job they can get in a small market and working their way up from job to job in various towns and cities. Internships, too, are useful for gaining experience.

5. The people we customarily think of as broadcast journalists are general assignment reporters and on-air anchors. But there are many other journalistic positions directly involved in broadcast news, including news directors, producers, field producers, photographers, sports reporters, weather reporters and writers.

6. News departments are part of the business of broadcasting. As such, they fit into a corporate hierarchy and are subject to business pressures—including the pressure to produce and maintain an audience.

7. The major difference in overall operations between television news and radio news is that radio news usually conforms to the format of the station; it must reinforce the station's sound, whether that sound is hard rock, easy listening or anything in between. This causes problems for radio journalists in certain formats. The style of some radio formats is to not take anything seriously, thus creating possible friction between news and programming.

EXERCISES

1. You are the news director of a financially struggling television station. Your boss, the general manager, informs you that a major client (a local department store) is going to pull its advertising from the station if you continue to cover demonstrations staged outside the store by anti-fur protestors.

 The demonstrations are quite large, have involved several arrests and have attracted a great deal of public attention.

 Although the general manager has not *directly asked* you to kill the coverage, he's made his message clear: The loss of this revenue just might mean the loss of the news department, which runs a yearly deficit.

 Write a two-page paper explaining how you would respond to this scenario. Would you capitulate? Why or why not? What would you say to the manager?

2. During this chapter's discussion of the structure of news departments, I purposely avoided listing organizational charts, for two reasons:

 a. They vary so much from market to market that they can be misleading.
 b. It would have spoiled this exercise.

 Your mission is to construct an organizational chart of local TV and radio stations. This is best accomplished as a group function; in other words, have a group of three or four chart the functions of TV station A, another group TV station B, another group radio station A and so on. Try to avoid any duplication. News directors are usually receptive to one project such as this, but they'll soon balk at going through the same material several times for different groups of people.

 The organizational chart should list the overall hierarchy of the station and, in this case, should have a detailed breakdown of the news department. If you are not familiar with an organizational chart, see the example in Figure 3.3; this might be a chart of the duties and chain of command in a typical medium-market radio station.

 The details of the news department hierarchy have been left blank. On your charts, fill in the boxes and lines of responsibility, making sure you include assignment editors, producers, writers and so forth.

 Be sure to annotate the chart. For example, if you have a box marked "producer," use a footnote to briefly explain what that producer does.

 If time and resources allow, you might wish to have one group prepare an annotated organizational chart for the local newspaper. This will allow you to compare and contrast structures and staff size between print and broadcast media.

Figure 3.3 *An organizational chart for a typical radio station.*

4

NEWS- GATHERING TECHNIQUES

News rarely unfolds before the reporter's eyes. Instead, the enterprising journalist has to harvest that information, using a variety of *newsgathering* techniques. Sometimes, newsgathering is a relatively passive process, involving alert use of the eyes, ears and mind. In other cases, the reporter's job becomes more active—requiring legwork and occasionally a bit of arm-twisting.

This chapter covers three classifications of newsgathering procedures: *interviewing, observation* and *research*. Note that these categories are not mutually exclusive. They are considered under these headings as a concession to organization and convenience. For example, an effective interview is often the result of extensive research conducted before the first phone call was made or the first camera uncapped. While research may be done in the library or at the computer terminal, it might also involve interviewing and observation. And observation involves more than keeping your eyes open: An observant journalist asks questions and spends time researching background material.

Interviewing

Asking a question and getting a straight answer is a more complicated process than you might expect. Interviewees frequently have vested interests, and seek to answer your questions circuitously. Sometimes, though, interviewees will tell you an outright lie, or they will flatly refuse to answer a question or evade an issue.

Journalists have developed a variety of specialized techniques for extracting information when confronted with the above circumstances. Journalistic interviewing is a three-part process. The experienced questioner:

1. Assesses the motivations of the person being questioned because those motivations play a

strong role in determining the interview's ambience and the type of information that will be provided.

2. Determines the appropriate structure for the interview.

3. Uses specially structured questions to evoke a meaningful response. Sometimes these questions lead directly to the point. Other times, they are open-ended "discovery" questions designed to get and keep the interviewee talking.

Please note that these are generalized categories, not prescriptions. Many journalists have their own styles; this chapter doesn't purport to inform you of the only way to do interviews. These methods, however, are good starting points.

MOTIVATIONS OF INTERVIEWEES

Why does someone talk with a reporter in the first place? It's an important question, because the character of the information you receive is determined in part by the circumstances that brought you into contact with the interviewee. Those circumstances include the interviewee's *professional obligation, personal or professional gain, inadvertent entry into the public eye,* and *the desire to confess or divulge information.*

Professional Obligation Some people are compelled to speak with the news media because it is their job to do so. For example, police departments have designated public affairs officers. The military often calls the person with that duty a public information officer (PIO). Public relations professionals for profit-making and non-profit organizations are also compelled to speak with the media; that is a function explicit in the job description.

A person bound by professional responsibility to speak with a reporter may do so with

some reluctance. For example, police departments are required to furnish certain facts to the media (see Chapter 2), but there is no law requiring them to do so *enthusiastically,* or to provide you with additional facts that will complete the story. And although police departments typically dispense information to the press over the phone, the officers involved often find it a bothersome chore. They sometimes "forget" to inform you of major incidents.

When a public relations representative is required to speak with a journalist purely because of professional obligation, he or she may provide incomplete data. No PR person will welcome an inquiry about toxic wastes you have found on the company's property. It is likely that you will receive perfunctory answers and that the PR representative will not volunteer potentially damaging information. There are few cases where anyone is *obligated* to give you a complete story. No law says a PR representative has to spill his or her guts just because a reporter is on the phone.

Information provided as a professional obligation may be perfunctory in nature, may be incomplete, since the person answering your questions may not be motivated to lead you to the heart of the story, and may be intentionally misleading if your inquiry involves a negative angle.

Personal or Professional Gain Some interviewees appear before cameras and mics for the sole purpose of promoting their organization, their product or themselves. There is nothing inherently wrong in this. However, a journalist has an obligation to present information in a balanced manner and to ensure that the facts aired are a matter of legitimate public interest— and not just a free advertisement for the person being interviewed.

Public relations agents often adopt a markedly different attitude when speaking with a journalist about a subject promising personal or professional gain (as opposed to those circum-

stances when they grudgingly face the media to fulfill a professional obligation concerning a story they don't particularly want publicized). PR professionals can be solicitous, sometimes charming, and will often provide you with valuable information. Good PR people (who often were reporters themselves, before entering the much more profitable field of public relations) know what reporters need and in what form they need it.

For example, on a day when there is a major confrontation in the Middle East, public relations representatives from universities across the nation are likely to be on the phones to major news media, attempting to line up interviews with their universities' Mideast affairs experts. Such an arrangement can benefit everyone. The reporter, who was scrambling to come up with an angle and an analysis, has an expert dumped in his or her lap. The university receives nationwide publicity and gains credibility in the eyes of potential students and their families.

However, information provided to you in such a situation may not always be of top quality. To continue the example of the university and the Mideast crisis, remember that the PR executive is under pressure to gain recognition for their faculty via news programs, and may supply you with an expert who is less qualified than someone you could have sought out on your own.

The PR people have a job to do, and *everyone* wants to be presented favorably. Almost all business representatives feel their organizations will benefit financially from positive publicity. For obvious reasons, politicians want good press. Although information provided to you for personal or professional gain is not necessarily duplicitous, such material is not presented merely for the sake of giving you information.

Here is another way of looking at the situation. Historians use the terms *document* and *instrument* to describe certain sources of informa-

tion. (Note that this information may be archival, printed material; however, the gathering of recent history also involves interviews with subjects who witnessed or participated in an event, so the work of a historian and a journalist are not dissimilar.)

A document, in the historian's vocabulary, is a piece of information that exists for no other reason than providing information. A transcript of a hearing, for example, exists only as a record, an artifact, an account. On the other hand, an instrument is a collection of data that exists *to serve some purpose*—to further a cause, perhaps, or to persuade a reader, viewer or listener. Information provided by a political candidate will almost certainly be in the form of an instrument. It is *instrumental* because the information serves some other purpose than simply providing facts.

Inadvertent Entry into the Public Eye Some people become caught up in events because of happenstance. They witness a tragic accident, or come home from work to find their homes burned to the ground. Crime victims, too, are unintentionally thrust into public scrutiny.

Such sources of interviews are under no obligation to provide you with information. Nor will they carry the ideological baggage of the political candidate who supplies information for his or her personal benefit, so they are not likely to give you instrumental material.

But veteran journalists know that people thrust into the public eye nevertheless do present two credibility problems: They often are *inexpert* witnesses, and they are frequently reluctant to provide information.

We can once again borrow the historian's technique of sifting and weighing information when assessing the inexpert evaluation provided by a subject suddenly asked for an interview. Historians who chronicle battles sometimes use a colloquial phrase called "the corporal on the battlefield syndrome." This refers

to the recounted memories of someone who viewed an event from a *limited perspective*. For example, the corporal may exaggerate the fierceness of the fighting because it was his first taste of combat. Or, he could overestimate his unit's role in winning the battle, basing his assessment on the justifiable exhilaration felt by a group of soldiers who fought shoulder to shoulder in a life-or-death situation.

Neither statement is inherently self-serving or intentionally deceptive—but both could be misleading. A general, with years of combat experience and access to the whole military operation, might note that the corporal's unit was involved in a relatively light engagement and played a small role in the battle. This is not to imply that generals speak only the truth; it does mean that they have access to the *totality* of information and are better able to evaluate that information in its proper context.

A broadcast journalist conducting an interview confronts precisely the same problem, irrespective of whether the interview takes place on a battlefield or a city street. For example, a pedestrian who has just witnessed an accident and finds him- or herself quizzed on the incident by a reporter may significantly exaggerate the severity of the mishap. There are two primary reasons why this could happen:

First, most people are not accustomed to the sights and sounds of a traffic accident. Even minor accidents can involve a surprising amount of blood and broken glass. What might appear to the untrained eye to be horrifying carnage could be nothing more than a scalp wound (the anatomy of the skin and blood vessels on the forehead and scalp produces a great deal of blood even on minor impact) and a shattered windshield. (U.S. automakers design windshields to shatter on impact, disintegrating into thousands of rounded pieces, rather than producing several long, jagged shards.)

So while your citizen witness may not intentionally lie to you, a description of the accident from a traffic cop or paramedic will generally be far more accurate and reliable.

The second reason for an exaggerated version of the accident is that the vast majority of people are not interviewed by the news media on a regular basis, and they view it as a privilege, an honor, their chance at fame. Therefore, people thrust into the public eye sometimes want to provide a reporter with what they think the reporter wants. This often results in a dramatized accounting of events.

Unfamiliarity with the whole situation and/or the desire to please a reporter can significantly skew the information provided to you by someone suddenly placed in the public eye. Here are some brief examples drawn from actual experience.

■ A worker for a financially troubled company informed me that he had been told by "absolutely reliable sources" that the entire operation was closing down. He was wrong. His information came from other assembly-line workers, people who received their information through the grapevine. He did not have access to the overall picture, and the company is still in business and prospering.

■ A caller maintained that there was a riot taking place at a nearby shopping center. The riot turned out to be seven police officers attempting to subdue a strong and combative drunk. Why seven cops? They were attempting to control the subject without causing him extensive injury. One cop could easily subdue an attacker by using a nightstick or a revolver, but it takes many people to wrestle and restrain a fighter without striking or shooting him.

To the untrained eye, the battalion of policemen fighting the drunk was a riot. But in the normal day's events, it was a routine arrest and a well-handled one. No one suffered any injury.

■ A resident of a neighborhood in which several recent crimes had occurred spoke of the "terror in the streets," alleging that "people were afraid to go out of their homes." This account almost made the nightly newscast until a reporter, driving home through the neighborhood in question, noted that the streets were *full* of people: shoppers, kids on bikes and elderly people sitting on park benches. The person who made the original statement was again contacted and admitted that she had perhaps exaggerated the situation. "But," she added, "I thought you wanted me to talk about how people were afraid."

Someone thrust into the limelight is generally an inexpert observer. Be very cautious in taking verbatim the information of a person who is not an experienced observer, does not have access to the overall picture, may be overreacting to an unfamiliar situation, or may be telling you what he or she *thinks* you want to hear.

Desire to Confess or Divulge Information Many people come forth with material because they want to confess something or feel they have knowledge of a situation that should be brought to the attention of the public.

When interviewing such people, there are two critical points to bear in mind. First, it is tempting to believe that when people say something negative about themselves, the information is true. Such negative information *may be* true, but people do confess to things they have not done, for reasons known only to themselves.

Second, when someone discloses information to you voluntarily, you need to know *why* the admission is being made. Does the person have an ulterior motive? If so, the information is suspect. For example, you may speak with someone from the law enforcement community who offers information, on condition of anonymity, that a prominent official is under investigation, but the investigation is being hushed up by higher authorities.

This informant may be giving you this tip because he or she is legitimately outraged that a high official is getting away with something. Providing such information could rightly be considered a public service. However, there is also the possibility that your interviewee has a personal grudge against the person allegedly under investigation, and is using you and your station as a weapon.

This is one of the classic problems of newsgathering and is given further consideration elsewhere. People who confess or divulge information do so for a variety of reasons—and not all of those reasons are laudable. Keep the motivation factor in mind when conducting your interview. Evaluate your interviewee's information much more carefully if there seems to be a hidden motive involved.

Now that we're more aware of the ways in which an interviewee's perspective and motivations can alter the character of information you receive, we are ready to plan the *basic structure* of the interview.

APPROPRIATE STRUCTURE FOR AN INTERVIEW

Several factors are involved in determining how the interview will be structured and carried out. Among them are *the intended use of the interview, the availability of the subject* and *the cooperation of the subject.*

Intended Use of the Interview There are three primary types of news interview: interviews meant for use as *background,* as an *actuality* or *sound bite,* or as a *talk show.*

The *background interview* is conducted to compile information that may be useful in the production of the story. However, this information will probably not be used directly on-air.

For example, when I worked as a medical reporter I frequently asked physician friends

about general trends and new information in the medical field. Everyone was aware that these sessions were conversations meant for brainstorming and not for attribution. The physicians would never have spoken as freely or given such strong and provocative opinions had they expected to be quoted. Likewise, I did not accept what they told me as fact; I *always* verified the information with an on-the-record interviewee because, as noted in Chapter 2, when people are not quoted they are not held directly accountable for their statements—and this allows them to exaggerate, slant or even lie.

The *actuality* or *sound bite* interview is designed to produce a segment of audio- or videotape that can be inserted into a radio voice-actuality or television package, or inserted directly into a newscast read by the anchor. The goal of an actuality or sound bite interview is to evoke an answer that is short, to the point and can stand on its own. There are several techniques (discussed in the following section) on ways to elicit a usable actuality or sound bite response.

A *news talk show* interview must usually run for a specified period of time and has a flow, a continuity; it moves from one subject to the next with a sense of progression. The guest on a talk show can speak at much greater length than during an actuality or sound bite interview.

Availability of the Subject The same quality that makes people newsworthy also limits the amount of time that they are available to the news media. In turn, this affects the way in which you will structure the interview.

How will you arrange to meet the interviewee? Will you visit the interviewee in person at a remote location, have him or her come to your station or do the interview over the phone?

An in-person interview at a remote location, often the subject's office or the site of an event in which the subject is participating, is usually the ideal choice for broadcast newsgathering.

For one thing, it captures the subject in his or her native environment and provides some of the physical or aural trappings that add color to the interview. Often, too, this is the only way you'll gain access to the person.

Having the interviewee visit the station is not a common option in most newsgathering operations. Although a convenience for the reporter, most newsmakers do not have time to make themselves available in this manner. The most frequent exceptions are guests who appear on talk shows. Talk shows may or may not be news-related productions, but you can generally arrange to use cuts from the talk show in a newscast should the program involve a newsworthy guest.

Often, a journalist must resort to a telephone interview. Radio stations, which typically have limited staff, frequently exploit this method of newsgathering. A telephone interview is also much more convenient for an interviewee, and it may be the only method to give you access to your subject.

But telephone interviews have significant disadvantages. Foremost is their sharply limited application for television. Showing a still photo of an interviewee and using audio from a phone conversation is acceptable when there is no other practical way to obtain an interview, but that is hardly evocative video. Even radio stations would rather have in-person taped interviews than interviews recorded off the phone. Recorded phone conversations are instantly recognizable as such, and many journalists feel they don't convey the immediacy or presence that makes radio a powerful medium. Some radio stations go so far as to disallow the use of phone interviews altogether, and insist that every piece of actuality be gathered in person using a high-quality microphone and recorder. However, this does not preclude the occasional use of phone interviews when that is the only logical alternative, such as speaking to a local citizen trapped in an overseas war zone.

Cooperation of the Subject For various reasons, interviewees may not wish to speak with you, or may be willing to cooperate only to a certain extent. Then, the structure of the interview revolves around this cooperation factor. Two particular problems arise:

1. Getting a subject on-camera or on-mic. In rare cases, you'll have to ambush the person on the street. A street is legally considered a public forum (a distinction clarified later in this chapter), meaning that a reporter has a greater right of access to the subject than if the person were on private property. The ambush interview should be considered only when repeated attempts to arrange a standard interview have been rebuffed and you feel the interview is necessary and newsworthy. Remember that an ambush often arouses sympathy for the subject, who the public may perceive as the victim of the ambush.

2. Circumventing a "no comment." Media-savvy public figures frequently exercise their constitutionally guaranteed right to keep their mouths shut. Although some critics argue that airing a "no comment" can make an innocent person appear guilty, many news veterans observe that people who exercise their no comment option can and do avoid accountability for their actions.

Setting aside that argument, which cannot be resolved here, a "no comment" does not make informative or compelling news. When structuring an interview, there are three primary methods of getting past the no comment stonewall.

First, if the subject refuses to consent to an interview, inform him or her that you will *report* that he or she refused such consent. This is a highly effective method of attitude adjustment. It may not necessarily circumvent the "no comment," but quite often it does prod the interviewee to talk.

Second, if on-camera or on-mic the interviewee replies "no comment," ask *why* he or she is refusing to comment. Should the interviewee respond, the explanation of the "no comment" might actually be the answer you wanted in the first place.

Finally, a variation on the no comment routine is the "no interview" dodge. If you cannot even get the interviewee on the phone—let's assume Mr. Big is always in a meeting—inform Mr. Big's secretary that you would like your phone call returned *at a specific time*. Be sure you are there to receive the call should it indeed be returned. Should Mr. Big not return the call, give this tactic one more try—but be certain to inform Mr. Big's secretary that if your phone call is not returned, you will air that fact. (An alternate option: Find out the name of Mr. Big's boss and ask Mr. Big's secretary to transfer the call to that office. Mr. Big may suddenly materialize.)

To summarize the information presented so far, we have (1) determined the motives and perspectives of your interviewee, and (2) determined the proper structure for the interview.

Next, we'll show how these factors contribute to the execution of the interview. The act of producing usable answers is a direct result of asking properly phrased questions. Certain techniques can help you gather reliable, direct and compelling quotes from interviewees.

QUESTIONS TO EVOKE A MEANINGFUL RESPONSE

A meaningful response means an answer that will serve your purposes and the purposes of the viewing or listening public. A meaningful response, one that is illuminating to the listener or viewer, must be:

1. Useful within its technical context—that is, a meaningful part of a package or voice-actuality

2. A direct response to the question, and to follow-up questions

Technical Context A rambling answer will be of little use to you if you need a 20-second reply for insertion into a 90-second package. Also, the interview segment won't be functional if it is too complex or too simplistic for the audience. And if you are interviewing a guest for a longer segment, such as a talk show, you must elicit responses that will sustain the listener's or viewer's interest for an extended period, perhaps a half-hour or even an hour. The following suggestions will help make the message fit your medium.

When asking a question for a brief sound bite, don't be reluctant to ask the same question several times. You may get some quizzical looks from your interviewee, but you will also obtain varied responses and, sometimes, *better* responses.

Let's say you ask the same question three times. What may happen is that you wind up with three successively more focused answers. The third might be the charm. Also, you will have more material to work with back in the editing suite. *A perfectly good answer may prove to be perfectly unusable* if it does not match properly with the video and other material you have for the package. (If you're interviewing for radio, you also obtain alternative audio for several radio newscasts.)

When using the technique of asking the same question several times, you can alter the questions slightly so it appears that you're asking a different question when in reality you're not. Alternately, you may elect to inform your interviewee in advance. "Sometimes, I ask the same question more than once," you might say, "so don't be surprised if you hear me repeat myself. I do this just so we can get different camera angles and cover ourselves in case there's a technical problem with one of the shots."

When you want a *short* answer, ask a *short* question! If you are looking for a 10-second sound bite, ask the Mayor, "What's the most pressing item on tonight's City Council agenda?" Don't ask, "Mayor, could you explain the priorities you've established for tonight's City Council meeting? How do you plan to deal with all the items on the agenda, and how did the schedule get so packed in the first place?"

If you want a *simple* answer, ask a *simple* question! For example, ask a physician, "How does cholesterol harm the body?" Unless you're producing a piece for a specially trained audience, don't start with, "Doctor, what is the mechanism by which cholesterol contributes to atherosclerosis?"

The latter question raises some interesting points about the entire interviewing process. Regardless of the type of interview—sound bite, talk show or background—the *beginning* question sets the tone for the entire interview. If you start the interview on a complicated theme, you will never get your expert back on a simple track.

Also, no matter how much knowledge you have obtained during your research, your audience will be starting from ground zero. Note, too, how the question about the mechanism by which cholesterol contributes to atherosclerosis forces the interviewee into deeper waters than you or your audience might care to venture. By asking about the mechanism by which cholesterol does damage, you are introducing a complex, still unclear process, and that is the point from which your physician interviewee will begin his or her answer. It will be virtually meaningless to the audience, who want a general idea of what cholesterol might do to their abused arteries.

Note, too, that you have assumed that your audience knows what atherosclerosis means. Do *you* know what it means? It's not quite the same thing as arteriosclerosis, and your

interviewee might feel obligated to explain that—so we're already miles off the track.

If you are doing a talk show (a show with an opening and closing and with a predetermined length), remember that a talk show is simply an imitation of a social situation. This means that the audience expects to be introduced to the guest. The topic should start general and become more specific; the conversation should begin formal and then become more personal; the questions should become more pointed as the conversation wears on.

There are two reasons for observing this convention: First, if you lead with an abrupt, challenging question, you may appear rude and boorish. Worse, you may force your guest into a defensive shell and be faced with 29 uncommunicative minutes of remaining program time.

This isn't always the case. There may be occasions where you will want to cut right to the heart of the matter. That depends on the interview and the interviewee. But most experienced interviewers know that it's safer to warm up the interviewee with some slow pitches and save the hardballs until the end.

To quickly review the ways to elicit a meaningful answer, it is often helpful to:

- Ask the question in different ways.
- Ask short questions if you want short answers.
- Ask simple questions if you want simple answers.
- Start on a general area and hone in on the specifics.

Extracting a Direct Response People evade questions for a variety of reasons. Sometimes, they are trying to hide something. More often, they are simply uneasy and afraid of being misinterpreted; they may avoid your question or not want to elaborate on the subject. It is a journalist's job to elicit a meaningful response despite these obstacles. Usually, this is a three-part task, involving *obtaining a direct answer, focusing the issue* and *stimulating further response.*[1]

Obtaining a direct answer means getting the respondent back on track. In these days of media advisors and public relations counselors, shrewd public figures are often taught to evade a question by giving the answer they want—irrespective of the question that was asked.

For example, you are forced to ask a direct yes-or-no question because you are getting nowhere with your interview with a political candidate. You come right out and ask:

Q: Do you plan to fire the aide who leaked the information about your opponent?

A: We're going to run an honest, straightforward campaign. It's important that we keep our efforts on track, because economic conditions in this city . . .

You're responsible for recapturing the focus of the interview. "I'm sorry," you might say, "but I didn't quite understand your answer. Are you firing him or not?"

This is one tactic. There are others. For instance, if the question is not being answered, *say so.* Start by repeating the question. If that does not work, mention that the question was not answered and ask it again. Should you still not get an answer, directly ask the interviewee why he or she is ducking your question.

Do not get drawn into a debate with your subject. This strategy—making you a part of the issue—is a method of evading a question. For example, your interviewee may respond to your question by giving an irrelevant response, and then asking you, "Is that fair?"

[1] These categories are further defined and discussed in Lewis O'Donnell, Carl Hausman and Philip Benoit, *Announcing: Broadcast Communicating Today* (Belmont, Calif.: Wadsworth, 1986).

Don't ever let the interviewee ask questions; that's your job. Just turn the question around again, or say, "My feelings aren't important. What is important is your action on the bill before your committee. Now, once again, do you intend . . ."

Focusing the issue means getting the interview back on track when your interviewee has wandered off the subject, either accidentally or on purpose. Sometimes you need to focus the issue because your interviewee is speaking gibberish. Two techniques are particularly useful.

First, use a paraphrase to force a clear response. If you are not getting a clear answer, sum up what you *think* the interviewee said and repeat it to him or her. Then ask point-blank, "Is this what you are saying?"

For example, if a public official has just told you: "We need to reevaluate the enhancement capabilities lost to us in the number of transactions that take place in certain economic categories, and reconsider the revenue structure of . . ."

You should paraphrase what you think you heard: "Mr. Representative, did you just say you favor an increase in the sales tax?" This method will allow you to force an answer in plain English.

The second strategy is to use a transition to get back to the subject. Guests, especially on long-form interviews such as talk shows, may accidentally or purposefully wander into the areas about which *they* want to talk. You can get them back on the subject without appearing abrupt or obstinate by relating what *they* want to talk about to what *you* want to talk about.

For example, the head of a city hospital, an administrator charged with running a sloppy operation, may be more interested in shifting the subject to the fact that the City Council has yet to draw up a firm budget for the year. Link the two subjects and force a transition back to your original topic:

Hospital manager: *. . . since January, and still no action.*

You: *Does the lack of a firm budget have anything to do with the charges that you are almost six months behind in your billings?*

Maybe there *is* a link between the two; maybe not. But you've prevented your guest from wandering off on a self-serving polemic.

Stimulating further response is necessary to keep the interview rolling and to allow you the time and opportunity to dig for real answers. A number of techniques have proven successful.

For example, don't ask dead-end questions unless you are forced to. Most books on interviewing advise you not to ask yes-or-no questions because such questions won't stimulate further response, and they will produce awkwardly short answers. That is true, but there are times when you must call for a yes or no. If your interviewee is evading an issue, don't be afraid to pose a yes-or-no interrogatory.

Also, you must master the art of out-waiting your interviewee. If you receive a curt, nonresponsive answer to your question, don't switch to another subject just because you feel the need to keep the conversation moving. Let the camera or tape recorder roll, keep the microphone in the subject's face and *wait*. Usually, he or she will break down before you do. The really smooth interviewees will just stare back at you as long as you care to continue the contest, but that in itself can make good tape.

In addition, be careful about letting your subject catch on to your pattern of taking notes. In other words, don't let the interviewee know when you have become excited by the information, because he or she will probably clam up. For example, basketball star Larry Bird reads reporters very well; when they stop writing and look up at you, he maintains, that's a good time to shut up because the subject is getting "too deep."

Interviewees are concerned about what you write—with good reason—and can make your job difficult when they ask "Aren't you going to write that down?" Just the opposite situation can arise when interviewees make a stunning statement and you scramble to write it into your notebook. They'll be struck with the magnitude of what they just said and will move to retract or mitigate it.

So, when you are doing a *notebook interview*—that is, newsgathering that does not involve the immediate presence of a camera or microphone—don't tip your hand by letting your interviewee discern your writing habits. One way to hide your note-taking pattern is to write all the time, even if you are just doodling in the notebook. This gives the interviewee no clue as to what you think is important and what is not, and avoids the "aren't you writing that down?" and the "wait, I didn't mean" syndromes.

Interviewing is a complex subject, and itself has been the subject of many books. But interviewing is just one aspect of newsgathering. Observation and research are critical skills, too.

Observation

Journalists sometimes rely too much on what they are *told* and not enough on what they *observe*. Journalists Ted White, Adrian Meppen and Steve Young provided a keen insight when describing the role observation plays in newsgathering:

> . . . It can support and strengthen the information developed during an interview. And at times—when interviews are not available—observation is all a reporter will have to work with.
>
> Broadcast reporters do most of their observing while covering a breaking story in the field. Record your sense impressions of sights—colors and forms—sounds, and smells at the scene of a

fire, storm or other disaster so you can describe an event vividly for your listeners.[2]

Your task as a professional observer, then, involves noticing details, and also noticing enough so that your observation leads to a general understanding of the situation. Another equally important task is observing inconsistencies—noting the differences between what you are supposed to see and what you actually see.

─────────

NOTICING DETAILS

Details are those seemingly small things that add color—a mixture of liveliness, realism and compelling detail—and impact to your story.

Color Whether captured on film, videotape or audiotape, the details of an incident are what make it evocative. For example, good video of the aftermath of a fire almost always includes some reminder that *people* were the ultimate victims—even if no one was physically hurt. For example, the twisted, blackened remains of a child's bicycle will bring home that point quite effectively.

Aspects of color are often the most difficult for a beginning newsgatherer to notice and incorporate into a story. An argument can be made that noticing color is not a natural skill: It is an acquired faculty, gained after some experience reporting in a particular medium.

While developing true skill in observing color does take experience, there are a few aids to help speed up the process. The first technique is to write down your impressions *immediately* if at all possible. If the words "roiling, greasy smoke" occur to you as you drive up to a fire scene, commit them to paper, because you're likely to

─────────

[2]Ted White, Adrian Meppen and Steve Young, *Broadcast News Writing, Reporting and Production* (New York: Macmillan, 1984), p. 36.

forget that vivid and compelling initial description once you start interviewing and lining up shots. Keep notes on your word-pictures; just a phrase will usually suffice:

"wind bent trees nearly double"

"fireman's eyes watering uncontrollably from the smoke"

"could actually *see* the rumor pass through the meeting room. Waves of people turned to each other"

In addition, don't forget the dramatic color that wild sound, the ambient sound of the environment, can provide—on radio or TV. One of the most vivid examples in my memory was of a story concerning a notoriously dangerous public housing unit. The pictures were expressive but not extraordinary. The narration was unremarkable. But the wild sound was eloquent: babies crying, music blaring, verbal confrontations in the parking lot and the general hubbub of too many people jammed into too small a space. The sound painted a vivid aural picture. (Always keep a mic open, even when you are shooting cover video. You never know when you'll need wild audio.)

The importance of wild audio for use in radio newsgathering should go without saying; however, after listening to a typical radio newscast, the message apparently has not been heard. Some radio news organizations just don't take the time to edit in background audio, and the voicers seem hollow.

The background sounds are what add texture to a radio report; listen to National Public Radio's "All Things Considered" and note how wild sound is used to communicate color.

Audio from the background also lends immediacy and authenticity to your work. J. J. Green, a reporter for WMAL-AM in Washington, D.C., noted that wild sound helped him feed effective coverage of the presidential inauguration. Using a cellular telephone (an increasingly important newsgathering tool), Green was able to put himself in the middle of the story—literally.

"All my interviews were live," Green noted, "and the cellular phone picked up all the street activity and background noise from the parade. One example was Vice President Dan Quayle talking to the crowd over the loudspeaker in his car near me while I was doing a live report."[3]

A final tip on adding color: When observing and gathering video, get close-ups. Television is an intimate medium. By all means, get a wide shot of the trailer park devastated by the tornado—you'll need it to establish the scene—but be sure to get close-ups that demonstrate the violence of the storm. For example, one particularly memorable shot showed a bathtub literally driven through a wall. *That* is the power of a tornado, and showing it close-up is the power of television.

Impact Observing detail lends an air of truthfulness to your story, and relevant detail *advances* the story, lending overall impact to the report. Also, such detail might become an important part of your coverage. For example, at one particular trial the plaintiff, a prominent local businessman, was called "Mr. Smith" by the judge. The defendant—easily the same age or older than the plaintiff—was referred to as "Willy."

An earthshaking revelation? No, but this detail did speak to the general atmosphere of the courtroom and may have reflected on the fairness of the proceedings. It became an important element in moving the story forward.

Keep your eyes open for those small things that add impact. Keep your ears open, too. Lis-

[3]Quote by Paul Courson, "Cellular Telephones for Radio Electronic News Gathering," *Communicator: The Magazine of the Radio-Television News Directors Association* (March 1989): 15.

ten to speech patterns; knowing the way people use words lends significant impact and credibility to your story. Do you know the latest street lingo referring to drugs, guns and violence? Listen for the street talk, use it, define it, because it will put you and your audience in closer contact with changing social conditions.[4]

Impact is also strengthened when the audience sees, hears or otherwise is informed that you *are on the scene,* not reporting the information second-hand. Thus, personal observation increases not only your accuracy and insight but also your audience's *perception* of same.

Access Problems Unfortunately, a reporter seeking this kind of observational impact does not have unrestricted access to any locale. For example, police may restrict your access to crime, accident and fire scenes on a more or less random basis.[5] And although the U.S. Supreme Court recognizes in general terms the relationship between a free press and free access, no constitutional rights of *access* have clearly been delineated.

You have unlimited access to things happening on the street or sidewalk, since these areas are considered in legalese to be *public forums.* However, there are exceptions: Police can forcibly remove you from an accident or fire scene, and various states have passed laws restricting reporters' rights to conduct exit polls on public forum property on election day.

Note that just because a building is public property, it is not necessarily a public forum. Journalists have only limited access to prisons, civic arenas (cameras may be banned during certain performances) and even certain offices in city hall.

Owners of private property have the right to keep journalists away even if that private property is venue to a newsworthy event—and even if that private property seems public in nature, such as a shopping mall or housing development.[6]

OBSERVING INCONSISTENCIES

Close observation also allows you to recognize when something you have been told does not square with something you see. This aspect of observation is critical to a journalist; and while observing inconsistencies is sometimes thought to be instinct, it is also an acquired proficiency. The following suggestions may help develop this ability.

The first tip is to be aware of the difference between what you are *supposed* to observe through the camera or microphone and what you observe with your eyes and ears. Remember the example of the speech given by the political candidate in a practically vacant room? Stay alert for any situation that may distort reality via radio or television.

Another suggestion is to use your instincts when evaluating consistency between image and reality. Sometimes things won't be as obvious as the case of the empty union hall and the tape-recorded brass band. But you should stay alert nonetheless. Richard Petrow, producer of the PBS "Constitution" series and a former reporter for the *New York Daily News* and several television stations and networks, noted that his suspicions about someone were once

[4]For a compelling account of how one reporter stayed in touch with life on the street, see Elissa Papirno, "Manchild in Ivory Towerland," *The Quill* (December 1989/January 1990): 20–23.

[5]See "Access to Places," *The News Media and the Law* (Summer 1989): 2–11.

[6]The thorny issue of access to private property and the legal ramifications involved is covered in "Access to Places," *The News Media and the Law* (Summer 1989): 5–8.

aroused because the man exaggerated his height on his resumé. While this was not in itself newsworthy or undeniably indicative of duplicitous traits, it did provide one more piece of information on which Petrow could base his judgment.[7]

Also, you must always be aware of the inconsistency *between what you are shown and what you could see on your own.* For example, if you are taken through an area in which there was a recent civil disturbance in a police patrol car, what you see will probably be very different from what you would observe if you toured the area on your own. If the police give you VIP treatment, you are removed from reality.

To follow up on the example above, observe things that are done just for you or just because you are there. Keep tabs on the special treatment or special access you are given. You do not necessarily have to mention it or rebel against it, but be cognizant of it. There is nothing wrong with an organization being concerned with its public image, but don't assume that the treatment given you is the same given the general public, or that the conditions you see are typical.

For a time, I was assigned to ride-along detail with the city police force. The chief of police, keenly concerned with his department's image, left standing orders that reporters would only be ferried about in freshly washed cars. But on two occasions the officer to whom I was assigned picked me up *and then drove through the car wash with me in the car.* This small point showed not only the chief's concern with public image but also that at least two street officers seemed oddly out of touch with the department's PR effort.

Interviewing and observation are the most active methods of newsgathering, but much of the research undertaken for broadcast news is done in a library or at the computer keyboard.

[7]Interview, Dec. 3, 1987.

Research

When we think of research, the image is often one of dusty textbooks. But the type of research undertaken by a broadcast journalist can be, if not fascinating, at least interesting.

Journalists involved in a complex story are as likely to be found sitting in the library as they are hoofing it on the beat. Also, they may not be using books and directories in their research. Much of the information may be called up through the computer keyboard. And research does not have to be a formal affair involving books or computers; sometimes newswriters conduct their research through their own informal network of contacts.

Research normally precedes an interview, but not all types of research discussed in the following section necessarily come before the interview nor are they necessarily linked with the interview/observation process. They are discussed here under one category for the sake of cohesiveness. Be aware, though, that the structure of this chapter—observation, interview and research—does not necessarily reflect the sequence in which these operations are carried out. There's no formula.

Suppose you witness an auto accident in which you think the cause might have been an overloaded truck. It makes no sense to immediately leave the scene and head for the library; get what you need through observation and interview and do the heavy research later. But in other cases you'll reverse the process. Should you be interviewing a rocket engineer, a night in the library will help you considerably in your effort to understand what he or she is talking about in the next day's interview.

We will examine all three areas—*library research, computer database research* and *informal networks.*

LIBRARY RESEARCH

Suppose you are trying to get local reaction about a 21-year-old city native who has just been arrested overseas, charged with being part of a terrorist murder plot. Where would you start?

Try the public library. Given a little time and a helpful librarian—a person who can provide you with invaluable assistance—you could:

1. *Find a picture of the subject.* Some libraries keep copies of yearbooks, and almost all school libraries have their own yearbooks on the shelves. The picture may be a bit dated, but using a close-up focus, you can at least get some footage for a TV newscast.

2. *Assuming the person was recently employed, get a reaction from the people with whom he worked.* City directories will list people's place of employment. If there's no listing for this year, check back in a couple of previous editions.

3. *Obtain some reaction from neighbors.* If you know the subject's address, you can use the library's (or the news department's) "criss-cross" directory, which lists addresses and then gives the name of the people living at those addresses. You can call for reactions from the neighbors next door ("Oh, he seemed like such a nice, quiet boy") and possibly set up some interviews.

You might also find some information about the subject in the local paper. Many large newspapers are indexed; should this person have been involved in some previous public incident, legal or otherwise, you might be able to gather some background.

Libraries are useful for finding all types of information. For example, if you are doing a story on high blood pressure, you would be wise to spend at least an hour scouting through recent books and articles on the subject. *It's much more productive to arm yourself with some basic facts before corralling an expert for an interview.* Don't arrive "cold" and expect a busy specialist to fill you in from the ground up.

The familiar *Readers' Guide to Periodical Literature* is a good place to start your search for recent articles on high blood pressure. The *Readers' Guide* will direct you to articles in popular magazines. Those articles will provide you with basic, generally reliable material *and*—perhaps more importantly, from the standpoint of your immediate needs—some ideas for new angles on the story.

For instance, if the news director has given you a vague assignment to "come up with something different on high blood pressure," you're obligated to develop a fresh approach. You *cannot* do a broad and bland book-report type of package. Your job is to find new angles.

Using the articles you've uncovered from respectable magazines, you identify a few possible approaches:

- There are new methods of treating high blood pressure that significantly reduce side effects from medication. Side effects are the reason most people with high blood pressure don't take their medicine—which is the reason why so many of them drop dead.

- Blacks have a significantly higher rate of high blood pressure than do whites. Why? What's being done to let blacks know about this risk?

- New medicines are helping people with previously untreatable (or at least very difficult to control) blood pressure to lead normal lives. Some of these medications are rather exotic—one, for example, is distilled from snake venom.

There! You've got three fresh angles. Now, you can call the public relations office of the local medical school and intelligently plan your interviews and cover shots.

Suppose you have to come up with a week-long series on high blood pressure. You'll need more detailed information than what is available in magazines. Check out the card catalog of the library. You may have to take several different approaches, depending on the way the library catalogs its holdings: As an example, there may be no listing for "high blood pressure," but the subject will be covered under "hypertension."

If the book holdings on a particular subject are fragmented, find a book that seems promising and locate it. Look to the left and the right; odds are, you will find other works that complement what you're researching. Physically observing, touching and flipping through the books available is more efficient in the long run than tracking down a notebook full of citations scrawled out at the card catalog.

There are thousands of useful sources available in the library; a listing of them would be far beyond the scope of this work. Instead, here is a sampling of the types of references you can exploit.

Periodical and Newspaper Indexes Some are general, while others are quite specialized. One of the best is *The New York Times Index*, which not only leads you to reliable stories, but also—when indexing major events—provides a chronology of the year's developments in a particular area.

Your local newspaper may also be indexed. If your broadcast station is affiliated with the local newspaper, you may also have access to the newspaper's own library, or "morgue."

Reference Books You won't believe the scope of reference books available. They cover every conceivable subject. There are so many references that it's wise to start your search with a reference book *of* reference books. Your librarian can lead you to several of these. Reference books don't list just academic subjects: You can

find anything from lists of what companies make what products (*The Thomas Register*) to biographies of notable people (*Who's Who*, among others).

Government Publications The United States government is probably the largest collector and distributor of information in the world. Thousands of government departments can provide you with information on anything from fruit flies to radon testing. Many government publications are on file at the library.

If you're really dead-ended in your research, call your congressional representative's office. Staffers will be able to point you in the right direction. And if you want to find out about the scope of the government's information-gathering arms, take a look at your local library's copy of the *United States Government Organization Manual* and *The Statistical Abstract of the United States*.

There is also quite a bit of information the government is not particularly happy to provide to you. See Chapter 13's discussion of the Freedom of Information Act.

COMPUTER DATABASE RESEARCH

There are literally thousands of databases available to anyone who has a computer, a modem and enough money to pay for the search fees.

A computer database is simply a collection of information that you access via your computer and a device called a modem, which stands for *MO*dulator-*DEM*odulator. It allows your computer to interact with another computer through a regular telephone line.

The primary strength of a computer is not so much *storing* information as *manipulating* information. If you were seeking information on the coal industry, for example, it would be simpler for you to peruse the shelves of your local library than to attempt to master the intricacies of a computer search (which you can also do at the

library). But suppose you wanted to do an article on job actions in the coal industry. Now, the computer's data-meshing capability shines, because you can search for *connections* between particular headings.

For example, the computer might prompt you:

SEARCH SUBJECT: ENTER KEY WORD(S)

You might enter

COAL

You'll be greeted with hundreds, maybe thousands, of entries on coal, ranging from heating with coal to coal mine disasters.

So you'll narrow things down a bit.

SEARCH SUBJECT: ENTER KEY WORD(S)

You respond with

COAL INDUSTRY/LABOR ACTIONS

Maybe you'll hit paydirt, although it is possible that the computer database won't use those exact words in its indexing protocol. You might have to enter "LABOR ACTIONS" first, for example, and then add "COAL INDUSTRY." Possibly the computer will not recognize "LABOR ACTIONS" but will respond to "STRIKE."

Sooner or later you'll hit on the right combination of key words that will give you a listing of all the stories from whatever publications that are indexed on the database that deal with both the coal industry and labor actions. This can be vital if you are doing a report on, let's say, a reputed strike-breaker brought to your city to quell a miner's strike. Maybe you can add a third key word, the name of the alleged strike-breaker, and come up with references to instances where he or she has been involved in previous labor actions.

All databases have their individual protocols, their particular methods of accessing informa-

tion. Some are quite user-friendly. Others require detailed knowledge in order to gain access. There is another difference, too: Certain databases contain general-interest material, while others are extremely specialized.

One of the newest trends in computer databases involves indexing news itself. VU/TEXT, a database from the Knight-Ridder Company, indexes more than 40 newspapers at last count. There are a number of similar services.

Most traditional databases provide you with references; you'll have to look up the articles yourself. Some provide abstracts, that is, partial summaries of the stories. A few provide full text of the articles.

INFORMAL NETWORKS

Various articles and studies have demonstrated how small the world really is. For example, most people could get a message directly to the president of the United States by a personal network of about a half-dozen friends and acquaintances. You probably know someone who knows someone who knows someone who knows someone who personally knows the president.

You would be surprised at how few layers exist between you and any particular person or source of information. The moral: When you are looking for a source, just ask. Ask *everybody.* Chances are, someone will know someone who can help you out. As an example, I was once dead-ended on a story about civil defense. Using the ask everybody technique, I found (after penetrating only three layers) that the man who designed the official U.S. government manual for fallout shelters lived two miles from my house and taught at a local university.

Asking around can also save you from figuratively reinventing the wheel. One reporter was collecting information for a story on health insurance plans offered by local employers. The research was tedious, and the work seemingly endless. But by putting out feelers, he was able

to find that a local non-profit group, affiliated with a major university, had already assembled such a collection. The university's document was not appropriated wholesale, which would be an act of plagiarism, but the collection served as a valuable reference and saved countless hours of footwork.

SUMMARY

1. There are three primary components to newsgathering: interviewing, observing and researching. They are not mutually exclusive categories; rather, they are complementary.

2. An interviewer first must calculate the motivations of the person being questioned. The journalist also determines the appropriate structure for the interview, and then asks questions in such a way as to provoke a meaningful response.

3. There are many different formats for an interview, but the primary distinction made is between an actuality interview and a talk show interview. An actuality interview is designed to produce a short reply suitable for insertion into a package, voice actuality or newscast. The talk show interview is longer and has a beginning, middle and end.

4. The most difficult part of doing an interview is often getting a straight answer that is directly responsive to your question. There are many techniques for doing this, the most basic being to say that you did not get a direct answer and repeat the question.

5. A journalist gathers information by observation; although observation involves many factors, two of the most important reasons for closely observing things around you are noticing details, which add color and life to your story, and observing inconsistencies, which help you separate what you have been told from what actually happened.

6. Some of the most compelling observation is done on the scenes of fires, crimes or disasters. But you are not guaranteed access to those scenes, even if they occur on public property. Access to private property is even more tightly controlled.

7. What people want you to see and what you actually see may be quite different, which is why keen observation skills are important. An observant journalist keeps an eye open for the difference between reality and a manufactured event.

8. Research can be done at a variety of venues, including a library and a computer database. Journalists often use their own informal networks to send out feelers for information.

9. Research does more than help you gather facts. It aids in interview preparation and helps you establish an angle for the story.

EXERCISES

1. Using a police 10-code, the code used by police in radio communication, establish a regular listening schedule (say, 3 to 4 p.m. each day) for a specified period of time. (Your local police station may provide you with their 10-code or whatever other code system they use. If they balk, try a store that sells police radios. No 10-code is printed here because they vary so much from city to city that it would be misleading.)

 Using any device you wish—a city map with differently colored pins, a computerized printout, whatever—gather information on the types, frequency and location of police calls *for a specific neighborhood, preferably the neighborhood in which your college or university is located.* Use any additional information you can gather, including clippings from the daily newspaper, interviews with local residents and eyewitness accounts.

 The goal is to take this research and make it into something meaningful. Use the facts to tell a story. This is an ideal team project and your instructor will define the specific parameters of the information-gathering and your final report.

 Since you cannot monitor the scanner 24 hours a day, your final report—whatever form it takes—will only reflect crime reports during the actual period in which you regularly listened. Keep in mind that you are not charting actual crime; you are keeping track of *reported crime.*

2. Here is an exercise that can take the form of a contest. Your instructor will divide your class into manageable groups (five to seven people each, perhaps) to visit the college or university library for a specified period of time. The goal is to cite how many times you can find a printed reference to a particular person, and take brief notes on each reference. Your instructor or chairperson of the journalism department might be a good target; if so, don't forget to check the *Directory of American Scholars,* distributed by R. R. Bowker Co.

 Here are some easy sources you might overlook:

 - The phone book
 - The college catalog
 - If your instructor has a doctorate, a publication called *Dissertation Abstracts International*

 You may come away with 40 or 50 references, and—in the process—construct an interesting paper trail of your target's background, interests and accomplishments.

5

ELEMENTS OF WRITING THE STORY: ASSEMBLING FACTS IN BASIC BROADCAST STYLE

There's more than a little mystery associated with broadcast newswriting. A cursory examination of some newswriting texts turns up such an elaborate collection of style guidelines, style taboos and technical jargon that it seems virtually impossible for anyone to master all the rules of the game.

I'm going to put off a discussion of what I call "script stuff" and begin with the assumption that broadcast newswriting is about communication, not style rules. I'll even predict that you will find broadcast newswriting a *natural, intuitive* process. Yes, there are some important style rules that must be learned, and some fundamental mistakes that must be avoided, but writing for the ear and eye is not that complicated. The rules and taboos will come later—and they'll make much more sense to you once you get a feel for what newswriting is about.

Writing for the broadcast media probably seems more complex than it really is because at first glance a script, particularly a TV script, contains many technical directions and unfamiliar markings. While these technical directions are important, they are not the be-all and end-all of broadcast newswriting. In fact, script formats vary from station to station—so we will not waste a great deal of time in learning the intricacies of a format that you may have to un-learn during your first job. Those technical directions are not all that complex, anyway. We'll sum them up *and* continue our discussion of basic newswriting in the next chapter.

Note, too, that if you have read the first four chapters, you have already learned quite a bit about broadcast newswriting, whether you realized it or not. You studied what constituted news, what news items were more important than others, and in evaluating the sources of news, you learned about broadcast style. In addition, you gained an understanding of how news is gathered. *All of these are elements of newswriting.*

If you are starting the book with this chapter, you will have an opportunity to review those elements at a later date. But the scope and structure of broadcast news will still emerge clearly to you as you read through this chapter and Chapters 6 and 7.

This chapter spells out the basics of structuring a story: the basics of broadcast newswriting, the fundamentals of writing a lead, and the use of quotes, actualities and sound bites. Chapter 6 explains some of the details of committing broadcast copy—*words meant to be spoken*—to paper. Chapter 7 examines more advanced methods of communicating via the broadcast medium, including an in-depth discussion of writing techniques and specialized skills for writing scripts that include audio and video.

Basics of Broadcast Newswriting

The process of writing for radio and television can be summed up in a few basic guidelines. Learning these guidelines won't automatically make you a broadcast newswriter, but having this fundamental understanding will give you a giant head start.

To begin with, remember these eight points. They will be relevant and valid to all of your newswriting, no matter how advanced your tasks become. (Portions of the following guidelines won't be fully addressed until the next chapter.)

1. Broadcast newswriting is short and conversational.

2. Each story begins with the most important fact, although broadcast style does allow for some variation on this theme.

3. In radio, the stories are often written so that they can incorporate taped interviews from newsmakers. We try to write the story so

that it does not repeat word for word what the newsmaker says or, conversely, have the newsmaker's tape repeat what the story says.

4. In television, we often write words that must be integrated with video. The goal here is to make the words jibe with the video but not duplicate what's shown or about to be shown, but not clash with it, either.

5. In either medium, radio or TV, we write copy that can comfortably be read aloud. That means that we do not use the "summary lead" approach used in a newspaper, where the *who, what, where, when* and *why* are often crammed into the first sentence—no one can read that much information out loud comfortably. Also, we ensure that the words we write are easily spoken.

6. Broadcast news is written to be *heard*, so it must be absolutely clear. Listeners or viewers cannot go back to decipher something they did not understand.

7. Broadcast news follows some standard conventions regarding sentence structure—including placing attribution, the indication of where the news came from, at the beginning of the sentence instead of at the end of the sentence. Also, broadcast news is written so it does not twist the tongue of the announcer. (Proper use of attribution will be covered in some depth in the next chapter.)

8. Broadcast news focuses on the *latest* developments. Newswriters must frequently update their copy to make sure they're not lagging behind the rest of the story. Listeners and viewers want to know what's happening now. That's why much broadcast copy is written in the present tense.

You will see how these principles are put into practice via some upcoming examples. Note that we are not strictly considering the principles in the order in which they were presented above;

we must do some hopping from place to place in order to present the material in a logical sequence. But at the end of these two chapters, you will find that all the material you've learned reflects those eight basic points.

So let's move on and start, as it seems logical to do, from the beginning.

THE LEAD AND THE INVERTED PYRAMID

Both print and broadcast news stories are generally written so that the most important information comes first. That way, the story can be cut from the bottom up. If a newspaper editor runs out of space, he or she can chop off the remaining paragraphs of the story, confident that the meaning will not be lost. This structure is known as the *inverted pyramid* (Figure 5.1).

Radio and TV stories may or may not be written precisely in the inverted pyramid style.

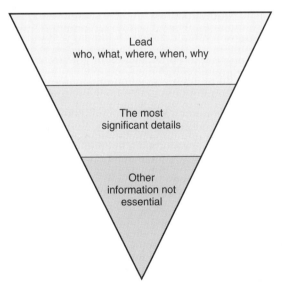

Figure 5.1 The inverted pyramid, representing how some stories are structured: The most important information at the top, with the remainder following. News stories written this way can be cut from the bottom.

Many stories, especially TV news packages (an assemblage of on-the-scene footage, the reporter reading and often the reporter doing a "standup" on-camera) have a beginning, middle and end—meaning that you could not very well just chop the piece off halfway through and expect it to make sense. But some broadcast copy is written in the inverted pyramid, especially the longer radio news stories and the type of TV story meant to be read to the camera, which is known as a "tell" story.

Don't worry about the specifics of packages and tell stories and so forth; that will come later. The hallmark of all newswriting is that *the most important material in the story generally comes first.* The fact that three people died in a car wreck is more important than the time when the crash occurred. "Three people died in a head-on collision . . ." will come long before "The accident took place at 7 o'clock last night."

Get the point? It would be very awkward to write a story that stated:

> At 7 o'clock last night, there was a head-on collision on Morrison Parkway. Three people died.

That sentence probably sounds inept to you, and it *is*. No competent journalist would write a lead that way; it violates the conventions—the standard methods—of newswriting.

A broadcaster does have some freedom in the way he or she writes the lead. It is perfectly acceptable to write:

> Tragedy last night on Morrison Parkway . . . three people died in a head-on collision.

The "Tragedy last night on Morrison Parkway . . ." is a suspense-builder, a headline, a scene-setter that leads into the important sentence. But the phrase "At 7 o'clock last night, there was a head-on collision on Morrison Parkway" is written as though the *time* is the important element—the statement of the essential

and most important fact of the story—which it obviously is not.

There are many styles of broadcast leads, and we will illustrate them shortly. But first, it will be instructive to compare *print* leads, the type you might find in a newspaper or print wire, to *broadcast* leads.[1] We are accustomed to seeing newspaper leads in print; but we are not used to seeing broadcast leads written out. Because we *see* one and *hear* the other, a stylistic comparison is rather difficult. But this comparison is necessary because the first and most fundamental mistake beginning broadcast writers make is to write broadcast copy that *looks* like a newspaper story. There are many important differences; let's see exactly what they are.

BROADCAST VERSUS PRINT

When President Bush and members of Congress got together to hammer out some sort of solution to the problem of the mushrooming federal budget, the national newspaper *USA Today* led the story this way:

> President Bush and congressional leaders started slowly Tuesday toward their goal of slashing more than $55 billion from the USA's federal deficit.
>
> Bush called for quick action, but both sides expect drawn-out negotiations.
>
> There was no agreement on a timetable or deadline.
>
> "You can't force things with a schedule," said House Majority Leader Richard Gephardt, D-Mo., who'll head Thursday's session at the Capitol.
>
> While the word "taxes" came up Tuesday, no one was willing to say who said it.

USA Today is one of the more informally written newspapers. Copy is short, direct and chatty. But still, this would be a difficult story to read aloud. Try it now; read the story aloud. Your tongue will trip in a couple of places—and one particularly awkward moment comes when you have to decide how to say "D-Mo." You know it means "Democrat from Missouri," but could you figure that out in a split second, under the glare of TV lights? And how about the phrase, "said House Majority Leader Richard Gephardt"? That doesn't roll off the tongue easily, and neither does the hissing alliteration, "started slowly Tuesday toward their goal of slashing."

Even in this short segment of the story, the inverted pyramid style is apparent. You can chop off the last paragraph and still know what the story is about. That's good: All the information is right up front. In short, it's a good newspaper lead—but not a good *broadcast* lead, because you cannot read it without sounding stiff and tongue-tied.

The Associated Press A-wire, the newspaper news service, tends to utilize longer paragraphs and more formal wording than *USA Today*. Here's how the AP print service led the story, along with a following paragraph:

> WASHINGTON (AP)—President Bush opened the domestic budget summit yesterday by calling the US economy "not as strong or secure as it should be" and urging fast action to trim a widening federal budget deficit.
>
> At the same time, Bush assured the team of 21 congressional negotiators there was no immediate crisis, participants said.

Please read this lead and the following paragraph aloud. It's still a little stiff, isn't it? And the attribution, "participants said," sounds very awkward when you say it in normal speech. What you've just discovered is that in conversa-

[1] If you are reading this chapter first, check back to Chapter 2 for an explanation of print and broadcast wire services.

tional speech it sounds unnatural to place attribution after the statement. We would be more comfortable in everyday conversation putting the attribution first: "Participants said Bush assured the team . . ."

Just by reading the *USA Today* story and the AP item aloud, you've already figured out three important dictates of writing in broadcast style:

- Keep it conversational.

- Watch out for tongue twisters.

- Put attribution first.

Remember that sentence length is generally shorter in broadcast news. The point is not so much the exact *length* of the sentence, but rather *if the sentence can be spoken in natural, bite-size conversational phrases.*

For example, here's how Peter Jennings led the same story on ABC's "World News Tonight."

> Good evening. In Washington today, when the Bush administration and the leadership of Congress began to negotiate the shape of the next federal budget—which also means trying to reduce the federal deficit by at least 50 billion dollars this year—everyone present had two very clear goals . . . how to raise money—so the government can operate satisfactorily—maybe even raise taxes, but avoid being blamed for it. Our first report on the budget summit is from the White House. ABC's Britt Hume . . .

That's a *very* long lead by broadcast standards. But note how it naturally breaks itself into readable chunks. Notice, too, how some of the facts are presented as conversational asides: You could almost picture yourself nudging someone with your elbow and saying,

> —which also means trying to reduce the federal deficit by at least 50 billion dollars this year—

While *grammatically* the lead is one long sentence, there are several phrases that could stand on their own as incomplete but still acceptable (for speech) sentences. For instance, what is the summit going to do? Jennings' lead contains a short phrase that provides the answer:

> Maybe even raise taxes, but avoid being blamed for it.

Go back and read the entire ABC lead aloud. With the proper phrasing—and you'll instinctively know where that is, because the writing mimics conversational speech—the piece will flow nicely. Probably not as nicely as when Peter Jennings read it, but remember that the lead was written to jibe with Jennings' style: fluid and comprehensive. Listen to Jennings read and ad-lib, and you'll find that he speaks in longer phrases than most newscasters. Therefore, the lead fits him.

Over at CBS, substitute anchor Bob Schieffer (Dan Rather was in Moscow) read a lead better-suited to his particular style: punchy and direct.

> And the top of the news here comes from Washington, where President Bush opened a budget summit with Congress today. The main emphasis of the opening round . . . All present, apparently, seemed determined not to mention the dreaded T-word, *taxes.* We have two reports and we begin at the White House and Wyatt Andrews.

Here, Schieffer's lead allows him to use a bit of drama when building the story. Notice how he sets up the viewer twice when reaching for the main point. Schieffer says:

> The main emphasis of the opening round . . .

And pauses, giving a second of anticipation. He then baits the trap a bit more:

All present, apparently, seemed determined not to mention the dreaded T-word . . .

After a split-second's dramatic pause, while we reflect on what the "T-word" is, he lowers the boom:

taxes.

Read Schieffer's lead out loud. Now, you've picked up another aspect of broadcast style:

A broadcaster does not always have to use direct, declarative statements. The broadcast writer has the option of building suspense and capping the sentence off with a punch line.

To reinforce the point, compare the difference between Schieffer's buildup to the punch line that no one wanted to mention taxes and the way *The New York Times* treated that aspect of the story:

Neither side touched on the pivotal question of whether tax increases would be required to reduce the deficit, which the budget director, Richard G. Darman, has said could soar as high as $190 billion in the next fiscal year. Since the question of higher taxes was not discussed, the politically sensitive question of who would first broach the subject was left unresolved.

The *Times* style is cool, elegant and complete—perfect for a reader engrossed in our national newspaper of record. But could you gracefully command viewers' attention by reading out loud, "Since the question of higher taxes was not discussed, the politically sensitive question of who would first broach the subject was left unresolved"? Probably not.

Over at NBC, that day's newscast was led with a story about U.S.-Soviet negotiations on missile reduction talks. When that report was completed, the newscast switched back to an-chor Tom Brokaw, who led into the budget story this way:

For the moment, however, President Bush is involved in still another summit involving explosive issues . . . the deficit and taxes. They can blow up political careers. [WE SEE A SPLIT SCREEN WITH BROKAW AND REPORTER JOHN COCHRAN] NBC's John Cochran is at the White House tonight. John, how did this first day go?

Brokaw's lead used vivid imagery that tied in the budget summit directly to the preceding story. Thus, another aspect of broadcast style becomes apparent:

Broadcast writing uses transitions, or segues, between stories; those transitions tie stories together in a newscast.

Remember, a newscast is a *linear* presentation; that is, all elements follow in a line, and the listener or viewer is figuratively led from story to story. A newspaper reader begins and ends reading where he or she chooses. It would be awkward indeed to attempt to tie a story on column 6 to a story on column 1 (or from page 3 to page 1), even if we had some assurance that the reader chose to peruse the paper in that particular order.

Using transitions from story to story in a newscast makes the program seem like a complete entity and prevents the story changes from being abrupt or jarring. Although it is important to *catch* the audience's attention, it is equally vital to *keep* the audience's attention.

A final comparison between broadcast and print style: A reader can go back and re-examine something he or she didn't catch the first time around, but a listener or viewer has no such luxury. Radio is particularly unforgiving of the inattentive news recipient. For one thing, radio has no pictures to back up the words. Secondly,

radio stories are generally very short, so they must provide the most information with the *maximum possible clarity.*

Here is how NBC radio news led its recap of the budget summit:

> The first round of the budget summit is over at the White House with President Bush and congressional leaders saying they're eager for a quick deal.

The copy is short, to the point, undecorated with extra words and unequivocal in its meaning. The entire story was told only by the above lead and this following sentence:

> However, Senate Republican Leader Bob Dole says the two sides aren't any closer to anything . . . that there's nothing on the table.

The example above illustrates this principle:

Broadcast copy, especially radio copy, must be concise and unequivocal in meaning. You do not need to write the direct summary lead found in newspapers, but you cannot afford to waste many words, either.

WHAT WE'VE SEEN SO FAR

As Yogi Berra allegedly said, you can observe a lot just by watching. Just by comparing leads on the same story, you have already figured out for yourself the basic guidelines of assembling story elements in broadcast style. To review:

- Keep it conversational.

- Watch out for tongue twisters.

- Put attribution first in broadcast copy.

- A broadcaster does not have to use direct, declarative statements. The broadcast writer has the option of building suspense and capping the sentence off with a punch line.

- Broadcast writing uses transitions between stories; those transitions tie stories together in a newscast.

- Broadcast copy, especially radio copy, must be concise and unequivocal in meaning. You do not need to write the direct summary lead found in newspapers, but you cannot afford to waste many words, either.

*L*eads

We've concentrated on leads because they are the most critical aspects of the story. If you get the lead right, the rest of the story tells itself.

A good lead is four things:

1. It is the most important part of the story, stated right up front. As mentioned above, in broadcast writing you do not have to make the most important aspect of the story the first word out of your mouth, but it has to be up there at the top, somewhere.

2. It is the attention-grabber, the sentence that seizes the listener or viewer by the lapels and demands further attention.

3. It is the road map for the rest of the story. The lead sets the tone, determines the thrust, and the story follows.

4. It is the indicator of the most current aspect of the story.

In their book *The News Business*, NBC's John Chancellor and the Associated Press' Walter Mears provided the definitive description of the role of the lead in newswriting:

> Leads are the keynotes, the overtures, the tee shots of news-writing. Properly crafted, the lead answers questions before they are asked and

promises more answers to follow. The lead sets the theme and points the way.

That is a lot to ask of a sentence or two. But it is neither so awesome nor so mysterious as it sounds. A lead is simply a *disciplined beginning*. [Emphasis mine.]

One of the biggest compliments in journalism is to have it said that the writer got the lead right. No one gets it right every time; the selection of facts and the way in which they are packaged is too complex a task for perfection every time.

Getting it right means finding the phrase, the quotation or the fact that reaches the essence of the story.

Sometimes that is easy: a President is elected, a leader is dead, a war has ended. These stories are the exceptions. More commonly, there are competing sets of facts, all clamoring in the writer's mind to go first.[2]

You have some freedom in creating your broadcast lead—more than you would in print. That's because broadcast newswriting is a representation of the *spoken* language, and we are not bound by the formality of written English.

There are many different types of leads, and while there are no truly definitive categories, most leads can be grouped into: the *standard hard lead*, the *broadcast feature lead*, the *headline lead*, the *umbrella lead* and the *tease lead*. There are also leads you want to avoid, and we'll briefly examine them at the end of this section.

THE STANDARD HARD LEAD

Remember that you, the broadcast newswriter, are under no obligation to present as many facts as possible in the lead—as is the print news reporter. There are many options, some of which will be described below.

But sometimes you have no choice but to immediately serve up the meat of the story:

[2]John Chancellor and Walter R. Mears, *The News Business* (New York: Harper & Row, 1983), p. 16.

> *Governor Bob Smith is dead following an apparent heart attack early this morning. He was jogging near his home.*

You cannot play around with a story like this. It would be inappropriate, insensitive and idiotic to concoct a cute and clever attempt at a lead:

> *After running a tough campaign, Governor Bob Smith finally ran a bit too hard . . .*

Leads for the big stories write themselves. Just put it down on paper the way you would tell someone about an emergency situation over the telephone: No frills, no beating around the bush, just a simple statement of fact followed by further details. *Don't* write a newspaper lead,

> *Governor Bob Smith, 56, collapsed and died at approximately 7:15 this morning of what emergency personnel termed "an apparent heart attack" as he jogged on Buena Vista Avenue, one block away from the Governor's mansion.*

because you *don't have to present as many details as possible in a hard-news broadcast lead.* It is not a summary newspaper lead! On the big, breaking stories, get to the point but don't stuff information into the first sentence.

THE BROADCAST FEATURE LEAD

On stories of less immediate and serious impact, you will have more options available when you sit down at the typewriter or VDT and try to capture the audience's attention.

You may elect to use a soft lead that presents a human interest angle on the story, or an angle predicting the future or a lead that relates the story to other items in the news. Here are several leads using those feature approaches. All are acceptable; they simply take a different slant.

General human interest

The New York-based Micro-Arc Technologies firm claims it can cut your heating and electrical bills in half. A new computer, nicknamed the Housekeeper, monitors and controls home energy use. You can program the Housekeeper to turn appliances on and off, lower the thermostat at night, and keep a running total of your electricity and fuel consumption.

Predicting the future

The home of the future just might be run by a microchip. A computer firm called Micro-Arc Technologies claims its newest product—called the Housekeeper—can take control of your fuel and electricity use and cut costs by 50 percent.

Tie-in to other newscast items

While fuel prices skyrocket in the wake of the latest developments in the Mideast, a New York firm claims to have a high-tech solution. Micro-Arc Technologies will sell you a computer that controls your fuel and electricity consumption . . . a spokesman for the firm says the electronic Housekeeper, as it's called, can cut 50 percent off your energy bills.

THE HEADLINE LEAD

A headline lead is just what it appears to be:

A space-age way to cut fuel bills . . .

Four die in the crash of an Air Force helicopter . . .

Unemployment tops 10 percent for the first time in ten years . . .

The headline lead is nothing but an incomplete sentence that announces the story to come. Incomplete sentences are acceptable in broadcast copy (as they are in newspaper headlines). Try this approach but don't overuse it, because you do not want an entire newscast to sound like it is being read off a ticker tape. Keep this device in your arsenal and use it sparingly. It injects variety and impact—but only if it lends an element of surprise.

THE UMBRELLA LEAD

Sometimes two or more stories are inextricably related, or are of such singular importance that the lead sentence of the broadcast has to cover more than one story. In this case, you'll need to write an umbrella lead, sometimes called a "roundup," "comprehensive" or "shotgun" lead.

Here's a true-life example of a situation that left no alternative other than an umbrella lead: In January 1981, President Reagan was inaugurated. Surely, that was the top story of the day. But wait . . . on the same day, *within an hour of the Reagan inauguration,* American hostages were released from Iran. Which is your lead?

Faced with what were arguably the two biggest stories in ten years, John Chancellor, then the anchor of "NBC Nightly News," combined them under this umbrella lead:

Good evening on the 444th and final day of the hostage crisis, which is also the first day of the new Reagan presidency.

That may have been one of the toughest calls in the news business, but it also produced one of broadcasting's most memorable leads. In this case, the facts spoke for themselves, but not without some help from Chancellor.

"I did not know [what the lead would be] until I rolled the paper into the typewriter and sat there and said, What the hell am I going to write," Chancellor recalled, "—and then all of a sudden it wrote itself. 'Final' and 'First' seemed to be the story to me."[3]

[3] Chancellor and Mears.

THE TEASE LEAD

There are many varieties of the tease lead. Sometimes it takes the form of an attention-grabbing statement that is made clear by the next line of copy.

> The city budget is probably going to go bust.
> That's the contention of City Councilor Ray Novello.

Use this technique with caution. Don't overstep the bounds of common sense. ("Nuclear holocaust is imminent. That's the opinion of Professor Myron Doomsayer of . . .")

The tease lead is akin to the feature lead, but it's entirely a hook; no news information is presented until the next sentence or the one following.

> Joe Smith says some days it just doesn't pay to get out of bed. He's living proof—and lucky to be living, at that. When Smith stepped out of bed this morning he plunged through the rotting floorboards into the basement of his building, where he was trapped for two hours. He was treated for minor injuries and released. Smith says he's not going back to his old apartment building. In his words, he wants a more stable environment.

Sometimes the whole story can be a tease, with the kicker at the end. Paul Harvey is famous for this technique. He can lead us through an elaborate story about how a man awoke in the middle of the night because of a pesky mosquito, sprayed the insect, and so on, and so on and so on . . . testing our patience and making us wonder why we're being told all this. Until, of course, Harvey slips in the fact that when the man awoke the next morning:

> what he thought was a can of insecticide . . . was really . . . a can . . . of blue spray paint.

This technique takes a certain knack to perfect, and you obviously cannot do it with serious stories, but making the whole story the tease and the final line the lead is a very effective way to end a newscast.

BAD LEADS

If you retain nothing else from this discussion, *never* write a lead like this:

> The City Council met last night.

That's a nothing lead, and it is the badge of the amateur. It's a nothing lead because it has no news value: The listeners or viewers don't know anything more about the story than they would have the day before. After all, the meeting was scheduled in advance. Barring some unusual catastrophe, it was going to be held, anyway. And it was. *So what?*

If you are going to write a straight news lead, it must contain some *news*, some *amplification* of the obvious. You can make the council meeting a story whether it was a major event or a complete yawner. Just use a news lead and not a nothing lead.

For example:

> The City Council spent more than a million dollars of your money last night.

This is an engaging lead; it would benefit from being in the present tense, but in this case the shock value of what happened makes past tense acceptable.

> City councilors sleepwalked through a 10-minute mid-summer session last night. They heard no testimony, passed no motions and adjourned after Council President Loren Blair asked, What the hell are we doing here?

You can always find news value in a story, even if nothing happens, as in the example above. But never go with the nothing lead.

Using Quotes, Actualities and Sound Bites

Once the lead is established, we're ready to integrate the elements that follow: most notably, quotes, actualities and sound bites.

This chapter does not delve deeply into script mechanics, advanced writing techniques, common mistakes, timing, editing and so forth. Most of that follows in the next chapters, and details specifically related to the production end of things are presented in Chapters 8 and 9.

An overload of detail is avoided here because I believe doing so would be counterproductive. Some texts and manuals begin with intricate instructions about use of prepositions, methods to round off numerical data, script formats and so on—details that while necessary are bewildering starting points.

The proper beginnings are, I think: understanding broadcast style, seeing and hearing how it differs from print, noting how the story's lead sets the tone for what is to follow, and—what we're now examining—how interview material is used when constructing a story.

QUOTES

In broadcast copy, quotes that are written into your script—not the ones recorded and played back over the air—are generally *paraphrased*. This means that they are rewritten in your own words to accurately reflect what the interviewee said. There are two primary reasons for doing this:

First, it is difficult to read copy that contains exact quotes. You're reading aloud in someone else's word pattern. Besides, people's quotes usually are too long to incorporate word for word, especially in radio copy.

Second, there is no convenient way to indicate the quote. Quotation marks serve no purpose in broadcast copy. You do not read "quote" and "close quote" or similar indicators over the air, except when the quote is of such a controversial or bizarre nature that you want to ensure that listeners or viewers completely understand that these are the newsmaker's words and not yours.

Let's assume that you have conducted an interview with the city public works commissioner about upcoming construction on Main Street. You visit his office, record the interview and plan to use it as the basis for a story. The commissioner tells you, word for word:

> We expect to begin laying the new water pipe in June. You know, we really have to. There's no choice. That pipe is leaking thousands of gallons a day, and where it's not leaking, internal buildup has compromised water flow to the extent that we're trying to push the flow of a main feed through a pipe that has the internal diameter of a garden hose. So Main Street will be closed to two lanes, one in each direction, starting June 15 and continuing probably through the first of July.

What do you do with a quote like this? On radio you could use a recorded portion of the quote as part of the story. That's known as using an *actuality*.

If this were a television interview, you could do the same thing: Insert a recorded portion of the commissioner's remarks into the newscast. In television parlance, that's called using a *sound bite*. *Actuality* and *sound bite* mean the same thing, but *actuality* is a radio word and *sound bite* is usually a TV term.

But you might choose not to directly use the recorded quote; you might want to take the information and write it into a brief news story to be read by the newscaster. Nothing the commissioner said is all that interesting, and this isn't a major event.

Should you elect to go with a straight "tell" story, paraphrasing the quote instead of playing it back over the air, a tease lead might work well. You might combine the tease with a

headline approach. Here's one way you could write the story and paraphrase the quote:

> More headaches for downtown motorists . . .
> Main Street will be narrowed to two lanes from
> June 15th through July 1st. City crews are going
> to be repairing a leaking water main. Public Works
> Commissioner Frank Link says the problem can't
> wait any longer—the old main is leaking thou-
> sands of gallons per day and the part that isn't
> leaking is so clogged up that it's smaller inside
> than a garden hose.

What you've done is to take a long and in-volved quote and simplify it so that it fits nicely into a short piece of copy. Notice how badly the story would read if you had tried to use a direct quote, newspaper-style, and read the commis-sioner's quote yourself:

> More headaches for downtown motorists . . .
> Main Street will be narrowed to two lanes from
> June 15th through July 1st. City crews are going
> to be repairing a leaking water main. Public Works
> Commissioner Frank Link says the problem can't
> wait any longer. "That pipe is leaking thousands of
> gallons a day," he said, "and where it's not leak-
> ing, internal buildup has compromised water flow
> to the extent that we're trying to push the flow of
> a main feed through a pipe that has the internal
> diameter of a garden hose."

Please read this version aloud. You'll dis-cover that it sounds awkward because *you* are trying to be conversational using the commis-sioner's words, and that just doesn't work.

You'll also find that even if you want to indi-cate that these are the commissioner's words (and explain to the audience why you are sud-denly speaking like a civil engineer), you have no way of doing it, other than saying "quote," or "in his words" or something like that. That practice is clumsy and will soon grate on your listeners' ears.

ACTUALITIES

On a slow news day you might want to insert a section of the interview into your radio news-cast. But it's not a particularly good piece of ac-tuality. Why? Because we like to use actuality when:

- *The recorded interview expresses opinion, rather than plain fact.* We, the newswriters, can usu-ally transmit facts just as well or better than the person being interviewed. But we can't capture the flavor of someone offering an opinion or a humorous observation on a situ-ation. Most of the commissioner's statement is factual.

- *There is something else in the interview segment that lends additional authority or interest to the cut.* Sirens in the background or noise from a construction site are a good example. There's nothing in the commissioner's interview like this. Had you interviewed him on the street with the sounds of water gushing onto the pavement, well, that's a different story—and a good one.

- *The interview segment expresses human drama.* The actual tape of an interview with a breath-less firefighter who has just carried a baby out of a burning building has much more impact than a script that paraphrases his words. There's not much drama in a water main story. (Hint: Try going back to Main Street when traffic is clogged for miles and inter-view drivers stuck in the gridlock. You'll get drama. You may not be able to use all of it on the air, but it will be dramatic.)

Let's go with the commissioner's quote, any-way. It's marginal, and all right for use on a day when there's not much else happening.

Here's what a radio story might look like. Note that it's not in a standard script format (in

radio there is no universal standard script format, but even if there were, it wouldn't look like this). Instead, it is shown in a way that illustrates the concept of integrating actuality.

Announcer: More headaches for downtown motorists . . . Public works commissioner Frank Link says Main Street will be torn up later this month to fix a water main. He hates to snarl traffic, but says we've really got no choice:

Commissioner: That pipe is leaking thousands of gallons a day and where it's not leaking, internal buildup has compromised water flow to the extent that we're trying to push the flow of a main feed through a pipe that has the internal diameter of a garden hose.

Announcer: Commissioner Link says Main Street will be narrowed to two lanes from June 15th through July 1st.

Note that after the recorded voice of the commissioner, he is identified again. Remember, this is *radio*. People cannot go back and check on the identity of the speaker, and, given the nature of radio listening, they may not have caught the identification the first time. Notice, too, that we were careful not to repeat what the commissioner said in our script or not to write the script in such a way that the commissioner repeats us. (That is a more advanced technique and will be addressed in the next chapter.)

When using radio actualities:

- Try to use actuality when it presents something other than plain fact—emotion, opinion or the sounds of a real-life situation. If it's just facts, paraphrase the quote and forget about the actuality.

- Always identify the speaker before the actuality. If there is an apparent need—if reidentifying the speaker is important for the credibility of the story—identify him or her after the actuality, too.

Actuality doesn't have to be earthshaking to be effective. Anything that provides commentary, enlightenment or an interesting angle is worthwhile. When Aardu—a wallaby who hopped away from custody in a Stoneham, Massachusetts, zoo—was finally recaptured, WBZ Radio in Boston used an actuality to lend authenticity and brightness to the piece.

Announcer: That wandering wallaby from the Stoneham Zoo is back behind bars tonight after escaping from the zoo ten days ago. Aardu was recaptured earlier today, and zookeepers said they did it by luring him with the scent of female wallabies. Dr. Mark Goldstein with Metro Parks Zoo says the animal is in good condition right now.

Goldstein: He was agitated when we first brought him in, as one would expect having been in a caged situation, and in doing that he abraded his face a little bit. Folks that come up to visit him this weekend at Stoneham Zoo will notice some scrapes and scratches, but they're all superficial.

Announcer: Veterinarian Goldstein says a wallaby is brown and resembles a small kangaroo.

This actuality is not crucial information, but Goldstein's remarks work better as an actuality than as a paraphrased quote because they are expressing expert opinion, and opinion makes for good actuality. It makes more sense for the veterinarian to say it than for the newscaster to *say* that the veterinarian said it.

As mentioned, actuality is especially effective when it incorporates the sound of the event. Top-notch radio journalists exploit actuality to its fullest when they let sound—sometimes just sound alone, known as wild sound—as well as voices tell the story. Here's how Jerry Dahmen of WSM Radio in Nashville used actuality in a story on drug abuse. The story was by Dahmen, Liz White, Dick Layman and engineered by Tom Bryant:

Announcer: Today, WSM AM News presents "Of Violence and Victims," the story of Nashville's rising crime rate. Today, prevention and protection . . .

Wild Sound: [Woman screaming]

Announcer: [Announcer's voice over the sound of the scream] Saturday night in General Hospital's emergency room . . . a woman in her 30s severely beaten by an attacker. Several days later, Davidson County's medical examiner conducts another autopsy—the victim of a brutal beating and stabbing.

Medical Examiner: I'm preparing to remove the interior chest case so that we can see into the interior chest cavity.

Wild Sound: [Saw cutting through bone]

Announcer: If you think you're immune from violence, think again. Nashville's crime rate has increased 15 percent from the first half of this year, and so have your chances of becoming a victim. These Nashvillians were probably like some of you . . .

It got your attention, didn't it—even though you were only reading the script and not hearing the screams of the victims and the whine of the saw as it cut through the cadaver of a crime victim. The wild sound and actuality made the situation *real* and *immediate*—and that is the heart of great radio news.

SOUND BITES

Television's version of the actuality, the *sound bite*, incorporates video with audio. This is both a plus and a minus for the TV reporter, because the audience virtually *demands* pictures—and so do news directors, who like to give the public what they want.

Pictures in television news may incorporate sound, (sound bites), or they may be pictures without audio, designed for the reporter to read over (*voice over*).

Most sound bite segments are interviews—actuality with a picture of the speaker talking. The terminology varies from station to station. Some radio stations call actualities sound bites,

and some TV stations call any picture that has audio a sound bite.

Most video used for voice over is designed to illustrate a concept. If the newscaster is reading a story about traffic congestion, it makes sense and is visually appealing to show some scenes of congested traffic.

When preparing a package—a television report that is narrated by the journalist and typically features one or more sound bites—the reporter tries to incorporate several factors.

First, the reporter tries to balance the story with a variety of representative sound bites, if that is appropriate to the story.

Second, the reporter tries to use cover video for voice-over sections in order to illustrate what is being said. The cover video is a shot of the event being reported, although sometimes generic file footage—like traffic congestion scenes—is used. When using generic cover shots be careful not to misrepresent what is actually happening.

Third, the reporter tries to show himself or herself at the scene of the event in order to establish credibility—to show that the reporter was really there. This is usually done at the end of the report in what is commonly called a standup close.

Remember the NBC lead into the budget summit story? Here is how the following report unfolded. First, the raw material: NBC's John Cochran told the story using these pieces of video:

1. Video footage of the president and attendees at the budget conference gathered around the conference table.

2. A diagram, prepared by the graphics department, showing budget numbers superimposed over a picture of the Capitol and an insert of President Bush. Numbers are difficult for the viewer to comprehend and remember when they are simply spoken, so the visual was used to display the figures and reinforce the script.

3. A shot of Republican Senate minority leader Bob Dole, a (presumed) ally of the president, holding a press conference, along with a close-up interview of Dole responding to a question about the budget deficit.

4. A shot of a press conference by Democratic Senate majority leader George Mitchell, and an interview with Mitchell, during which he says he's frankly suspicious of Bush's motives in calling this summit—speculating that Bush wants the Democrats to be the first to mention the T-word and thus be stuck with the blame.

5. A post-conference interview with Kansas Congressman James Slattery, a Democrat, who backhandedly indicates that he thinks Americans will accept higher taxes ("some big compromises," as he puts it) in order to solve the budget mess.

6. A post-conference interview with Ohio Congressman John Kasich, a Republican, who echoes the theme that new taxes aren't the solution, but cutting spending is.

7. Some stock footage of a classroom, a housing project and a nursing home to briefly illustrate three references in Cochran's narration to education, poverty and care for the elderly.

8. A standup close in which Cochran sums up the two big questions: whether Americans will stand for higher taxes and what role President Bush will serve in straightening out the budget dilemma.

Using those eight pieces of video, Cochran told a complex story in exactly 1 minute and 58 seconds.

Note that many packages are not scripted. They are composed of ad-libbed on-scene reporting, sometimes live reporting; pretaped interviews; and narration (used under the video), which is written and recorded back at the studio. Notice how Cochran integrated the material he gathered into a coherent story.

There are only three technical abbreviations you'll need to know to understand this particular reconstructed representation of the story:

CU close-up

ECU extreme close-up

LS long shot (a shot taken from some distance)

CS cover shot (video used as a general indication—visual reinforcement—of what's being talked about)

The piece opens with Cochran and Brokaw in split screen. Brokaw asks Cochran how the first day of the budget summit went. We cut to a CU of Cochran (Figure 5.2).

That is how a broadcast package is written. The word *written* assumes some different meanings in broadcast journalism than in other disciplines. While most broadcast copy is written in the sense that it is committed to paper, much of what a broadcast reporter does involves taking prerecorded pieces and editing and assembling them. Is that writing?

Yes, I believe it is. The process of editing and assembling involves telling a story and maintaining a narrative flow, and that qualifies as a form of writing. But words are still the fundamentals of broadcast journalism; we'll take a closer look at words and scripts in the next chapter.

Figure 5.2 *Video script of John Cochran's budget summit report.*

VIDEO	AUDIO
Cochran on White House lawn	Well, the Democrats came here this afternoon saying the budget summit was George Bush's idea, so he should make the first move, and he did. But being George Bush, it was a very prudent first move.
Pan across conference table	The Democrats joked that in the budget talks, President Bush really has put everything on the table, including cookies provided by the White House.
CU Bush reaching for cookie	But the President didn't give the Democrats much else to sink their teeth into. Instead of solutions, Bush emphasized the problem.
Graphic showing Bush, and Capitol Hill. Budget numbers appear on screen	Under the Gramm–Rudman Law, the 91 budget deficit may not exceed 64 billion dollars. But today the White House said it could reach 141 billion dollars . . . 188 billion if the savings and loan bailout is included.
LS Dole press conference	And yet congressional leaders say Americans don't seem to realize there's a big problem.

Q: So the parents were all right? They had to watch the house burn down with the kids inside?

A: Yeah, they both had to be restrained from going back into the house. But they were uninjured, far as I know.

Q: Any idea what started the fire?

A: The father reported hearing an explosion downstairs, so it could be a gas leak. Looked like it, too—the foundation walls were blown outward. But you didn't get that from me, right? Call the fire prevention office, they're investigating. Listen, I gotta go. Call me back later.

Now, write two versions of the first paragraph of this story (three or four sentences). For each version, use a different type of lead.

Version 1: Use a direct, hard-news lead.

Version 2: Use a headline lead.

2. Using the techniques you have learned so far, write the whole story in broadcast style, *using a section of the recorded interview as actuality.* (This will be made easier by the fact that you've already got two versions of the lead; pick whichever you like best.) Give some careful thought as to which piece of the interview you want to see as actuality. Review the guidelines outlined in this chapter.

3. Pick a story from your local newspaper and rewrite it into broadcast style. Don't worry about timing, script, format or any of those details: just make it shorter, more conversational and easier on the ear. Try to come up with a story you can comfortably read aloud in 30 to 45 seconds.

As an example, I've done one for you. Figure 5.3 shows a somewhat

Figure 5.3
A story written in print style.

State police officers won a surprise victory at the Capitol last night as house members rebuffed Governor Clyde Smith's plea for "fiscal responsibility" and voted overwhelmingly to increase police salaries by 10 percent, retroactive to the start of contract talks three years ago. The raise will cost taxpayers almost $151,300,000, according to aides to the governor.

The 97–22 vote was a devastating setback for the Democratic Smith administration, which had declared its intention of radically paring back state spending. Both the governor and the Democratic leadership were attempting to stem the tide of further spending hikes. It is also viewed as a stunning victory for the House GOP.

Representative Melvin Roberts, D-Centerville, said the bill as it now stands is "unsignable." He urged House members to reconsider. "We're spending money we just don't have," he said.

George Lewis, Michael Antionette and Marvin McFarlane, the governor's chief budget aides, scheduled a meeting for today with the governor and House Speaker May Lewis in an effort to draft compromise legislation.

The measure will come up for a final vote later this week.

Figure 5.4
The same story re-
written in broad-
cast style.

The governor, his aides, and the house speaker will huddle today to try and figure out what to do about the major defeat handed them last night. They were clobbered at the Capitol, when house members overwhelmingly voted a ten percent pay raise for state police.

That vote is a stunning victory for Smith's GOP opponents, because many of the governor's supporters turned their backs on Democratic party leadership to support the measure.

According to the governor's aides, the raise—which will be retroactive to the start of contract talks three years ago—will cost taxpayers about 150 million dollars. And that, according to Centerville Democrat Melvin Roberts, is money we just don't have.

The bill comes up for a final vote later this week.

complex story written in print style. Figure 5.4 shows how that same story might be written for a radio newscast that would air at roughly the same time the story was finished and set into type. (About midnight.) Try to keep the time factor constant in your story. Most afternoon papers are "put to bed" around noon, and the first editions of most morning papers at about midnight.

Don't pick a short, simple story. You'll be robbing yourself of the practice and violating the principle of the exercise.

6

PUTTING IT ON PAPER: MECHANICS OF BROADCAST STYLE AND SCRIPTING

Broadcast newswriting is simple and conversational. The words put on paper or typed onto a computer monitor are meant to be read out loud, so they must mimic common speech patterns.

This chapter recaps some of the writing techniques we've studied so far and adds new information about broadcast newswriting conventions and style. Specifically, we will: *discuss and demonstrate the mechanics of scriptwriting for radio; do the same for television;* and *demonstrate some of the more common conventions of broadcast newswriting* relating to punctuation, word choice and numbers.

The Medium and the Message: Spoken Words on Paper

There are few universally accepted conventions in broadcast newswriting. (By *convention*, we mean a particular way that something is customarily done.) Examining scripts from radio and TV stations across the country quickly disabuses us of the notion that there is a standard way to write them. At the same time, it is pointless to try to illustrate all the variations.

The standard methods demonstrated in this section are representative of the way that some, but *not all*, stations write their news. When a generalization is made, it represents what I believe to be the most typical approach found in the business today. When a *prescription* is made—an advisory on how something ought to be done—that prescription is based on general principles that will remain the same from station to station. And here is one prescription that will always hold true:

The writing style you use for broadcast will not be the same style used for written reports, term papers, newspaper copy, or anything meant to take a direct path from paper to eye to brain. Broadcast copy makes a path from eye to mouth

to ear, so it must be different in style, punctuation and sentence structure.

Don't try to write broadcast copy using the same punctuation and sentence structure you'd use in a term paper or business report; you'll wind up with unreadable broadcast copy. Conversely, don't use broadcast style to write your reports or papers: The work will come back disfigured by angry red scrawls scolding you for "Incomplete-sentence!" "Poor sentence structure!" "Paragraphs too short!" "Ideas not fully developed!" "Do not use contractions!"

With broadcast newswriting you're not exactly writing. You're committing speech to paper. You are telling a story, a story that will be spoken. You must use words and phrases that can be spoken naturally and relay the story in the form we're used to hearing people use when they tell a story.

For example, suppose you just received a letter informing you that you've won a full scholarship to Harvard Law School. You pick up the phone to call your father. After "Hello, Dad," would you be likely to say:

Example 1

After four years of diligent work, my efforts were rewarded. I received a letter from Harvard Law School today. "We are pleased to inform you that you have been awarded a full scholarship covering all tuition, fees, room and board," the letter said.

I doubt it. No one speaks that way—not even the *professors* at Harvard Law School. More than likely, the conversation would sound like this:

Example 2

I'm going to Harvard Law School—for free! The hardest four years of my life finally paid off. *A full scholarship.* The letter I got today says the scholarship covers tuition, fees, and room and board.

What we've seen is another comparison between print style and broadcast style. The first example, although lucid in print, is unreadable if you try to say it out loud. Example 1 does not tell a story conversationally. Example 2 does.

With that in mind, let's see how broadcast stories are told on paper.

Radio Script Conventions

Many of the standard methods of writing for radio also apply to video, so this section will apply to both media. The formatting conventions specific to video are summed up in the following section.

What we'll do here is build a radio story from top to bottom to illustrate the way a radio script is put on paper. The goal of this section is not so much to demonstrate techniques of writing, but the way the standard story is constructed and scripted.

To follow the chain of events from the beginning, we'll start with the paper and typewriter, then begin at the top of the script page, and work our way down to the ending.

PAPER AND PRINT

Even with the spread of computers into radio and TV newsrooms, hard copy will always be part of the newswriting process. Many radio newsrooms are not yet computerized and may never be; the investment simply cannot be translated to the bottom line. (Many radio newsrooms have not yet graduated to electric typewriters.)

This is not entirely a matter of economics. Modern computer systems perform several functions that are not needed in a small radio newsroom, such as calling up graphics or listing

the dozens of events found in a half-hour newscast.

Most copy winds up on paper, anyway. Even the bravest newscaster reading from a new-generation computer-driven prompting device would be reluctant to go on-air without hard copy clutched in his or her hand in case of a computer crash.

Given the fact that broadcast newswriting still involves words on a page, those words have to be easily readable. That means a lot of white space on the page, as few corrections as possible, clearly made corrections when they are necessary and a large, clear type. Many stations use a special large typeface, sometimes called Executive or Orator.

It's very hard to read copy that is crammed tightly on the page, so many radio and TV stations triple-space their copy. Some stations double-space, but triple-spacing has traditionally been more common. Triple-spaced copy is more readable than double- or single-spaced, and it leaves room for last-minute corrections to be penciled in. Wide side-to-side margins are also helpful.

SOME NEWSCASTERS FIND COPY WRITTEN IN ALL CAPS TO BE MORE READABLE. THAT MAY BE BECAUSE THEY ARE USED TO SEEING COPY TYPED OUT THAT WAY; IT'S SOMETHING OF A TRADITION IN NEWSWRITING. THERE IS NO UNIVERSAL STANDARD; SOME STATIONS USE ALL CAPS AND SOME USE STANDARD UPPER- AND LOWERCASE. MANY BROADCAST WIRES USE ALL CAPS, BUT LOCAL NEWS DEPARTMENTS OFTEN FAVOR UPPER- AND LOWERCASE. WHAT'S YOUR OPINION?

The choice will usually be made for you, since you're obligated to adopt whatever system is used in your particular newsroom. Should you have a choice, I would suggest upper- and lowercase, a format that appears to be the growing trend in broadcast copywriting. Some announcers contend that copy written in all caps

is more readable, but we are used to seeing upper- and lowercase English in almost every other written work.

Also, writing in upper- and lowercase makes it easier to determine whether a word is a proper name:

THE FIRE IN OVERLAND, OHIO . . .

can cause a second of doubt and hesitation for an anchor who might wonder if OVERLAND is a town or if the writer is trying to make some distinction between "over land" and "over sea."

The fire in Overland, Ohio . . .

can't cause such confusion.

One last word about paper and typing: In radio, there is rarely a need for multiple copies of the script, and the increasing use of computers allows copies to be stored electronically and called up at will. Having two copies of the script for radio is usually enough. The script is typed on either plain paper or sometimes special carbonless script paper. Copies are made with a photocopier or carbon paper.

THE HEADER

Broadcast news departments require writers to put some basic information right at the top of the page: the *slug*, which is a very brief description, usually just a key word, that identifies the story; the *writer's name or initials;* and *the date.*

The exact location of these entries varies from newsroom to newsroom; some departments put the three slug items on separate lines, flush against the left margin:

NURSES

HAUSMAN

9/11/92

Or across the top line:

NURSES HAUSMAN 9/11/92

The header provides a means of quickly identifying the story itself and who wrote it, in case something about the story is questioned or another reporter needs additional information from the writer. The date is essential: Scripts are kept in archives, which means you'll need to know when the events described happened. For example, this story concerns a nursing shortage at a city hospital and features an actuality from the hospital administrator as she addressed the City Council. Should you do a follow-up story next month, or next year, you'll need to know when the meeting took place.

A second reason for including the date is that all scripts look the same, and you need a reliable way to tell an old story from a new story. *Always* double-check the dates of local and wire service copy before you read it. (A janitor once found a 2-year-old piece of wire copy behind a desk he'd moved when waxing the floor. He put the paper with the rest of the pile on the desk—that day's news copy—and I read it on the air. The story referred to a bill being vetoed by a president who was no longer in office.)

A very good practice in some radio newsrooms is to mark on the script the time of the newscast during which the story was read. You can handwrite or type this at the end of the header. Since most radio news stories are rewritten during the day, keeping track of the newscast time will clue you in as to how the story has evolved through several rewrites; it will also save confusion if a listener or management has a question about the story on the 7:30 a.m. newscast and you need to figure out what version went over the air. Your final header format, which I'd recommend, might look like this:

NURSES HAUSMAN 9/11/92 7:30 A

THE STORY

Now comes the body of the story. Drop down two triple-spaced lines and begin writing (Figure 6.1).[1]

TAPE CUES

An actuality from Smith is on cartridge, a special type of tape that automatically recues itself and starts instantly. (See Chapter 8.) You need to indicate certain information about the tape. The reader of the script needs to know three things:

1. That there *is* a tape and it should run at *this point* in the story. The script should contain an advisory listing the name of the tape—the title with which the tape is labeled. In this case it would be "Smith." "Smith" would be written on a peel-off label and affixed to the cart, a common shorthand term for cartridge. A broadcast cart is a type of tape cartridge that starts instantly and automatically recues itself. If there are two cuts from Smith, the carts would be labeled "Smith 1" and "Smith 2."

2. The running time of the tape. The newscaster must be ready to start reading at the appropriate time—when the taped segment ends. Also, if it's a long actuality, say, 20 seconds, the newscaster may elect to use those 20 seconds to perform some last-minute chore, such as quickly proofreading a story he or she just pulled from the typewriter.

3. The *outcue*. An outcue is a written transcription of the final words spoken on the tape.

[1] Although actual scripts are usually typed triple- or double-spaced, because of space constraints, the sample scripts shown in the book are not.

Figure 6.1 *The body of the story.*

```
NURSES     HAUSMAN     9/11/92              7:30 A

        The administrator of City Hospital says the nursing staff

    is in critical condition. Jane Smith appeared before the City

    Council last night to warn that a severe shortage of nurses is

    causing a health-care crisis. Smith says almost a third of the

    nursing positions are currently unfilled. And, she says, everyone

    suffers because of the shortage.
```

This is the newscaster's cue to begin reading the rest of the story.

It is also helpful to know the *incue* for the actuality. This immediately reassures the newscaster that the correct tape is being played. Conversely, the incue warns the newscaster if the wrong cart has been "fired," giving him or her the opportunity to cut the tape quickly and avoid prolonged embarrassment while the newscaster tries to figure out if the wrong cut is going out over the air.

Inserting the actuality advisory into the script is sometimes done as in Figure 6.2. There are many variations on methods of indicating tape cues, but most involve a recognizable combination of the items in Figure 6.2.

One less common but very effective method is to type out the entire actuality on the script. This way, if the tape does not roll, the newscaster can read the quote as if nothing had happened, ad-libbing the "she saids" as appropriate. A complete transcription of the actuality would look like Figure 6.3 when incorporated into the script.

Some major news organizations, such as network radio news centers, transcribe all actualities used during the newscast. This is not on the script, but rather on a separate form that includes other information about the actuality. The transcription is available to the newscaster (kept in a separate pile from the script) to serve as an emergency paraphrase if the tape fails. This practice, unfortunately, is becoming increasingly rare as network budget cuts eat into news operations.

STORY TAGS

The final step is to conclude the story with a sentence or two, known as a tag. It is considered poor form to end with an actuality and go to the next story. Doing that confuses the listeners and makes the story seem oddly incomplete. Besides, in this case there is still more detail begging to be written. We know there's a nursing shortage, we know that the administrator is complaining about it, but why is there a shortage? And is anything going to be done about this situation? Figure 6.4 demonstrates how those questions might be answered and the story concluded.

Notice the # at the bottom of the page, indicating that the story has ended. It shows the reader that there is no second page. Most radio

Figure 6.2 *Story with tape cues.*

NURSES HAUSMAN 9/11/92 7:30 A

 The administrator of City Hospital says the nursing staff is in critical condition. Jane Smith appeared before the City Council last night to warn that a severe shortage of nurses is causing a health—care crisis. Smith says almost a third of the nursing positions are currently unfilled. And, she says, everyone suffers because of the shortage.

 TAPE: SMITH Runs :20
 INCUE: ''LAST NIGHT WE HAD . . .''
 OUTCUE: '' . . . CAN'T GO ON MUCH LONGER.''

Figure 6.3 *Story with transcription of actuality.*

NURSES HAUSMAN 9/11/92 7:30 A

 The administrator of City Hospital says the nursing staff is in critical condition. Jane Smith appeared before the City Council last night to warn that a severe shortage of nurses is causing a health—care crisis. Smith says almost a third of the nursing positions are currently unfilled. And, she says, everyone suffers because of the shortage.

 TAPE: SMITH RUNS :20
''LAST NIGHT WE HAD ONE ELDERLY GENTLEMAN WAIT AN EXTRA HOUR AND A HALF FOR HIS PAIN MEDICATION. WE JUST COULDN'T GET TO HIM. WE WERE STACKED UP WITH THREE EMERGENCY CASES AND WERE SHORT FIVE NURSES ON THE SURGICAL FLOOR. I'M AFRAID, REALLY AFRAID, THAT THE NEXT TIME THIS HAPPENS IT'S GOING TO BE WORSE THAN LEAVING AN OLD MAN IN PAIN. HE JUST MIGHT DIE WAITING . . . AND I LITERALLY THINK THE STRESS IS KILLING THE NURSES. THIS CAN'T GO ON MUCH LONGER.''

Figure 6.4 Story with tag.

NURSES HAUSMAN 9/11/92 7:30 A

 The administrator of City Hospital says the nursing staff

is in critical condition. Jane Smith appeared before the City

Council last night to warn that a severe shortage of nurses is

causing a health-care crisis. Smith says almost a third of the

nursing positions are currently unfilled at City Hospital. And,

she says, everyone suffers because of the shortage.

 TAPE: SMITH RUNS :20

 INCUE: ''LAST NIGHT WE HAD . . .''

 OUTCUE: ''. . . CAN'T GO ON MUCH LONGER.''

 City Hospital Administrator Smith says she simply can't

attract nurses because of what she called a double whammy. She says

there is a statewide shortage of nurses . . . and claims that City

Hospital cannot compete for those nurses because of poor working

conditions and lower than average salaries.

 City Council Chairman Arthur Lake says he'll establish a

task force to look into the option of hiring an outside firm to

recruit nurses from other cities.

 #

stories do not run longer than one page, but when they do it is *imperative* to indicate that there is more copy to follow. Some newswriters put

 (more)

at the bottom of the page. Others draw an arrow indicating that the story is continued. If the story we're working with now were on two pages, it might be so indicated as in Figure 6.5. If you must split a story into two pages, never break a sentence. Always end one page with a complete sentence.

 Notice that we reidentified the speaker in a slightly abbreviated form after the taped actuality ran. Making a second reference after the actuality helps clarify the story in the listener's mind. Radio listeners are often distracted or for

Figure 6.5 *Story with indication of more than one page.*

The administrator of City Hospital says the nursing staff is in critical condition. Jane Smith appeared before the City Council last night to warn that a severe shortage of nurses is causing a health-care crisis. Smith says almost a third of the nursing positions are currently unfilled at City Hospital. And, she says, everyone suffers because of the shortage.

 TAPE: SMITH RUNS :20

 INCUE: ''LAST NIGHT WE HAD . . .''

 OUTCUE: ''. . . CAN'T GO ON MUCH LONGER.''

City Hospital Administrator Smith says she simply can't attract nurses because of what she called a double whammy. She says there is a statewide shortage of nurses . . . and claims that City Hospital cannot compete for those nurses because of poor working conditions and lower than average salaries.

(more)

City Council Chairman Arthur Lake says he'll establish a task force to look into the option of hiring an outside firm to recruit nurses from other cities.

\#

some other reason miss part of a story; perhaps they just drove through a tunnel, or only now tuned in. Using a shortened second reference after the actuality gently reminds the listener who has just spoken and keeps the listener on track.

Some news organizations ask the story's writer to time the script. The running time, including the actuality, is frequently written in the upper right-hand corner. You can approximate the script time by reading the copy out loud or counting lines. Line counting depends on your typewriter and margin setup and is less accurate than reading aloud. Many computer programs will, as previously mentioned, time the story based on the newscaster's typical reading speed.

LEAD-IN TO VOICE REPORTS

This type of story—a report on a city council meeting—may be filed by a field reporter, taped in its entirety and left for the morning newscaster. The story will be protected and concluded with the station's *standard outcue* (SOC): what reporters are instructed to say at the conclusion of their piece, such as "Mike Michaels reporting from City Hall for WXXX News." Mike Michaels' report, a voice-actuality (sometimes called a wrap-around), might read like Figure 6.6.

You will frequently write scripted intros for a voice report or voice-actuality. The intro may just be a handoff to the piece, but it may also be used to update the story, making it more current by reporting on the status of protected items in the recorded piece (Figure 6.7).

You'll note several points relating to the intro in Figure 6.10. First, the time element (last night) is written in the intro and not the V-A (voice-actuality). Therefore, the V-A could be used in the 11 p.m. report and the 7:30 a.m. report.

What's on tape won't spoil because it's been intelligently protected. The intro can be adjusted to compensate for the time element.

Second, the intro does not repeat Mike Michaels' first sentence. It sounds very awkward to have the same words repeated:

> Mike Michaels says there's a health-care crisis brewing at City Hospital.
> MICHAELS TAPE: "There's a health-care crisis brewing at City Hospital. Last night . . ."

However, the introduction does make a declarative statement about the news event. This practice is much better than saying, "Now, Mike Michaels has a report about the nursing shortage at City Hospital."

In addition to the information you would expect (the time, the name of the label on the tape and the fact that it ends with a *Standard OutCue*), this introduction also includes a brief summary of the story. Writing this kind of intro takes time, a commodity in short supply in broadcast journalism, so many newsrooms don't follow this practice. But it is highly recommended. If the tape doesn't roll, the newscaster can read the summary—and no one listening will be the wiser. (Another alternative is to have Mike Michaels leave a copy of his script handy, assuming the report was fully scripted and not partially ad-libbed. You can cover by ad-libbing from Michaels' script.)

Television Script Conventions

Television scripting mechanics are even more varied than in radio. There are many other factors to be included in the script, such as descriptions of the video shots and other technical details. Adding new variables increases the diversity of approaches.

Figure 6.6 Story with voice-actuality and standard outcue.

City Hospital Administrator Jane Smith warned the City Council that a severe shortage of nurses is causing a health-care crisis. Smith says almost a third of the nursing positions at City Hospital are currently unfilled. And, she says, everyone suffers because of the shortage.

''LAST NIGHT WE HAD ONE ELDERLY GENTLEMAN WAIT AN EXTRA HOUR AND A HALF FOR HIS PAIN MEDICATION. WE JUST COULDN'T GET TO HIM. WE WERE STACKED UP WITH THREE EMERGENCY CASES AND WERE SHORT FIVE NURSES ON THE SURGICAL FLOOR. I'M AFRAID, REALLY AFRAID, THAT THE NEXT TIME THIS HAPPENS IT'S GOING TO BE WORSE THAN LEAVING AN OLD MAN IN PAIN. HE JUST MIGHT DIE WAITING . . . AND I LITERALLY THINK THE STRESS IS KILLING THE NURSES. THIS CAN'T GO ON MUCH LONGER.''

City Hospital Administrator Smith says she simply can't attract nurses because of what she called a double whammy. She says there is a statewide shortage of nurses . . . and claims that City Hospital cannot compete for those nurses because of poor working conditions and lower than average salaries.

City Council Chairman Arthur Lake says he'll establish a task force to look into the option of hiring an outside firm to recruit nurses from other cities. This is Mike Michaels reporting from City Hall for WXXX News.

Another complicating factor is that much of what appears on television is not scripted in its entirety. News reports gathered in the field are edited together, using:

1. *Sound bites*—usually interview segments, television's equivalent of radio's actuality. The term is sometimes used to refer to anything recorded on videotape where the sound

*Figure 6.7 Story
with intro added.*

NURSES MICHAELS V-A INTRO HAUSMAN 9/17/92

City officials are meeting today to start looking for
solutions to what's been called a health-care crisis in the
making. Council President Arthur Lake is holding a meeting with
the City Hospital administrator at this hour. Lake and the City
Council got an earful about the situation at last night's meeting,
and Mike Michaels was there.

 TAPE: MICHAELS

 RUNS: :58

 OUT: SOC

(MICHAELS REPORTED THAT CITY HOSPITAL ADMINISTRATOR JANE SMITH
WARNED THE COUNCILORS THAT A NURSING SHORTAGE AT THE HOSPITAL
IS JEOPARDIZING PATIENT CARE AND CAUSING ENORMOUS STRESS AMONG
THE NURSES. THE CITY COUNCIL IS GOING TO SET UP A TASK FORCE TO
INVESTIGATE NEW METHODS OF RECRUITING NURSES.)

is intended to be broadcast with the video, although SOT (see following) might be a more commonly used appellation.

2. *SOT*—sound-on-tape. Depending on how this term is used, it can be either a scripting convention instructing the director to keep the audio from the videotape recorder on, or a descriptive reference to anything meant to be played on-air using both video and audio. For example, you might encounter a script line indicating that the director will air "SOT AMBULANCE CREW SHOUTING FOR TRAFFIC TO CLEAR," or "SOT MIKE MICHAELS HOSPITAL REPORT."

3. *Cover video*—used to illustrate what the reporter is saying in his or her voice over (described next).

4. *Voice over*—refers to the reporter reading script copy over the video. A VO example would be the reporter—off-camera—saying, "investigators combed the scene of the disaster" while the silent video showed a police officer sifting through rubble. Sometimes the wild sound—in this case, the sounds of the police officer heaving and tossing the rubble—is mixed with the voice over.

5. *Standup opens, bridges and closes.* A reporter sometimes opens his or her field report with

an on-camera standup, although this is not so common nowadays. Bridges—appearances by the reporter in the middle of the story—are relatively rare and typically used when there is a need to make a transition from one subject area to another. But standup closes are almost always included in a field report, primarily due to tradition.

We're used to seeing reporters give a standup close, wrapping up the story. From a reporter's standpoint, though, a standup close is a journalistic oddity since it forces the reporter to write the conclusion of the story before all the facts are gathered. Even though much of the fact-gathering may be done by phone *after* the crew leaves the State House, the reporter needs to be shown wrapping up while standing in front of the Capitol.

These are the basic elements of the field report script—which may not exist in its entirety, since only the voice over is written and sometimes the VO is actually ad-libbed. The standup close is sometimes written word for word, but is usually ad-libbed.

However, scripts *are* used in documentary work, and in some cases field reports are scripted. Anchor segments are almost always fully scripted. So it's worthwhile seeing how a standard field report would be constructed on paper.

VIDEO SHORTHAND

The first aspect of video scripting is the division of video and audio. Video goes in the left-hand column; audio in the right.

There's usually a header on the video script. The header is typically generated by the computer program (computers are becoming the rule and not the exception in television), but it's the same combination of writer, date and time found on radio scripts.

The left-hand column contains a shorthand description of what's being shown. There are many variations. MOC, meaning man on-camera, was once the standard term for a shot of a performer, but it's not used often today. Usually the name of the announcer is listed as being on-camera, or OC. So the left-hand column might read, "JOHN OC" or "JEAN OC." The video directions are generally capitalized.

A heavily scripted program will use camera commands to further describe the scene. Among them:

LS	long shot
MS	medium shot
CU	close-up
ECU	extreme close-up
OS	over-the-shoulder shot
2S	two shot

In other cases, the video shorthand will refer to camera movements:

TRUCK:	Physically move the camera from side to side
DOLLY:	Physically move the camera toward or away from the subject
ZOOM:	Gradually magnify the scene using the automatic zoom on the camera
PAN:	Sweep the camera across a scene

Often the video directions are plain English.

SHOT OF FLAMES SHOOTING THROUGH ROOF
CLOSE-UP OF BROKEN WINDOW

Many video scripts used in this book contain plain-English directions; reporters interviewed about their scripts generally favor plain-English commands, supplemented with the basic picture descriptions listed above, for the left-hand column when they script material. For the time being, stick to plain English. Should you find yourself at a station where highly technical abbreviations and camera commands are used,

you'll have no trouble picking them up since you already know the basic concepts.[2]

WRITING A VIDEO SCRIPT

Let's construct a video script around the story previously covered for radio. With video, you have an even greater opportunity to let the story tell itself, so it's likely that you would use more sound bites. Since a dramatic sound bite is a good way to open a story, you might begin the script as in Figure 6.8.

The script in Figure 6.8 contains fewer shots than most video reports because it is an introductory example. In Chapter 9 on TV news production, we'll see more elaborate efforts, which use more sound bites and cover video. But this *structure* is fairly common: sound bite open, voice over and cover video to tell the story and standup close.

In many situations a TV report won't be fully scripted like this. The reporter might just use the abbreviation SMITH SOT RUNS :14 instead of transcribing the segment. In some stations, the only script that might exist is the written copy for the voice over—and under severe time restrictions the voice over might be ad-libbed from the notebook.

Note that the script in Figure 6.8 used "hospital officials say" instead of "Smith says." "Hospital officials say" is a journalistic device to avoid naming Smith. Why did we want to avoid naming her? Because at the time, there was a shot of the City Council and a graphic identifying Council Chairman Lake. *Don't name one person when you are showing another.*

You'll also note that we used a graphic identifying the tape of the City Hospital ward as "file footage." This was done because we don't want to mislead the viewers into believing that what they are seeing is a depiction of the event that actually happened last night (the elderly man, the emergency room stackup and so on). We're openly identifying the tape as file footage, and also avoiding making ourselves look silly, because if we *actually had* specific video of the events, why didn't we show it—instead of the generic scenes of the ward?

P*unctuation, Words and Other Script Specifics*

Script mechanics are important, even though there is no universal standard. Therefore, we must understand the mechanics before tackling more advanced writing chores and the basics of TV and radio news production. (Production is a type of writing, too, since you are using actualities, sound bites and cover video to tell the story.)

We'll wrap up this chapter with a look at some specific suggestions for punctuation, word use and other topics germane to the broadcast script.

PUNCTUATION

Some broadcast newswriters use marks of ellipsis (. . .) to indicate the pauses in a story.

> More bad news from the State House today . . . state taxes are on their way up again.

There are no hard-and-fast rules regarding the use of ellipses in broadcast newswriting.[3]

[2] I am also reluctant to specify left-hand column abbreviations since stations are idiosyncratic in their use of such shorthand.

[3] *Ellipses* is the technical term for the three dots, but most people in the news business just call them "dots." *Dots* is the more correct term, because *ellipses* can imply that something is missing from the printed material.

Figure 6.8 Video
script of story.

NURSES	HAUSMAN	9/11/92	11P	RUNS 1:20
VIDEO		AUDIO		

VIDEO	AUDIO
CU SMITH SPEAKING	Smith: Last night we had one elderly gentleman wait an extra hour and a half for his pain medication. We just couldn't get to him. We were stacked up with three emergency cases and were short five nurses on the surgical floor.
LS COUNCIL MEETING	Hausman VO: City Hospital Administrator Jane Smith warned the City Council that there's a crisis brewing at City Hospital . . . too many patients, not enough nurses.
COVER VIDEO CITY HOSPITAL WARD SUPER GRAPHIC: FILE FOOTAGE	Hausman VO: According to Smith, the nursing staff is a third short of what it should be. And that means everyone suffers.
CU SMITH	Smith: I'm afraid, really afraid, that the next time it happens it's going to be worse than leaving an old man in pain. He just might die waiting . . . and I literally think the stress is killing the nurses.
LS CITY COUNCIL; ZOOM IN ON CHAIR LAKE	Hausman VO: Hospital officials say that City Hospital is caught in a double whammy. There's a shortage

VIDEO	AUDIO
	of nurses statewide, and it's harder to recruit nurses for a public hospital. City Council Chairman
SUPER GRAPHIC ID LAKE	Arthur Lake, though, thinks he might have a solution.
LAKE OC	Lake: It's true that the City can't meet the salaries of private hospitals. We just don't have the money in the budget. And I believe Mrs. Smith when she says there's a shortage of nurses throughout the state. But we do have good weather, a low cost of living and very low crime rate here. I'm inclined to think that we could take out ads in cities that aren't so lucky and attract a qualified pool of applicants.
HAUSMAN OC STANDUP CLOSE	Council Chairman Lake says he's going to set up a task force to look into the idea of recruiting nurses from other states, and he's already been in contact with a private firm that specializes in doing just that. From City Hall, this is Carl Hausman, WXXX News.

Some newswriters like using dots. Mike Ludlum, former executive director of news for CBS radio stations and the former news director of all-news radio stations in New York and Boston, finds them useful. "Dots work very well to show the flow of the writing," he says, "and to indicate effective pauses and emphases."

But Ludlum also notes that many news anchors prefer incomplete sentences with periods to reproduce the conversational style so often used in broadcast newswriting.

> More bad news from the State House today. Taxes are on their way up again.

Either technique is fine. Use what's standard in your department or station. Dashes are OK, too, and are especially useful for setting off a clause in the middle of a sentence.

> A long day—and a soggy one—for runners in the Marine Corps Marathon.

Commas are used as they are in standard print writing: to separate clauses and items in a list. There are elaborate and highly specific rules for comma use in standard *written* English, but for broadcast newswriting *use a comma where you would normally pause when speaking out loud.*

Which is easier to say?

Example 1

> The officers who saved the woman from the fire have been identified as Tom Roberts Melvin Hastings and Bob Griffith all of the 14th precinct.

Example 2

> The officers who saved the woman from the fire have been identified as Tom Roberts, Melvin Hastings and Bob Griffith, all of the 14th precinct.

This sentence is a bit long. Let's use dots to break out another phrase and make the sentence more readable.

Example 3

> The officers who saved the woman from the fire are Tom Roberts, Melvin Hastings and Bob Griffith . . . all of the 14th precinct.

The use of contractions is also the subject of some debate, although most newswriters use contractions freely because they make the phrases more conversational. As a general rule, contractions are fine—recommended, in fact—*except* when there's a possibility of misunderstanding.

You'll note that in the previous sentence I wrote *there's*, and in this sentence I used the contraction *you'll*. If spoken aloud, there would be no question that I meant *there is* and *you will*. But be careful with *can't*.

> The school board president says she can't grant the wage increase sought by union clerical workers.

This is a difficult sentence sentence in which to read *can't*, and have it clearly understood. The word might easily be misunderstood as *can*, which will obviously change the meaning and anger or perplex some members of the audience. Better to use *can not*. Spell it out as two words, just for emphasis. It's better still to recast the whole sentence to avoid the can/can't problem altogether.

> The school board president says there's absolutely no way she can grant the wage increase sought by union clerical workers.

WORDS

Some words and sentences sound stilted when read aloud. Others are tongue twisters that may cause the newscaster to stumble, hiss or pop.

The formula is simple: If you can't comfortably read it out loud, or if it sounds unnatural when spoken, *don't write it on paper.*

A giant pall hangs over Washington as the House writhes in internecine party warfare.

Nobody uses "giant pall" in conversation except, perhaps, for newspaper headline writers. Very few people can *say* "House writhes" without stumbling or spitting, so don't write it. *Internecine* is a word best saved for your master's thesis: Few people know what it means and those who do would find it inappropriate for news copy.

Jargon and Technical Words Be wary of technical terms or jargon. You may know what a CAT scanner is, but many in the audience won't. Saying that CAT is an acronym for computerized axial tomography won't help, since few people will know those terms, either. Define it in lay language:

Riverdale Memorial Hospital has filed for funding to buy a CAT scanner, a multimillion dollar machine that visualizes the inside of the human body without using x-rays.

Slang is acceptable in some situations, but if you use a slang term, be sure that it's a word that people understand, that does not make your English sound substandard and that is not offensive.

Active Versus Passive Broadcast newswriting is more effective, direct and understandable when it is in the active voice, rather than the passive voice. A sentence is in the active voice when the subject performs the action:

Mayor Leavitt delivered the report.

A sentence is in the passive voice when the subject of the sentence is acted upon via the object, using the word *by*. (This informal definition is specific to our example; it does not apply to every case.)

The report was delivered by Mayor Leavitt.

Attempt to keep your writing in the active voice. An occasional use of the passive is acceptable for variety in sentence structure, but the active voice vigorously carries the story forward. You can use a lot of simple, active-voice subject-verb-object sentences in broadcast newswriting. Stick to the basics, especially in a confusing story laden with heavy detail. Subject-verb-object constructions are easy to write and easy to understand.

Says *and the Use of Present Tense* The word *says* is part of two common scripting conventions. One is the use of the present tense whenever possible. If you look back over the radio script slugged NURSES, you'll see *says* used several times. *Says* is generally a better choice for broadcast copy than *said* because it is in the present tense—and radio and television are "now" media. But there is an inherent inaccuracy in using the present tense *says* because what someone said yesterday is not necessarily what someone says today. Use *says* under most circumstances, but if you are quoting a controversial statement or a statement pegged to a particular time, use *said*.

Senator Smith says his opponent is a fraud and a liar.

Better pin that down to a time and place, because Senator Smith might not be saying that today.

Senator Smith—in a speech last night before the West Side Veterans of Foreign Wars annual banquet—said his opponent is a fraud and a liar.

Also, use *said* if the statement is placed in time or space, regardless of whether it is controversial.

As he stood before the Memorial Day crowd, the mayor said that the threat of nuclear war must be eliminated—forever.

There is another problem with *says* or *said*. We get tired of writing it. We *assume* that people get tired of hearing it, but there is some debate as to whether anyone in the audience really notices. So we hunt for alternatives.

Note that in one section of the radio script we used the word *claimed* instead of *says* or *said*.

> She says there is a statewide shortage of nurses . . . and claims that City Hospital cannot compete for those nurses because of poor working conditions and lower than average salaries.

Claims is an entirely different word than *says*. It implies a degree of skepticism—which is warranted in this case. As a reporter, I would not be comfortable using *says* in the clause that alleges that City Hospital has poor working conditions because the statement is just that—an allegation. *Claim* implies that this is an unproven statement made by a person or group, which is the literal definition of the word *claim*.

However, in a statement of plain fact, *claim* can lend an unintended air of suspicion.

> State College President Martin Gold claims enrollments are up this year.

Is there some suspicion that he's lying? If so, *claims* is all right, but if not, it adds an unintended twist of skepticism to the story. Stick with *says* most of the time. While it is tempting to use *claims, declares, pronounces* and so on, *says* is generally your best option.

One more consideration about verb tenses is important. Although *says* is an example of the basic principle of keeping broadcast copy in the present tense, don't shift tenses so that they cause a silly sentence or distort reality.

> A man is dead this afternoon after committing suicide this morning.

That's a real example that, while not misleading, sounds idiotic. But here's another real example:

> A Bronx woman is shot to death . . . and police continue their manhunt.

That *was* misleading because the woman was shot a full day before the story aired. The lead might cause people who saw yesterday's news to believe that *another* Bronx woman was shot. When something important *happened*, don't get cute with the tenses. Just say that it happened and when it happened.

NUMBERS, ABBREVIATIONS AND NAMES

Some characters that are clear in written English are jarring to the newscaster who has to read them aloud. Numbers, symbols and abbreviations may be tongue-twisting or might take a split-second to decode, so newswriters have developed specific conventions to deal with them.

Numbers Usually you can round off large numbers. A city budget of "almost 50 million dollars" is reasonably accurate if the figure is $4,887,211.12. You can also round off distances. "A 200-mile trip" is all right even if you know it is really 202.5 miles.

But don't round off specific statements of important fact where the number makes a difference. For example, you would not round off figures in an airline disaster (unless the numbers were estimates of deaths, in which case, *say* they are estimates.)

In general, follow the broadcast news Associated Press Stylebook for rules for numbers. Spell out numbers from one to eleven, and use numerals after that. (If your station policy differs, follow the station's guidelines.) Follow the same rules for ordinal numbers: first, fifth, 12th, 26th. Use numerals for all ages: "4-year-old" not "four-year-old." Ages are given before the name: "19-year-old Mark Smith . . ."

Symbols and Abbreviations Symbols and abbreviations are distracting in copy meant to be read. For example, the $ symbol is best left

unused; write "500 dollars." Parentheses are rarely used. Spell out *percent*. Quotation marks are hardly ever used since broadcast quotes are paraphrased or orally attributed.

Unfamiliar abbreviations can stop anchors dead in their tracks, so be careful. Be *especially* careful if you are writing copy to be read by people new to your area. TPK may be a standard abbreviation for *turnpike* in your city, but an out-of-towner may have no idea what it means. Short of Mr., Mrs., Ms. and Dr., spell it out.

Names Broadcast newswriters generally do not use middle initials. However, there is a notable exception: Should you be reporting that a man named Frank Jones died in a traffic accident, it's best to give as much information as possible, including the middle initial and the complete ad-

dress. There may be dozens of Frank Jones in a major city—even in a medium-sized city—and reporting the death of Frank Jones could panic the friends and family of Frank A. Jones, Frank B. Jones, Frank C. Jones and so on.

The conventions in this chapter are not universal. Don't think that a script that differs from the specifications outlined here is wrong or that the book is wrong. Many idiosyncratic variations are found in broadcast newswriting and script formats.

Use whatever format is common in your department or station, but be prepared to adapt to different ways of doing things when you move on. That won't be any trouble since you've learned the *basic principles*. The technicalities can be picked up in an afternoon.

SUMMARY

1. The way scripts are prepared differs from station to station and market to market, but there are some general principles, some basic conventions, that are followed everywhere.

2. The broadcast style you use for a script will be different from the style used for print.

3. In broadcast newswriting you're committing spoken words to paper. If it doesn't sound right when read aloud, it's not good broadcast style.

4. In radio you'll only need one extra copy of the script. But in TV, there are many people who need copies.

5. You can write in all caps or caps and lowercase, but caps and lowercase is the more popular newswriting format today. Still, there are some announcers who insist that all caps is easier to read aloud. Triple-spacing is the rule in most radio and TV stations.

6. Almost all broadcast copy has a header. The header includes the slug, the writer's name and the date the story was written. Often the header will also include the particular newscast on which the story was aired and the time of the story.

7. Radio newswriters must indicate the presence of tape in the story. This is done by writing the title of the tape (SMITH 1), the incue, the outcue and the time of the actuality right on the script page.

8. The tag after the actuality should include another mention of the name of the person speaking the actuality.

9. When you finish the story, make some indication that it's done; the # mark is often used. If you must use two or more pages, indicate that another page follows—and never break a story page in mid-sentence.

10. When you write an intro to a voice-actuality, don't duplicate the first few words of the report. The taped report is probably protected, so you need to include the time element in the lead-in.

11. Sound bites, sound-on-tape (SOT), cover video, voice overs, and standup opens, bridges and closes are the tools of constructing the TV news report script (although you won't always completely script such reports).

12. The left-hand side of a video script contains video directions, descriptions of what's on the screen at a given time. Audio is on the right—usually what the anchor or reporter is reading.

13. Don't be reluctant to use incomplete sentences, dots and dashes in your copy. They mimic speech patterns and make the script easier for the anchors to read.

14. Contractions are acceptable, too. Just be careful of using the word *can't* when there's a chance the word could be confused with *can*.

15. Use common words—no jargon, little slang, no undefined scientific terms—and try to write in the active voice.

16. Try to use present tense, but not when it alters reality.

17. Round off numbers and avoid symbols and abbreviations.

EXERCISES

1. Here is a hypothetical interview segment with Fillmore County District Attorney Jack Smith about a murderer who was arrested last night in the city where you work, the city of Millard (which is the county seat). Use the transcript to prepare a 50-second (approximately) voice-actuality. Try to make the actuality run no longer than 15 seconds. Time the actuality by reading it out loud at your normal reading rate.

 Q: I understand you've made an arrest in a two-year-old murder case?
 A: That's right. The murder happened two years ago February. That was before you came to work at your station, right?
 Q: Yes. I've only been here a year. Is it all right with you if I record this for airplay?
 A: Sure.
 Q: Mr. Smith, who was arrested and what was the charge?

A: A sheriff's deputy attached to my department arrested Dan Jones, last known address Attica state prison. Jones was picked up drunk at a bar. This was his first day out of prison. He'd been in prison for two years on a robbery charge, an unrelated charge to the murder.

Q: And what murder was that?

A: The murder of Louise Richards in a street holdup. She was shot dead on Main Street after she refused to give up her purse. The robber shot her and ran away with the purse.

Q: How old was Louise Richards?

A: 22.

Q: Where did she live and work?

A: She lived at . . . let's see . . . 51 Elm Street here in Millard. She worked downtown as a dental hygienist. I forget what dentist.

Q: So the murder went unsolved for two years?

A: That's right. Apparently Jones committed a robbery in Madison—that's about two hours from here—the next day and was tried and convicted. He never had a permanent address, so nobody ever made the connection.

Q: Well, how'd you find out about the murder?

A: Jones started bragging about it last night in the Dew Drop Inn, you know, the dive on 411 Chandler. Somebody turned him in. I'm not going to tell you the name of the informant . . . if you know that place, you know he'd be dead in a minute if I ID'ed him.

Q: Is that all you have to go on? What he said in the bar?

A: Hell, no. He gave a complete confession last night at police headquarters. And we know it's for real because he knew details of the case that we never revealed to the press. Also, we were able to match a palm print from the purse of the victim— we kept the purse as evidence—to Jones.

Q: Details? Can you tell me now?

A: I guess. What happened was, he took the purse after he shot the victim and ran away. Two blocks away, a construction worker wrestled the purse away but couldn't catch Jones. We kept the construction worker's name secret because he was afraid of retaliation. Listen, I'm due in court. One more question?

Q: Yeah . . . have you ever heard of anything like this happening before?

A: Well, a case like this pops up from time to time, but it's the first I've handled. Sometimes you get lucky. But there's more to it than luck. Some people just can't control their mouths . . . or maybe it's their conscience. After two years, this guy was home free. But something made him confess to a crime the minute he got out of jail. You tell me. . . .

Hint: You have to pick one or more sections of the tape for actuality. When making that decision, remember that actuality is more effective when it communicates emotion or opinion, instead of imparting plain fact. What's the best piece of actuality in this tape?

2. You work at a television station. You have the above interview on videotape. In addition, you have:

 a. A still photo of the victim, shot with your videocamera, from a two-year-old newspaper you picked up from the back issues desk of the paper's archives.

 b. A pan of the scene of the murder, shot this morning.

 c. About 10 seconds of video of the accused murderer being led from the courthouse to a transportation van after his arraignment.

 d. A shot of the purse. The DA arranged for you to get into the evidence room and be shown the purse.

 e. Your standup close—done from the scene of the murder.
Write the script, including your voice over and standup close. Include sound bite(s) from the DA.

3. Compare your video scripts with scripts from classmates or co-workers. Do a mutual critique on this topic: How well does your voice over coincide with the video? Does what the writer says in the VO wander too far from what's on the screen? Or is it so obvious as to be superfluous? For example, is it necessary to say, "The purse the DA mentioned is shown here. It is being held by a clerk from the police property room"?

 Come up with a mutual rationale as to how you think it best to write VO to cover video. What techniques did you find particularly effective?

7

ADVANCED NEWS-WRITING TECHNIQUES

"It is death that causes this blinding show of color, but it is a fierce and flaming death. To drive along a Vermont country road in this season is to be dazzled by the shower of lemon and scarlet and gold that washes across your windshield."

Charles Kuralt, October 1967, for the first "On the Road" report, a series expected to last only three months.

Good writing is the essence of good journalism. Good writing is what makes news come to life; what makes radio a magic medium that intrigues listeners, convincing them to stay tuned. Good writing is what makes television a compelling source of news and information, instead of what Edward R. Murrow warned TV could become if we ignored the quality of what we put on the tube: "Nothing but lights and wires in a box."

Good writing consists of words that evoke images, *specific and vivid* words, like Kurault's depiction of a "fierce and flaming" death, and his description of a "shower of lemon and scarlet and gold."

This chapter surveys advanced techniques of newswriting, those techniques that make the difference between good broadcast news and what is simply a lifeless collection of dead words on paper. Specifically, we will: *examine how to write to sound and video; explore the details of painting vivid, powerful word-pictures; and show how broadcast writing incorporates the human element,* the elusive quality that makes it appeal to readers and viewers.

Matching Words with Sound and Picture

The last exercise in Chapter 6 asked you to compare various treatments of integrating voice and video. If you performed that exercise, you intuitively learned something about the delicate relationship of writing and sound-picture.

Learning this technique is not difficult; and since you've now been exposed to a substantial amount of broadcast copy, this is a good opportunity to sum up what we've learned so far and add some fine points to the discussion of "writing to tape."

RADIO NEWS COPY: HOW TO INTEGRATE WORDS WITH WILD SOUND AND ACTUALITY

We've already seen in the previous chapter that introductions to tape segments should:

1. Not repeat word for word what the tape will say.

2. At the same time, be close enough to the topic so that the tape is not jarring.

Those are the two fundamental tenets of writing to audiotape. We'll now discuss some others:

There's a basic rule in writing to tape that is sometimes known as CYA: cover your . . . actuality. Leave yourself an out if the tape does not roll. Some newswriters will make a direct introduction to the tape:

> . . . and here's how the president responded.
> TAPE: "I have complete confidence in the secretary's ability to resolve the situation. . . ."

But that's risky. A more comfortable option:

> . . . the president says he's not worried.
> TAPE: "I have complete confidence in the secretary's ability to resolve the situation. . . ."

In addition, use wild sound in your radio pieces, but never fake sound. Don't dub gunshots from a sound effects record; in some stations, that is a firing offense. Also, be careful not to overlay sound in such a way as to mislead the listener. For example, you might have some excellent wild sound of a picket line cheering and chanting, and an actuality of a union leader giving a speech to a few people an hour later. It's tempting to juxtapose the two, but don't; you're distorting reality.

Also, as you're aware by now, choosing what portion of an interview to use is part art and part science. You'll develop your own standards for judgment, but in general it's best to use as actuality pieces that express emotion, analysis or reaction—as opposed to those pieces that recite plain fact. Use the plain fact part of the recorded interview to write your script. Choose as actuality the part that expresses emotion.

Another actuality tip is to try to choose actuality that won't go out of date quickly. Use the material that is time-sensitive (mentions of today, tonight, this afternoon) as the basis for your script. You can always rewrite a line of the script to compensate for time changes. But editing in another actuality is time-consuming. Attempt to make the actuality as timeless as possible.

VOICE-OVER COPY: HOW TO WRITE WITHOUT DETRACTING FROM THE PICTURE

Almost every point listed in the radio category applies to video, but there are additional techniques involving the proper style of voice-over copy to be juxtaposed with the videotape. Of primary importance is the fact that voice and video must be *reasonably* related. They cannot be related *too closely*, and at the same time they cannot be *at odds* with each other.

In almost all cases, the central thought of the copy must relate to the basic theme of the picture. We can't have a close-up shot showing only construction workers while the copy describes the massive traffic jam created by the construction. The traffic jam is the story—at least at the point in the story where the copy refers to it—and we *have* to have a shot of the traffic. If that video isn't available, have the anchor read the copy to the camera as a "tell" story.

You can use the tape of the construction workers under a line such as, "Construction has been underway for six months, and is expected to continue for another year."

On the other end of the spectrum, do not write voice-over copy that repeats what people can see for themselves. What's the point of writ-

ing, "This is the room where the school's computers are housed. There are computers at each student's desk," when you are showing a pan of the room clearly depicting: (1) a room full of computers; (2) a computer at each desk; and (3) a superimposed graphic that says "Metro School District Computer Center."

Instead, use the voice-over copy to tell more of the story while you are illustrating the obvious visuals.

> This learning center, equipped with 35 computers, is the Metro School District's pilot program in what it hopes will be . . .

You can "point" to the picture with your script, as in the example above (*this* learning center) but you don't have to. While pointing to the picture makes editing and scripting easier, you can with practice develop the knack of weaving complementary video and audio together without pointing. For example, you could write the computer copy very indirectly . . .

> Some educators predict computer technology will be the wave of the future, and the Metro School District is betting over three million dollars that a computer learning center will . . .

While we've been thinking in terms of voice over strictly as announcer copy over video, you can use sound bites to create voice overs, too. What could be more effective than using the voice of a person burned out of his home as voice-over copy for scenes of the wreckage? *You don't have to write everything. A lot of the news writes itself.*

An important part of writing to video is timing. In many cases, especially when you are writing copy to be read by an anchor over video, you may need to have the tape and the anchor hit the same point at the same time. A familiar example is voice-over copy on top of generic footage at the mayor's press conference, lead-

ing up to the SOT section of the press conference during which you air the mayor's audio and video.

Part of this skill is nothing more than using a stopwatch as you read the copy out loud. For example, if you want 8 seconds of generic cover for the anchor's voice over and then the mayor's statement, you back up the tape to the point 8 seconds before the mayor's statement; you know it's 8 seconds' worth of copy because you've read it aloud and timed it. (The control room staff will back up more than 8 seconds because it takes the tape a few seconds to get up to speed. But for now, we'll assume that's the director's problem. More on this type of "backtiming" is in Chapter 10.)

All you need to do is to decide how much of the anchor's copy totals 8 seconds, and mark the appropriate point in the script to roll the tape (you'll consult with the director on this). Then, assuming you've matched the anchor's reading rate, everything will come off smoothly.

Anchors with experience become skilled at hitting SOT inserts. All they require is an accurate reading on how much silent video precedes the SOT. Also, it's wise to go to a separate shot, such as a close-up, of the mayor right before he or she speaks. This is a cue for the anchor and makes for good-looking video as well.

Sometimes newswriters will "write away" from the visuals, producing copy that has a weak relationship to the visuals. Usually, they do this as a last resort when they don't have appropriate visuals. It's difficult to illustrate stories about inflation, deflation, tax increases or any story dealing with fiscal abstractions. (However, the increasing ease of producing good computer-generated visuals allows creative producers to partially overcome this problem.) On occasion you'll be rummaging through file footage and wind up writing away from it when, for example, you use shots of Christmas shoppers to cover copy about new figures that show a drop in consumer buying power.

If that's all you have, that's all you have, so write away at your discretion. But *do* use discretion, because so-called wallpaper video can get you into trouble if used carelessly. If your copy is about a government investigation into car repair rip-offs, *don't dip into your tape file and grab some wallpaper video of any old car repair shop.* If anything in that video identifies an innocent party, you're vulnerable to a libel suit. One reporter (in a case still in litigation) used a stylized visual of a wedding, produced from a stock visual, to illustrate a story about rising divorce rates. It was inconceivable to him that the bride could be identified, but she managed to recognize herself—and claimed that other people recognized her—and filed suit. She was still happily married.

There are times when you deliberately want to write away from the visuals, but that's normally for novelty or comic effect. If you are writing a story about a wave of cockroach infestation, you might juxtapose videotape of cockroaches with announcer copy reading, "Americans love animals, and statistics show most households have at least one pet." You've caught the viewers' attention ("What the . . . those are *cockroaches*"), and now you can lead them into the joke about the "unwanted members of the animal kingdom that are finding new homes in many parts of the city." A little of this is OK. Too much is . . . well, too much.

Painting Pictures with Words

Which copy intrigues you more?

Example 1

A truck tipped over on the interstate today. It broke open and its contents spilled all over the pavement.

Example 2

A truck flipped over on the interstate today. It ruptured . . . and its contents spewed all over the pavement.

Strong, active words make copy come to life: *flipped, ruptured, spewed.* It's difficult to prescribe methods of writing in strong language, but if you pay attention to the writing principles described in this book and *listen* for the word patterns that attract your attention in the newscasts you hear and see, you'll catch on quickly. The next time a piece of copy interests you, remember it. Write it down. Analyze it. Decide why it was effective and borrow from the writer's skill.

VIVID DESCRIPTION

Strong words and clear, precise description go hand in hand. In addition to strong verbs, use explicit adjectives and descriptive phrases that make the images absolutely lifelike and compelling.

Would *you* be able to tune out a radio report that began this way?

A black woman and her two children leave a suburban St. Louis neighborhood after someone plants a burning cross in front of their apartment. Three young white men plead guilty to charges they defaced a black church in southern Illinois with racial slogans and swastikas. In another St. Louis suburb, someone fires shots, throws rocks through the window and tosses a smokebomb in the yard of a black family that had moved into a mostly white neighborhood. Authorities say all of these incidents are racially motivated. They are just some of the shocking stories uncovered by a four-month KMOX Radio investigation into racial violence and intimidation.

From "Hate Crimes: America's Cancer," a Peabody Award-winning piece from KMOX, St. Louis; the series

that was credited with putting pressure on the state legislature to strengthen laws dealing with racially motivated crime.

One strength of radio news is the medium's ability to use vivid description, powerful words *and* candid actuality to let the story tell itself. WSM Radio (Nashville) News Director Jerry Dahmen noted that the power of the medium was instrumental in making his city aware of it's child sexual abuse problem. In a piece produced and narrated by Dahmen, he used strong and direct copy and actuality to paint an all-too-vivid picture. This is powerful and unpleasant material, but it's fine radio.

> Dahmen: Laurie was like most parents. The Nashville mother didn't know much about child sexual abuse until it happened to her 4-year-old daughter.
>
> TAPE . . . Laurie: I picked up Jennifer and we had went home, and she had come out the bathroom and she said that her pee-pee hurt. I asked her what do you mean, do you have to use the bathroom? And she says no, John stuck his fingers up me. And at that time, I completely lost it. I picked her up, and I laid her on the counter to look, and it was extremely red and swollen, and I asked her if he tried to do anything else, and at that time she said yes, he tried to sodomize her . . . she didn't use those words, but that's what it was.
>
> Dahmen: Laurie was in a state of shock . . .

The series, titled "Innocence Abused," was a success from a variety of perspectives. It received an Edward R. Murrow Award for Excellence in Journalism and a major award from the International Radio Festival of New York. More importantly, though, police credited it with prompting many calls reporting cases of sexual abuse—and a tape of the series became a useful tool at the metropolitan police department training academy.

SPARE BUT EVOCATIVE COPY

The pieces from KMOX and WSM both used powerful words, *but not a lot of words.* That's the key to telling the story effectively: Don't overload it with verbiage, and let the story tell itself when possible.

Phil Rogers (Figure 7.1) of WBBM, an all-news radio station in Chicago, produced a major story from an unadorned and straightforward idea. "Big things happen from very simple stories," Rogers says. "Not only was it a big story, but we're still [I interviewed Rogers in August 1990] doing follow-ups."

Rogers, an award-winning investigative reporter, received an anonymous tip about a security gap at O'Hare Airport. The tipster was a deliveryman who told Rogers that security could easily be penetrated at one gate.

Figure 7.1 *WBBM (Chicago) reporter Phil Rogers showed how good investigative radio news can break a major story—demonstrating in the process that sometimes the best stories are simple stories. (Courtesy WBBM Newsradio 78.)*

Listen in your mind's ear to the crisp cadences and skillful ease of Rogers' writing as he tells a simple story about a complicated problem.

> Rogers: The Achilles heel of O'Hare security is the Mount Prospect Road entrance to the field from Touhy Avenue. When you get to the guard house there, procedure is for your vehicle to be escorted to wherever you're going. We drove in aboard a semi-trailer truck making a regular delivery, were asked by the guard if we knew the way and went in unescorted.
>
> From there we had a free ride around the service road, which leads to active taxiways and runways. Our driver makes regular deliveries through that entrance. He says his load is NEVER checked and he is NEVER escorted.
>
> TAPE . . . Driver: Not if you appear to know what you're doing, know where you're going. They will let you just go. You say, I've got a delivery for such and such, they say, have you been here before? You say, plenty of times, and they say, go ahead.
>
> Rogers: Although we had told the guard that we had a delivery for American Airlines, in fact our truck could have contained dozens of men and hundreds of pounds of explosives. And from the taxiway, we could have rammed aircraft taking off, the terminal itself, or could have pulled up next to any aircraft at virtually any gate.

Take a moment and read Rogers' copy out loud. Notice how it is direct, declarative and—most importantly—not overblown or inflated with excess words. Each word, each sentence, is there for a discrete purpose. The simple, declarative, largely subject-verb-object sentence structures tell the story clearly and evocatively.

And more to the point, Rogers used his writing skills to tell a story that needed to be told. You won't be able to wander onto an O'Hare runway anymore. After the story aired, the FAA and the city of Chicago launched investigations and tightened up security.

The Human Element

What makes a story well-written and interesting? People are interested in stories about people and, ultimately, about themselves. The examples we've seen so far are remarkable not only for the technical quality of the writing but also for their clear focus on important stories of overriding human interest.

Good writing also deals with life's ironies and the effect of disruption on people's lives. But keep in mind that *people* are the key to telling a good story, not the events. For example, Stapleton Airport in Denver was the scene of a miserable July 4th, a day when just about everything went wrong: Planes blew tires, narrowly missed each other on runways and in a few cases never got off the ground.

KMGH-TV's Paul Reinertson (Figure 7.2) could have recited a litany of what happened to the planes, but he didn't. He started the story dealing with planes, but he quickly shifted the focus to the *people*. Figure 7.3 shows part of his report.

Reinertson's report continues with details of two other incidents—an aborted takeoff and a

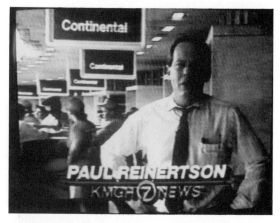

Figure 7.2 Reporter Paul Reinertson of KMGH-TV, Denver.

Figure 7.3 How Reinertson made people, instead of things, the focus of his story.

Anchor: This was no holiday for Stapleton. . . . Paul Reinertson has the story.

VIDEO	AUDIO
CS AIRPLANES	Reinertson: Airplanes did not have a good day at Stapleton today.
CONTINENTAL PLANE	This Continental Airbus headed for Texas never made it beyond the end of the runway.
CU AIRPORT OFFICIAL	Airport official: Continental Airlines flight 1232, our A300 Airbus flying to Houston, had to abort takeoff on runway 35 due to a fire in the number one engine.
PLANE ON RUNWAY	Reinertson: With the plane screeching to a halt, four tires blew, and the airport had to take
TELESCOPIC SHOT, PASSENGERS DISEMBARKING	passengers off the plane at the end of the runway. One woman aboard just knew there was going to be a problem.
CU WOMAN, NAME SUPERED	Woman: Well, I had a premonition. I don't get these things often . . . and you heard this thing was rattling, and you heard this boom like an explosion, and the flight attendants said, get down, get your heads down, get down.
PLANE ON RUNWAY	Passengers didn't have time to think. They just reacted.

continued

Figure 7.3
continued

VIDEO	AUDIO
CU ANOTHER PASSENGER	Another passenger: The whole airplane started shaking like this, and I was sitting kind of by the wing and we were looking out the window and there was smoke rising from it. And the lady to my side started screaming. And the pilot came on the intercom and told us to put our heads between our knees.
TELESCOPIC SHOT	Reinertson: They praised the pilot, just happy he didn't take off.
CU ANOTHER PASSENGER, NAME SUPERED	Another passenger: that airplane only has two engines on it, and if we had to climb out at this altitude and this heat with only one engine, we would have been in real trouble.
REINERTSON OC	Reinertson: These people behind me in the red t-shirts are called Continental Airlines go-getters, and they had a lot of go-getting to do today.

United 727 that had to be diverted because of hydraulic problems. Throughout, we're consistently shown *reaction* and the feelings of the *people*.

━━━━━

MAKING COPY MOVING BUT NOT MAUDLIN

Don't conclude that sensational, sob stories are the only raw material for good newswriting. That's not the case. At the same time, don't dismiss the human element: That's what makes us care about what's happening.

There's a fine line between the *moving* and the *maudlin*. That line is not always easy to draw, but I do believe that it is responsible to show human suffering—it is in many cases the duty of a journalist to show human suffering—as long as we don't exploit it.

For example, fire is an everyday occurrence that causes suffering that is often unnoticed. We

see the flames; we see the fire trucks and the firefighters; but we don't see the people who lose their homes.

Much has been made of some reporters' proclivity for sticking a mic in the face of someone watching his or her home burn down and asking how it feels; that is an insensitive practice. But there are tasteful and sensitive ways to handle the aftermath of a fire. Dave Dent, a reporter for WKRN-TV in Nashville, and now a professor at New York University, handled such a story (Figure 7.4).

The script illustrates how Dent braided details of the fire with effects on lives. We can also see how he integrated video with script to move the story forward temporally from the fire, which occurred at night, to the aftermath, which evolved over the next day. In italics are my comments about the techniques Dent used to write and construct the story.

Figure 7.4 How David Dent handled a tragic fire story with taste and sensitivity. (Photos and story courtesy David Dent.)

The report opened with a shot, taken a few hours earlier, of a home engulfed in flames (Figure 7.4A).

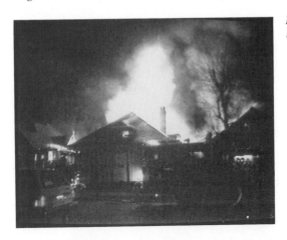

Figure 7.4A An opening shot of Dent's piece.

VIDEO	AUDIO
FLAMES SHOOTING FROM HOUSE—LAST NIGHT VIDEO	Dent: The fire started late last night . . .
CU FLAMES	The flames raced through this house on
FRONT OF HOUSE	Woodland Street, roaring

continued

Figure 7.4
continued

Now, we're moved forward in the story, as we see the firefighters attempting to douse the flames (Figure 7.4B).

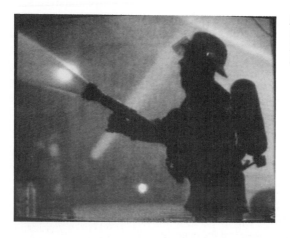

Figure 7.4B *Good video captures the drama of the moment. Here, a firefighter battles the blaze.*

```
FIREMAN SPRAYING              for hours into the morning.
FLAMES

SHOT OF FLAME UPDRAFT         Wild sound: Roar of flames

CU EXHAUSTED FIREMAN          Fire officials say seven families
                             lived in this

EXTERIOR OF BUILDING         converted apartment house, and they
```

Now, a more direct reflection of the human element. A shot, although not an offensive or intrusive one, of the victims of the fire (Figure 7.4C).

Figure 7.4C *This shot shows the victims of the fire; it imparts an idea of the realistic consequences but is not maudlin or exploitative.*

RESIDENTS AT CURB,	watched the place they call
WATCHING HOUSE BURN	home go
EXTERIOR OF BUILDING	up in smoke. Many residents have no
	idea where they will spend
	the night.

Remember when we discussed bridges earlier—how they are used only when there's a need to make a transition? Here, Dent appears on camera (Figure 7.4D) to help clearly make the transition from last night to today. He points up the time element—noting that victims spent the day HERE, a clear indication to the viewer that we've moved from the coverage taped the night before to the next day, since he is obviously standing outside in broad daylight.

Figure 7.4D Reporter David Dent appears in a standup bridge to move the story from one time and place to another.

DENT OC AT SCENE	Many spent the day here, trying
	to salvage whatever belongings
	they could.

Now, a scene of a man picking through the rubble of his life. Dent uses the sound bite as the voice over, and lets the man tell his own story. The fire victim's name has been changed.

continued

Figure 7.4
continued

MAN PICKING THROUGH RUBBLE	VO: I had just moved into this apartment last week, Monday or Tuesday, paid the rent, two weeks' rent, $120.
CU BURNED FURNITURE	I fixed it up nice . . . I was enjoying it, I liked it.
MAN STANDING ON SITE OF BURNED—OUT APARTMENT	Dent VO: Jack Edwards returned to what was left of his apartment this morning. He had to borrow a shirt and shoes . . . all of his belongings were destroyed in the blaze.
CU DESTROYED PROPERTY	Edwards VO: Everything I had is gone . . . I ain't got nothing. I'm out everything now.
LS EDWARDS	Dent VO: But Edwards also feels fortunate . . . he was here when the fire started, and he managed to escape with no injuries.
CU EDWARDS	Edwards: If it hadn't been for the firemen I don't know what I woulda done. I was up on that roof, and the fire was coming toward me . . . in fact it got out on the roof.

Now, a transition . . . a discussion of the fire and good video to reinforce it: the fire investigator handling the item he thinks may have touched off the blaze (Figure 7.4E).

Figure 7.4E *This shot of the fire investigator illustrates both the fact that the investigation is being held and the probable cause of the fire—the hibachi shown in the lower part of the screen.*

INVESTIGATOR PICKING UP TOP OF CHARRED GRILL	Dent VO: Fire investigators were also here today to determine what caused the blaze.
	Fire investigator VO: My opinion is that the fire started from a charcoal grill on a wood deck in the rear of the home.
CU INVESTIGATOR, NAME SUPERED	It was a hibachi pot, that's what they call them.
INVESTIGATOR ENTERING SIDE OF BUILDING	Dent VO: Wadell says the landlord may have violated housing code regulations.
	Investigator VO: What I've been informed is that this is supposed to be a duplex, and it appears that sleeping rooms were being rented to individuals.

continued

Figure 7.4
continued

VICTIM SURVEYING DAMAGE	Dent VO: But the victims living here were not worrying about code violations today . . . they were worrying about where they will spend the night.
	Edwards VO: I don't know where I'm gonna be, what I'm gonna do, or where I'm going.
ECU EDWARDS	I'm gonna have to do the best I can. EDWARDS SNIFFS, WIPES TEAR FROM EYE.
	Dent VO: David Dent, Channel 2 News.

SUMMARY

1. Good broadcast newswriting uses powerful and vivid words to paint clear, evocative pictures.

2. One of the more difficult aspects of broadcast newswriting is matching words with audio and video. With audio, the main task is to gracefully introduce the actualities without being redundant or, on the other hand, without straying too far from the central meaning of the picture. It is also useful to write in a way that covers your actuality if the tape does not roll.

3. Writing to video is more complex. The newswriter wants the voice-over copy to match what's on the screen, but not to describe it so closely that there is no point in showing the picture. Conversely, we want the audio close enough to the picture so that the story makes sense.

4. Sometimes the video has little relation to what's on the screen. It might be cover video used to dress up the story. Be careful when you use cover video that nothing can be misinterpreted.

5. Strong, meaty verbs are the essence of good writing. Clear, vivid adjectives and nouns help, too.

6. Try to write spare copy. Don't use more words than you need. Lean, simple sentences propel your story forward.

7. The human element is important in writing broadcast news. Effective stories are about people, not things.

8. There is a fine line between copy that is moving and copy that is maudlin. But remember that it is acceptable—indeed it is your job—to show the effects of events on people. Give them reasonable respect.

EXERCISES

1. Using a standard audiotape recorder, interview a classmate or co-worker about an important event in his or her life. (A recent award, the birth of a child or even a personal tragedy are all possibilities.)

 Write a 1-minute voice-actuality (wrap) about the event, transcribing the section of the tape you intend to use. Be sure to time the actuality segment. And keep the tape; we'll be using it later.

 In your V-A, use powerful, descriptive language. Keep rewriting until all the flat, dead words are excised. Also, be ruthless in your deletion of extra words that do not add anything to the story.

2. Here is a poor excuse for broadcast copy. Edit it mercilessly. Take out the weak words and replace them with powerful ones. Eliminate the bland. Eradicate the vague. Untangle the distortions.

```
TEACHERS  MC BLAH   9/11    7:30 A

     The Fillmore County school district has decided not to do

much of anything too risky as negotiations with teachers

continue to not go very well. The district has bought and paid

for ads in newspapers in nearby Garfield and Polk. The ads say

that the district is looking for applications for replacement

teachers.

     Superintendent Jack Smith says that replacement

teachers could be hired to teach if the 300 teachers in the

Fillmore district decide they will strike when they vote on the

strike issue next month.

     Pretty soon there will not be much time left.

Negotiations are not accomplishing anything right now, and

school starts in two weeks.
```

3. Describe something in 100 words, using broadcast style. It doesn't matter what it is, as long as what you're describing *does* something: a compact disc player, a personal computer, your dog. Paint a vivid word-picture, using the kind of strong verbs and crisp adjectives you might imagine Charles Kurault would use if he were doing this assignment.

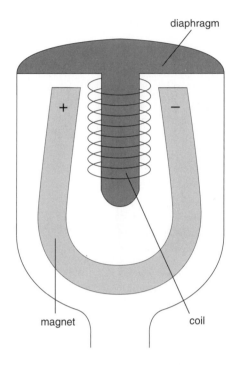

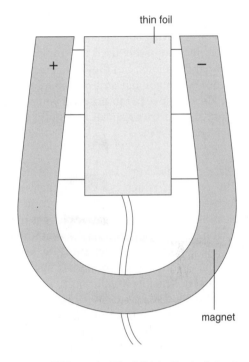

Figure 8.2 *Moving coil mic. Diaphragm (a) vibrates in sympathy with sound waves, causing coil (b) to cut lines of force created by magnets (c).*

Figure 8.3 *Ribbon mic. The foil (a) vibrates between poles of the magnet (b), cutting lines of force and producing modulated current.*

ure 8.2). As it vibrates, an attached coil of wire moves through a magnetic field and creates an electrical (audio) signal. Moving a coil through magnetic lines of force is also precisely the way in which a generator produces electricity. Alternating current is produced by moving a conductor through magnetism. When a generator turns, all it is doing is spinning coils of wire through a field of magnets.

A moving coil has the advantage of being very sturdy. The diaphragm-coil arrangement is resistant to physical shock and to handling noises. The only real disadvantage of a moving-coil mic is that the hardy coil-diaphragm device does

not vibrate very quickly, so very-high-frequency sounds won't be picked up well. This is rarely a problem with radio news operations, unless you are covering a concert and want high-quality sound reproduction.

Ribbon A ribbon mic uses a thin metallic strip suspended between two poles of a magnet (Figure 8.3). A ribbon mic responds beautifully to high and low frequencies and produces a rich, warm sound. Unfortunately, the ribbon mechanism is delicate. The thin ribbon can be damaged by wind or physical shock to the mic. Also, announcers who tend to pop their *P*s and *B*s will

find this problem more noticeable on a ribbon mic than on a moving coil mic.

Ribbon mics are rarely used in remote news-gathering applications, but they are common in the studio. When you use a ribbon-element studio mic, do not move in too closely if you are a *P* or *B* popper, and try to speak at a slight angle across the mic.

Condenser Condenser is an old-fashioned term for *capacitor*, which is a device that stores an electrical charge. The capacitor mic operates by releasing positive and negative charges in accordance with the vibration of the diaphragm.

Without going any further into the technicalities, the advantage of a condenser mic is that it is extremely sensitive to all ranges of sound. This is also its disadvantage, since you don't necessarily want all the sounds produced during a newscast (teeth clicking, breathing and so forth) reproduced faithfully for the listeners. Also, a condenser mic needs a separate power supply, which is a nuisance for fieldwork.

You won't usually find condenser mics used in the field, with the exception of lavaliere mics (mics clipped to the clothing); these are becoming increasingly popular in remote television production. However, condenser mics *are* popular in studio applications. When you use a condenser mic, be sure not to move in too closely or your listeners will be distracted by mouth-sounds. Also, be very cautious about rustling papers and clicking pens and pencils.

A natural question has probably occurred to you by now: How do you tell what element is inside a mic? The simplest way is to ask your engineer or technician. Barring that, Stanley Alten's *Audio in Media*[1] offers an encyclopedic guide to mics and their workings. *Modern Radio*

Figure 8.4 *Omnidirectional mic pattern. Omni mic picks up equally well in all directions.*

Production[2] provides a smaller table of mics, showing their elements and pickup patterns.

Pickup Patterns The pickup pattern, sometimes called the polar pattern, is a graphic representation of how and from which direction a mic will accept sound. The typical patterns are *omnidirectional, cardioid* and *bidirectional.*

Omnidirectional These mics accept sound from all directions (Figure 8.4). The advantage of an omnidirectional mic is that you don't have

[1]Stanley Alten, *Audio in Media* 2nd ed. (Belmont, Calif.: Wadsworth, 1989).

[2]Lewis O'Donnell, Philip Benoit and Carl Hausman, *Modern Radio Production* 2nd ed. (Belmont, Calif.: Wadsworth, 1990).

to be particularly careful in which direction you point it. Also, you can clip or tape it to a lectern during a press conference and not worry about the subject moving out of the pickup range.

Omnidirectionality is not always an advantage. In noisy situations, such as a locker room, it is a decided advantage to have a mic that rejects sounds from certain directions. Also, if you are speaking into your mic and operating your own console in the studio, having a mic that picks up the sounds of you moving tapes and pressing buttons is a drawback.

Cardioid *Cardioid* means "heart-shaped." Its root is the same as the word *cardiac*. Indeed, the pickup pattern as viewed from the top (Figure 8.5) does resemble a heart. But this is a three-dimensional representation. The cardioid pattern might be better visualized by imagining that the mic is the stem of giant apple with the apple representing the portion of the pattern that will pick up sound.

Cardioid mics are useful tools in news operations because they pick up sound from only one direction. Cardioids allow better-quality pickup in situations in which you're surrounded by noise and want that noise filtered out.

The only disadvantage of a cardioid is that you run the risk of your subject moving out of the pickup pattern. A quality that can be either a disadvantage or advantage is that cardioid mics tend to accentuate bass pitches when the subject moves closer to the mic. This is known as a proximity effect. The proximity effect is a plus for announcers with high voices who wish to sound more authoritative, but it tends to muffle the sound quality of announcers who already have deep voices.

Bidirectional You won't encounter a bidirectional pattern (Figure 8.6) in fieldwork, since it is a pattern produced only by a few ribbon and

Figure 8.5 Cardioid pickup pattern.

condenser mics used for studio work. In the studio, bidirectional mics can be handy for conducting two-person interviews.

The Audio Console Back at the studio, you will need some apparatus for playing back your cassette and perhaps mixing what's on the cassette with a narration you type up and read in the studio.

The audio console performs these two basic functions: putting an audio source on the air (or feeding it to the tape recorder that is recording the final product) and governing how loudly the audio source plays.

Think of a radio disc jockey who plays a cut of music and talks over the instrumental open-

Figure 8.6 Bidirectional pickup pattern. As viewed from above, mic picks up from either side.

ing to the cut. The disc jockey must have a device to put his or her mic and the music selection over the air at the same time, *and* adjust the level of the two sources. He or she would regulate the level of both the music and the voice so that a proper mix could be obtained. The music would be loud enough to be heard but not so loud as to drown out the announcer's voice.

A simplistic diagram representing the console is pictured in Figure 8.7. You'll note that there is a knob labeled MIC 1 (the station's only mic) and TT1 (the station's only turntable). The knobs that govern the volume are called *potentiometers*, or simply, *pots*. They are nothing more than volume controls.

Above the pots are the keys. The keys allow you to put the source—in this case, a turntable or a microphone—over the air or to the master tape recorder, which will save the program for later playback. On most boards, when the keys are thrown all the way to the right the source is on the air, or in the program channel. The middle position is off. When the keys are thrown to the left, it puts the sound source over the audition channel. Audition has a number of uses, including allowing the operator to hear the source off-air on a good-quality speaker. (You can also do some production work on the audition channel, but that's a topic beyond the scope of this chapter.)

There's another channel on the board, called cue. Cue allows you to hear a source off-air through a small speaker built into the console. You can't hear the sound very well—it's not a high-quality speaker—but it does allow you to listen for the beginning of a cut on a record, stop the LP, and back the LP up a quarter of a turn to ready it for instantaneous airplay.

The console pictured in Figure 8.8 is fine for a station that plays one record at a time and uses only one mic, but it's severely limited in other applications. Let's look at a more complex but still oversimplified console that might be used in a radio station newsroom or news production area (Figure 8.9).

This console has a pot for a microphone, a cassette deck, a cartridge machine (a device we'll explain momentarily) and a reel-to-reel

Figure 8.7 *A hypothetical console where the operator needs to control only one mic and one turntable. The pots control volume (a), and the keys allow the operator to choose audition or program (b). Turning the pot all the way to the left clicks it into "cue."*

Figure 8.8 *A console similar to the one pictured in Figure 8.7, but to which we've added two new controls: a VU meter (a) and a pot that controls the volume of the cue speaker (b). The cue speaker is inside the console.*

Figure 8.9 *A slightly more complex audio console—one that might be workable for news production.*

Figure 8.10 *A volume unit (VU) meter. The goal is to keep the needle floating around the zero or 100 percent modulation indicator. Here, we're just slightly "into the red."*

tape deck. Using this console, you can bring any source "up on the board" and control its volume.

Audio equipment likes to "hear" sources at an ideal volume, which is indicated by the volume unit, or VU, meter (Figure 8.10). We do not need to delve into acoustic intricacies here, but the audio quality will be at its best if the loudest component of the signal drives the meter to the point marked "0 dB" and/or "100% modulation." Too much signal will cause distortion; too little will permit other noise to be mixed in with the signal. Keeping the needle at around zero decibels/100 percent modulation is not as difficult as it might seem, since the needle is damped and tends to float, finding an average level.

The sole purpose of the console you'll use in radio news production is to put audio sources over the air and control their levels. Once you

realize that, the console becomes less mysterious; as you experiment a bit and learn the basic principles, you'll find that *all* consoles operate in the same way. You'll be able to learn a new board in an afternoon, regardless of how different it may appear from the one you are used to.

For example, many modern boards don't use the familiar circular pot. Instead, they use vertical sliders, which are sometimes still called pots. But irrespective of the configuration, the function is the same.

Reel-to-Reel Tape Decks Reel-to-reel audio equipment is not often used by consumers nowadays, having been largely replaced by the audiocassette, but reel-to-reel tape still has many uses in broadcasting, especially broadcast journalism.

Figure 8.11 *The order and location of heads on a reel-to-reel tape recorder.*

Reel-to-reel tape decks are simple mechanisms. The tape, usually ¼-inch wide in standard broadcast applications, is transported from a supply reel to a takeup reel. The tape itself is made either of mylar, a strong and stretchy plastic, or of acetate, a base substance similar to standard office-style adhesive tape.

The mylar or acetate base is coated with iron oxide (rust), and the audio signal is impressed on the tape by a magnetic device that lines up the iron oxide particles in a particular pattern. This magnetic device is called a *head*. The record head produces the signal that arranges the particles, and the playback head senses the arrangement and converts the magnetically stored pattern back into audio.

Most reel-to-reel tape recorders have three heads: erase (E), record (R) and play (P) (Figure 8.11). The erase head scrambles the iron oxide particles and removes any previous signal. Record and play are self-explanatory.

We'll refer back to this arrangement in the upcoming section on editing.

Cartridge Machines The cartridge machine, usually known as a cart machine (Figure 8.12), plays back and sometimes records audio on an endless loop of tape. (Many cart machines are playback only.) The cart is loaded with a lubricated tape that slides out from the middle of the reel. The tape would play endlessly were it not for the addition of a "cue tone" that tells the cart machine when to stop.

As you start recording onto cart, the cart machine automatically places a cue tone *where you begin recording*. Here's an illustration. Let's assume you have the following actuality on cassette. You play it back through your studio audiocassette player and hear . . .

> Are we rolling? All right, in answer to your question, all I can tell you is that the police patrols in the Dorsey Heights section of the city are going to be doubled as of right now. Like I told you before, we aren't going to take any chances on gang violence breaking out again. We're hitting the streets and if we see kids in gang colors we're going to be on them like ants on a picnic basket.

For your newscast, you want to write up a brief story about this statement made by the police commissioner and use as actuality the section of the tape where the police commissioner says, ". . . police patrols in the Dorsey Heights section of the city are going to be doubled as of right now."

Figure 8.12 *To the far right, a bank of three cart machines in a news production and announcing studio. The carts are piled on top of the machine.*

To cart this actuality, you would use the following procedure:

1. Play back the reel-to-reel tape through the board and establish a proper average VU reading. There's a VU on the board and sometimes on the cart machine. It's important that they match.

2. Mentally note or jot down where you want the actuality to begin and end.

3. Press the record button on the cart machine. This will ready the cart machine to record, but the tape won't begin to move until you hit the start button. (Be sure that the cart machine is not up on the board when you intend to record or it will record and play back at the same time, causing feedback.)

4. Rewind the audiotape and play it back. You'll hear:

 Are we rolling? All right, in answer to your question, all I can tell you is that . . .

 Now, hit the start button on the cart machine.

 the police patrols in the Dorsey Heights section of the city are going to be doubled as of right now.

 Now, hit the stop button on the cart machine.

If you've timed it correctly, you'll catch that 5-second phrase on cart. Now, hit the start button again. Be sure *not* to hit the record button again. All you want to do is to let the cart play until it reaches the point where you start it. Many carts in the newsroom are 70 seconds long, so you'll have to wait 65 seconds for it to

recue, unless you have a fast-forward device on your cart machine.

When the cart machine recues—it does *not* rewind but plays forward until it stops—it will clunk to a stop right at the beginning of the 5-second piece of audio. The audio, the actuality, will be ready to fire instantaneously when you put the cart up on the board (turn on the key and bring up the pot).

You can now write copy to go with your tape. The intro on your news copy might read:

> Everyone at City Hall agrees that gang violence in Dorsey Heights is out of hand, and measures taken so far haven't helped. But Police Commissioner Charles McCorkindale thinks more cops on the beat will help.

Then, the actuality:

> The police patrols in the Dorsey Heights section of the city are going to be doubled as of right now.

And you'll close with your tag, which should reidentify the speaker.

> Commissioner McCorkindale says the stepped-up patrols will be on the lookout for anyone wearing gang colors. And when police spot kids wearing those colors, McCorkindale says they'll be all over them like, in his words, ants on a picnic basket.

When you read the story over the air, you'll fire the cart by pressing the start button an instant before you want McCorkindale's voice to appear. Cart machines come up to speed almost instantly as long as the cart is locked into place. In some stations, an engineer or the staff announcer will play your carts, in which case you'll cue him or her when to fire the cart.

The way we've written this story is not the only way, or even the best way, to construct it, but it does illustrate one method of using the cart machine in radio news. Another method of handling the actuality will be examined later in this chapter.

Special Equipment for Radio Newsgathering

The equipment and devices we've discussed so far are used by almost everyone at the radio station who produces on-air material. But there are a few specialized tools useful primarily to the newsperson.

REMOTE TRANSMITTING DEVICES

Most news vehicles have a two-way FM radio that can be used to file reports back to the station. However, this transmittal system is limited because the tape recorder usually isn't wired into the two-way radio. Under duress, some reporters simply play back the tape and hold the mic next to the speaker. You *can* produce a voice-actuality wrap this way, but the sound quality will be poor.

The same holds true for transmitting back over the telephone. Reporters sometimes create their own live wraps simply by reading or ad-libbing the script, quickly holding the telephone mouthpiece in front of the speaker of the portable cassette player as they start the cued tape, and then talking into the mouthpiece again to finish the wrap. Again, this produces sound quality that is marginal.

A better option, if you have time, is to feed the voice and actuality separately and have a newsperson back at the station edit the story together. This way, you won't have to fumble back and forth between phone and tape.

New technology has enabled radio news reporters to feed their actuality and their voice reports (and the combination of the two) back to

the station conveniently and with good sound fidelity.

FEEDING ACTUALITY AND VOICE

Let's first talk about feeding actuality and voice over a standard telephone line. You need a hookup to feed the output of your tape recorder into the phone. (You might also want to feed your own voice through the tape recorder. While it is less complicated to talk directly into the phone mouthpiece, your mic will produce better audio that, even after being degraded by the relatively poor transmission qualities of the phone line, will still sound better than a straight narration into the phone.)

Feeding tape over the phone used to be a simple matter. On older phones, you could just unscrew the mouthpiece and remove the telephone's microphone, which was about the size and shape of a 50-cent piece. A pair of alligator clips and a wire terminating in a mini-phone jack could be used to connect your tape recorder's output to the terminals against which the removable microphone rested.

But today, public phones using that arrangement are about as rare as a 50-cent piece. That's mainly due to the fact that people tended to steal the microphones. Where there were banks of pay phones lined up outside of rooms where major events took place, such as court rooms, some reporters would unscrew the mouthpiece and pocket the microphone to make sure that they would have access to a phone that everyone else passed by because it didn't work.

Manufacturers of audio equipment have come up with some alternatives for the modern telephone. One such alternative is a more sophisticated way of holding the phone to the speaker. It's called an acoustic coupler, a device that connects to the telephone mouthpiece, amplifies the output of the tape recorder's speaker, and also allows you to speak into the telephone

before and after the actuality.[3] The Shure Model 50AC coupler works in this manner, and produces good results for a reasonable price.

Other devices use electronic fields to feed over the phone. Some loop around the mouthpiece; some screw over it; there are pluses and minuses to each.

The problem with a standard phone line is that it does not provide a wide range of frequencies: It chops off the low and high components of the sound. Sound is a combination of waves, and the highs and lows—those frequencies that cannot be carried on a telephone line—provide the character and timbre that make a sound complete. As of this writing, some manufacturers were developing devices to digitally modify the signals so that a decoder back at the station could reconstruct them with a wider frequency range, and certain devices used several phone lines at once to transmit a wider range of frequencies.[4]

But regardless of the equipment to enhance the signal, when reporting by telephone you have an obvious limit: You have to be near a phone. New technologies are changing that situation, and those technologies are improving even as you read this chapter.

The two-way radio, as mentioned, is a traditionally handy way to feed material back to the station, but anyone who's ever worked a two-way knows that they have a propensity to drop off or "chop" when their signal is blocked. (FM two-way radio travels on a line of sight.) This makes transmission, especially from a moving vehicle, an iffy prospect.

[3]For further details see Chuck Crouse, "Reporting for Radio," *Communicator* (June 1990): 21. Crouse's column is one of the best sources of late-breaking news and information about the technology and techniques of radio newsgathering and production.
[4]Crouse, "Reporting for Radio."

Portable FM units cut the newsperson's tie to the vehicle, and many stations use a trade-named device called a Marti to transmit a very good-quality signal. But expense and certain limitations of the signal still cause problems for many news operations.

However, the cellular telephone is changing the complexion of remote radio newsgathering and reporting. A cellular telephone derives its name from transmission "cells" that pick up the signal and move it to the next best available cell (a geographic region) and so on until it reaches its destination.

Cellular telephones can produce quality that rivals traditional FM two-way transmission at a much lower cost. Also, cellular phones are continually shrinking in size, already thrashing FM two-way in the portability race.

In addition, since cellular telephones link with other cells and to standard land-lines, distance is not generally a problem. You can call from New York to California with a cellular phone almost as easily as with a desk-top model, so reporters don't have the nagging worry about driving out of two-way FM range.

Cellular service isn't perfect, though. It is still subject to "chop" in moving vehicles, and in some parts of the country cellular frequencies are quite busy. You may want to file a story in a hurry and find—just like when you want to call home on Christmas—that "all circuits are busy."

But the cellular network holds great promise for radio. Resourceful radio station engineers have developed several methods of integrating the reporter's tape recorder with the cellular phone, meaning that actualities and even wraps can be filed from anywhere there is a cellular phone network in place.

I hesitate to prescribe any rules or techniques for use of cellular technology for newsgathering because the field is changing so rapidly that such advice is doomed to be outdated from the moment it is set into print. But do keep current with your engineering staff and, if at all feasible,

encourage them (and news management) to investigate the remarkable possibilities generated by this new technology.

The development of such technology is a boon to what ABC Information Network News Director Rob Sunde calls "one of the greatest things that radio newspeople can do . . . stand in the middle of something and describe what's going on . . . and bring the listener into that scene of action."[5]

Techniques of Radio News Production and Editing

Now that we've discussed the tools and some of their basic uses, let's briefly examine some of the techniques you'll use in producing radio news. Up to this point, we've learned: (1) how to produce a decent-quality voicer or actuality, and how you can use the cart machine to extract an actuality from a tape you've recorded in the field; and (2) how to feed what you record back to the station if you don't have time to physically return the tape.

Now, we'll explore what you'll do if *you* are the one responsible for putting the pieces together in the studio. This section deals with: *splicing, dubbing, electronic editing on the cart machine* and *on-air coordination with the board operator.*

SPLICING

There will be times when you want to physically cut and paste a reel-to-reel tape together—such as when you need to repair a broken tape or cut out a very short segment of the tape, an

[5] Quoted by Chuck Crouse, "Reporting for Radio," *Communicator* (November 1990): 38.

Figure 8.13 *A typical reel-to-reel tape recorder. The grease pencil is pointing toward the editing block, which has a channel where you will insert and cut the tape.*

exacting process difficult to accomplish by dubbing. This is accomplished by marking—using a china marker or grease pencil—the beginning of the piece of tape you want to cut out, marking the end of the piece, and then performing the surgery with a single-edged razor blade and an editing block (Figure 8.13).

The grooved channel of the editing block has lips that hold the tape in place. You draw the razor blade through the 45-degree angled groove to smoothly and cleanly make the cuts. The vertical groove is for extremely tight edits; it is not used except under dire circumstances because a vertical cut often causes a popping noise, while the diagonal slice produces a less-detectable edit.

Before showing the mechanics of the editing procedure, let's offer an example of why it might be done. Remember the interview with the police commissioner?

Are we rolling? All right, in answer to your question, all I can tell you is that the police patrols in

the Dorsey Heights section of the city are going to be doubled as of right now. Like I told you before, we aren't going to take any chances on gang violence breaking out again. We're hitting the streets and if we see kids in gang colors we're going to be on them like ants on a picnic basket.

Suppose you wanted to use one long actuality in your piece. Would you run the actuality as is? No. You certainly don't want to start with "Are we rolling?" Eliminating that phrase is no problem, because you could wait until after the word *rolling* to begin carting the piece. But there is one other statement in this actuality you could do without: "Like I told you before." The audience has no idea what McCorkindale told you before, so these five words are best removed.

Let's assume that you have recorded this interview off the telephone directly onto reel-to-reel (I'll explain the reasoning for that assumption in a moment). You've got the segment cued up, and have china marker, razor blade and splicing tape in hand. Here's what you'd do.

Figure 8.14 The dot, indicating the point at which you want to cut, has been positioned in the channel in line with the slanting razor-blade guide. You'll insert the razor blade into the diagonal groove and slice the tape.

1. Play the tape until you reach the end of "as of right now." Rock the reels back and forth until you find the beginning of the word *like* in the sentence "like I told you before." This is not as precise an action as it might seem. Tape typically runs at 7½ inches per second, and if the commissioner took a break between the two phrases, you have plenty of tape to play with. Rock the reels until you find the midpoint between "now" and "like."

2. Using your china marker, place a dot on the tape where it rests on the play head (Figure 8.14). Be very careful not to get any marker on the head itself.

3. You can make the cut now, or make the next mark and then make two cuts. It's probably easier to make the second mark before cutting. Keep playing the tape until "like I told you before" is finished, and find the midpoint between the words *before* and *we*. Mark that spot. Now, place the tape in the channel of the editing block, lining up the dot with the 45-degree groove. Make the cut precisely over the second mark (Figure 8.15). You can now pull the tape off the takeup reel until you return to the first mark.

4. Repeat the cutting procedure. Don't throw away the three seconds' worth of tape (about 22½ inches) because if you have made a mistake, you may want to do some repair work later.

5. Now, line up both ends in the channel of the editing block (Figure 8.16). Slide them together until they butt up (don't overlap them), and connect them with a piece of adhesive splicing tape. Use a piece of splicing

Figure 8.15 *Here's how you actually make the cut . . . slide the blade smoothly through the diagonal groove.*

Figure 8.16 *After you join the two ends and tape them together with splicing tape, the finished product should look like this.*

tape ½ to ¾ of an inch long. Press it over the cut and burnish it with your fingernail. Make sure it is completely pressed onto the tape, or the splice may come apart.

Now, you have removed the "like I told you before," and can proceed to cart the cut.

DUBBING

We assumed that this was taped over the phone directly onto reel-to-reel because if the tape were originally recorded onto cassette a possible problem with multiple dubs would have been raised. To "dub" is to copy from one source to another. You can't make too many dubs before sound quality deteriorates. It is like making a photocopy of a photocopy of a photocopy. If we had dubbed the cassette to reel-to-reel tape for editing, a common practice, and then dubbed it onto cart for airplay, that may be one generation of dubs too many.

Some equipment can handle this many dubs easily; in fact, dubbing from cassette to reel-to-reel for editing and then dubbing to cart would be standard operating procedure in many newsrooms. But if the tape quality were marginal to begin with, making three generations of tape might make the audio quality unacceptable.

An alternative would be to dub the material on one reel-to-reel machine, eliminating the unwanted section during the copying process, and playing back the reel-to-reel over the air. That's not very commonly done; it's being described here for the sake of illustration.

Aside from the generation issue, dubbing is often a more convenient way of editing than splicing is. Rather than cutting out the offending section, you could put the original tape on Reel-to-Reel A and copy it to Reel-to-Reel B. When you reach the part you want to edit out, you stop both machines, advance Reel-to-Reel A past the unneeded five words, *leave Reel-to-Reel B where it is* and continue the copy.

This doesn't always produce as clean an edit as cutting and splicing, but it's quicker and eliminates the possibility of ruining your original tape through clumsy cutting. If the dub doesn't work, you can simply try it again.

ELECTRONIC EDITING ON THE CART MACHINE

Some cart machines allow you to disable the cue tone, meaning you can dub directly onto cart.

Every time you start to record on a cart machine you add a cue tone. That's all right if, for example, you want to put six 10-second station identifications on one cart because you want the cart to stop every 10 seconds. But having more than one cue tone is not convenient if you want to edit the police commissioner's statement.

However, some cart machines allow you to stop the cue tone. On one common model, this is done by removing the cover and unplugging the green wire. *Ask permission before you do this, and rearm the cue tone before you leave.* Using this technique, you can record in standard fashion the opening of the cut, but . . .

1. Stop the cart as soon as you hear the word *now.*

2. Start the cart machine again, with the cue tone disabled, right before the word *we.* (You'll have to stop the reel-to-reel while you disable the cart machine, but just back the reel-to-reel up a few seconds and put it in play, waiting—with the cart machine in "record"—for the word *we.*)

FINAL NOTES ON CART MACHINES

Cart machines make a journalist's job much easier, except on the occasions where you foul up the cart. Here are some suggestions on handling carts in news operations.

First, label every cart. Put a time, incue and

outcue on each one. Remember, you may be handling dozens of carts during the day. For example, if your station produces a newscast using national audio, you might cart 15 cuts from one UPI audio feed alone; add this to the local material carted and you've got big trouble brewing if you don't have a precise, *readable* label on each one.

Most news announce booths (or newsrooms, if that's where you read the newscast) have their own cart machines, but sometimes you'll have someone else playing back your carts. In this case, it is imperative that each cart be labeled clearly. Don't just hand the operator a stack of carts in the order to be played. Suppose he or she drops them? Or forgets if the cart in the machine was just inserted or was just played? Having the speaker's name on the cart will help the operator figure out where things stand.

Another tip is to always recue your carts. An unpleasant situation unfolds when you say, "Mary Smith was at the meeting . . .", hit the cart and hear *nothing*. Cautious newswriting can help you work around this problem, but no matter how well you cover for a miscued cart, listeners can usually tell something went wrong. Sometimes you'll have no choice but to pull an un-recued cart out of the machine because you need the machine for another cart immediately—but put the cart where you'll remember to recue it later.

Carts don't erase themselves. You have to do it manually. You use what's called a bulk eraser, which is a large electromagnet. To "bulk" a cart, wipe the bulk eraser across one side, flip the cart over and wipe the other side, and then wipe the bulker across the head area of the cart. Then pull the cart slowly away from the bulk eraser. If you yank it away, or just shut the bulker off, you'll cause the magnetic field to collapse suddenly, which will produce a distracting sound on the tape. (Remove your wristwatch before bulking a tape because the magnetic field can damage it.)

Bulk carts before you record on them, or else you'll get double audio. (Why don't carts have an erase head? Because they would erase the cue tone, obviating the rationale for having a cart in the first place.)

You'll have to cue the operator if you're not playing back your carts. The cue to play a cart is to point your finger, usually with a sharp downward motion of the hand. In order to keep the playback tight, start your cue as you say the last word before going to cart.

When you label a cart, you will occasionally encounter a double outcue—the words specified as an outcue are said twice on the cart. If you don't give some indication of this, you and other newspeople will step on the actuality. If your actuality is:

> Tom could never go through that again. A mistrial would be just as bad as a guilty verdict, because it will kill him to go through that again.

label it like this:

> Outcue: DOUBLE OUTCUE: "That again"
> SECOND TIME

SUMMARY

1. A radio journalist communicates with equipment; the tapes, consoles and editing equipment are used to write a story.

2. Production equipment looks more complex than it is. Attempt to learn the basics, because even though equipment differs, the fundamental operating principles do not.

3. Audio is the electrical signal that represents sound. It is transduced from sound into electricity by the microphone.

4. The workhorse of radio news is the audiocassette recorder.

5. Buy good-quality cassettes, but don't use the 90-minute variety. Keep a generous supply with you when out on assignment. Likewise, keep an extra pack of batteries.

6. Even a fine audiocassette recorder will sound terrible if you use a cheap mic. Use the best mic available. Professional mics, especially those most popular among journalists, provide good-quality sound and are very sturdy.

7. Mics used in broadcast news have three types of elements: moving coil, ribbon and condenser. The moving coil is by far the sturdiest and is much preferred for fieldwork.

8. The pickup patterns commonly found in mics are omnidirectional, cardioid and bidirectional.

9. The audio console turns audio sources on and off and regulates their volume. It allows you to mix sounds.

10. The device that turns the audio up or down is called a potentiometer, or pot.

11. Reel-to-reel tape decks are common in broadcast newsrooms because they facilitate editing.

12. There are several devices to allow you to connect your tape recorder to the phone. The increasing versatility of the cellular phone in newsgathering is one of the most exciting developments in radio news.

13. Splicing is one form of editing. It involves cutting the tape, removing unwanted tape and joining the ends with an adhesive splicing tape.

14. Dubbing accomplishes much the same thing. You can dub from one source to another and not copy parts that you do not want. The problem with dubbing is that you add a generation each time you dub.

15. But you must do some dubbing because it is very difficult to cue up audiocassettes for easy playback during a newscast. The relevant actualities are generally dubbed to cart.

16. A radio journalist will use many carts in the preparation and presentation of a newscast. Therefore, it is important to label carts correctly and make sure they are recued.

EXERCISES

1. Record the following on reel-to-reel tape.

 Seven . . . one . . . three . . . nine . . . ten . . . two . . . eight . . . four . . . six . . . five.

 Read slowly and allow a generous pause between numbers. Now, using your editing equipment, cut and splice the tape together so that the numbers are in their proper order. Your goal is not only to order the numbers properly but to provide an even break between numbers; the final outcome should sound natural.

2. Record the actuality of the police commissioner yourself. Put the actuality on cart exactly as described in the text (page 150). Then, make a voice-actuality wrap using the script provided in the chapter.

3. Monitor the morning newscasts of three different stations in your area. It would be best if you could monitor the three newscasts on the same day and, if possible, during the same hour. If you have logistical problems—say, if two stations do their local news at 8 a.m.—you can use a portable cassette unit to record one while you listen to the other.

 Which stations had actuality from the same newsmakers, and were there any substantial differences in the way they used it? Also, did you notice any differences in the stations' general philosophy about actuality? Does one station appear to like a great deal of it? Does one station use actuality all gathered by phone? Does one station use long actualities while another uses short pieces?

 In a brief paper, document these differences and speculate as to the reasons for each station's use of the particular day's actualities and its use of actuality in general.

9

TELEVISION
NEWS
PRODUCTION

Television news is produced differently—and taught differently—at virtually every media outlet and communications program in the nation. That's why this chapter will offer general guidelines rather than a prescription of "this is how it's done." We'll examine the principles that apply to virtually every station or department. Once you develop an understanding of the fundamentals, picking up the details will be relatively simple.

With that in mind, let's look at the basics of the *TV studio news production, electronic newsgathering* and *news editing.*

The Studio

A course in TV production is beyond the scope of this book, but you may have taken such a course already or be planning to take one in the future. If not, there are several excellent reference books available that will lead you through the details of TV production; they are listed in the Suggested Readings at the end of this book.

LAYOUT OF A NEWS SET AND STUDIO

In popular usage, the TV studio (Figure 9.1) is where the programming originates, the room where performers speak to cameras. But that's not the only area involved in production. From the studio, the signals from the cameras and microphones are fed to the control room (Figure 9.2).

The director is in charge of the control room. He or she determines which camera shot will go over the air and which tape will run at a specified time. Depending on size and complexity of the operation, a number of other crewpeople populate the control room, too. They include:

Figure 9.1 The CBS newsroom is part working newsroom and part set. Here you see the view from the balcony level, where many producers' and editors' offices are located.

Figure 9.2 The control room where the CBS evening newscast is literally put together. The director calls the shots, choosing from among the many different audio and video sources, and specifies what will go on the air, and when.

Figure 9.3 *Studio operations don't have to be large-scale. Here's an audio console for a small studio located at New York University. The newscast is sent out over cable to various destinations at NYU.*

- *The assistant director.* The AD generally helps with the details of news production, such as keeping track of how long a tape is running so that he or she can prepare the director to cue the anchor to resume speaking.

- *The technical director.* The TD operates the console, pushing the buttons that place the camera shot or the tape on-air.

- *The audio director.* This crewperson is in charge of placing mics before the program and running an audio console, which is a device to mix audio sources and control their levels. The audio director makes sure that the audio levels remain fairly constant, an action known as riding gain, throughout the newscast (Figure 9.3).

There are sometimes dozens of other crewpeople with whom you'll interact during the process of studio-based news production. They include specialists who operate videotape machines, lighting directors, camera people, the floor director and engineers.

We're currently discussing *studio*-based production, a loose term referring to news production not done in the field. Because the studio is the center of newscast production, we'll discuss the topic further in the following chapter.

To review, the studio is the location of the on-air performers, the cameras and the microphones. The control room is where the director and other members of the production staff choose which camera shots or tape replays go over the air.

One person we did not mention is the *producer*, a news executive who often inhabits the control room during the newscast. The producer may or may not take an active role in the newscast production. Sometimes he or she simply watches and waits, standing by to handle any emergencies that might arise. In other cases, the producer is a hands-on crewmember,

actively shuffling script pages, reading the stop-watch and changing newscast content to keep up with breaking events.

CAMERAS AND PROMPTING DEVICES

The prompting device displays the audio portion of the script, a narrow column written on the right-hand side of the paper. Some television stations now use computer-generated prompting devices, rather than the older style, which projects an image from the script as the script is dragged on a conveyor belt beneath a camera that points straight down at the belt.

There are three main points concerning cameras and prompting devices that are helpful to newscasters and producers working in the studio.

First, newscasters frequently have trouble reading at a pace that consistently matches the roll (the vertical motion of the script) on the prompter. The operator of the prompter can help eliminate this by realizing that he or she should follow the newscaster, and not vice versa.

The newscaster can help the prompter operator produce the proper roll rate by reading at a steady pace. If you are a newscaster, or plan to be, try consistently reading the copy that appears as the third line down on the prompter screen. This will give adequate cushion above and below. And if you tell the prompter operator that you are following this strategy, he or she can adjust the roll rate accordingly. We'll review prompting devices and their relationship to news announcing in Chapter 11.

Second, directors must be particularly careful to "match shots" during studio-based news programming. Matching shots means keeping the relative visual size of the newscasters, and their position on-camera, the same. It is disconcerting to the viewer to see one anchor pictured from the waist up while the next shot cuts to an anchor whose head fills the entire screen.

Third, tally lights should be in operation during a newscast. The tally light is the red light on top of the camera that indicates when that camera is on the air. Tallies are often disabled when there are amateur performers on the set (say, during a public affairs interview program) because a person not used to television can become excessively preoccupied with which camera is on the air. But newscasters need to know which camera is on-air because they will be speaking directly to it. (Guests on interview programs aren't supposed to look at the camera, which is why those lights are turned off.)

However, the most important factor is not whether the tally lights are on or not: it's the strategy involved in finding the on-air camera when the newscaster has tally indicators, knows which camera is on-air, but finds himself or herself speaking to the wrong camera. Directors and newscasters should work out—in advance of the newscast—an answer to this question: If the newscaster finds that he or she is reading to the wrong camera, does the *newscaster* take responsibility for finding the on-air camera, or does the director switch to the camera into which the newscaster is speaking?

Answering this question ahead of time saves everyone involved from the visual Ping-Pong in which the newscaster reads to the wrong camera, notices the mistake because the tally light is not on, and switches his or her gaze to the other camera—just in time for the director to change back to the original camera, meaning that the newscaster is *still* looking in the wrong direction.

WORKING WITH THE STUDIO CREW

One of the most important people in the studio is the floor director, the crewperson who is the link between the director in the control room and the talent in the studio. The floor director handles any emergencies that crop up on the set, cues the anchor when to begin speaking,

and uses hand signals to instruct the newscaster to speed up, slow down or adjust for a technical problem (for instance, the expected tape isn't going to play).

Hand signals used to be fairly standardized, but now they have become highly idiosyncratic to particular operations. The only standard signals that you can count on being recognized everywhere are the pointed finger—meaning "you're on!"—and time signals given with the fingers (five fingers for 5 seconds). Floor directors will also point to the appropriate camera when cuing an announcer.

However, the studio crew may be an endangered species in newscast production. Robot cameras controlled by computers programmed by the director are replacing camera operators in some large operations. Robot cameras allow a newscaster to work in a virtually empty room (an eerie feeling to those used to working with a full crew).

ENG and EFP

ENG is an acronym for electronic newsgathering. EFP refers to electronic field production. There's no exact differentiation between the terms because the meanings of the acronyms themselves aren't universally consistent.

EFP is generally used to refer to non-news production done outside the studio, such as production of commercials or magazine shows. Sometimes, EFP means production done entirely on location, with editing equipment as well as cameras on site; the program, in its completed form, is produced in the field.

But this is more and more the way news is produced, too. ENG used to mean gathering sound bites (interviews) and cover video that would be edited back at the station. Today, it is increasingly common for major news organizations to send a truck equipped with editing gear and a satellite device to the site of the news event and produce a completed tape that is fed back to the station. News crews can also pack up their editing gear in boxes and locate an ad-hoc studio wherever they please.

For example, when a network wants to cover events in Damascus, they load their gear, ship it and reassemble it in a Damascus hotel room. (The full complement of editing gear and cameras can fit in ten to 15 heavy-duty crates.) This practice, known as parachute journalism, is becoming more popular as the size of equipment decreases and its durability improves. It's now possible to have a fully equipped studio in place in a matter of hours anywhere in the world.

TOOLS OF ENG AND EFP

Bearing in mind that ENG and EFP are overlapping terminologies, we will use ENG as the term to refer to field-based news operations.

There's little mystery attached to the tools of ENG, since they are becoming startlingly similar to the type of equipment available at a department store.

An ENG setup includes a portable camera, a microphone, a videocassette recorder and sometimes lighting instruments. We won't explore the technical details too heavily because equipment described may quickly become outdated, and because you will be working with what is available to you.

The Camera ENG cameras are either held on the shoulder or mounted on a tripod (Figure 9.4). ENG cameras have a zoom control and an adjustment called a white balance, which allows you to set the camera to properly perceive the color your eyes would judge to be white. After the camera knows what white looks like, it can reproduce other colors accurately. This is particularly important for proper reproduction of flesh tones.

Figure 9.4 *Although it's not easy to carry, a tripod is an enormous help if you are going to be taping a long shoot. The same can be said for lighting instruments. Even in broad daylight they are useful for highlighting shots.*

White balance is a frequently misunderstood concept. A camera must be white balanced—told what white looks like—because the imaging device of a camera is a poor substitute for your eye. Your eye can compensate for the hue of the prevailing light and adjust accordingly. Flesh tones will look like flesh tones to you under almost any lighting condition. But the camera's "eye" cannot make this compensation. Even a slight change in hue throws its entire color scheme into disarray.

When we discuss the hue of prevailing light, we are referring to the *color temperature*. Devices that produce light do so by heating an element that, when heated, gives off a certain color of light. If you were to heat a fireplace poker, it would eventually give off its own light, a reddish light—which is exactly the meaning of "red hot."

If you continued to raise the temperature of the poker, it would glow white, or "white hot." If you had access to a device to superheat the poker (to its melting point), the iron would give off a bluish glow.

The same phenomenon occurs with standard lighting elements, and with the sun. A normal household bulb, which heats tungsten, produces light that emanates at a very low color temperature, thus producing a reddish light. A fluorescent bulb produces a light of a very high color temperature, a bluish light. The sun produces a high color temperature light, too.

We're talking about the color temperature produced by the lighting element, not necessarily the thermal temperature of the bulb itself. An incandescent household bulb may feel hotter than a fluorescent bulb to the touch, but that is not the same phenomenon as the electromag-

netic radiation of light related to the color temperature produced by the heated element of the lighting unit.

If you shoot indoors with a camera set for outdoor light, almost everything, including flesh tones, will adopt a reddish hue. Alternately, if you shoot outdoors with a camera set for indoor light, your pictures will assume a bluish hue.

The real question is How is the camera *set* for indoor or outdoor light? On nearly all cameras there is a control, usually a button, marked "white balance." To white balance the camera, focus on a white object, such as a piece of paper (making sure it fills the frame), and press the white balance button. The camera will then adjust itself to the prevailing color temperatures.

You must repeat the white balance procedure every time you change location. By eye, you cannot perceive small differences in color temperature—but the camera can see the difference.

One final tip about setting white balance: Since the most critical area (from the standpoint of color balance) of news video photography is the location of the news reporter's face, hold the white balance card at face level when setting the control.

Microphones For grab-it-on-the-run news coverage, the shotgun mic, either held with a fishpole or attached to the camera, is the mic of choice.

Reporters doing standups or covering situations like press conferences generally elect to use hand-held mics. By placing the mic on the lectern, you can achieve superior sound quality and—a self-serving benefit—get your mic flag and station logo into the scene.

Interview segments caught spontaneously are often done with a hand-held mic, too, but many producers elect to use lavalieres if there is any preparation time available. If you are planning to interview the mayor in her office, two lavalieres represent a much better choice than a hand-held mic. You can engage in rapid-fire question and answer without losing any audio, and the back-and-forth motion of a hand-held mic won't distract the viewer (or the mayor). As mentioned in the previous chapter, reporters are with increasing frequency relying on lavalieres for their standups.

Videocassette Recorders The VCR is often slung from the shoulder, although there is an increasing tendency for the VCR and camera to be combined into one unit called a camcorder. The emergence of the camcorder indicates an inevitable trend for the future of TV news, and many industry observers predict that the separate camera and VCR will someday be obsolete.

That is not entirely good news to videographers and producers because video equipment does break down, and when your camcorder isn't working you are without a camera *and* a VCR. Also, miniaturization of the equipment makes it more difficult to repair.

Currently, there's no consensus on a standard camera, camcorder or videotape format. Television stations across the country are experimenting with new designs and attempting to determine the best videotape recording format for their particular needs.

There are four main categories of VCRs and videocassettes.

1. High-end units using ½-inch cassettes that record on extremely high-quality tape, often metal-particle tape. Sony Beta tape and Panasonic M-II tape machines are popular for ENG. Tapes such as Beta cassettes are small, a consideration not only in the designer's ability to reduce the size of the camera but also in the station's ability to store an extensive library of tapes.

2. Broadcast-quality ¾-inch cassette units. The ¾-inch cassette has been the workhorse for TV news for more than two decades now,

Figure 9.5 While not yet common in broadcast work, 8mm video may become a viable medium in the future. It produces a surprisingly good picture, considering the small size of the camera.

and since there are many ¾-inch (refers to the width of the tape inside the cassette) units in operation and extensive ¾-inch editing systems at almost every television and cable station, this venerable format will have an extended lifetime, even if other methods prove technically superior.

In addition, practical news directors are quick to note that a ¾-inch cassette costs about half as much as high-end ½-inch.

3. Super VHS. This system uses the same electronics as home camcorders and VCRs, although the signal quality is better than home units. The tape, usually called S-VHS, is superior in quality to the tape you buy at the store, but the units will work with consumer-grade tape in a pinch. This is a true convenience if you run out of tape on a shoot.

4. High-end 8mm. 8mm (which refers to the width of the tape inside the cassette) is find-

ing its way into the professional TV cameraperson's arsenal. The 8mm units are extremely small but produce an amazingly good picture. Some consumer units produce signals that are high quality, too. The unit shown in Figure 9.5 shows just how small the camcorder has become. Some maintain that the quality of such units does not produce an air-worthy tape, but I have compared shots produced with the unit pictured in Figure 9.5 with footage from a well-used professional ¾-inch camera and recorder and found them to be indistinguishable.

Also, note that many smaller stations are coming to rely on consumer-grade gear, in the hands of local stringers, for footage of events that the station does not have the staff to cover.

The fact that video gear is in the hands of many amateurs and hobbyists also means that more news is being recorded by non-

professionals. For example, the buckling of the Bay Bridge during the 1989 San Francisco earthquake was recorded on a consumer camcorder, as was the incident involving the beating of Rodney King by Los Angeles police in 1991.

The problem with this format confusion is just that: confusion. The tape itself is typically not ready for air until you edit it, and the editing equipment for the various formats are nearly always incompatible. You must either wait until the appropriate editing system is free or dub (copy) your tape to the format in which you have available editing decks, meaning that your eventual air tape will be a copy of a copy, and picture quality will suffer.[1]

Lighting Instruments Often, a catch-as-catch-can news shot will be with natural lighting or, if the scene is dark, with a light attached to the camera, on a portable battery-powered light separate from the camera.

A camera light does not produce the highest-quality picture, since it is coming from precisely the same direction as the camera lens and will not "mold" the features of the subject. In ideal studio conditions, performers are lighted with a spotlight from one side of the camera, about 30 degrees off the axis of the line between camera and performer; in addition, the harsh shadows are filled in with a floodlight shining from the opposite 30-degree angle. A back light, coming from the rear and aimed at the top of the performer's head, separates him or her from the background.

Obviously, this is impractical in most ENG situations. If lighting other than the camera light is used, it will often be a single instrument

Figure 9.6 A lighting umbrella can turn a hard light into a soft light. Point the lighting instrument into the umbrella and use the soft, diffused reflection.

designed to produce a soft light that illuminates and fills in shadows. An umbrella attached to a focusable lighting instrument (Figure 9.6) is a good compromise, because the lighting instrument itself can be used as a spotlight without the umbrella (should you need a hard, focused light) or as a soft light if aimed into the umbrella and diffused when reflected backward. You can also shine the lighting instrument at a reflective wall to create a soft fill light.

One last word about color temperature. Lighting instruments are set to burn at what we have arbitrarily defined as standard indoor lighting temperature. That temperature is 3,200 degrees

[1]See Rob Puglisi, "Video Format Wars," *Communicator* (June 1989): 26, 27.

Kelvin. Outdoor lighting instruments burn at 5,600 degrees Kelvin.

These are arbitrary standards, designed so that cameras and lighting instruments can be calibrated to identical standards, so that they recognize the same temperature of light as white.

If you are shooting in an office illuminated by a large window and use an indoor lighting instrument, you'll be mixing color temperatures. The outdoor light will be bluish; the indoor light—supplied by your instrument—will be reddish. This is usually not a problem unless the light comes from opposite directions (in which case you may have a face in your picture that is half blue and half red). Modern cameras are quite capable of handling a mixture of two color temperatures.

But if you do have a problem, you can use a blue gel (a gelatinelike filter) over the indoor-temperature lamp to help smooth the color mixture. Also, you can use a Halogen-Metal-Iodine (HMI) lamp, which produces an outdoor temperature light. The drawbacks to HMI lights are that they are expensive, they require a separate power unit, and they sometimes create a noticeable hum.

Under some conditions, you might want to use HMI lights outdoors. Using lighting instruments in bright daylight is sometimes necessary because intense sun can cause harsh shadows that need to be filled with a light from another angle. A more realistic solution is to use a reflector made of crumpled aluminum foil over a sheet of cardboard. But most ENG operations do not require highly sophisticated lighting procedures.

EXECUTION OF ENG

You now understand enough about cameras and lights to pick up the specifics of your particular equipment. Let's examine what you'll be *doing* with this hardware: gathering the sound bites, standups and cover video that comprise the stories we've described in the previous chapters.

We've gone through the mechanics of the video story and script; now it will be productive to examine camera-operation hints that will be useful for the camera operator, producer or reporter.

First, always keep an audio channel open. This point bears repeating. Wild sound adds to the impact of a story, and if you are running the camera without a mic open and something newsworthy and unexpected happens, you're out of luck. Remember, even if you are shooting cover footage, the audio can be removed back at the editing suite merely by adjusting one control on the console.

Another vital suggestion is to slate your shots. Always announce or visually indicate the take number and whatever other identifying information might be needed at the beginning of the take. For example, you might say, "shot of administration building, take one," or "interview with John Roberts, take three." That way you'll be able to identify the shot. If you have many details that need to be incorporated—such as time of day, take number and other information—you can write them on a piece of paper and videotape that paper. Just be sure you indicate the tape number visually if you don't do it aurally.

In addition, write down the tape location of your shots if at all possible. Use the counter number on the VCR to keep a record of where the shot is located. Don't forget to write a number on the cassette and record that information as well. If you are lucky enough to use equipment that generates a time code, you'll have a much more accurate indication of shot location than if you have a mechanical counter.

A time code is usually called SMPTE (Society of Motion Picture and Television Engineers) Code. SMPTE time code labels each part of the tape with the hour, minute and second it was recorded; this information is visible only on a special edit deck equipped to read the time code.

If you keep an accurate "spot sheet," you'll instantly be able to find the cut you need. An

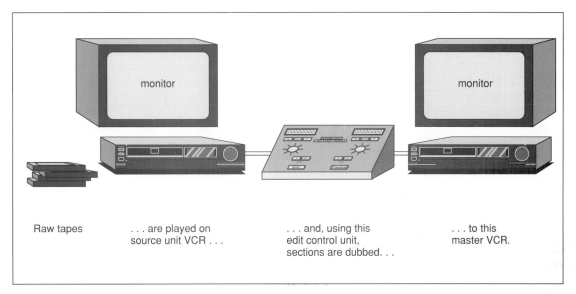

Raw tapes . . . are played on . . . and, using this . . . to this
 source unit VCR . . . edit control unit, master VCR.
 sections are dubbed. . .

Figure 9.14 A simple editing system: tapes, source VCR, edit control unit and master VCR.

Figure 9.15 A video editor in a modern editing suite.

very good at their jobs and can cut and recut tapes under severe deadlines. (*Cut* is a figure of speech left over from film days, when the film actually was cut; videotape is not cut and spliced in the editing process.) Note, however, that in smaller stations you will probably edit your own tape, so this is an important skill to learn.

Editing equipment also allows for the inclusion of new audio (such as a voice over recorded on audio cartridge) and new video (such as cover video from the station's library).

The master tape needs a continuous "control track" in order to perform most editing functions. A control track is a series of electronic pulses that act like sprocket holes in film: They keep the tape running at a constant rate. If you don't have a control track, the VCR will lose "lockup" and the picture will break up momentarily. To lay down a control track, you can record as much black (broadcast "black" is a black signal generated by the system) as you think you will need onto the master tape.

The term *master tape* denotes the tape onto which the final product is edited, although this usage is not universal. Find out what the local terms are in your area and facility.

The editing control unit allows you to set the exact location where the copying process will begin and end. It rolls the tapes backward before making the edit (to ensure that both tapes are up to speed and moving at precisely the same speed) and performs the copy automatically. It even allows you to preview the edit before making the dub.

Now it's easier to understand what "shooting for the edit" means. Simply put, shooting for the edit is a process whereby you produce shots that will be optimally usable in the editing process.

If you have a 5-minute segment of the governor being interviewed by a reporter, and shoot *only* the 5 minutes of the governor, you're going to have problems back at the editing suite. In a typical newscast, you cannot use all 5 minutes,

nor would you want to. But how could you join two 15-second segments together without producing a jump cut—an effect where the governor suddenly appears to move an inch or two—at the edit point?

One solution is to shoot for the edit by taking a reverse shot, say, a shot of the reporter nodding or taking notes. Now, you can do a video-only edit, an effect easily achieved by the edit control unit, to cover the jump cut.

Some reporters will re-ask the question in a reverse shot. This practice raises some ethical considerations, since reporters may change the tone of their questions to appear to pry information out of an interviewee when that information was originally offered willingly. Having casually observed current news practices, I think that reverse questions are falling into disfavor because they can change the reality of the situation pictured.

Some news organizations elect simply to use the jump cut (softened with an electronic dissolve), while others tape the question-and-answer session with two cameras, editing the real questions and the real answers together back at the editing suite.

But the point is that you must never return to the studio with footage that cannot be edited properly. Although jump cuts are acceptable under certain circumstances, they are usually awkward. Shoot plenty of cover video. Make sure you have enough cover video, and the *right type* of cover video, to cover your narration.

If you have questions about the technicalities of editing, see the box on pages 182–187.

ROLE OF THE FIELD PRODUCER

To conclude this brief discussion of ENG, note that in many large news organizations there is an additional player other than the camera operator and the reporter. A staffer known as a *field producer* is often employed to collect the initial facts and lay out the basic guidelines of the

story. The field producer may arrive before the reporter or correspondent, set up initial interviews, perhaps conduct some of the interviews and gather facts relevant to the story. The reporter or correspondent will do the on-air work (usually the interviews and always the standup) and will often write the final version of the story as well.

Techniques of News Editing and Production

You've gotten your shots. You've taken your notes. What's next?

SHOOTING THE STANDUP

Before you leave the scene, you will want to shoot a standup report. While some packages begin with a standup and some have a bridge in the middle, most packages end with a standup.

It's an oddity of television news that you are often forced by the very nature of the medium to write the conclusion to your story before you know what the conclusion is, but there really is no way around it. The best strategy is to say something of substance but not something that is likely to date the story or something that is idiotically banal. (Any report that ends with a statement such as, "We don't know what will happen, but when it does it will, and only time will tell" falls into that latter category.)

ORGANIZATION OF RAW MATERIAL

The next step in the process involves nothing more exciting than riding back to the station— but this is where a great deal of work is done. You can review the tape and start writing your script in your notebook (assuming that you're not driving).

It's inconvenient to view a videotape during a car ride, which is often why reporters carry a small audiocassette recorder. You can hold the audio recorder in the same hand as your mic (unless there is a station or union restriction against a reporter operating an audiotape recorder) and record the same sound bites as on the videotape. You can use the audiotape to review the interview segments you want to incorporate into the package.

When you arrive back at the station, you will want to view the tapes to find the best pictures. What constitutes the "best picture"? Reporter Dave Dent, who produced the piece about the apartment house fire in Chapter 7, says the best pictures "are the ones that tell it all. The man with the tear in his eye, that told it all. It showed you that he was a victim."[2]

Dent thinks it's critical to view and discuss shots with your editor (assuming that you work in a station where you do not operate the editing gear yourself). Editors, he contends, are more than button-pushers. They frequently have a keen eye for finding the shots that work and the shot that will be best suited for the edit.

Now, let's pursue the editing process step by step. We'll discuss it in general terms, but note that this is the same strategy Dent used in preparing his story.

1. Once you have selected the shots, including the sound bites and standups (if you have one or more standup segments), write your narration. The narration will include the location of SOTs (sound bites) and will also include the voice-over narration.

2. Record your narration. Remember, by this point you have (in a typical package) identified two or three sound bites you want to use, plus the standup close or bridge you want to include. The narration must tie them

[2]Interview, Nov. 11, 1990.

together. *Don't write narration if you don't have video to cover it.* Record the narration on cartridge and give the cartridge to the tape editor. (Note that in small stations, *you* may be the tape editor as well as the reporter.)

3. The editor will then lay down the sound bites and the narration in the order you have specified in your script. He or she will leave black video where your narration is laid down.

4. Next, you and the editor will lay down the cover video over the narration. This is where you must match shots carefully. The editor (the person) and the edit control unit (the machine) have the capability of mixing the relative volumes of your narration and the wild sound on the tape in any proportions you deem fit. *That's why it is so important to leave a mic open during shooting of cover video.* If your cover video (the video over your narration) includes the sound of flames roaring and fire engines screaming, so much the better. There are two audio channels on a videotape. The editor usually lays down narration on one channel and wild audio on another, and balancing the two to proper levels is easy.

5. Finally, review the piece to ensure that it makes sense. It is very easy to leave an essential piece out of a video story because you are not writing it in a linear fashion, as you would with a newspaper article. That is, you are mixing and matching and recording items out of their original order. That leaves much more opportunity for a hole in the story to go unnoticed.

Also, review the story to see if a better piece of video might be used as cover. Chances are, your station will have an extensive library; perhaps a piece of file footage would better illustrate the particular line of narration. If the narration reads, "Ten years ago, this area was home to a dozen stores," you just might find some ten-year-old footage in your station archives.

6. Graphics may or may not be added during the editing process. Sometimes the graphics, such as superimposition of the reporter's name and station logo and supers identifying other people pictured on the tape, are added as the tape runs during the newscast.

In many stations, your final package or voice over will be cued up on tape and the tape placed in a video cart machine. The function of a video cart machine is similar to that of an audio cart unit, in that the piece can be fired by the push of a button. Now, you'll write up the introduction to your package and the producer will schedule it for airplay in the newscast.

EDITING BASICS

The physical process of editing can be confusing, especially to those without a background in television production. If you are going to be manipulating the editing equipment itself and don't have extensive familiarity at the controls, the material in this box may help.

Let's start by restating that editing is simply copying segments of one tape to another. There are several components on the tape, and they vary according to the tape format.

The variations are not particularly important as long as you grasp the concept that audio, video and control track (which will be defined in a moment) are on different parts of the tape. Figure 9.16 shows where the "tracks" of information are placed on one type of ¾-inch tape.

sync pulses—
control track

video

audio 1
audio 2

Figure 9.16 *The signals laid down on a typical video tape. Sync pulses are at the top, video is in the middle and audio tracks are at the bottom. Not all tape lays out its recording components this way, but all tape formats do have specific areas where audio, video and control track are placed. This is what allows the edit control unit to choose some or all of the signal to transfer from the source tape to the record tape.*

The control track is a series of electronic pulses that keeps the tape moving at a steady speed, much like the sprocket holes in motion picture film. There are 30 control track pulses per second; each marks the beginning of a new *frame* of information.

A frame is a complete picture, and it is composed from two *fields*. To briefly illustrate the meaning of frames and fields, consider the fact that the television picture is made up of a series of lines and dots, with the entire picture consisting of 525 horizontal lines. An election gun at the back of the picture tube "sprays" the odd lines first (one field) and the even lines next (the second field). The beam scans across the inside of the picture tube 60 times per second, and lights tiny dots of color as it goes along; when all these dots are viewed from a distance, they produce a picture. If you don't believe that the television picture is really a series of colored dots laid out along a series of horizontal lines, grab a powerful magnifying glass and take a close look at your TV picture.

Why bother scanning the odd lines first and the even lines second? Because if the picture were created by scanning all 525 lines in order, we would begin to see the top of the picture fade out before the new picture was created. That is why American television uses the odd-and-even 60 fields (a field is a scan of the odd or even lines) per second, which add up to 30

frames per second (a frame is a complete picture consisting of both the odd and even fields.)

The exact corollary of this process occurs when the picture is photographed by the video-camera. The image is focused through the lens and electronically scanned onto the receiving plate of the camera pickup element in fields and frames. The output of the camera is then fed, via various mechanisms, to the TV screen.

What does this have to do with editing? Understanding how the frames are constructed gives you a better idea of what you'll see when you look at an editing control unit. In most cases, you will see a readout in hours, minutes, seconds and frames. You will set the edit points to the exact frames where you want the edit to start and to stop.

Some machines perform edits by marking parts of the source unit tape according to the control track. Others use the SMPTE (Society of Motion Picture and Television Engineers) time code, a readout of hours, minutes, seconds and frames encoded onto the tape. Some VCRs place the time code on an unused video track, but most modern units cleverly embed the time code information into the video signal. (You won't see the time code signal on a television screen unless the monitor has been specially set up to detect it.)

One advantage of time code is that it is a constant on the tape. The time code is permanently

emblazoned on the shot and won't change. When the editing system counts only control track sync pulses, it starts counting from whatever point you arbitrarily choose as zero and as the start of the tape. As a result, when using a time code system, you will rewind the tapes to the beginning and reset the counters to zero.

Irrespective of whether your edit control unit operates by sensing the time pulses on the control track or reading the SMPTE time code, the process of editing is the same. You'll generally be doing what's called off-line editing, meaning editing done with cuts only and no dissolves. Dissolves, gradual replacement of one picture with another, require a much more sophisticated system (an "on-line" system), which is not typically used in editing local news segments.

There are two basic types of editing methods: *insert editing* and *assemble editing*. Assemble editing copies everything from the source tape—control track, video track and both audio tracks—onto the record unit or "master" tape.

Insert editing places audio and/or video onto an existing tape, but without disturbing the existing control track. The only hitch is that you must already have a control track on tape before you can insert edit. The problems with assemble editing are threefold:

1. You need to join control tracks together. Most machines can handle this, but occasionally you'll encounter a glitch when the machines do not exactly match up the sync pulses.

2. Since a complete break in control track—in other words, a space of several seconds with no control track—causes the picture to break up entirely, you must lay down control track in sequence in order for the machine to accurately produce a smooth edit. This is generally all right if you have three complete segments you know you want joined together in order, although you may still encounter a snag when control tracks are matched. But

you cannot lay down the beginning, then the end and then the middle—which is what you will often want to do in the editing process.

3. With assemble editing, you cannot choose to dub audio only or video only. It's all or nothing.

Insert editing involves copying some or all of the components (video, audio 1, audio 2 or all three) from the source tape to the record unit tape. You can also do this copying in any order you wish.

Why? Because in insert editing, the control track has already been laid down on the record unit tape. You do not have to worry about tape breakup, and the insert edit mode lets you take what you want—*except for control track*—and copy it from tape to tape.

The only real disadvantage of the insert edit mode is that you must lay down a control track on the record unit tape first. However, generally editors (the people) lay down a black signal on several tapes that are kept in reserve for editing. That obviates the problem of having to lay down the control track before doing the editing.

Now, you must pick and choose what you want to copy from the source unit tape onto the record unit tape. The aesthetics of editing together different pictures and sounds have been explained in the text, so here we will concentrate on the mechanics.

Although editing control units vary greatly, you will usually confront a control panel that looks something like the one illustrated in the diagram in Figure 9.17.

There's nothing too mysterious about the controls. The knobs jog the tape back and forth; you can see and hear the speeded-up image. The farther clockwise, the faster the forward speed. The farther counterclockwise, the faster the reverse speed.

Controls for marking in and out points are

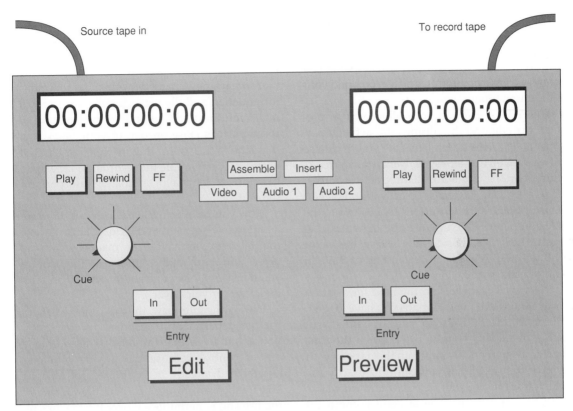

Figure 9.17 *You won't ever see an edit record unit that looks exactly like this, because the controls have been diagrammed only for the sake of explanation. But this illustration does picture the basic elements in off-line edit control units: counters, play, fast-forward and rewind controls; a shuttle knob; controls for choosing insert or assemble editing (very often there is only one control and the machine defaults to one mode unless you use the control to instruct it otherwise); buttons for marking the in and out exit points; and buttons to preview and perform the edit.*

duplicated on each side. The left side governs the source unit tape, while the right side governs the record unit tape. There is usually an edit mode selection control, allowing you to choose assemble or insert. You will do most editing in the insert mode on tape on which black (control track) has already been established.

When you want to copy over the beginning and end of a reporter's standup opening, you play through the source unit tape until you come across the take you want. Mark the begin-

ning by pushing the *in* button on the entry controls for the source unit. (Most reporters lead in their on-camera segments by saying something like, "This is take one of the City Hall standup, rolling in five, four, three, two, [pause], The mayor continues to drop bombshells on the City Council . . ."

The [pause] is just that, a pause in place of saying "one," done so the word *one* does not wind up on the air. It is at this pause that you set the in point. When you reach the closing remarks

of the standup, the point at which you would like to make a transition to the next scene, you strike the *out* key on the source unit side control. The edit control unit now knows precisely what you want to copy from unit to unit as you build your record unit tape.

The edit execute buttons allow you to preview the edit and, by hitting edit, actually perform it. Those buttons also allow you to choose what part of the tape you want transferred—video, audio 1, audio 2 or all three of the sources. (There are other controls typically found on edit control units, such as buttons that return to the last edit point, which we are not illustrating because they vary considerably and at this point will not add to your understanding of the edit control unit.)

Now, you want to find the next segment on your source unit tape. Perhaps you have logged, "Tape 2, mayor says 15 percent budget cut across the board," and written down the time or frame numbers. By cuing up that tape in your source unit machine, you can find exactly the cut you want. Set your *in* points and *out* points on your source unit. The *in* point is the point where the mayor begins saying the cut you want to use. The *out* point is where she concludes the relevant portion of the remark.

But don't forget, you must cue up your record unit tape, too. You want to cue up the record unit tape to the end of the reporter's introduction, so that the introduction will lead right into the mayor's remarks. So check to see that the record unit tape—which now holds the reporter's intro—is cued up to the correct spot (the end of the intro) and the source unit tape is cued up to the correct spot (the beginning of the mayor's remarks).

What you've done is to set two *in* points and one *out* point. You can set the *out* point on either machine, but since you are viewing the tape on the source unit it makes sense to set the *out* point on the source unit. When you make the edit, the edit control unit will back the machines up a predetermined amount, usually 5

seconds' worth of tape, and then "pre-roll" them, so that both tapes come up to exactly the same speed and the control tracks match precisely.

You have now made two edits: the reporter's introduction and the mayor's remarks. You will make your next edit by finding the best take of the reporter's close on one of your tapes; put that tape in the source unit machine and set the *in* and *out* points. Cue the record unit tape up to the close of the mayor's remarks, and perform the edit.

Now you have a simple package—a standup, an interview segment and a close. Let's assume that all the edits have been made by copying video and both audio channels. (Sometimes you'll just copy over one audio channel and use the other for voice over.)

During the interview, the mayor talked about the fire department in response to your question about a fire that fire officials allege raged out of control because the fire department's budget had already been slashed too deeply. You might want to dig up some file footage of the fire and superimpose it over the mayor's remarks. She might have said, "I don't want to do this, but I'm forced to under state law. You remember that last week we had a fire where we had trouble finding enough fire equipment . . . it was a disaster. We're going to see more like that if I have to continue to cut budgets. And I *have* to cut budgets unless Proposition 13 is changed."

How would you do this? By making a *video-only edit*. Punch the button that says "video" and not either audio button. (You have to be in the insert mode to perform this task.) Since most of these controls are on-off toggles, you would punch the audio buttons to turn them off. Generally, their internal lights go out to indicate that they are off.

Now, mark the *in* and *out* points of the *video* that you want to cover the mayor's audio, and perform the edit. Here's a case where you would probably want to mark the *out* point on the

Mayor's on-camera image.

Mayor's voice on audio.

Copy *video only* of fire over mayor.
Mayor's audio stays intact.
This is a *video-only* edit.

Video of fire.

Figure 9.18 *Here we've created a fanciful diagram of what a video-only edit might look like, since we can't see the pictures on the tape. But if we could, the process of transferring just the video from the bottom tape to the top tape—while keeping the mayor's audio intact—would look like this.*

record unit machine, just to make sure that you are not adding on too much video and covering up the major's final remarks.

If you could see the structure of the tape, it would now look like Figure 9.18.

We haven't covered every nuance of editing, but aside from the features particular to your hardware and best explained by your instructor, the above-described process of choosing the edit mode, shuttling the tape, marking the *in* and *out* points, and previewing and performing the edit is basically the same among all units.

THE BASIC PACKAGE STRUCTURE

A package generally consists of an arresting opening, often with natural sound of something happening, such as police cars screaming to the scene of an accident, several SOTs (sound-on-tape interviews), occasionally an appearance by the on-camera reporter in the middle of the story and a standup close by the reporter. There are several portions of narration over which cover video is laid.

If we were to chart a story prepared along the lines of the preceding description, the package might be structured like this:

1. An opening scene with natural sound.

2. Narration voiced over cover video. The cover video might be a continuation of the opening scene. (Describing cover video as something that covers a voice over seems verbally illogical but that is the way the terms have evolved.)

3. A change of scene with natural sound, leading to the next narration.

4. Brief narration that leads into a SOT interview (a sound bite).

5. The first interview segment.

6. Narration over cover video, with an occasional piece of cover video shown without narration, just with natural sound.

7. The narration leads into the next interview segment.

8. Interview segment 2.

9. Narration that advances the story, relating interview segment 2 with interview segment 3.

10. Interview segment 3.

11. Narration that continues to move the story forward to another interview segment. Interview segment 4 will reinforce the basic idea of the piece while showing another angle of the story.

12. Interview segment 4.

13. A standup bridge. A bridge is a reporter's on-camera appearance in the middle of the segment. It is generally used only when location or time is changed and the reporter's appearance is necessary to help make that clear. Let's assume that the reporter, off-camera, had been talking about a training center but now wanted to shift location, discussing a neighborhood down the street (change in location).

14. Narration over cover video of the new scene.

15. For variety, an interview segment of a person previously introduced over some cover video relating to what he's talking about.

16. Reporter's narration again, beginning to wrap up the story.

17. A quick SOT from one of the people interviewed. He offers a concluding remark.

18. A quick SOT from another person interviewed. The pace is increasing, the remarks are of a concluding nature and it becomes apparent that the piece is about to wrap up.

19. A concluding statement by the narrator and the narrator's standard outcue: name, news organization, location.

That is a total of 19 separate elements in a news package that will run 3 minutes and 18 seconds—a long story by broadcast news standards.

There are probably a few more cuts in this story than most, and there also is a standup bridge, a somewhat unusual technique. Finally, there is a segment in which the voice of a newsmaker is used as voice over for cover video. That can be very effective.

If you can understand the logic of the above structure, you're prepared to tackle any package construction. The logic is this:

The story opened with a compelling visual, made a clear statement of theme and then used examples—in the form of SOT interviews—to document the case. Since the scene of the story had to be moved, the reporter made an on-camera bridge. To illustrate the connection between what the next interviewee was saying and the reality of

the story, the interviewee's voice was used as voice over for the related video. Some quick interview segments served notice that the piece was coming to a close, and then the reporter signed off.

Does it seem clearer now? If not, read through the actual piece. This report (Figure 9.19) was produced by Carl Ginsburg, producer for "The CBS Evening News with Dan Rather," and written and narrated by correspondent Bob Faw.

The beauty of studying this report as a model—aside from the fact that it's a good piece of journalism—is that it incorporates most of the structures you'll use in package production. You will at first produce smaller reports using fewer of the illustrated techniques, but you'll find a usable example of most of the common strategies in the piece presented in Figure 9.19.

LIVE REMOTES

Finally, a concluding note about an increasingly popular form of television: the live report from a remote site. The satellite news vehicle (Figure 9.20) makes live reporting easy. Some would argue that it makes live reporting *too* easy, since there is a temptation to hype events—to exaggerate their importance—just because they can be captured live.

Irrespective of this debate, the advent of the SNV has forced many reporters to polish their ad-libbing skills, a topic covered at some length in Chapter 11. From a production standpoint, the important point to remember is that any live report poses a potential logistical nightmare for the crew on the scene. When things go wrong

Figure 9.19 While script formats vary, here's the way it's done at CBS. (Courtesy CBS News.)

```
MILWAUKEE'S SMALL HOPE

FAW/GINSBURG/MIKLAUS

EVE NEWS

NAT SOUND--- DEMOLITION

NARR: AS AMERICA'S RUST BUCKET CRUMBLES . . . NEIGHBORHOODS

GUTTED, JOBS MOVED AWAY AND PEOPLE FORGOTTEN. . . A PROGRAM IN ONE

SMALL BUILDING NO ONE WANTED ON MILWAUKEE'S SOUTH SIDE, IS NOT ONLY

HELPING SALVAGE A POOR COMMUNITY. . . IT'S ALSO SERVING AS A MODEL

FOR THE REST OF THE COUNTRY.

NAT SOUND--- REPAIR SHOP

NARR: ESPERANZA UNIDA IS A COMMUNITY ORGANIZATION WHICH PRODUCES

JOBS -- SKILLED JOBS -- AND, AS ITS SPANISH NAME SUGGESTS, HOPE.
```

continued

Figure 9.19
continued

SOT: (RICHARD OULAHAN, DIRECTOR, ESPERANZA UNIDA) ''YOU CAN PUT ANYBODY INTO A MINIMUM WAGE JOB. . . I'LL PUT EVERYBODY INTO MINIMUM WAGE JOBS TOMORROW, BUT THAT'S NOT WHAT WE'RE ABOUT: HOW DO YOU PUT HIM INTO A JOB THAT SUPPORTS HIS FAMILY. THAT'S WHAT WE'RE ABOUT.''

NARR: HERE, TRAINEES LIKE DUANE VANLOAN, LEARNING FRONT-END ALIGNMENT. . . OR STEVE DEAN WORKING ON BRAKES. . . REPAIR CARS IN THIS ONCE ABANDONED CAR DEALERSHIP. . . THE MONEY MADE FROM THE REPAIR WORK GOES TO HIRE OTHER TRAINEES.

NAT SOUND--- RICARDO, HAMMERING AWAY ON DOOR.

NARR: RICARDO RAMIREZ CAME TO MILWAUKEE. HE WAS UNEMPLOYED AND ON WELFARE. . . NOW HE'S IN LINE FOR A $30,000 A YEAR JOB WITH A CAR DEALER.

SOT: (OULAHAN) ''WE GET DISLOCATED WORKERS WHO WENT FROM $16 AN HOUR TO $6. . . WE GET PEOPLE WHO NEVER WORKED IN GENERATIONS. AND WE'RE SAYING: WE WANT TO MOVE THOSE PEOPLE INTO OUR ECONOMY BECAUSE IF THEY'RE NOT, WE'RE NOT GOING TO MAKE IT AS A COUNTRY.''

NARR: ESPERANZA UNIDA'S SUCCESS IS ITS FORMULA--- GOVERNMENT AND PRIVATE GRANTS, BUT MOSTLY THE MONEY IT MAKES. AND THAT MEANS COMPETING SUCCESSFULLY, FOR CUSTOMERS LIKE RAOUL MAYAN.

SOT: (RAOUL) ''GOOD LOCATION, GOOD PLACE, AND THEY DO A GOOD JOB. Q: AND THE PRICE? A: IT'S GOOD.''

NARR: AND IT'S NOT JUST RUNNING AN AUTO REPAIR SHOP. . . THE SHOP'S PROFITS ARE PLOUGHED INTO A WOODWORKING SHOP TO TRAIN CABINETMAKERS. . . AN AUTO BODY SHOP WHICH REBUILDS THEN SELLS DONATED JUNK HEAPS. . . AND A TRAINING PROGRAM WHICH TEACHES NEIGHBORHOOD MOTHERS HOW TO SET UP AND RUN DAY CARE CENTERS. . . ALL UNDER ONE ROOF.

SOT: (JEANETTE BARQUET, DAY CARE TRAINER) ''THIS IS ANOTHER WAY TO STAY HOME WITH THEIR KIDS, TAKE CARE OF THEIR KIDS, PLUS GET SOME INCOME FROM THE OUTSIDE.''

O/C: (BOB FAW) WHAT STARTED IN THE AUTO REPAIR SHOP DIDN'T END THERE. . . JUST DOWN THE STREET AND AROUND THE CORNER WERE ABANDONED HOMES. . . OPPORTUNITIES TO TRAIN NEW CARPENTERS AND HELP REBUILD THE COMMUNITY.

NARR: ESPERANZA UNIDA IS NOW TURNING DILAPIDATED EYESORES LIKE THIS. . . INTO HANDSOME DUPLEXES LIKE THIS. . . BY TEACHING AND TRAINING UNEMPLOYED RESIDENTS IN THE COMMUNITY.

SOT: (VOICE OF OULAHAN OVER WORKING IN HOUSE) ''WE REHAB HOUSES EVERYONE ELSE GIVES UP ON--- DEVELOPERS, THE CITY WAS READY TO TEAR THESE DOWN. WE SAY GIVE THEM TO US. WE'LL TRAIN PEOPLE, WE'LL RENOVATE, WE'LL GIVE THEM SKILLS, WE DO IT AND SELL THEM AT A PRICE PEOPLE CAN AFFORD. . . . THAT'S HOW YOU STABILIZE A NEIGHBORHOOD: GIVE A PERSON A JOB, AND A CHANCE AT A DECENT HOUSE, AND YOU'LL SEE SOCIAL PROBLEMS REDUCED. . .''

NARR: FRANK MARTINEZ -- WHO'S OVERSEEN EIGHT REHAB PROJECTS -- KNOWS WHAT A SHOT IN THE ARM THEY'VE BEEN IN RUNDOWN AREAS.

SOT: (MARTINEZ) ''AFTER I FINISHED THIS HOUSE, MORE THAN 90 PERCENT OF THE NEIGHBORS HERE, THEY FIXED THEIR HOUSES, TOO.''

SOT: (OULAHAN) ''IF WE EMPHASIZE OUR PEOPLE, AND THEIR STRENGTHS, THEN WE'LL GET OUT OF OUR PROBLEMS. OTHERWISE, WE'RE JUST MARKING TIME.''

NARR: HOUSES REHABBED BY ESPERANZA UNIDA COME WITH A 20-YEAR GUARANTEE. . . HERE THERE ARE NO GUARANTEES. . . ONLY AN OPPORTUNITY TO GET AHEAD. . . IN A COMMUNITY WHICH DIDN'T HAVE A CHANCE BEFORE. BOB FAW, CBS NEWS, MILWAUKEE.

Figure 9.20 A modern satellite news vehicle.

live, they go very wrong. So it's incumbent upon producers and reporters to get it right the first (and only) time.

What is supposed to happen is this: The reporter assigned to the story will produce, either in the field or at the station, a package covering the event. The package is fully protected for two reasons:

1. The reporter does not want to have the information in the package spoil before airtime.

2. The reporter wants to lead—*live*—with the latest information and lead into the package. Even though the live information may not be much newer than what's on tape, it's still *live* and gives immediacy to the entire 2-, 3- or 4-minute piece.

Sometimes, interviews are broadcast live, a tricky strategy best reserved for people you know to be responsible and responsive. The whole situation might be labeled "tricky" because, in most cases, the field reporter is listening, through an earpiece, to audio of both the program *and* the director's instructions.

As remote gear becomes more affordable and commonplace, TV news reporters and producers will find themselves confronted once more with the difficulties of going live, a skill much valued in the early days of broadcasting. Ironically, the advent of reliable and transportable audio- and videotape recording units may have eroded the skill that is currently in great demand.

SUMMARY

1. The techniques of producing television news differ from station to station and market to market, but the basics are the same. If you can master the basics, the details won't be a problem.

2. The studio is the physical location of the talent and the cameras; the control room is where the director chooses which shot or tape will go over the air.

3. A variety of crewpeople, including the assistant director, the technical director, the audio director and the lighting director, work in the control room.

4. The studio crew includes camerapeople, the floor director and the prompter operator. Crews may be shrinking in the next few years as robot-controlled cameras become more common.

5. ENG stands for electronic newsgathering and EFP stands for electronic field production. In many ways the acronyms are synonymous.

6. The basic tools of ENG are cameras, mics, VCRs and sometimes lighting equipment. At times, news is produced in the field; portable, lightweight editing equipment can be shipped virtually anywhere in a matter of hours or days; this has become known as parachute journalism.

7. A camera must be white balanced to compensate for the color temperature of ambient light. If not properly balanced, your camera could produce hues that are too reddish or too bluish.

8. There are several varieties of VCR formats. The industry is currently in a state of flux.

9. When shooting in the field, keep a mic open to record wild sound, slate your shots and keep a written record (a spot sheet) of your shots.

10. It's important to shoot for the edit. Don't leave yourself with no way to avoid a jump cut or no cover video to hide your other edits.

11. An editing system generally consists of a source deck and a master deck, with an editing control unit synchronizing the two.

12. If you're covering an event, shoot an adequate standup before you leave. On the way back to the station, you might start organizing your material and writing your script in your notebook. Then, with the help of your tape editor, you will choose your shots, write your narration and edit the whole package together.

13. The basic package usually consists of one or more SOT interviews, voice-over narration, cover video, a standup tag and sometimes other appearances by the reporter on-camera, maybe in a bridge or in the opening.

14. The live remote is an increasingly popular format. Typically, the live remote is a live introduction to a prerecorded package. The shot then returns to the live remote. It's a complex procedure because the reporter going live must keep track of the program and the director's commands at the same time.

EXERCISES

1. Record a package from an evening newscast on your home or department VCR and log the shots, as I have done in the numbered list in this chapter. Now, compare the structure with the structures of the packages your classmates or co-workers logged. How do the structures differ? What do you think is the logic behind the structure?

2. Take a newspaper article and distill it into a 2-minute package. You'll have to use your imagination for the wild sound and the scenes of action, but use quotes exactly as they are written and write your own narration. Utilize the format used by CBS. (You don't have to use the same sequence or numbers of interviews; by *format* I mean the method of writing down the text of the package.)

3. If you have access to the proper equipment, produce a package about a current event. Aim for this structure:

 a. A natural sound opening.
 b. Narration over natural sound, explaining the theme of the story.
 c. One sound bite from an interview.
 d. A standup tag.

 If you can arrange it, have crews from your group cover the *same* story. That way, you can compare news judgment and story execution.

CHAPTER

10

THE
NEWSCAST

This chapter deals with some of the ways in which a newscast is structured. Since the term *newscast* covers a lot of territory, we'll limit the discussion to the most immediate and broad-based principles, principles *that can be applied to almost any type of newscast.*

We'll examine *the structure of the radio newscast, the television newscast,* and *questions of flow and continuity* that apply to both media.

The Radio Newscast

Radio newscasts differ from their TV counterparts in that they are shorter and are repeated with greater regularity during the day. The practical outcome is that lead stories—indeed, *all stories*—are shuffled frequently. The lead story of the 7 a.m. news might not be the lead of the 7:30 newscast.

STORY ORDER

There's a tendency to change story order in radio so that listeners do not feel that they are hearing the same news repeated every half-hour. That is a legitimate reason for shuffling story order, as long as journalistic considerations are not ignored. Don't lead with an insignificant story and bury an important story deep in the lineup just for the sake of variety. If you need variety (and you will), it is better to extensively rewrite the important lead story, perhaps using different actualities, instead of engaging in a dubious story-shuffle.

Try to present stories in order of importance. *Importance* is a relative term, but as discussed back in Chapter 1, the more important stories are usually the ones with the greatest impact on the greatest numbers of audience members.

Stories also assume importance when they are timely or involve a subject with which the audience can readily identify.

Also, stories that are *live* or that have *compelling actuality* are better suited to be lead stories.

GROUPING STORIES

Stories within a radio or television newscast are often grouped by subject or theme. International stories, economic stories and crime stories flow more naturally within a newscast when they are delivered within the same blocks.

There are a couple of reasons why this is effective. First, the listeners' (or viewers') attention is kept focused on one general theme. Secondly, the newscaster can write or ad-lib logical transitions between thematically grouped stories (". . . another sign of bad economic times . . . the Consumer Price Index . . ."); such transitions smooth the flow and help keep the listener's attention on track. We'll deal with transitions later in this chapter.

Stories can also be grouped geographically. If you're reading a newscast containing national material, it makes sense to group the three West Coast stories together. Overseas stories fall into a natural cluster. Even in a local newscast, three stories from the same county can make an interesting grouping.

Stories also are grouped according to whether or not they have tape accompanying them. Several stories with tape are typically not placed back to back because this leaves a long block of "tell" stories. You will produce a more lively newscast if you spread the taped voice-actualities (wraps) and actualities throughout the newscast.

When stories are grouped in blocks separated by commercials, it's permissible, and in most cases advisable, to end each block with a lighter story, a "kicker." Kickers are generally humorous and involve a subject of human interest. However, don't use an exceptionally light kicker when you will be coming back (after the commercial) to a tragic story.

A kicker is appropriate at the end of the entire newscast, unless that newscast deals with a major disaster or tragedy. (If the president is shot or a space shuttle is lost, don't end with a kicker. That's a matter of good taste and common sense.)

INTEGRATING ACTUALITY

The radio newscaster has a tremendous advantage over his or her television counterparts because playing back interview segments and reports from other journalists is vastly less complicated in radio. A newscaster with a bank of cartridge machines (Figure 10.1) can handle a complex newscast single-handedly.

Some operations require, because of union restrictions, that an engineer play back the cartridges. In some radio stations, there aren't enough cart machines in the news booth so the staff announcer plays back the carts. If you are not playing your own carts, provide whomever is playing the carts with a clear rundown of your newscast and the order in which the carts are to be played. A simple rundown might look like this:

```
Garbage strike

Bronx homicide

    TAPE: LAWSON/BRONX SHOOT,

    :50 VO, SOQ

Subway breakdown

    TAPE: MELANDEZ, :12 A, ''another

    hour down there.''

NJ flooding

Continued flood warning for
```

Figure 10.1 *Newspeople often run their newscasts combo—that is, they insert and punch up their own carts.*

```
Westchester

    TAPE: MARTIN/WESTFLOOD,

    :44 V/A, SOQ

WX
```

This lineup tells the engineer you have three carts, each labeled with their respective slugs: LAWSON/BRONX SHOOT, MELANDEZ, and MARTIN/WESTFLOOD. The lineup also lets the engineer know in what order the stories *and* the carts are coming, the time of the carts and the outcues. If you surrender your carts to the engineer, *you'll* want a copy of the rundown because the carts labeled with the outcue will be out of your range of vision. Incidentally, WX is the common newsroom abbreviation for weather.

Although some radio newspeople use much more extensive lineups than the one illustrated above, others don't use lineups at all. Going without a lineup is all right for a veteran newscaster who is handling his or her own carts. That flexibility allows the newscaster to instantly change story order if breaking information changes the priority of the newscast.

But is a good idea to provide a lineup to an engineer running your carts so that he or she can reconstruct your story order if necessary.

LIVE REPORTS AND INTERVIEWS

Radio's forte is its ability to accommodate live material on a moment's notice. That is also radio's weakness, because live reporting must be

virtually perfect to be credible. Not being able to find the right button to bring up the voice of your live newscaster ("Charlie . . . Charlie . . . are you there?") sounds infinitely worse than no report at all.

Luckily, most radio news reporters become amazingly facile with their equipment, and also are able to do an enormous amount of planning during, let's say, a 30-second tape.

Here's an example: Suppose you are reading a newscast when a member of the department passes you a note:

> The verdict in the Villella kidnapping case is in, and Charlie's on the private line with a report.

If you are running your own console, you'll be able to put the phone line over the air with the flick of a lever or the push of a button. But you may want to talk with Charlie before going live.

That's why most newscasters like to keep a public service announcement (PSA) handy. A public service announcement is an announcement for a non-profit agency, such as a promotional spot for an upcoming community orchestra concert. PSAs can be played at will (it's tricky, for a number of reasons too complex to discuss here, to play commercials randomly) and are excellent provisions in an emergency.

Let's say you read the note and decide to go live with the report. Next, you'd grab a 30-second PSA, insert it in the cart machine as you talk, and say,

> This just in . . . a verdict is handed down in the Villella case. We'll have the story right after this.

Thirty seconds, by radio standards, is a lot of time. You can get on the phone with the reporter (off-air, of course), and plan the upcoming live report/interview. You *can* put Charlie directly on the air without that 30 seconds of planning,

but you had better be sure that Charlie *knows* he's going live as soon as he hears your voice. If not, the first words of the voicer might be, "Allison, this is Charlie. What the hell took you so long?"

Whenever you go to a live report without advance planning, be sure to cue the reporter on the other end of the phone that he or she is on the air.

> We're live on the air with Charlie Brooks, who's just heard the verdict in the Villella kidnapping case. Charlie—what did the jury say?

You probably have heard about 7-second delay systems in radio, but those systems are used for call-in programs involving the general public. News is delivered live, or at least recorded in its entirety for later replay. Because you won't have the luxury of a delay system for news, be careful about airing an interview with a non-professional. In exciting or heated situations, people sometimes say things not suitable for airplay.

The Television Newscast

With the possible exception of a symphony orchestra concert, a television newscast is one of the most remarkable exhibitions of human teamwork you're ever likely to see. The public has no idea of the complexity of the event—which is a sign that newscasts are generally done well.

Unlike radio, it is more difficult to wing a TV newscast. There are so many people involved that written documentation, including rundowns, copies of scripts and copies of individual stories, must be circulated to a wide variety of staffers.

THE RUNDOWN

Some elements are common to all newscasts, and among those elements is the rundown. This is a list of stories in the order in which they will play.

But let's back up a bit to determine how the rundown is constructed. We'll use a typical day at the CBS evening newscast headquarters as an example.

■ Staffers arrive between 8 and 10 o'clock in the morning and check through the major newspapers: *The New York Times,* the *Washington Post,* the *Wall Street Journal* and several local newspapers. The papers give producers an idea of what happened yesterday and help set an agenda for what will be covered today.

■ Some of the international news has come in overnight. Overnight in New York is daytime in Europe. Most of the international news will keep until the evening newscast because it is now nighttime in the Eastern Hemisphere. At about 9:30 a.m., the evening news' three senior producers hold a meeting to discuss the major international stories of the day and pick the ones they believe to be likely candidates for that evening's news program.

■ At 10:30, CBS's domestic bureaus call New York. The conference call from the domestic bureaus (CBS branch offices in cities such as Chicago, Los Angeles, Dallas, Atlanta, Washington and so forth) inform the show's producers of the major stories developing in their areas. This is a lobbying session since, as CBS evening newscast Producer Carl Ginsburg notes, "the name of the game here is to make air."[1]

[1] Interview, Nov. 27, 1990.

■ Events are covered, stories are written and packages are produced throughout the day. At 3 p.m., the initial lineup meeting is held. Senior producers and editors meet with Dan Rather and make preliminary choices about the content of that evening's show.

A preliminary lineup is entered into the network computer (Figure 10.2). The first column contains the time of the written copy that Dan Rather will read. The second column lists the "vtime," or time of the video inserts. Column 3 shows the origin of the video report. As you read down the sheet, you can see the progression of stories and the times allotted for the commercial inserts.

■ As airtime approaches, the atmosphere heats up considerably. Final versions of stories are being fed to New York. As late as an hour before airtime, editors are recutting stories that the senior producers want changed. (If you have had some experience in television editing, you cannot help but be impressed by the glacial calm of these editors as they go about completely recutting a tape moments before air.)

Throughout this process, the news value of stories continues to be evaluated, and the lineup changes again (Figure 10.3). You'll notice that the order of the leading stories— Senate hearings, action at the United Nations and a voice-over report read by Dan Rather that refers to Muhammad Ali's efforts to free American hostages—have remained intact.

Note, too, that the story we examined in Chapter 9, slugged FAW/RETRAINING, remains in the last spot of the lineup. Since it is a timeless feature story, there's a good chance it might get bumped for something more urgent.

■ At 6:04, the final lineup appears (Figure 10.4). It's printed on blue paper to distinguish it

```
lineup                        15:25:14                        display 1
the cbs evening news with dan rather                          11-27-90
          correspondent/story         copy   vtime   orig/city
--------------------------------------------------------------------------
aa        LEADER                      *0:00
bb        Headline                     0:20
cc        ANIMATION                   *0:00
1.        Good Evening                 0:10
2.        Hearing                      0:25
3.          SCHIEFFER/HEARINGS                2:00    WASH
4.        Uninations                   0:15
5.          PLANTE/UNINATIONS                 1:45    WASH
6.          MOHAMMED vo              0:25
7.          HOSTAGE SOT                       0:45    AMMAN
8.        Troops                       0:15
8a.       Vols                         0:20
9.          THRELKELD/VOLUNTEER ARMY          3:00    NY
10.       Tease: FENTON-PETERSEN vo    0:20
--------------------------------------------------------------------------
11.       1st cml                              1:35
--------------------------------------------------------------------------
12.       Major                        0:15
13.         FENTON/MAJOR                      1:45    LON
14.       Soviet                       0:20
15.         PETERSEN/SOVSHORTAGES             2:15    MOSCOW
16.         ISRAEL vo                  0:20            LON
16z.      Stay: BRAVER vo              0:10
--------------------------------------------------------------------------
17.       2nd cml                              1:50
--------------------------------------------------------------------------
18.         TORNADO vo                 0:25
18a.      Fatty                        0:25
19.         BRAVER/FATTY                      1:45    WASH
20.       Discrim                      0:25
20a.      Trade                        0:20
--------------------------------------------------------------------------
          STOX BUMPER
21.       3rd cml                              1:40
--------------------------------------------------------------------------
22.       Retrain                      0:20
23.         FAW/RETRAINING                    3:18    NY
24.       Goodnight                    0:15
--------------------------------------------------------------------------
25.       4th cml                              1:35
--------------------------------------------------------------------------
26.         CREDITS: FAW               0:20
27.         CTN: MORNING               0:15
--------------------------------------------------------------------------
                                     6:20 23:13
      lee's clock 00:06:20           cx+copy+vtr 00:29:33
          +00:00:38 OVER
```

Figure 10.2 *The first, tentative lineup of news stories. (Courtesy CBS News.)*

from the earlier versions. It's similar to the 3:25 and 5:33 lineups, although our feature story on Milwaukee's job retraining program has been replaced with a kicker about sea lions. (The retraining story reappeared at a later date.)

■ Airtime is anticlimactic. The staff knows their jobs so well—and planning has been so thorough—that any last-minute changes are handled as a matter of routine. For example, about 5 minutes into the program the director will decide that he needs an animated

```
lineup                        17:33:47                        display 1
the cbs evening news with dan rather                          11-27-90
        correspondent/story       copy  vtime   orig/city
-----------------------------------------------------------------------
aa      LEADER                    *0:00
bb      Headline                   0:20
cc        ANIMATION               *0:00
1.      Good Evening               0:10
2.      Hearing                    0:25
3.        SCHIEFFER/HEARINGS              2:00    WASH
4.      Uninations                 0:15
5.        PLANTE/UNINATIONS               1:45    WASH/LIVE SANDWICH
6.        MUHAMMAD vo              0:20            AMMAN
8.      Troops                     0:15
8a.     Vols                       0:20
9.        THRELKELD/VOLUNTEER ARMY        3:25    NY
10.     Tease: FENTON-PETERSEN vo  0:20           LONDON-MOSCOW
-----------------------------------------------------------------------
11.     1st cml:KEL/THERA/KMART*/SUN      1:35
-----------------------------------------------------------------------
12.     Major                      0:15
13.       FENTON/MAJOR                    1:45    LON
14.     Soviet                     0:20
15.       PETERSEN/SOVSHORTAGES           2:20    MOSCOW
16.       ISRAEL vo                0:20            LON
16z.    Stay: BRAVER vo            0:10            WASH
-----------------------------------------------------------------------
17.     2nd cml:OLDS/NABISCO*/NESTLE      1:50
-----------------------------------------------------------------------
18.       TORNADO vo               0:25            COLUMBIA
18a.    Fatty                      0:25
19.       BRAVER/FATTY                    1:45    WASH
20.     Discrim                    0:25
-----------------------------------------------------------------------
        STOX BUMPER
21.     3rd cml:MET/ROB/SALAD/RL-PET      1:40
-----------------------------------------------------------------------
20a.    Trade                      0:20
22.     Retrain                    0:20
23.       FAW/RETRAINING                  3:18    NY
24.     Goodnight                  0:15
-----------------------------------------------------------------------
25.     4th cml:SINE/KMART*/DAIRY/DP      1:35
-----------------------------------------------------------------------
26.       CREDITS: THRELKELD       0:20            NY
27.       CTN: MORNING             0:15
-----------------------------------------------------------------------
                                  6:15 22:58
      lee's clock 00:06:15        cx+copy+vtr 00:29:13
            +00:00:18 OVER
```

Figure 10.3 *A close-to-final version of the lineup for the CBS evening newscast. (Courtesy CBS News.)*

graphic of a tornado to insert in the box to the right of Dan Rather's head. "Get me a tornado," he says to the graphics director.

Done. No questions asked. The animated tornado graphic was up and swirling in about 6 minutes.

TIMING OF KEY ELEMENTS

When an enormous staff of top professionals puts together a newscast, it looks deceptively easy. Everything is timed to the second and each individual is an expert at his or her job.

```
lineup                    18:04:18                              display 1
the cbs evening news with dan rather                            11-27-90
        correspondent/story         copy  vtime   orig/city
---------------------------------------------------------------------------
aa      LEADER                      *0:00
bb      Headline                     0:20
cc      ANIMATION                   *0:00
1.      Good Evening                 0:10
2.      Hearing                      0:25
3.         SCHIEFFER/HEARINGS                2:00   WASH/LIVE SANDWICH
4.      Uninations                   0:15
5.         PLANTE/UNINATIONS                 1:45   WASH/LIVE SANDWICH
6.         MUHAMMAD vo               0:20          AMMAN
8.      Troops                      *0:15
8a.     Vols                         0:20
9.         THRELKELD/VOLUNTEER ARMY          3:25   NY
10.     Tease: BRAVER-BLACKSTN vo    0:20          LONDON-MOSCOW
---------------------------------------------------------------------------
11.     1st cml:KEL/THERA/KMART*/SUN          1:35
---------------------------------------------------------------------------
18.        TORNADO vo                0:25          COLUMBIA
30.     Keating                      0:20
31.        TAIRA/KEATING                     1:45   WASH
18a.    Fatty                        0:25
19.        BRAVER/FATTY                      1:45   WASH
20.     Discrim                      0:25
S16z.   Stay: PETERSEN vo            0:10          WASH
---------------------------------------------------------------------------
17.     2nd cml:OLDS/NABISCO*/NESTLE          1:50
---------------------------------------------------------------------------
12.     Major                        0:15
13.        FENTON/MAJOR                      1:45   LON
14.     Soviet                       0:20
15.        PETERSEN/SOVSHORTAGES             2:27   MOSCOW
16.     Israel                      *0:20
---------------------------------------------------------------------------
        STOX BUMPER
21.     3rd cml:MET/ROB/SALAD/RL-PET          1:40
---------------------------------------------------------------------------
20a.    Trade                       *0:20
22.     Retrain                      0:20
S23.       BLACKSTONE/SEALIONS               2:09   NY
24.     Goodnight                    0:15
---------------------------------------------------------------------------
25.     4th cml:SINE/KMART*/DAIRY/DP          1:35
---------------------------------------------------------------------------
26.        CREDITS: BLACKSTONE       0:20          NY
27.        CTN: MORNING              0:15
---------------------------------------------------------------------------
                                5:40 23:41
    lee's clock 00:05:40        cx+copy+vtr 00:29:21
           +00:00:26 OVER
```

Figure 10.4 *The final lineup for the CBS evening newscast. The final lineup is on blue tinted paper (shown here as gray) to avoid confusion with all the previous versions that have been printed on white paper. (Courtesy CBS News.)*

Most newscast producers do not have the resources to staff every position with a specialist and produce continually changing rundowns to reflect each change. *But irrespective of the complexity of the operation, the basic principles of newscast construction remain the same.*

For example, students at New York University produce a weekly newscast titled "The

Figure 10.5 Small news operations may not use rundowns, but it's still essential to ensure that everyone knows the story order before the program goes live. Here, a producer checks with on-air talent moments before airtime.

Washington Square News." The process they follow is strikingly similar to what happens at CBS.

"The Washington Square News" airs at 9 p.m., so the writing process begins in late afternoon. In addition to the "tell" stories, the news producer integrates a voice over, two taped packages and an interview segment into the newscast.

The show is done without a lineup. Instead, the physical order of the stories is shuffled as airtime approaches. This involves some risk, because there's always the possibility that someone will mix stories in a different order. That's why an assistant producer checks with anchors shortly before air (Figure 10.5) to ensure that everyone has the same stories in the same order, and that the anchors and the director know which story is assigned to which anchor.

At 9 p.m., it's airtime (Figure 10.6). As the show progresses, the assistant director keeps track of the *lead-in* time for the tape inserts and the *running time* of the tapes. The AD reminds

Figure 10.6 Airtime.

the director that the tape must roll 5 seconds before the anchor calls for it. The AD will also notify the director when there are 20, 10 and 5 seconds left before the end of the tape.

As his or her ultimate responsibility, the director must open and close the show *exactly* on time. Since "The Washington Square News" does not have a computer-controlled printout and timing system, the director and AD use a method known as backtiming. Backtiming is the process of locating that point in the script that is, let's say, exactly 2 minutes from the end of the anchor's sign-off. In other words, the director now knows where the anchors are *supposed* to be in the script. If they are ahead or behind, the director will instruct them (via the floor director) to speed up, slow down or add another kicker to fill in the time.

Newscast Aesthetics

What makes a newscast "work"? Aside from having no mistakes (or at least having the mistakes covered by alert producers and anchors), there are two factors frequently cited: immediacy and cohesiveness.

IMMEDIACY

No one wants to watch old news. As a result, there's a growing emphasis on live coverage. Thus, many local newscasts open with a live shot. The live shot is often preceded by a tease that captures the viewer's attention. And as a bonus, the interaction of the anchors and field reporter brings everyone involved into the present tense.

You don't need an earthshaking story to integrate a live report and a prerecorded package. Figure 10.7 shows how KSTP-TV (Minneapolis) reported the first day of sales for lottery tickets.

After the opening, "This is Eyewitness News, Live at Five," the segment teases the audience by cutting directly to a man on the street (MOS). And after the live remote, the newscast goes to taped segments, to live remote again and finally back to the anchors (Figure 10.8).

COHESIVENESS

Notice the importance of transitions in the newscast scripts in Figures 10.7 and 10.8. In fact, more stories about the lottery will follow. Since they've been set up by the live open, they flow naturally (see Figure 10.9).

Transitions help make the newscast more complete and ease organization of stories into blocks. A transition is nothing more than a line in a story that leads from one item into the next. For instance, you can tie two items together by using the "same time" approach:

> While riots continue along the West Bank, there's civil strife right here at home.

Or contrast:

> But there won't be much holiday spirit at the Emerson Street homeless shelter, where budget cutbacks . . .

Or a simple change of locale:

> Closer to home . . .

Time is useful:

> Two hours after the press conference, the major found himself embroiled in another controversy.

And finally, remember the word *finally:*

> Finally, a look at the outcome of today's . . .

Figure 10.7 Newscast opening tease—live remote.

CU (MOS)	Everybody's got the same amount of chance as everybody else walking along, I guess.
CU LOTTERY TICKET	Anchor (Mark, at studio): That same amount of chance starts tomorrow when Minnesotans get their pick of new lottery games.
ANCHOR (MARK)	Good afternoon to you. The stakes in the Minnesota lottery are about to go way up.
ANCHOR (WENDY)	They certainly are. Tomorrow Minnesota becomes part of Lotto America and the Pick Three Game also makes its debut here.
CU WENDY	The new games are being put on–line here today so that retailers can see how they work. Randy Meier joins us live from
''WINDOW'' OPENS BEHIND RANDY AND WENDY; REPORTER IS PICTURED ON SCENE	(Wendy continues voice over) one of the many local lottery ticket outlets, Super America. . . . Randy, sounds like good news for a lot of lottery players.
CU RANDY	It sure is, Wendy. You know, if you're a player, going for the big bucks is going to be a lot easier in Minnesota. Typically, thousands of people travel to Wisconsin for their Lotto America tickets. But beginning tomorrow, you can purchase your Lotto America tickets in places like this Super America on University Avenue. Just think . . . a little gas, and maybe several million dollars, all in one trip.

Figure 10.8 The newscast continues now with a taped segment. Then it integrates the live remote again with the conversation between the anchors and the reporter.

SIGNS BEING CHANGED	The old lottery game signs are coming down and the new more lucrative ones are going up. Minnesota as of tomorrow will officially be part of the multistate Lotto America.
CU SIGN	Just in time for an estimated 21 million dollar drawing for Wednesday.
CU SPOKESPERSON, NAME AND TITLE SUPERED	The industry research has shown that anytime a lottery jackpot goes over ten million dollars people who don't normally play the lottery plan a purchase of lottery tickets. So our retailers are very excited about joining the Lotto America network at this time.
SHOTS OF CLERK, SCREEN AND TERMINAL	Randy VO: Today was the day for retailers to get acquainted with the new Minnesota Lotto ticket terminals that employees will have to operate. Randy McGaver manages the Super America on University Avenue. He thinks he's got it all figured out.
CU MCGAVER	McGaver: It's not as complicated as you really think. There are just a lot of buttons you have to know how to punch at the proper time. Besides that it's OK. Randy off-camera: Do you think you'll have it all worked out? Well, I don't know . . . hopefully by tomorrow. But it looks pretty good.
EXTERIOR OF STORE	This Super America joins about 1,500 other retailers in the state that

	will sell Lotto America and Pick Three tickets.
CLERK TYPING	Being a part guarantees businesses a 5 percent return on their ticket sales, and a constant flow of customers—people like Dale Pince of Arden Hills.
CU PINCE	Randy off-camera: Are you going to play tomorrow?
	Pince: Sure, I might buy a few dollars' worth. In fact, I want to try and get paid right now.
BACK LIVE TO RANDY; CU RANDY	You know, Mark and Wendy, I thought they might give me the opportunity to buy the first 21 million dollar Lotto Minnesota ticket, but no go. Again, ticket sales start at 6 a.m. tomorrow, so if you're a player, get your tickets on the way to work.
BACK TO ANCHOR DESK, RANDY IN WINDOW	
ANCHOR (MARK)	No special privileges, buddy.
ANCHOR (WENDY)	Randy, I know the Minnesota lottery started back in April. Has it been pretty successful so far?
RANDY	You know, Wendy, as of this last weekend, state-sponsored lottery ticket sales topped 100 million dollars, and lottery officials consider that very, very good.
ANCHOR (MARK)	Well, good luck tomorrow, Randy.
ANCHOR (WENDY)	Thanks, Randy.

Figure 10.9
Transition.

```
CU ANCHOR (MARK);          So you've never bet a dime on any

''HOW TO PLAY'' GRAPHIC    lottery, but now you may gamble a buck or

                           two on the Minnesota lotto or the daily

                           Pick Three game. How do you play? Let me

                           show you how.
```

SUMMARY

1. The order of radio news stories is frequently shifted during a newscast. That is acceptable as long as you do not lead with a weak story.

2. If you have the option, rewrite legitimate lead stories rather than shuffling a weak story to a higher position.

3. In radio or TV news, you will often group stories by theme or by geography. You also want to ensure that you don't run all the tape stories in one batch and all the "tell" stories in another batch. Strive for variety.

4. You can usually use a kicker at the end of a block, before a commercial and almost always at the end of the newscast.

5. Although many radio newscasters do not use rundown sheets, such sheets are helpful if you must surrender your carts to an engineer or staff announcer for playback in another room.

6. A television newscast is considerably more complex than its radio counterpart, primarily because more people are involved. The rundowns for most newscasts change several times during the day as the news unfolds, and many people are involved in the decision-making process.

7. Newscasts are often considered to be more effective if they convey immediacy. That is why so many newscasts lead with a live story and integrate the anchors into the live coverage.

8. Cohesiveness is another important aspect of the newscast. Effective transitions—devices to tie stories together—aid the flow of the presentation.

EXERCISES

1. Using your home or department VCR, record two local newscasts. Prepare a log of the newscasts (you'll have to do a great deal of rewinding to do this accurately, so a remote control will help), and write a short paper describ-

ing the differences. Do more than list the differences. Describe the variety in the *approach* of the newscasts; explain why you believe the story order was different *and* why the stories in each station's newscast were grouped as they were.

2. There's only one way to practice producing a newscast—and that is to produce a newscast. Write about eight stories in broadcast style, and record at least two packages and one voice over.

 If you do not have the capability to produce the packages and voice over, record them off-air from a newscast. *Be sure, when you record the tapes off-air, that you allow at least 10 seconds before the beginning of the package of the voice-over segment.*

 You must find a point 5 seconds before the start of the cut and use that location to cue up the tape. Remember, you'll have to mark a spot in the script to begin the roll in order to bring the tape up to speed.

 Make up a detailed rundown before going on-air. List subject and time of stories, location of tape and tape times, and outcues. Time this newscast to last exactly 15 minutes.

CHAPTER

11

NEWS
ANNOUNCING

Despite some popular opinion to the contrary, broadcast news announcers are not cosmetically correct robots who are hired solely on the basis of their booming voices or sparkling teeth. A good voice or appearance doesn't hurt, certainly, but those qualities are not the basic requirements for the job. They are *additional* advantages for a job in broadcast journalism.

A broadcast journalist needs the ability to *communicate,* to clearly express ideas, project energy and keep the audience involved in the story. And you cannot attempt to do this if you do not have bona fide credentials as a journalist. That is the fundamental qualification, and no amount of vocal coaching or hairspray can compensate if news judgment is missing. Misunderstanding the role of performance skills in broadcast journalism sabotages the careers of many aspiring on-air newspeople. There is a tendency to equate appearance and reading ability with the ability to work as on-air news talent—but *those qualities are not synonymous.*

If voice and appearance were the prime qualifications of on-air talent, news directors would hire actors. As a group, professional actors are better-looking and usually are more accurate and compelling readers than most newspeople. If you doubt this, compare the cast of characters in a movie or TV series to the people who populate network and local news. Who is more handsome, Tom Selleck or Ted Koppel? Who has the more commanding voice, James Earl Jones or Tom Brokaw?

The answers are obvious. Why, then, don't TV news directors fill the news sets with beautiful and photogenic stars, or even the hopefuls who work bit roles in Hollywood or wait tables in New York's theater district? (If you were to throw a rock on a theater district street on the day of an open casting call, it would bounce off at least three people better-looking than your

local anchors.) Wouldn't this be a more effective way to choose talent?

Well, that approach has been tried, and it's proved a dismal failure. While actors may have the edge in appearance, voice and on-screen magnetism, they are not *convincing*. And that is why, with the exception of a few European countries where "news readers" are employed (who make no pretense of being journalists and sign off by saying, "This news has been read by . . ."), people with solid journalism skills dominate the air waves.

This chapter deals with announcing techniques for radio and TV field reporting as well as TV anchoring, but let's pursue the anchor function a bit further because it is the most tangible example of this point. As the most visible job in TV news, the anchor chair exemplifies the qualities that differentiate a broadcast journalist from a performer. So what do news executives view as the key factors that make an anchor?

Bill Leonard, who as president of CBS News was responsible for putting Dan Rather in the nation's most venerated anchor chair, put it this way: "There are four things you look for in an anchorman. [The same criteria obviously apply to anchor*women*, but Leonard was referring to his choice of Dan Rather.] Three are journalistic. One is not."

First, you have got to be able to communicate on television. You have to be able to broadcast, write, and look well.

Number two is your ability as a journalist behind the scenes. What kind of story judgment do you have? How good a reporter are you? How well do you run your staff, if you run it at all? Can you smell a story? Can you recognize something that will become a story?

Number three relates to moments of crisis—when you are on the air in live situations, when you are under fire—elections, conventions, space shots, and things that come out of nowhere, like the shooting of a president. How well can you ad-lib intelligently?

Number four I like to think of as the least important, but it does count . . . the public and private responsibilities of the anchor. The anchor is, after all, the most apparent symbol of what CBS News and CBS itself stand for to the public.[1]

You can rightly infer that the qualities outlined by Leonard apply to any news position, anywhere. Ability to communicate, journalistic skill, grace under pressure and good character are the skills of your craft.

The basic skills and attributes of an on-air journalist are what let you get your foot in the door. Later in your career, you may find that you have that elusive quality that the news consultants claim makes viewers feel warm all over, but you'll never get that chance if you cannot pass muster on the basic skills.

Remember that those skills are largely *learned*, acquired through practice. Although there are many naturals in the business, the on-air polish did not come without practice. Even Walter Cronkite had to overcome bad habits; when he first went on the air, many thought he read the copy too quickly.

It's also worth noting that fear and tension can be overcome only by practice. Newcomers often assume that they can easily adapt to on-air situations because the job *appears* easy. (Of course it appears easy when you are watching a professional with 20 years of experience.)

But the first time before the mic or camera usually turns out to be a nerve-wracking affair. Suddenly, things don't seem so easy . . . and the newcomer is wondering how he could function in front of an audience of thousands when he was terrified before a college announcing class.

If this happens, don't worry, because this is how it's *supposed* to work. *Everyone* is ner-

[1] Quoted by Linda Ellerbee, *And So it Goes* (New York: G. P. Putnam's, 1986), p. 23.

Figure 11.1 *Veteran broadcast journalist Hugh Downs.*
(© 1990 copyright Capital Cities/ABC, Inc.)

vous their first few times on-air, and for many performers those butterflies never go away; they just learn to channel that nervous energy constructively.

We will work on techniques for overcoming mic- or camera-fright in the final section of this chapter, but it is critical to stress right from the start that *you will feel uneasy.* Too many newcomers give up too quickly because they fear they'll never be able to overcome performance anxiety; they assume that since they are so frightened on their first on-air excursion that they are not naturals, and never will be comfortable on-air. That's just not true. Hugh Downs, for example, (Figure 11.1) recalls that in his early days as a radio newscaster his hands shook so

violently that he had to clasp his suit lapel in the same hand with which he held his copy so that listeners couldn't hear the paper rattling. Today, he's one of the most relaxed performers on the air.

Before we get involved with the specifics of news announcing, remember that on-air reporters must be reporters first and performers second; news talent need to *communicate* instead of merely looking and sounding good; and your first time reading to a mic or camera will be a nerve-wracking experience but it's *supposed* to be and you can overcome performance anxiety with practice.

Elements of Broadcast Communication

The days of the golden-throated booming baritone are just about finished in modern broadcasting—but you cannot convince some people of that fact. Many aspiring broadcast journalists cripple their careers by donning an affected "announcer voice." That old-fashioned approach has no place in modern news broadcasting.

In the early days of broadcasting, studio operations were much more formal—and much more removed from the realities of everyday life—than they are today. Studios were lavishly furnished and the announcer sometimes wore a tuxedo (yes, on *radio*).

Great pains were taken to make the studio look like a formal parlor, and sometimes the microphones were hidden behind plants—which gave rise to the sarcastic description of the "potted palm" era of broadcasting. (Some of the older studios at NBC headquarters in New York, such as the announcer's studio at WYNY, still have *fireplaces*.)

Just as the environment was different, so was the job. An announcer in early radio (in the

mid-1930s) was part circus ringmaster, part master of ceremonies and part salesman. He (announcers of the era were almost all male) used an artificial and highly inflected tone of voice and an unnatural delivery.

The artificial announcer voice remained in vogue for many years, but it eventually became obvious that this affectation hurt, rather than helped, communication between communicator and audience. Now, the announcer voice is used by only two constituencies: (1) people who are doing parodies of old-style announcers; and (2) bad announcers who—whether they realize it or not—are doing parodies of themselves. You are doing yourself a disservice by trying to adopt an artificially low, booming voice or—worse—the sing-song pattern of a bad disc jockey.

ESSENTIALS OF COMMUNICATING COPY

While the word *announcer* will stay in our lexicon, the last thing you want to do is announce your copy. (*Copy* means anything written, but what we're saying also applies to ad-libbing; and since much ad-libbed material is delivered from written notes, there is a hazy line between copy and ad-lib anyway.) Instead of announcing, you must communicate the copy in a manner that appears *energetic, believable* and *conversational*.

This involves analyzing the copy, determining what the key concepts are and communicating those key concepts. Those goals can be accomplished by stressing the correct words in the copy, a technique that will be demonstrated later in this chapter.

BASIC VOCAL TECHNIQUE

You don't need a golden throat and the diction of a Shakespearean actor to broadcast on radio or television, but you will need a clear, natural and reasonably powerful voice free of distract-

ing defects. There are several easily grasped techniques that can be applied to broadcast delivery. Among them are *diaphragmatic breathing, elimination of distracting vocal habits, clear diction* and *proper pitch.*

Diaphragmatic Breathing The diaphragm is a tough layer of muscle that is attached by fibers and tendons to your breastbone, ribs and spine (Figure 11.2). It is the diaphragm—not the lungs—that controls breathing. Lungs, located higher in your chest, are immobile spongelike organs that, among other functions, filter oxygen out of the air. They don't *propel* the air. The diaphragm does.

The power that propels the voice emanates from your abdomen—where the diaphragm is—and not the chest. Despite what you may have been taught in elementary-school gym class, "throwing out your chest" does not allow you to take a deep breath. *Expanding the waist allows that deep breath; contraction of the abdomen helps the diaphragm contract, and thereby provides*

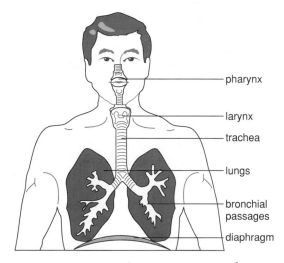

Figure 11.2 *The parts of your anatomy most relevant to voice production.*

great support to the column of air that vibrates your vocal cords.

Everyone uses their diaphragm when they breathe. It's unavoidable. But some people don't expand the diaphragm fully—meaning that they do not take a deep, supporting breath, and do not rely enough on the contraction of the diaphragm to propel the exhalation. When this happens, the voice doesn't get full support because the speaker doesn't have a full tank of air; the voice tends to become breathy and weak, and the speaker must take in frequent gulps of air to make it through his or her copy.

To breathe diaphragmatically, expand your waist when you take a breath. An easy way to make sure you're dong this properly is to put your hand a couple of inches below your breastbone. When you inhale, you should feel and see an expansion beneath your hand. When you speak, you should feel the muscles beneath your hand contracting and pushing. If you have trouble invoking this effect, push in with your hand while you speak. You will feel and hear the difference.

In addition, mind your posture. You'll have trouble breathing diaphragmatically if your back has too much of an inward curve. Sit or stand straight. One way to accomplish this is to make a conscious effort to press the small of your back against the back of the chair.

Finally, don't chest-breathe. If you're expanding your chest too much, you're sabotaging your efforts to breath from the diaphragm. David Blair McClosky, a voice coach whose clients have included President John F. Kennedy, actor Al Pacino and broadcaster Curt Gowdy, once showed me an uncomplicated way to guard against shallow chest-breathing. Press your fingers against your lowest set of ribs, the so-called floating ribs. If the ribs expand when you take a deep breath, you're chest-breathing. Make a conscious effort to expand the *abdomen* and not the *rib cage*, and you'll automatically breathe diaphragmatically.

Elimination of Distracting Vocal Habits A problem faced by everyone who attempts to improve their speech is that we cannot perceive many of our own flaws. Speech therapists note that even people with severe lisps sometimes cannot identify the difference between their S and a normal S—even when audiotapes are played back to them.

Help from a second party is needed. Your instructor can aid you in correcting many bad speech habits. Should you have a pathological problem in voice or diction, such as a lisp or a stutter, you would be well-advised to seek the services of a speech pathologist.

With the assistance of an objective observer, evaluate your delivery for these problems:

Monotone Failure to change your pitch during delivery makes your voice seem dull and lifeless. In addition, speaking in a monotone can sometimes damage your vocal cords. Attempt to add more inflection to your voice; your pitch should rise and fall naturally. Don't overdo it, though, or you may fall victim to the next problem.

Sing-Song Speech A predictable rising and falling of the voice, usually over wide ranges of pitch, is not only distracting but irritating. If your speech has a sing-song pattern, try for a more conversational tone. A newscaster wants to sound like an intelligent next-door neighbor, not like a caricature of a disc jockey.

Weakness, Breathiness or "Thinness" Not everyone is born with a powerful voice, but you can make the best of what you have by avoiding this "thin" quality. You do that by providing a powerful column of air—in other words, using that diaphragm for support.

If your voice is breathy, it may be because you are breathing too shallowly. A thin voice often results not only from lack of diaphragmatic support, but also from a lack of what

speakers and singers call head resonance. Some of the air you expel during speech must go into the nasal cavities; it is supposed to. Try saying an *MMMMMMMMMMM* sound without air escaping through your nose, and you'll immediately understand this concept. Speakers who are "de-nasal," meaning that they don't expel enough air through their nasal passages, often have thin voices because the air does not have a chance to resonate in the head, and in particular, in the sinus cavities.

You can diminish this lack of resonance by landing a little harder on the *M* and *N* sounds in your speech. Those sounds resonate nasally (there's no way to say them other than letting them resonate in the nasal cavities), and emphasizing those sounds can add color to your voice.

Ending Patterns Be careful of your pitch patterns. Don't fall into this trap:

Everything
 you
 say
 goes
 down
 at
 the
 end.

This is an extremely common problem, but it's easily fixed. Find places where your inflection can naturally rise at the end, or stay at roughly the same pitch, and mark those spots right in your copy. Write "DON'T DROP PITCH" or "RISE IN PITCH" or whatever it takes to remind you not to fall into an ending pattern. (Some people always *raise* their pitch at the end; if that's the case, reverse the process.)

Clear Diction Diction has a specific meaning in speech science, but for the sake of this discussion we will use the common, colloquial meaning that indicates precise and proper pronunciation. (In fact, the terms used throughout this discussion are informal words related to the practicalities of announcing.)

There are various diction problems confronting the announcer, including *popping plosives, mumbling/cluttering* and *regionalisms.*

Plosives Plosives are sounds like *P* and *B* that "explode" from the lips. (The root derivation of *plosive* and *explode* is the same.) Speakers who are too vigorous in their pronunciation of the letter *P* tend to "pop" those sounds when speaking into a mic. Certain mics, like the ribbon mic, are especially sensitive to popping plosives and greatly exaggerate them. What might go unnoticed in face-to-face speech sounds like an aerial bombardment if a *P*-popping radio newscaster using a ribbon mic signs off by saying, "This is Paul Pendergast for WPPP Public Radio."

Sometimes, being aware of the problem allows you to cure it. You simply cut down on the volume of air behind your *P*s and *B*s. Other remedies include backing away from the mic, using a large wind filter over the mic (that not only blocks the air but forces you to keep a minimum distance), and speaking across, rather than directly into, the diaphragm of the mic.

Mumbling/cluttering Mumbled speech is never particularly engaging, but it becomes painfully annoying over the air. Assuming there are no underlying physical problems associated with your speech pattern, mumbling can often be helped just by *opening your mouth more when you talk.* Don't be lip-lazy on-air.

To eliminate lip laziness, in addition to opening your mouth far enough, be sure to pronounce *all* the sounds in the words you are saying. The word *lists* has three distinct sounds at the end. Pronounce them all; don't say "liss." Don't drop or substitute different sounds in

words ending with "*ng*." It's *beginning*, not *be-ginnin'*. Not pronouncing "*ng*" sounds at the ends of words is so glaring an error that you will be disqualified from on-air work if you do it habitually.

Sometimes people who speak indistinctly clutter their words, telescoping them together. (To be technically precise, this is a problem of *articulation* as opposed to diction.) When clutterers run words together, they not only make their speech less attractive, but also make it less intelligible.

Some people who speak normally during conversation will clutter when reading aloud—rattling off the words at a much faster than normal rate, using no inflection and thereby distorting their usual phrasing.

Cluttering, if it is not a pathological problem, can be helped by slowing the rate at which you read, marking the copy so that you stress the correct words and phrases, and remembering that you are *communicating* and not just reading out loud.

Regionalisms Accents and dialects do not belong on the air—even in local markets where the regional accent is common outside the studio. Although you can sometimes get by with a thick Southern drawl or a sharp New England twang within those regions, if you want to relocate to another market—the way a broadcast journalist typically makes a career move—the accent will be a handicap. Do not count on the accent being tolerated within your area, either; many would-be announcers have been disappointed because the local station in the city in which they lived all their lives will not hire them because they speak with the regional accent. Only in exceptional cases have announcers succeeded while retaining their regional accents.

Unaccented speech free from a regional dialect (note, again, that we are using informal forms of the words *dialect* and *accent*) is sometimes called general American speech. General American speech means speech free from re-

gional peculiarities. That standard, however, is difficult to discuss with precision because a standard is something against which something else is compared, and it is hard to track down a readily identifiable general American. As a result, we increasingly tend to rely on the term *network* standard—the way newscasters on network television speak.

Two major network newscasters had, and dropped, strong regional accents. Peter Jennings, a Canadian, used to have quite a noticeable dialect; he said the word *been*, for example, as "bean"—a habit he has since eliminated. Dan Rather, a Texan, significantly modified his drawl as he advanced in the news business. If you listen closely, you can still detect just a hint of their regional backgrounds, but they both now speak in network standard. Any accented speech, be it Southern, Northern or urban, inner-city African-American, could hold you back.

Another consideration relating to speech has to do with what is called a social dialect. Network standard reflects the type of speech used by well-educated Americans; saying "youse people" and "watcha lookin' at?" do not meet that standard. While social dialects may be acceptable in face-to-face conversations, they do not belong on the air.

Just as social dialects are unacceptable, so is substandard word usage. On-air journalists (indeed, anyone in virtually any profession) is obliged to use what is termed standard English. Standard English means the English language as it is written and spoken by educated people. (*General American speech* is a term primarily applied to pronunciation, rather than usage.) You simply cannot use offenses to standard English such as double negatives ("didn't do no good").

Also, you must use words correctly. Don't say "heart rendering" when you mean "heart rending," or "irregardless" instead of "regardless." You'll be laughed out of town if you attempt to say "one scintilla of evidence" and come out with a reference to a "chinchilla."

Proper Pitch Do not try to force your voice down into an unnaturally low pitch. Why? There are a number of reasons. First, your voice will lack expression because you are speaking at the bottom of your vocal range. Also, you cannot vary your pitch downward, and you'll therefore end up speaking in a semimonotone. In addition, this practice may damage your vocal cords.

Some people tend to speak in too high a pitch. If that's the case, then yes, lower your pitch a bit. But reworking the basic pitch of your voice is something you'll be better able to accomplish with the help of a professional voice coach or certified speech pathologist; a professional can determine your proper pitch placement.

Should you want help with speech problems, many colleges have speech pathology training programs, usually under the umbrella of the learning disorders department, or sometimes within the broadcasting, speech or theater department. Assistance is generally available at nominal cost, or even for free, since graduate students need clients with whom they can gain experience. Don't worry about working with students, because they are under the supervision of an experienced professional who is responsible for the handling of your case and therefore monitors your progress at every step.

Often, what you may regard as a pitch problem is lack of resonance. Many people whom we assume have deep voices really have resonant and relaxed voices. Resonance is produced by letting some air up into the nasal passages, an effect you can enhance by putting greater emphasis on your *M* and *N* sounds; those sounds have to travel through the nasal passages since your mouth is closed when you pronounce them.

Also, relaxation techniques can help the pitch of your voice seem lower and more resonant. Long vocalizations, such as saying "haaaaaaaaaah" in a descending pitch, can help relax the voice. Gently massaging the lower part of your jaw also relieves tension in the tongue; tongue tension often accounts for vocal tension.

A final relaxation technique is to move your jaw with your hand, bouncing the jaw up and down. This is *far* more difficult than it might seem, since most of us keep our jaw muscles quite rigid. When you can relax the jaw to the extent where you can easily raise and lower it with your hand, your vocal apparatus will relax considerably.

In fact, relaxing the whole body can help the voice. There are many relaxation programs and tapes available; find one that suits your needs. In general, your performance and voice quality will be improved by any type of relaxation (and it does not have to be a formal method) that involves progressively tensing and then relaxing the major muscles of your body. It's important to tense them first so that you can realize what tension feels like, and then make every effort to relax the muscle group. For example, hunch up your shoulders and stiffen your neck. Do you feel the tension? Now, relieve all the tension you feel by letting your shoulders slump and your head hang loose.[2]

WORKING TO CAMERAS AND MICROPHONES

You can eliminate some of the more common problems of working to cameras and mics by remembering the technical workings of the devices as they were described in the previous chapters. Therefore, we will not pursue production-oriented problems in this chapter. Instead, we will briefly address the techniques that fall entirely into the category of announcing skills: *dress and appearance for television, playing to the camera* and *working with the mic.*

[2]Should you be interested in further developing your voice, a full range of vocal improvement techniques are demonstrated in Lewis O'Donnell, Carl Hausman and Philip Benoit, *Announcing: Broadcast Communicating Today*, 2nd ed. (Belmont, Calif.: Wadsworth, 1991).

Dress and Appearance for Television Clothes do not make the man or woman on TV. While executives in many major corporations judge each other by the cut of their clothes and use their dress standard as an indication of status, television does not require you to invest in a wardrobe of $800 suits. In fact, dressing for success on TV is more a matter of knowing what *not* to wear.

Certain items of clothing do not appear well on the screen, and will distract the viewer. That's why we're addressing clothing and appearance as an element of broadcast communication: You will have difficulty getting your message across if your viewers' attention is diverted to your poor choice of clothing, jewelry or hairstyle. Both men and women are wise to avoid:

■ Anything bulky or featuring obvious patterns. Heavy-weight clothes tend to bunch up and make the wearer look chunkier; big patterns have the same effect. Small, intricate patterns, such as herringbones, often make the camera "strobe"—produce a wavy pattern across the herringbone. Interestingly, this strobing effect might not be noticed in the studio, where technicians use high-quality monitors, but it becomes apparent to viewers who are watching the program on lower-quality home television sets.

■ Suits (both men's and women's) that are very dark and are placed next to a very light shirt or blouse. Today, this means not wearing a black suit with a white shirt or blouse; modern cameras can handle virtually any other contrast range with ease.

A few years ago, it was standard procedure to wear a blue shirt or blouse because color cameras had difficulty handling bright white, but that's no longer a problem, unless the studio equipment is old *or* unless you are wearing a dark black suit. ("Dark black" seems redundant, but there are shades of black; some clothes are more of a dark charcoal than actual black.) Most cameras can cope with black-over-white, but it does take some adjustment; and black is so highly formal (and funereal) that it is not a good TV color, irrespective of how well the cameras photograph it.

■ Clothes that don't fit. Clothes sold off the rack are made to fit a model with supposedly perfect measurements. Most of us are not so perfect. (This works both ways. Men and women who exercise regularly, a growing segment of the population, have become more broad-shouldered and narrow-waisted than the models to whom clothes are generally fitted. Major clothing manufacturers have had to reshape some of their lines to accommodate this.)

The worst-case scenario—for television, anyway—is the man's suit that humps up in back of the neck. Square-shouldered men (men whose shoulders don't slope as much as normal) usually have an extra inch or so of collar sticking up when they wear an off-the-rack suit. Tailors refer to this as a bubble below the collar. If this is the case, ask the tailor to lower the collar. Tailors don't like to do this, because it involves disassembling the entire collar and shoulder portions of the suit, but it has to be done to ensure a correct fit.

Also, make sure that there is enough room in the middle for you to keep the coat buttoned while seated without a visible strain on the button or without the lapels bunching out. Some men undo the jacket button while seated on-air, but most don't; it looks neater to keep the button fastened. Having enough room to allow for comfortable sitting is especially important in double-breasted suits or jackets, which do not look right when left unfastened.

■ Women might be cautious of extremely frilly blouses and collars, because they can be dis-

tracting on-camera and have a tendency to go askew when you move. It is also wise to avoid bulky or very large jewelry; it can appear awkward or even grotesque on-camera.

Remember, though, that you do not have to wear man-tailored clothing. While this was in fashion at one time, women now are free to wear any sort of clothing that's acceptable for normal wear as long as it is not bulky, bunchy, or small-patterned, such as a herringbone.

Sticking to basics is good advice for all aspects of on-camera appearance. Standard, fairly conservative clothes are the norm. You do not need to invest in expensive, high-quality fabrics for TV, for a number of reasons. First, the beautiful texture of an all-wool $500 suit won't be as apparent on-air as in person. Secondly, if you are assigned to field reporting, as is virtually everyone who enters TV news, your clothes are going to take a real beating. You'll be in and out of cars, carrying equipment, running and so forth.

It is more important to make sure that your clothes fit correctly and that they do not call attention to themselves. Good first choices for both men and women assembling their on-air wardrobe are navy blazers and/or any dark-colored, lightweight jacket. Light-colored outfits are fine, but stick to the darker shades of beige, and don't choose the extremely light varieties of light blue and light gray. Very light clothes tend not to photograph well, and in many sections of the country they'll seem inappropriate for winter wear. Men should avoid ostentatious ties. Women are advised to stay away from excessively frilly blouses. Open-collared blouses or blouses without a collar are fine, but avoid plunging necklines.

For men, haircut choice is simple: side-parted, not too short and not too long. African-American males often do not part their hair, but most male anchors keep it relatively short (but again, not too short).

Women have a wider choice of hairstyles. Usually, you will be better off with a shoulder-length cut, since that is conservative and fairly easy to manage. Steve Osborne, former news director of WOR Television, New York (now WWOR-TV, licensed to Secaucus, New Jersey), recommends that women stay away from any hairstyle that appears flashy.

And on the subject of flash, Osborne points out that a newsperson presenting him- or herself as a fashionplate can commit a mistake from both an aesthetic and a professional point of view. "They should remember that they are newspeople, not aristocracy," he said. Despite the fact that some newspeople command respectable salaries, their wardrobe "should not say, 'Look at me, I can afford nice clothes.'"[3]

Playing to the Camera The most basic and useful piece of advice offered to television performers is to *look directly into the lens*. Even a minute deflection of your gaze will be evident to the viewer. Looking dead-center into the lens takes practice, because we're not used to adopting that visual mode when conversing with people. We avert our gaze, look from side to side and gaze downward. While you do not want to effect a fish-eyed stare, remember that side-to-side eye movement looks shifty on-camera, and the camera *vastly* magnifies such eye movement. It's all right to look downward from time to time; in fact, that is preferable because it naturally breaks the monotony of looking into the camera. You may have to look at your script, and viewers expect that. But again, don't look to the side. If you are working with cue cards, ask that they be held beneath the lens, not on either side of it. Hints for using a prompting device follow in the next section.

When working on-camera, have an idea of the size of the shot. If a monitor is available,

[3] Interview conducted by research assistant Philip Benoit, July 24, 1990.

take a peek; if not, ask the director or field producer beforehand what shot you will be in. If you know the size of the shot, you can calculate the proper amount of movement and animation to be injected into the shot. Close-ups require that your head be held very still, but medium-long shots permit—in fact, cry out for—some restrained gestures and body movement.

The use of proper facial expression is difficult to master and is a skill you can acquire only by viewing tapes of yourself delivering news copy. Having said that, there are two bad habits about which you can be forewarned, and possibly you can sidestep them right from the start. First, avoid stiff, mechanical expressions; don't retrieve your "concerned" expression every time you read an accident story, or your "beaming smile" when you read an upbeat item. The effect is obvious and offensive. Second, assuming you can communicate with genuine expression, *hold* your expression for a bit longer than you think necessary. Dropping your expression ("letting your face fall") the instant you complete your line is amateurish and distracting.

Working with the Mic Microphone technique for radio and television is fundamentally the same, except you will use large studio mics in radio control-room and announce-booth operations, whereas a television announcer typically uses hand-held mics and lavalieres. (When shotgun mics are used, they are mounted at the end of a pole and wielded by a member of the production crew; the guideline for use of shotguns is to get them as close as possible to the subject but keep them out of the picture.)

The following suggestions apply to both media:

■ Keep a standard distance from the mic. In other words, don't move your head in and out or move the mic closer and farther. Aside from irritating the audio control people, you'll distract the listeners and viewers.

■ How close should you be to the mic? That depends on the circumstance and the microphone, but 8 to 10 inches (a little more than the width of an outstretched hand) works well. In noisy situations, such as an on-scene report at a construction site, you will want to move closer to capture more of your voice and less of the surrounding noise. In such cases, you will want the microphone right at chin level, but be careful not to place it in front of your mouth.

TV on-scene reports, as well as interviews, are frequently carried out with lavaliere mics, which are usually clipped on the tie, lapel or shirt about 6 inches below the chin.

■ Be careful of noise if you hand-hold the mic. Mics chosen for fieldwork are generally not very susceptible to noise from handling, but that doesn't mean they're immune to it. Cables transmit noise, too, so don't kick or rub against them. If you are wearing a lavaliere, be careful not to brush papers against it or wear any jewelry that will knock against the mic.

■ A final note about lavalieres: This sounds absurdly obvious, but under the pressure of deadlines and other demands many performers forget to take them off when they leave the location or set. At best, you'll shred your blouse or necktie when you reach the end of the wire; at worst, you'll rip the wiring out of a $200 mic.

USING A PROMPTING DEVICE

A prompting device such as the TelePrompTer (a trade name) projects the image of the script onto a one-way mirror that covers the lens of the camera. The prompting device (Figure 11.3) usually works this way:

1. The pages of the script are loaded onto a conveyor belt that pulls them beneath the lens of a small, vertically mounted TV camera.

Figure 11.3 *Anchor Robin Garrison reads from a prompting device during the noon news-cast at WPVI-TV, Philadelphia. We have arranged a monitor in the foreground to show you what the script she is reading looks like when viewed on the prompter.*

2. The speed of the prompting device is governed by an operator who uses a hand-held control to regulate how fast the belt moves.

3. The image is transmitted to a monitor that lies on its back directly beneath the camera lens.

4. The image is reflected onto the mirror; the reflected script can be seen by the performer on one side of the mirror, but not by the camera lens.

Advantages of a Prompting Device A prompter enables the announcer to maintain eye contact with the lens (and the viewer). This is much more appealing than watching an announcer read from the printed script. (Copies of the script are held by the announcer, however, in case of prompter breakdown.)

Eye contact was a problem in early TV, before prompting devices were perfected; even the best announcers had difficulty dividing their attention between script and lens. Some novel approaches were attempted. Don Hewitt tried to convince a pioneer CBS newscaster, Douglas Edwards, to learn Braille. The scripts, according to Hewitt's scheme, would be printed in Braille, and Edwards could follow with his fingers and keep his gaze on the camera. Edwards declined.

A New York announcer named Robert Earle, who was once host of a popular program titled the "GE College Bowl," used an interesting approach when he was a newscaster: He read his script into a tape recorder beforehand, played the tape back during the show through an earpiece and repeated the script as he heard it in his earpiece.

Earle's method never caught on for newscasts, but it is a handy technique for on-scene reports delivered to the camera, and is, in reality, a type of homemade prompting device. Should you have a long section to be delivered as an ad-lib standup, you can record on a commercial

cassette recorder and play it back through your earpiece. There are also new commercial units designed specifically for this purpose. This technique takes some practice, but should you master it your viewers and colleagues will marvel at your memory and ad-libbing skills.

Disadvantages of a Prompting Device There are only two problems associated with prompters. One is easily overcome; the other is not.

The first problem is that some announcers have difficulty reading from the devices. The techniques presented below will usually eliminate those problems.

But no one can read well from a prompter when it is running too fast, too slow, not running at all or the script has been fed in upside down. And that happens. In some markets, the job of prompter operator is filled by a new-hire or an intern. The only remedy is to keep your place in the hand-held copy of the script and be prepared to read from it in the event of prompter failure. Don't be reluctant to look down from time to time to check your place.

Using a Prompter Announcers usually experience some difficulty the first time they use the device. Using a prompter is a skill that requires practice.

- Pick one line of copy and try to consistently read that line on the air. A good choice is the line that appears as the third line down from the top. With many prompting devices and script formats, this will give you a cushion of two lines of copy above and three below. This way, you won't feel as though you are going to run out of copy to read or have the copy scrolled by you too quickly.

- When doing this, try to maintain a reasonably steady pace throughout. That way, the prompter operator will be better able to accommodate the speed of the moving text to your delivery. Try *not* to adjust to the rate of the prompter operator if you can avoid doing so; if you start slowing down, he or she might think you *want* the scroll at that speed and will overcompensate. *Let the operator adjust to you.* It's also useful to practice with the operator off-air.

- Another painfully obvious suggestion is to make sure you can *see* the TelePrompTer. Production people sometimes set the cameras and attached prompters without considering the fact that you need to comfortably read the screen. They don't realize that you need to read with precision, or that you may not have perfect vision. No one will be offended if you ask that your camera be moved closer.

Marking and Interpreting Copy

Taking a pencil to your news copy can vastly improve your delivery. By marking up the copy you can identify difficult or unfamiliar pronunciations and, if necessary, write the pronunciation into the script. You can also insert symbols to help you interpret the copy, giving words and phrases their proper meaning.

As noted in the chapters on scriptwriting, it is best to insert pronouncers on unfamiliar names, places and words right into the script, but what may be familiar to the writer of the script may be entirely foreign to you—meaning that you may be handed a script with names you're not familiar with and no pronouncers written into the copy. This particular difficulty is one you'll face when moving into a new market. Everyone—except you—will know that Commissioner Blostein's name is pronounced BLAH-steen, not BLOW-stine. (That was a real name and pronunciation—Chemung County, New

York—and a real and embarrassing mistake—mine.)

In various localities, pronunciations that may seem obvious can sneak up on you, and *practically nothing* damages your credibility faster than mispronouncing the name of a local politician, street or town. In some communities, for example, people named Gentile pronounce it as you would expect, GEN-tile. But in at least one city, members of a prominent family pronounce it gen-TILL-ee.

In Decatur, Illinois, El Dorado Boulevard isn't pronounced the way anyone not from Decatur would expect. It's el-dor-AY-do. New Athens, Ohio, is not new ATH-ens . . . it's new AY-thens. The Rochester, New York, market is brutal for broadcast newcomers: Chili, a suburb of Rochester, is not pronounced like the popular Mexican dish, but rather CHEYE-LIE, with the accent equal on both syllables. Avon, an outlying community, is not pronounced like the cosmetics firm but instead as AV (short *A* like in *man*) -on.

So check your copy carefully, and don't be reluctant to ask about any word that you even remotely suspect may tangle you up. You can use whatever convention is common in your news department for writing out pronunciation. After that, screen the copy for key words and concepts.

IDENTIFYING KEY WORDS AND CONCEPTS

Here, you will decide what the story is about and how you can get that message across. You must have a clear and precise understanding of the meaning of the copy before you can read it accurately.

That sounds simple. It is not. Perhaps the most common criticism of poor reading is, "The announcer doesn't sound like he knows what he's talking about." That's more than criticism in the news business; it is damnation.

On-air performance in any role boils down to communication.

Probably the worst example of reading-without-understanding was committed by a staff announcer who, because of the currently fluctuating libel law, I will not name. The man had a superb voice, was an accurate reader and seemed destined for a fine career. And he probably would have fulfilled that goal had he been able to understand his copy.

The nadir of his career came on the day that he read, live, a commercial pegged to that day's weather. The announcer was supposed to open the spot with one of the following three options:

"What a beautiful sunny day . . ."

"Look at all that rain . . ."

"We've had more than our share of snow . . ."

If you haven't already guessed, he read all three. And his career did not exactly skyrocket. The point is that a good voice and accurate reading do not ensure good delivery; a mechanical approach to reading copy that you have not analyzed is not only lazy but dangerous.

Every line of news copy has words that clarify the meaning and lend the story impact. For example,

FOUR people DIED, and TWO were INJURED, in a fiery CRASH last night on INTERSTATE 290.

All copy also has natural pauses that break the copy into understandable and meaningful phrases. The location of commas in the above example shows where the pauses belong.

A mechanical rendition of this copy, especially one done in disc-jockey style where the announcer's voice modulates unnaturally, could completely hide the meaning of the sentence.

Four PEOPLE died and, two WERE injured in a FIERY, crash LAST night on Interstate 290.

Read the second example aloud, using the indicated stresses and pauses, and you'll see that it not only doesn't make sense, but it is difficult to remember and understand.

This may seem an extreme example, but it does show how key words help the listener and viewer understand what is being read. When key words are selected properly, they virtually tell the story themselves in a verbal shorthand.

FOUR DIED . . . TWO INJURED . . . CRASH . . . INTERSTATE 290.

Now, let's apply the same concept to a real story. What would you choose as the key words?

(UPI)_At least 116 people are dead and more than 750 wounded in two days of street warfare between Shiite (Shee'-isht) Moslems and Palestinians in Beirut. The battles raged on today . . . even after a peace committee agreed to a truce. The Red Cross says the fighting has been so intense that paramedics are not able to reach some of the casualties in three refugee camps.

The strongest and most meaningful words in the above copy include:

116 dead . . . 750 wounded . . . street warfare . . . Beirut . . . battles raged on . . . even after . . . truce. So intense . . . paramedics not able to reach . . . refugee camps.

You cannot punch up *every* important word in the copy because so many of the words would be emphasized that the phrases would lose their meaning. All of the words above would not be stressed with equal force, but you are on the right track if you stress, to some degree, the words indicated. *Those words tell the story.*

Another consideration is phrasing, that is, the way in which you group words together.

Part of phrasing is dictated by your need to breathe, of course. You probably cannot get through all the lines of copy above in one breath and even if you could, you would gasp for air at the end. In addition, you want and need natural stops to emphasize what you are saying and add grace to your delivery.

If you were to look for natural rhythmic breaks in the copy, you would probably want to phrase it this way:

At least 116 people are dead [PAUSE]

and more than 750 wounded [SLIGHT PAUSE]

in two days of street warfare between Shiite (Shee'-ight) Moslems and Palestinians in Beirut. [BIG PAUSE—YOU'RE CHANGING THE TOPIC A BIT AND NEED TO BREATHE, ANYWAY]

The battles raged on today . . . [PAUSE FOR DRAMATIC EFFECT; THE PAUSE IS WRITTEN RIGHT INTO THE COPY]

even after a peace committee agreed to a truce. [SLIGHT PAUSE]

The Red Cross says the fighting has been so intense that paramedics are not able to reach some of the casualties in three refugee camps. [THIS SENTENCE IS ALL ONE DRAMATIC UNIT. DO IN ONE PHRASE IF YOU CAN]

STRESS AND EMPHASIS

How do you go about remembering all those stresses, points of emphasis and phrases? Lewis O'Donnell, Carl Hausman and Philip Benoit, in their book *Announcing: Broadcast Communicating Today,* devised a system of script markings shown in Figure 11.4.

You might use those markings to add points of stress, emphasis and phrasing to the story we've been discussing. One possible way of marking up the script is shown in Figure 11.5.

Marking up the script is useful in practice

METHODS OF AD-LIBBING

As mentioned earlier, an ad-lib is *not necessarily* made up entirely on the spot. In fact, *the better-prepared you are, the better your ad-lib will be.* At the same time, *the more you know, the more rich detail you will be able to inject into your ad-lib.* The details—the stench of the air raid shelters or the level of the flood water—are what make the news immediate and give it believability and impact.

Political convention reporters and anchors bury themselves in homework weeks or months before the event. Sometimes they keep a stack of 3 × 5 cards; in other cases, they compile their information in easily accessed three-ring binders. That is how they know that the congresswoman from a particular district was a corporate lawyer, that this is her first re-election bid and her husband is a movie producer. No one can keep that much information in his or her head. Once you realize that coherent ad-libbing is as much a function of preparation as talent, the task seems less daunting.

There are some useful routines that may prove helpful to your ad-libbing. They involve *keeping the ad-lib brief, putting the facts in order, encapsulating the ideas* and *delivering the ad-lib gracefully.*

STRIVING FOR BREVITY

Ironically, first-time ad-libbers usually experience great trepidation about having to *fill* the allotted time—the "oh-lord-what-am-I-going-to-say-for-90-seconds?" syndrome. Realistically, that is the least of your worries. In fact, it is precisely the opposite of what you should be concerned about: *condensing the material down to a usable length.*

Reporters worried about "filling" usually dredge up about five times the material needed

for the report, and wind up being cut short by the field producer or by the anchor desk. We all tend at first to drastically overestimate how much we need to say to fill a minute or so, so don't get caught in this trap.

Besides, should you wind up short there is usually no great harm done. If, for example, the ad-lib is a live report back to the anchor desk, the anchor may ask you a question to fill time and/or elaborate on certain details.

PUTTING FACTS IN ORDER

Remember that although your ad-lib must appear natural, the process of ad-libbing is anything but natural. Hardly anyone speaks in the complete, logical and thorough phrases of skilled reporters. Should you ever have the opportunity to read a literal transcript of what you say before, perhaps, a legislative body or a court hearing, you'll undoubtedly be shocked at how rambling, disorganized and subliterate your remarks appear when entombed in paper.

Listeners and viewers expect the same type of completeness and order in an ad-libbed report as in a written report. You can meet that demand if you know the proper technique.

Here is an example of what someone might say in what would pass for either a normal conversation or a bad ad-lib.

> The water is covering Main Street, the river, you know, has been rising. It's about 8 inches deep on the road. The weather people I spoke with say that we're likely to see about another half-inch. In the meantime, police have banned travel. We're probably not going to get much farther, because the water is up to the fenders on the remote van. Like I said, the weather service says another half-inch is coming, but it's supposed to clear after that and the water is not expected to rise much beyond its current level. We expect the rain to stop in about an hour. Meanwhile, we can see many stalled vehicles here on Main Street, where

the water is about 8 inches high. Remember, the police have banned travel, and the situation is not expected to get any worse, so stay where you are. We're live, this is Bob Parker, WXXX.

This report wandered all over the place: It started with a description of a downtown street, alluded to the weather forecast, went back to downtown conditions, briefly mentioned the most important point—that the flood waters are not expected to rise significantly—and then meandered back to describing Main Street.

Let's try to sort out the most important points in this report and put them in a semblance of order. If you were to write reminders to yourself in your notebook of what you want to say, your notes might look like this:

1. Downtown inundated
2. But not expected to get worse
3. Forecast
4. Police ban . . . stay in houses

PLANNING AND ENCAPSULATING

What you've done is to plan what you expect to say and encapsulate your remarks in four main points. Those points can be written in your notebook or just stored in your brain.

Now, you can deliver a more cohesive ad-lib. After you've planned and encapsulated, present the piece in short, bite-size portions. Think about what you have already accomplished: *Now,* you are giving 15-second summaries of four main points instead of a full minute's worth of ad-libbed news. Doesn't that seem less onerous?

Finally, remember to keep it *brief.* You do not need to fill. There is plenty of material.

DELIVERING THE AD-LIB

When you are ready to go live, or to deliver the ad-lib on tape, half the battle is already won if you have planned, encapsulated and are ready to give a brief summary of the material. Now, as you actually deliver the report, you will want to remember these points:

- If you are on-camera, don't be afraid to look down at your notes if necessary. There is no need to be furtive about the fact that you are consulting a notebook. Reporters are *supposed* to keep notes.

- Eliminate unnecessary interjections. "Uhhh" and "you know" are extremely distracting. They are habits, and anything learned can be unlearned. Train yourself not to say "uhhh" when searching for a word. It's better not to say anything than to say "uhhh." If you say nothing, listeners and viewers may think you're thoughtful, or making a dramatic pause. They certainly won't hold that opinion if you continually say "uhhh."

- Be *absolutely clear* about what you are supposed to do when on-air and stick to that plan. If the producer wants you to do a 10-second live open and then go to tape, don't ramble on for 20 seconds; you will throw the entire production unit off stride. Also, never let there be any doubt in your mind as to when you are supposed to open and close the piece. From whom do you take your cue? To whom do you throw your line when you're finished? If necessary, write your cues into your notes. This is one area where you cannot afford a flub.

With those points in mind, you're ready to deliver your live report. Remember, you are going to give a synopsis of the four main points you've already written in your notebook.

1. Downtown inundated
2. But not expected to get worse
3. Forecast
4. Police ban . . . stay in houses

Your report, then, might go like this:

> Here on Main Street, the water is about 8 inches high. It's up to the fenders on the mobile van and many other vehicles have stalled throughout the downtown area.
>
> But the good news, according to forecasters at the National Weather Service, is that it's not going to get any worse. Forecasters do *not* [NOTE: REFRAIN FROM SAYING THE CONTRACTION "DON'T" HERE BECAUSE IT COULD EASILY BE MISUNDERSTOOD AS "DO"—IN THIS CASE, YOU CANNOT AFFORD *ANY MISUNDERSTANDING*] expect the floodwaters to rise.
>
> We can expect another half-inch or so of rain, but that's not anticipated to make much difference in the groundwater level, and the skies are going to start to clear in about an hour.
>
> Meanwhile, stay put! Police have banned travel except for emergency and public service vehicles. All you're going to do, police say, is stall your auto and clog up the road . . . so stay home, stay dry and stay tuned for further information. This is Bob Parker . . . *live* . . . from the WXXX news van.

An ad-lib is a brief summary of main points. Keep that in mind and you'll successfully ad-lib your piece.

Overcoming Performance Anxiety

Let's conclude by reviewing the role of performance anxiety, or stage fright, on broadcast announcing.

Earlier, we discussed the fact that everyone is nervous their first few times on the air, or their first few years on the air or maybe throughout their entire career. Some veteran entertainers experienced ghastly stage fright every time they appeared, including singer Barbra Streisand and the late Sir Laurence Olivier. But they worked through their fear, and *translated* their nerves into nervous energy.

Many cures for performance anxiety have been proposed, including realistically evaluating the worst possible case. (After all, what really could happen? If you perform poorly, you're not going to be beaten up or sent to jail.) Some experts advise using mental tricks, such as picturing the audience in their underwear, a device that requires a little more imagination in broadcasting than on a live stage performance.

These devices may be helpful, or they may not. What I believe *will* help you cope with nerves in any situation is the knowledge that anxiety over appearing on-air is natural, and most performers suffer from it to some degree. Being on-air is a tense situation, and only someone with a nervous system made of steel will fail to be frightened. (Some people are like this; they do not experience the highs and lows of life with the same intensity as most of us. But while people with nerves of steel make great astronauts, they are *horrible* performers because they cannot get themselves "up" for a performance.)

Performance anxiety is a variant of what Winston Churchill, the leader of Great Britain during the dark days of World War II, called the fear of fear itself. Most victims of performance anxiety do not fear the situation as much as they fear their *reaction* to it. Will my voice shake uncontrollably? Will I go blank? Will my knees knock together?

Maybe. But your voice will quaver only for a second, and you'll have just a momentary lapse in your thought processes—as everyone does—and no one will notice your knees knocking unless the director takes an extreme close-up of your legs, which is highly unlikely.

Practical experience and a wide body of experimental research have shown that an audience is a *very poor perceptor* of a performer's nervousness. The audience does not know your stomach is churning or your palms are sweat-

ing. As disturbing as these symptoms are to you, they are all but invisible to the audience.

A television documentary[6] on the life of Edward R. Murrow showed a portion of Murrow's interview with actress Lauren Bacall on the 1950s TV program "Person to Person," a show in which a camera was brought into a celebrity's home or apartment. Remember, this was something new to even the most experienced performers: They were shown *as themselves*, not as a character in a movie, on nationwide television.

Bacall remembers that she was terrified. In her words, she thought she was going to "faint from fright." Yet the kinescope (film taken from the TV picture) showed her appearing as utterly calm, collected and charming.

In sum, you are better off not trying to fight performance anxiety. Let it happen! It happens

to the best of performers; they worked through it, and so can you. With that realization in mind, you can let the nervous energy work for you instead of against you. We conjure up all sorts of imaginative scenarios of what might happen to us in performance situations, but you probably have a greater chance of being struck by lightning than having one of the nightmares come true.

I spent several years as host of a television talk show. During that time, I interviewed roughly a thousand guests, many of whom had never appeared on television before. Some were candid with me and acknowledged that they were in a state of terror moments before airtime. Of those people, none, *not one, ever,* melted down on the air. Only one guest performed so poorly that the tape had to be stopped. The program was halted not because the guest was panicked, but because she was so unemotional and uncommunicative that I may as well have been interviewing an empty chair.

[6] The PBS series "American Masters," broadcast on WGBH-TV, Aug. 6, 1990.

SUMMARY

1. On-air newspeople need a solid grounding in journalism. No matter how well they appear or read copy, they won't be believable if they don't fully comprehend what they are saying.

2. Announcers today are misnamed, because they no longer *announce* in the strict sense of the word. Rather, they are expected to *communicate*.

3. An on-air broadcast newsperson needs to be energetic, believable and conversational.

4. Your voice can be improved if you pay attention to diaphragmatic breathing, elimination of distracting vocal habits, clear diction and proper pitch.

5. On-air newspeople need to adopt certain methods for putting their best foot forward. Among those methods are dressing correctly and working properly to cameras and mics.

6. Prompting devices allow you to maintain eye contact with the viewer, but using them properly requires technique and practice. One worthwhile ap-

proach is to read the third line down on the scroll; that way, you will have a comfortable cushion of copy above and below your line.

7. Whenever possible, and always when practicing, look over your copy and mark it up, using symbols to indicate proper pronunciations and to identify areas that need stress and emphasis.

8. You *must* inject energy into your on-air performance. Announcers who do not consciously boost their energy level appear lackluster and dull on-air.

9. Do not try to imitate other journalists. You can borrow bits and pieces of their technique, but trying to become a carbon copy of someone else is an attempt doomed to failure.

10. Ad-libbing is one of the most important parts of the job. Indeed, it is the task by which your potential may be judged. A successful ad-lib is planned in advance; you don't need to do a great deal of planning, or script the whole piece, but be sure to list a few *major points* that you want to stress. Encapsulate those points. Keep it short. Never try to pad an ad-lib.

11. Many performers feel anxious when going on-air. This is natural. Rather than fighting to control your nervousness you can recognize that it is a natural feeling and let it work *for* you.

EXERCISES

1. Pick a story from a local newspaper and prepare an ad-lib using the details from the article. The amount of notes you can use is limited to what you can fit on one side of a 3 × 5 index card. Remember to plan and encapsulate the story into a few main points. Bring the newspaper clipping with you the day you are to do the ad-lib before class or in the radio or TV studio. (*Hint:* Remember, when it comes to your notes, more is not necessarily better.)

2. In a brief paper, assume that you are producing a series of programs and cast well-known broadcast journalists to host the programs. Choose a different journalist for each. In your paper, explain precisely what qualities this journalist projects that make you feel he or she would be best for the job. Programs:

 a. A program to be carried live from a war zone, explaining American troop movements and filling in listeners or viewers on the latest developments.
 b. A 1-hour documentary on new advances in the treatment of cancer.
 c. A half-hour program featuring interviews with the country's wealthiest people. Your goal as producer is to disarm the people, perhaps deflate them a bit, and reveal their personalities as much as possible.

d. A talk show with a noted scientist. You need a host who can help the listeners or viewers relate to the scientist's philosophies and views of the future—all the while keeping their attention.

3. Using a portable tape recorder, describe something: The members of your car pool, the local swimming pool, the local pool hall, or the hall of records will do. In approximately 60 seconds, use *vivid* detail to help the listener form a clear mental picture of your subject.

12

ETHICS

Although journalists in the United States enjoy constitutionally protected freedoms, we realize that from a practical standpoint freedom of the press is not and cannot be absolute. There are *internal* and *external* restrictions that combine to draw lines on how far a news organization can go in covering a story, or how much privacy must be accorded a subject or how a wronged person can seek redress against the press.

For the sake of discussion, we can lump most of those internal controls under the broad category of ethical constraints, while external controls over the media are generally imposed by the government, usually the court system, in the form of laws. Those categories are not definitive nor completely mutually exclusive; they've been invented to provide an initial frame of reference.

This chapter will consider ethics. Chapter 13 will examine laws. Here, we will examine:

- The nature of ethics: what the field of ethics is and how ethics relate to journalistic decisions
- Ethics in the newsroom: how the principles of ethics are utilized in typical scenarios
- Codes of ethics: what they say, and why

The Nature of Ethics

You have probably noted that ethical issues are a recurring theme interwoven throughout the entire text. Why, then, is a separate chapter devoted to ethics?

The field of ethics (which we will define in a moment) is becoming inextricably linked with the practice and study of journalism. Although journalists usually don't spice their newsroom debates with quotations from philosophers such

as Kant, Bentham and Aristotle, *some do*—and even if they don't cite classical ethicists by name, journalists often invoke the principles that make up the infrastructure of ethics.

The ability to think about ethical terms and concepts is becoming integral to a journalist's daily routine. Debate about the ethics of journalism is liberally sprinkled with terms you would more commonly expect to find in dusty, leather-bound volumes—instead of in journalism trade journals or in works of media criticism. Consider these examples:

- Former CBS News President Fred Friendly recently advised viewers of the PBS series "Ethics in America" to adhere to a "categorical imperative." Act, he said, as though your principles would become a universal rule followed by everyone.

- A former managing editor once masterminded a controversial investigative piece about a judge who was involved in a series of bizarre scandals. After the story broke, the judge committed suicide. The editor, in recalling the incident, maintained that he was guided by the *utilitarian* principle of "producing the greatest good for the greatest number." It was troubling and tragic that the judge had killed himself, but this was a legitimate story about a public official. In the long run, more people were helped than hurt by the story.

Both cases illustrate classic methods of ethical reasoning, and also portray how the fields of journalism and ethics are being melded with increasing regularity. And those ethical principles make an examination of newsroom ethics a more orderly affair. This chapter will demonstrate that an understanding of the underpinnings of ethical thought can be much more useful than a case-by-case rote memorization of how journalists resolved various quandaries.

What do we mean by *ethics*? There are at least two definitions of ethics, the first being the branch of philosophy that studies questions of right or wrong. The second definition comprises the more common understanding of the term, and identifies ethical behavior with good behavior.

The word *moral* is sometimes used synonymously with *ethical*, although morality usually refers not so much to philosophy as to prevailing customs. We have a tendency to use the word *moral* in matters dealing primarily with those customs and not with fundamental questions of right or wrong. We would be far more likely to describe marital infidelity as "immoral" as opposed to "unethical."

Another point of usage: *Ethics*, when used to refer to the branch of philosophy, is treated as a singular noun, for example, "Ethics is a controversial subject." When referring to individual collections of ethical principles—"My personal ethics are quite flexible"—the word takes a plural form.

Having disposed of those matters, let's return to the idea that the study of journalism and the study of classical ethics are melding, as we probe some of the ethical dilemmas that have recently grabbed the attention of the listening and viewing public.

We'll relate some contemporary problems to this crash course in classical ethics. Thoughtful people have through centuries built frameworks for analysis of ethical dilemmas—and those frameworks are still very much in use today. The stuff of those dusty philosophical tomes has a *real impact* on understanding modern media decision making.

An initial point of analysis begins with the two camps into which philosophers tend to fall when discussing ethics: They are *consequentialists* or *non-consequentialists*. Some gravitate toward the middle, advocating an approach that adds up the pluses and the minuses and produces an average, or *mean*, that balances the two extremes (Figure 12.1).

Consequentialists believe that instead of attempting to judge whether an act itself is right

Figure 12.1 One view of ethical reasoning.

or wrong, the judgment should be predicated on the *outcome*. John Stuart Mill and Jeremy Bentham were noted consequentialists. They advocated a type of consequentialism called utilitarianism, the course of action that produces the greatest good for the greatest number, or as Mill put it, the greatest happiness. (Note that I'm oversimplifying; Mill and Bentham shared basic ideas but there are differences in their philosophies.)

Consequentialists will argue that the ends justify the means, and that *motives* are not a particularly relevant factor in that analysis. If someone saves me from drowning, a consequentialist might argue, it makes no difference if he saved me out of the goodness of his heart or because he wanted to get his picture on the 6 o'clock news. I was saved, and that's all that counts.

Non-consequentialists, on the other hand, contend that *results* are not the standards by which we should judge an action; *motives* are. Immanuel Kant was the most widely recognized non-consequentialist, and his philosophies still guide those who advocate adherence to the "categorical imperative." The categorical im-

perative means that each person should act as if his or her "maxim should become a universal law." Kant might argue that you have no right to steal food even if you are lost and starving. Stealing is wrong, he would contend, under *any* circumstances. It cannot *become right* when it proves convenient, because if everyone adopted that handy and painless approach to ethics, we would see theft become rampant as people bent their ethics to fit the situation.

Ethicists who have taken the middle ground put their trust in the individual's judgment. A person attempting to come up with an ethical solution to a problem would aim for a point halfway between excess and deficiency. Aristotle called this the *golden mean*. He claimed it was the quickest path to excellence, and that virtue is the mean between extremes—a mean that can be determined not by blind adherence to consequences, or to motives, but to rational principle . . . that principle by which the man or woman of practical reason would make a decision.

Consequentialist, non-consequentialist and golden mean thinking are used every day in analyses of ethical problems. Here is an example.

Most broadcast news departments do not air the names of suicide victims if those people are essentially private persons and the suicide an essentially private act. That is a *non-consequentialist* rule, grounded in the decent categorical imperative that families have already suffered enough at this point, and there is little to be gained by dragging the name of the victim out into the public spotlight. So we just won't use the name of the victim, ever.

But things don't always work out so neatly. Let's assume that the suicide victim was a popular young man, the captain of the football team, a person who seemingly had everything going for him. A *consequentialist* might argue that this is a case that merits breaking the rules. Why? Because it shatters the myth that only lonely, reclusive people take their own lives. Teen-age suicide is indeed a growing problem, and potential suicide victims often drop hints or display symptoms disclosing that they are at risk. Those symptoms, however, are frequently ignored by friends and family members who find it impossible to believe that popular kids kill themselves. "Sure," a consequentialist might argue, "using the victim's name will cause the family pain, but in the long run we'll save lives."

An advocate of the *golden mean* might search for a reasonable middle ground. Perhaps the story could be handled in such a way as to avoid identification of the victim. If they were willing, family members could be unidentified and be interviewed in silhouette, and thereby pass along their valuable albeit tragic experience to family and friends of other teens. (However, there are some serious problems with any compromise approach, and they will be pointed out shortly.)

Those are the most simplistic approaches to one common ethical dilemma. You will find those rationales (consequentialist, non-consequentialist and golden mean) served up at some point during almost every ethical debate. But remember that they are not foolproof formulas (they hardly could be foolproof, since conse-

quentialism and non-consequentialism are diametrically opposed to each other). At least, though, they help to illuminate our thinking patterns. We can shed light on whether we are thinking and arguing from a consequentialist, non-consequentialist or golden mean point of view.

Once we understand why we reason a particular way, we can take a step back and gain a clearer perspective of our thought process. We can also, by examining our thinking and the well-established criticisms of non-consequentialist, consequentialist and golden mean thinking, search for flaws in our ethical reasoning.

Here are some examples of ways in which we might sift through our reasoning process.

NON-CONSEQUENTIALISM: PRO AND CON

Arguments in Favor of Non-Consequentialism
Non-consequentialism has a strong philosophical base, and within the context of our example (the suicide victim) it offers many valid points. Why should we suddenly decide to break a rule because we *think* it will produce some benefit? What proof can we offer that airing the name of the suicide victim will prevent further suicides?

Another point follows: If we're not going to stick to a rule, what is the point of having it? Rules are meant for the tough choices; you cannot choose to invoke them only in the easy cases.

Those are the arguments non-consequentialists use to bolster their case. But their opponents can peck away at that logic.

Arguments Opposed to Non-Consequentialism
Critics of non-consequentialism argue that clinging to a categorical imperative is, in itself, logically inconsistent. Why? Because a non-consequentialist says that consequences don't count—but at the same time, he or she is *anticipating* consequences. By imposing a rule pro-

hibiting the use of suicide victims' names, for example, aren't we *predicting* consequences—*assuming* that we will besmirch the name of the victim, disgrace the family, glamorize suicide and so forth?

Also, it is arguable that we are blocking an act of good will—bringing the issue of teen-age suicide more directly into the spotlight—by blind adherence to a rule. Perhaps these are special circumstances that should cause us to change our thinking. We cannot adapt to unfolding situations if we are obsessed with following the rules.

CONSEQUENTIALISM: PRO AND CON

Arguments in Favor of Consequentialism The above-stated rebuttals to non-consequentialism serve as the consequentialist's platform when he or she defends the concept that the ends justify the means.

- We are not hidebound to a set of inflexible rules. We can adapt.
- We can look past the immediate situation and do what will provide the greatest good for the greatest number.
- We do not anticipate consequences while at the same time pretending to ignore them.

Arguments Opposed to Consequentialism Consequentialists also take their lumps in ethical analysis. As mentioned above, the consequentialist argument about preventing teen-age suicide sounds appealing, but how do we know what the outcome will be? Will breaking our rule and running the story deter teen-age suicide? Maybe. Maybe not.

Doesn't it make sense to base our decision on the premises of which we are sure: our policy that, for good reason, protects the privacy of the families of terribly disturbed people who, confronting their private demons, take their own lives?

THE GOLDEN MEAN: PRO AND CON

Arguments in Favor of Golden Mean Thinking
The best we can hope for is to make a rational decision based upon what we know. Instead of trying to predict the outcomes, and instead of clinging to an inflexible rule, we must add up pluses and minuses and come to a reasonable decision halfway between the extremes.

Arguments Opposed to Golden Mean Thinking Although the idea of adhering to a golden mean is appealing, there are self-reference problems involved. If you are the one making up the two extremes, you can still wind up with a distorted mean. ("How many people will I murder today, one or ten? Oh, let's compromise and make it five.")

On a more realistic level, let us also note that a compromise is not always the best solution. Since this is first and foremost a journalism text, we need to point out that there *may not be a reasonable middle ground* when reporting an event of this nature. You could not hedge indefinitely; it would be ludicrous to write a story about "the captain of the Central High School football team, whose name is being withheld." Also, if the event occurred in a public place, and many citizens witnessed rescue units dashing to the high school, you could be accused of showing poor judgment by going on-air at noon with a story saying, "a student died by suicide this morning at Central High" and not naming the student. That could start a panic among parents.

Ethics in the Newsroom

There is no precise right or wrong in a situation such as the one presented, and experienced newspeople can and do take opposite sides in the debate on breaking the rules and using suicide victims' names. And although our intro-

duction to consequentialism, non-consequentialism and golden mean thinking won't solve the problem, it at least gives us an insight into the thought processes involved, and provides a more ordered way to evaluate our thinking.

The case outlined above is not entirely hypothetical. It is based on an event that occurred in Minnesota, and the arguments used mirror many of the contentions made by members of the news media in the Minneapolis-St. Paul market as they tried to sort out this sensitive issue. (The details presented in the discussion are identical to the actual situation. Some news organizations initially withheld the name, while others used it. Eventually, after the identity of the victim became common knowledge, the name was used by most of the media.)

The suicide story, which primarily hinged on a question of privacy (privacy is a weighty issue and as such is addressed more fully in the next chapter), was used as an opening illustration because it clearly depicts how there often is no easily identifiable right or wrong in a given situation.

The same holds true for some of the more typical topics of debate in journalism ethics: *truth, objectivity, fairness, conflict of interest, sensationalism* and *misrepresentation*.

TRUTH

Truth is a sacred tenet of journalism, but *truth* is not always an easy term to define. There are many *shades* of truth, and fundamentally correct information can be used to convey a false impression. For example, a school board candidate could rightly contend that half the reading scores in the district are below average, and might insert this in a press release that ostensibly proves that education in the city is substandard (*obviously* the fault of the incumbent!). An average, of course, is taken to mean the point where half are above and half are below, so *of course* half the students' scores will be below average.

This is a case in which the candidate probably knew the truth but was unwilling to tell it. Or, perhaps he or she is statistically illiterate and did not have the ability to understand why the statement is misleading.

In either event, willingness and ability to tell the truth (as discussed in Chapter 4) are major considerations when weighing the contributions of any sources, particularly anonymous ones. Most news organizations require that a story based on unidentified sources must be backed up by two or more such sources, or that the tip must be verified some other way. That procedure is not always possible. Experienced journalists sometimes feel justified in proceeding with a story based on a tip from a single, unidentified source.

Richard Petrow, the journalism professor and former network news producer we met in Chapter 4, encountered such an ethical dilemma when he worked as a television journalist in New York. He received a tip from a source informing him that a local politician was about to be indicted on criminal charges. Petrow could obtain no further information. And the clock was ticking.

Before letting you in on his decision, let's briefly note that using an unattributed source is risky because people will often provide inaccurate facts—either accidentally or on purpose—when they know that they are not going to be held *publicly accountable* for those statements. Therefore, the journalist in the middle must decide on the veracity of the item and the source.

Petrow decided to run the story. His ethical reasoning process (fundamentally a consequentialist rationale for running a story with much less confirmation than he would have liked to have had) was this:

1. He knew the source and felt the source had no ax to grind. In other words, the source of

the information did not stand to benefit by the revelation of the embarrassing information. The source, then, was *willing* to tell the truth.

2. Petrow also knew that the source had access to the indictment proceedings, and had been truthful when providing past tips. In addition, the politician had been involved in previous dealings that Petrow characterized as being on the outskirts of legality.

The story proved true, but Petrow's station never used it. ("Cautious lawyers," he maintains.) Petrow gave the story to a newspaper, which did run it.

OBJECTIVITY

An objective reporter is supposed to report just the facts and keep his or her personal opinions out of the piece. Sometimes, this is relatively straightforward. If you are a Republican reporting on a Democratic candidate, there is generally no insurmountable problem involved in keeping your personal perspective out of the piece. That is because the issues are relatively clear-cut; you can sort them out in your mind, saying, "I don't agree with what Politician A says but I will report it without overloading my story with my sentiments. I may call her statements into question if there is a clear error of fact or interpretation, but I will not use this as a forum for my personal views."

But other problems with objectivity run far deeper than sorting out election issues. In partisan politics, we're familiar with the whole field of events, and therefore have a clear idea of what a down-the-middle report will be. In other cases, though, we're pulled and tugged by issues about which we may not be consciously aware.

For example, can a reporter shed his or her ethnic, social and economic background when working on a story? Can the journalist always maintain a lofty perspective when dealing with stories that hit uncomfortably close to home?

Those were some of the questions that come to haunt the news media after the post-mortem of press coverage of the Stuart murder case. Briefly, the facts are these:

On October 24, 1989, CBS News broadcast a report of a horrifying incident that had taken place the night before in Boston. The piece, according to some observers, including former CBS News President Fred Friendly, "set a national agenda"[1] for what would be a disturbing blow to the accuracy and objectivity of the news media.

The television report, prepared by CBS reporter Betsy Aaron and aired on "The CBS Evening News with Dan Rather," opened with video footage of a woman slumped across the seat of an auto, while emergency medical technicians attempted to remove her from the vehicle. The story unfolded as in Figure 12.2.

The Stuart case would shake the public's faith in the journalistic precept of objectivity and the related assumption that an objective story will be accurate in tone and content. Why? Because Charles Stuart had apparently fabricated the gunman story. In January 1990, Stuart's brother offered damning evidence to indicate that Charles Stuart had killed his wife and inflicted his own gunshot wound. And when the net began to tighten, and police identified Charles Stuart as the prime suspect in the death of his wife and infant son, Stuart killed himself, jumping into the icy waters of Boston Harbor.

Stuart's tale that he and his wife were shot by a black gunman was relayed at face value by most media for weeks after the story broke.

[1] Remark made on the program "The Other Side of the News," Columbia University Seminar, videotaped Jan. 17, 1990.

Figure 12.2 Broadcast transcript of Stuart murder case.

VIDEO	AUDIO
PARAMEDICS WORKING TO EXTRACT WOMAN FROM AUTO	Chuck Stuart: I've been shot . . .
	Reporter: A husband calls 911 from his car phone . . .
BRIEF SHOT OF POLICE DEPARTMENT EMERGENCY SWITCHBOARD	Police officer: Where are you now, sir? Can you indicate to me?
CU CAR PHONE	Chuck Stuart: No, I don't know . . . he made us go to an abandoned area, I don't see any sights . . . oh, God . . .
PHOTOS, SIDE BY SIDE OF CHUCK AND CAROL STUART, BOTH SMILING	Reporter: Carol and Charles Stuart had just left a birthing class at Boston's Brigham and Women's Hospital, when a gunman
RETURN TO CAR, POLICE AND PARAMEDICS	forced his way into the car, robbed them of a hundred dollars and two watches, and then shot them.
CU CAROL IN CAR	Carol, with a bullet in her head, was slumped but breathing beside her husband. Charles, with a bullet in his abdomen, picked up the car phone to call for help.
	911 operator: Is your wife breathing?
	Chuck Stuart: Oh, man, ahhh . . .

VIDEO	AUDIO
SHOT OF CAROL BEING UNLOADED FROM CAR BY PARAMEDICS	911 operator: Hang in there with me, Chuck.
SHOT OF CHUCK BEING LOADED INTO AMBULANCE	Chuck Stuart: Oh, man, I'm going to pass out.
	911 operator: Chuck!
	Chuck Stuart: I'm blanking out.
	911 operator: You can't blank out on me, I need you, man . . . I need a little better location to find you immediately. Hello, Chuck? Chuck? Can you hear me, Chuck?
	Reporter: For 13 minutes, Massachusetts State Police Dispatcher Gary McLaughlin kept Chuck Stuart talking.
CU DISPATCHER MCLAUGHLIN	McLaughlin: This is our job, that's what we do every day.
SHOT OF AMBULANCE	Reporter: No call has ever been like this one.
AMBULANCE SPEEDING DOWN ROADWAY	When Chuck Stuart lost consciousness, his phone was still open. Police were able to locate the car by listening to the sound of the sirens over the phone.
INTERIOR SHOT OF AMBULANCE	Carol Stuart was rushed to Brigham and Women's Hospital, where doctors

continued

Figure 12.2 *continued*	VIDEO	AUDIO
		performed an emergency Caesarean section, removing her son.
	AMBULANCE PULLING AWAY	And then she died.
	SHOT OF CHUCK STUART BEING ATTENDED TO BY PARAMEDICS	Chuck Stuart is in Boston City Hospital in fair condition.
	INTERIOR OF AMBULANCE	He was able to give police a sketchy description of the gunman. There has been no information released on the condition of Chuck Stuart's son. Betsy Aaron, CBS News, Boston.

After the apparent truth came out, the media were confronted by a thorny question. Why was the evidence in the Stuart case believed, digested and regurgitated so uncritically by the news media?

Media critic Mark Jankowitz of the *Boston Phoenix* noted in a television interview that "page one of the manual" tells a crime reporter to "assume that the spouse is the suspect." In this case, Jankowitz admitted, "we slipped up. If there's one lesson to be learned from this [it is the need for] independent investigation."[2]

In fact, many journalists *did* harbor suspicions about the case, but those doubts were never aired or printed. This exchange that took place during a Columbia University Seminar[3] helps outline the situation. During the seminar, Fred Friendly and Bill Kovach, the curator of Harvard's Neiman Foundation (an institute for the study of the press), discussed a sensitive issue relating to reporters' objectivity in the Stuart case:

Kovach: *From the beginning of this story, every journalist covering it was skeptical of the story as it first came out.*

Friendly: *But I've read all the papers, I've seen all the television . . . I've never heard anybody express any cynicism or skepticism. The skepticism was all in the closet. How come the newspapers and the television didn't say, "Yes, but . . ."?*

Kovach: *That's a question I have. I have talked to the journalists involved and they were skeptical . . . I did not see the skepticism reflected in terms of "alleged," "allegations," "police say." Most of the accusations were flat, accusatory statements.*

Friendly also noted that the coverage turned the Stuarts into martyrs, and the press—

[2]Mark Jankowitz, "This Week with Connie Chung," television interview, Jan. 12, 1990.

[3]"The Other Side of the News," Columbia University Seminar, videotaped Jan. 17, 1990.

reflecting a need for compelling stories that display the good versus the bad—portrayed them as an all-American family, victims with whom *the reporters identified*.

After the fact, many journalists were willing to admit that such personal identification blurred their objectivity. For example, the *Phoenix*'s Jankowitz pointed out that "this was a ready-made for media crime." It was a story, he alleged, that depicted ordinary people (presumably ordinary middle-class people whose circumstances bear a strong resemblance to the lives of journalists) who left an inner-city hospital "and took a right turn into hell."[4]

In retrospect, there are many processes that went wrong in the coverage of the Stuart case; among them is the way information is sanctified once it is printed or broadcast by one news organization. Other media may uncritically repeat the story.

But a deeper problem precipitates lapses in objectivity and accuracy, and that is the unfortunate truth that we, as humans, are simply not capable of dealing with *facts* per se. A "fact" is not a tangible object. It becomes a fact only after we have filtered it through our personal set of ideas and perceptions. The image of a white, middle-class couple being victimized by a black robber was probably one easily accepted by the news media—the majority of whom are white and middle class.

That is why some members and critics of the media insist that objectivity is an elusive quality at best. Walter Lippmann, a journalist, political scientist and something of a public philosopher, wrote an influential book titled *Public Opinion*, in which he argued that we interpret events in the world outside in accordance with the "pictures in our heads"—meaning that objective interpretation of fact is profoundly difficult because of the influence of our individual experiences and memories.

The Stuart case should not be taken as an indictment of the news media, since no one is immune to being misled by a bizarre and sinister plot. If anything, it is a good example of how golden mean thinking can lead us astray if our *premises* are wrong. Coverage of the event did appear to be objective, if we mean that it was not intended to be inflammatory and did attempt to present a reasoned point of view. Unfortunately, self-reference problems narrowed our focus to the point where we wore blinders.

FAIRNESS

Fairness and objectivity are not quite the same quality, although the concepts are strongly related. While *objectivity* implies that we have a neutral mind going into the story, *fairness* usually means a forthright balance within the story. If we're fair, we present differing sides of the story.

Reporters seeking to be fair usually try to *mechanically* balance the story. Note how stories about proposed sanctions against the sale of semiautomatic weapons typically include a spokesperson from a prominent pro-gun lobby who presents a view opposing such control. By including an opposing view, we ostensibly show that we have been fair-minded in assembling the report.

But mechanical balance does not necessarily ensure fairness, and some critics view it as a knee-jerk reaction to a complex issue. Edward R. Murrow once half-jokingly contended that adherence to a mechanical-balance mentality would compel reporters to give Judas equal space for his point of view if they were recounting the story of the Bible.

Modern critics cite contemporary problems in our attempts at fairness, too. *Time* magazine news critic Thomas Griffith alleges that news organizations increasingly concerned about their credibility "parade" their fairness. "Let so-and-so be accused of defrauding a widow," Griffith contends, "and *The New York Times* will meticu-

[4]"Other Side of the News."

lously note that he 'did not return phone calls. A guilty person can no longer just hide out waiting for a story to blow over; he also stands convicted of not answering his phone."[5]

Despite the fact that such attempts at fairness may not always work perfectly, they're better than making no attempt at all. Many news organizations have policies requiring that reporters ask for a response to unofficial charges. Even when not required to do so by a code of ethics or book of procedures, most reporters strive for balance by seeking a response to controversial issues and unofficial charges. Note that "unofficial charges" refers to a contention that is not leveled as part of the legal system; journalists are not compelled to ask for reaction from someone officially arrested and charged.

Again, balancing a story to make it fair and to make it objective is a worthy but elusive goal. At best, you can hope to meet these criteria:

■ Do include the opposing view, but don't be afraid to use your good judgment about how much should be included. A story about the governor's race merits a 50-50 split in time and attention, assuming there are two candidates. But during early primaries you cannot hope to incorporate all 12 candidates into every story. (More on the nuances of this type of coverage follows in the next chapter.)

 At the same time, remember that you cannot and need not balance every story. Thirty seconds with the secretary of state and 30 seconds with a terrorist do not necessarily make a balanced story.

■ Be sure that the story presents an overall perspective. Don't lead with something unrepresentative of what happened. For example, avoid using a brief shouting match as the top

of your story on the city council, unless that shouting match was really important.

■ Look for unanswered questions—and ask them. The questions we don't ask are often the ones that betray our lack of objectivity. Force yourself to think in different directions. Ask *why* so-and-so is or is not a suspect. Ask *how* this issue became a news item—was it legitimate news or the efforts of a pressure group?

■ Get information from a variety of sources. Interpretations of what happened can be *drastically* different. Get as many versions of the story as possible. You don't have to use each version, necessarily; just mentally put it in your "perspective" file.

CONFLICTS OF INTEREST

In Chapter 2, we briefly touched upon the fact that it is not unusual for newspeople to become friendly with, and work closely with, public relations representatives. The same holds true for journalists' relationships with public officials and others frequently in the news. And reporters are likely to develop friendships, or at least cordial relationships, with people they cover.

How close is too close? That is a good question, and a difficult one. Walter Lippmann maintained that there are rules of "hygiene" a journalist should follow when interacting with a source, but that did not stop Lippmann from helping U.S. presidents write their speeches.

You may soon find yourself handling cases where an important public official—a mayor or police chief—becomes a friend and/or a valuable news source. The time may come when that friend asks you to run a story that is more fluff than news. Or perhaps an important official provides you with a wellspring of valuable news, but you come across a negative story concerning your confidant. Do you air it and risk losing a friend and a source?

[5]Thomas Griffith, "The Trouble with Being Fair," *Time* (Jan. 27, 1986): 61.

Publicly, many journalists would proclaim that they would not be influenced by their friendships or by the possibility of losing a source. Privately, virtually all will admit to a hazy area in which there are no clear answers. You'll have to rely on your own best judgment. Perhaps you will placate your source by using a piece of marginal news value, as long as that piece is harmless, not misleading and does not squeeze out other legitimate news. Some would argue that this is a small price to pay for continued information from a good source. Others argue that personal considerations should never enter into journalistic decisions—a sound philosophy but one that may dry up your sources.

The situation becomes more clear-cut, however, when conflicts of interest involve the exchange of something of value. That's clearly out of bounds. But the definition of "something of value" is vague. Are you compromised if a source buys you a cup of coffee? Not really. How about a lobster dinner? Probably. Even if you're not influenced, the expensive dinner may give the *appearance* that you are in your benefactor's pocket.

Extracurricular activities also pose a problem. News organizations frown on outside activities that create a conflict of interest or the appearance of such a conflict, although—again—the definition of the "unacceptable" activity varies widely. Some news departments prohibit staffers from teaching college journalism classes, partly on the grounds that the reporter may have to cover a story involving the college (his or her part-time employer) and could therefore have his or her integrity questioned.

The majority of news departments will not allow a journalist to do commercials, although some news anchors do read commercials (especially on all-news radio stations). Any relationship between a journalist and a sponsor is rather "unhygienic" on the face of things; the arrangement poses possible conflicts if the reporter has to cover a story involving the sponsor or the sponsor's competitors.

Almost all news organizations prohibit currently employed reporters from running for public office. In most cases, there is an obvious and clearly compelling reason: An anchor cannot possibly run for city council and objectively report on his or her campaign. (And even if he or she could, who would believe it?) But the issues do get blurry with non-partisan offices. Is it all right for the news director of a radio station to be an officer in a parent-teacher organization? Or belong to a downtown beautification committee? Some stations would object; others would not.

Perhaps the most flagrant conflict of interest involves benefitting from inside information. Here the lines are clear: If, in your capacity as a business reporter, you learn that a local firm is going to be the subject of a takeover bid, it is unethical for you to buy stock in that firm. Period.

But much of the conflict of interest debate is cloudy because individual situations vary to such a great extent. The wisest course is not to become mired in all the possible permutations and to adhere to your news department's policy. In addition, follow the guidelines listed below.

First, it is inevitable that you will find yourself in contact with sources in social and civic situations. But although social contacts with sources are permissible at certain levels, close friendships will endanger your judgment or at the very least compromise your *appearance* of possessing unclouded judgment.

The next guideline regards the important people you will meet as a broadcast journalist. That is one of the nice aspects of the job. Those important people may someday start asking you for advice. That is flattering but dangerous— because what they're often really asking is, "How can I get good coverage in your newscast?" How can you critically examine an idea when it was ostensibly *yours* in the first place? Remember that your job is to report on policy, not to dictate it.

Another interesting aspect of being a reporter is that people want to give you things.

The problem is that these things are rarely free; a number of strings are usually attached, somewhere, somehow. Tickets to the debut of the new play are often a ploy for a plug, and free trips may be a method of garnering good publicity for a vacation spot.

The rules on freebies have changed considerably in the past couple of decades. Many news departments now specify that reporters will buy their own meals when dining with sources or buy their own tickets to sporting events or plays. Such gifts used to be routine and were considered by many to be perquisites of the job. But those days are gone. Your news department may have formal guidelines on what you can and cannot accept. Remember that if it looks like a bribe and sounds like a bribe, it probably *is* a bribe, despite your efforts to rationalize otherwise.

A final tip on the journalist's conflict of interest issue concerns personal opinions. Although you have every right to your views on politics, civic affairs, education and so forth, it is wise to guard your opinions a little more tightly than the average person. For example, there have been recent controversies over whether reporters should be allowed to engage in public demonstrations. Although no news organization expects a journalist to abandon his or her beliefs, news organizations do worry about the credibility of their coverage. That credibility is damaged when a journalist is openly partisan on an issue.

Most journalists probably do believe they can report objectively and fairly on an issue even if they have marched in a protest rally concerning that very issue. But it is doubtful that all the listening or viewing public can be persuaded of that. As a result, you may inadvertently damage your cause because when you only report on a positive issue related to the cause, your audience may suspect that your coverage is biased.

The suggestions presented here provide a convenient non-consequentialist rationale for avoiding conflicts of interest. Adopting a blanket rule against accepting a free meal from anyone spares you the endless equivocation of trying to determine, on a case-by-case basis, if you are providing the greatest service to your audience by putting yourself in a potentially compromising position.

SENSATIONALISM

Critics of broadcast journalism level the charge of sensationalism with some regularity, but these contentions are difficult to prove because it is nearly impossible to define sensationalism or, closer to the root of the matter, to determine what is offensive to whom.

There is no question that in a business dependent upon ratings points some journalists will adopt a wildly consequentialist, ends-justify-the-means approach to garnering viewers. "Tabloid" TV shows militantly exploit sensationalism; a recent teaser, "New skimpy bathing suit banned on Florida beaches . . . stay tuned!" immediately comes to mind.

Revealing bathing suits, however, are mild examples; the deadly serious problems relating to broadcasting sensational material pose formidable ethical quandaries. In January 1987, Pennsylvania State Treasurer R. Budd Dwyer, who was under investigation for fraud charges, called a news conference. Before the assembled reporters and cameras, he shot himself in the mouth with a powerful handgun.

The television tape and still photos were made available to media across the nation, who found themselves confronted with a very difficult predicament. What amount of material should be aired? Would anything be accomplished—other than pandering to morbid curiosity—by showing the actual moment when the bullet tore through Dwyer's skull?

Major TV networks did not run tape of the precise instant of impact on their newscasts.

But some local stations did, including a station in Harrisburg, the state capital. Similarly grotesque photos were run in some newspapers.

The majority of opinion in the industry seemed to fall heavily in favor of not showing the gruesome details. In fact, stations that *did* were roundly condemned by many in the journalistic community, who reasoned thusly: Depicting the instant of death was not essential to the story. The full set of relevant facts could be communicated without the ghoulish replay of an event that was an intensely private agony of a seriously disturbed man.

The issue of sensationalism will not be settled soon. Some who have studied the matter maintain that the best you can do is to consider your own motives in a detached, non-consequentialist manner; in other words, if you are running a story *only* because it is sensational it probably isn't news.

But remember that "news" is not a scientifically defined commodity. If you subscribe to the theory that news is what your listeners and viewers are interested in, then the decision becomes more complicated. After all, virtually everyone is interested in some aspect of the unusual, the extraordinary, even the grotesque. Journalism Professor John D. Stevens, who has chronicled some of the history of sensationalism in news, suggests that

> Perhaps the real reason for anger at the mass media for sensationalism is that most adults realize they are morbidly fascinated by sex and violence and wish they were not. They have not resolved their ambiguous attitudes, and they dislike the media for forcing them to confront their own uncertainties. As Pogo Possum said, "we have met the enemy, and they are us."[6]

[6]John D. Stevens, "Sensationalism in Perspective," *Journalism Quarterly,* 12:3–4 (Winter-Autumn 1985): 79.

MISREPRESENTATION

What is your opinion on this scenario?

You are doing a story on the homeless. To further your investigation, you pose as a bag lady. Is this a proper way to pursue a story?

Don't be concerned with being right or wrong, because there is no clear-cut answer. Critics and journalists came down on both sides of the fence on this case, a real one, which we will discuss in a moment.

First, an observation about the ethical implications of misrepresentation. In general, a journalist ventures into muddy and dangerous waters when he or she pretends to be someone else. Sometimes misrepresentation is not only blatantly unethical but illegal; posing as a uniformed police officer will not only get you fired but jailed in the process. But in other cases, we allow for *a degree* of misrepresentation.

The ever-popular story in which a reporter drives his or her perfectly tuned auto into a repair shop is a good example. Here, the misrepresentation involves simply not telling anyone you are a reporter and doing something that any citizen has a right to do. (As far as I know, there is no law prohibiting a private citizen from testing the honesty of an auto repair shop by bringing in a mechanically sound car.)

So, let's assume that the "fix-my-car" ruse is within acceptable boundaries. But is it going too far to paint on fake bruises and pose as a bag lady in order to gather information for a story on the homeless? Some critics thought so, and lambasted WNBC-TV (New York) anchor Pat Harper for her masquerade, maintaining that she exploited the plight of the homeless by her misrepresentation.

Others, though, defended Harper, saying that some misrepresentation is permissible if it is the only way to get the story, and Harper certainly got a sharper insight into the problem

than she possibly could have by maintaining her identity as an anchorwoman and conducting interviews. CBS' "60 Minutes" Executive Producer Don Hewitt, speaking in support of Harper's actions, used a strong strain of consequentialist reasoning: "Misrepresentation," he said, "is probably not a good idea, but in specific cases it's a sensational idea."[7]

The industry's ambivalence toward misrepresentation by journalists is often reflected in written policy. Officially, many news organizations frown on misrepresentation but still allow it in *specific cases* where it is deemed appropriate—usually, when it is the only way to get the story. Conventional wisdom seems to dictate that necessity plays a strong consequentialist role in the ethics of deception.

The *degree* of misrepresentation also tips the ethical scale. Posing as a police officer would be considered a serious ethical breach by most if not all news organizations. However, there are several acres of gray area covered in the definition of the word *posing*. I have walked into many a crime scene where I was not supposed to be, knowing full well that any man with a moustache and closely cropped hair is practically invisible in a mix of police from various departments who may or may not know each other. In such a case the degree of artifice was not carried to an extreme. I didn't flash a badge or pretend to be someone I was not. When my identity was questioned, I excused myself and left the scene.

From gauging the reaction among journalists, we can assume that the degree of deception plays an important role in ethical judgments relating to impersonation. Any citizen can take his or her car to a repair shop, even if there's nothing wrong with the auto. Not telling the mechanic of your identity as a reporter is a small degree of artifice and deception. But posing as a police officer—stating you are a law enforcement agent and/or flashing a badge—allows you privileges and power you do not rightly have. There, the degree of artifice is high enough to merit unanimous condemnation.

It might be noted, however, that the legendary Mr. Hewitt, one of TV news' pioneers and still one of its major players, once managed to skirt the very edge of this proscription. During the 1959 visit of Nikita Khrushchev to a farm in Iowa, Hewitt, arriving to coordinate CBS' coverage, first took care of some small items of business, including hijacking NBC's remote truck and hiding it in a cornfield. He then set about the serious task of spying on NBC.

Hewitt hired the local ex-police chief as a driver, guaranteeing CBS crews access to any place they wanted to go. But to prepare for those times when the ex-chief was not around, Hewitt had himself appointed "honorary sheriff." The next day, sporting his new badge and Stetson, Hewitt wandered over to the NBC remote truck. (They had found it by then.)

"Morning boys," said Hewitt. "What's goin' on?" And the NBC crew told the "sheriff" *exactly* what was going on, including the placement of their secret cameras.

NBC later complained about Hewitt impersonating a police officer. "I'm not impersonating anything," Hewitt replied. "I'm an honorary sheriff and I've got the hat and badge to prove it."[8]

One of the oddities of the news business is that while codes of ethics and the general professional demeanor of newspeople stress a high ethical and moral tone, escapades on the fringes of ethical conduct often become the stuff of which journalistic legends are made.

[7]Hewitt quoted by N. D. Palmer, "Going After the Truth in Disguise: The Ethics of Misrepresentation," *Washington Journalism Review* (November 1987): 20–22.

[8]Don Hewitt, *Minute by Minute* (New York: Random House, 1985), p. 165.

Still, there are those who reject the consequentialism shown by Hewitt and maintain a categorical imperative against all forms of misrepresentation. Ben Bradlee, the executive editor of the *Washington Post*, opposes any and all use of misrepresentation.

He pounded this point home in journalism's most noted case involving misrepresentation, the Mirage affair. In 1978, the *Chicago Sun-Times* newspaper set up a bar, appropriately named the Mirage, and conducted an investigation exposing the ways in which city officials extorted bribes from tavern owners. Despite high expectations, the series did not win a Pulitzer Prize. Two members of the Pulitzer advisory board (one of whom was the Post's Bradlee) objected to the means used to obtain the end result. Bradlee questioned how newspapers could promote honesty and integrity when they, themselves, are dishonest in gathering facts for the story.[9]

C *odes of Ethics*

You can readily observe from the dilemma surrounding the issue of misrepresentation that there is no universal standard of ethics agreeable to all journalists. But there are ethical codes, both at the national level and at individual news organizations. Some news departments' ethics codes are largely informal, either passed along verbally or assembled in memo fashion, while others are extensively detailed via formal written documentation.

National codes promulgated by professional organizations serve as models for local codes and set consistent standards, but those national organizations hold no real enforcement power. The codes most applicable to broadcast journalists are the codes of ethics of the Society of Professional Journalists (an organization that formerly was known as the Society of Professional Journalists/Sigma Delta Chi) and the Radio-Television News Directors Association (RTNDA).

Instead of presenting these codes in a pro forma manner, we'll examine the content of these codes more closely, and include in our analysis two other major national codes: those of the American Society of Newspaper Editors and the Associated Press Managing Editors Association. Because ethics is an issue that is not limited to broadcasting, a cross-disciplinary view is illuminating. The summaries and comparisons below will give you a reasonably comprehensive understanding of how news organizations view the issues surrounding journalism ethics.[10]

THE SOCIETY OF PROFESSIONAL JOURNALISTS

The Code of Ethics of the Society of Professional Journalists was adopted in 1926, and revised in 1973, 1984 and 1987. The 1987 revision was a hotly contested one—the organization's members' magazine still bristles with comment about it—because that revision removed a self-censure clause

[9]The Pulitzer's snubbing of the Mirage story came as a surprise, since the Pulitzer had gone, on at least four previous occasions, to reporters who assumed a guise. A newspaper reporter from the *Buffalo Evening News*, who posed as a caseworker to expose welfare mismanagement, received the coveted award in 1961. A journalist from the *Chicago Tribune* who masqueraded as an ambulance driver in 1971 to bring to light the discrepancies in medical care given to rich and poor won a Pulitzer. In 1971, a reporter from the *New York Daily News* pretended to be a medicaid recipient and won the award, as did Bob Greene and a *Newsday* team involved in a story about the drug trade, during the development of which Greene posed as a lawyer. For further details on misrepresentation and the Pulitzer committee, see Tom Goldstein, *The News at Any Cost* (New York: Simon & Schuster, 1985), pp. 127–151.

[10]Summaries adapted from author's work, *Crisis of Conscience: Perspectives on Journalism Ethics*, to be published in 1992 by HarperCollins Publishers.

from the code. The previous code ended with a pledge stating, in part, that "journalists should actively censure and try to prevent violations of these standards, and they should encourage their observance by all newspeople." The 1987 revision modified the comparable portion of the pledge to read: "The Society shall—by programs of education and other means—encourage individual journalists to adhere to these tenets, and shall encourage journalistic publications and broadcasters to recognize their responsibility to frame codes of ethics in concert with their employees to serve as guidelines in furthering these goals." (*Censure* to *encourage* is a sizeable semantic shift.)

Other sections of the SPJ code are grouped under five headings: Responsibility, Freedom of the Press, Ethics, Accuracy and Objectivity and Fair Play. Entries under the first two headings make reference to "the public's right to know of events of public importance and interest," and the "inalienable right" of press freedom. There are six entries under the ethics heading; many restate the obvious ("plagiarism is dishonest") but others are quite specific. Point 2 of the ethics section, for example, advises that secondary employment, political involvement, holding public office and service in community organizations should be avoided if "it compromises the integrity of journalists and their employers." The ethics section also cautions reporters to avoid freebies. "Nothing of value," the code flatly states, "shall be accepted."

The accuracy and objectivity heading stresses the journalist's responsibility for telling the truth, obtaining information from reliable sources and ensuring that "newspaper headlines should be fully warranted by the content of the articles they accompany." (SPJ membership is open to broadcasters and members of the print media, as well as educators, students and professionals involved in other non-news media.) Photographs and telecasts should "give an accurate picture of an event and not highlight an incident out of context." Reporting and commentary, the code advises, must always be clearly separated and commentary must be labeled as such.

Under Fair Play, SPJ members are advised that they will at all times show respect for the "dignity, privacy, rights, and well-being of people encountered in the course of gathering the news." Also, there is a specific mention that newspeople should not communicate "unofficial charges affecting reputation or moral character without giving the accused a chance to reply." It is also noted that journalists should be accountable to the public and the public should be encouraged to voice grievances against the media.

RADIO-TELEVISION NEWS DIRECTORS ASSOCIATION

The Code of Broadcast News Ethics of the Radio-Television News Directors Association is briefer than the SPJ code, listing seven fundamental points, the last of which is another admonition to "encourage" observance of the code by all journalists.

There are many similarities to the SPJ code in regard to integrity (declining gifts) and respecting the dignity, privacy and well-being of people with whom broadcast journalists deal. The first point in the credo (there are no headings) implores members to be accurate, keep news and commentary respectably compartmentalized, and not mislead the public into believing that something that is staged and rehearsed is spontaneous.

The RTNDA code calls for members to respect the confidentiality of sources. The code also advises members to promptly acknowledge and correct errors.

AMERICAN SOCIETY OF NEWSPAPER EDITORS

The American Society of Newspaper Editors (ASNE) Statement of Principles was adopted in 1975, and replaced the 1922 code of ethics that was origi-

nally titled *Canons of Journalism.* It contains six articles, dealing with responsibility, freedom of the press, independence, truth and accuracy, impartiality and fair play. It reads very much like a shortened version of the SPJ code, and calls for the standard virtues of separation of commentary and reporting, and freedom of the press (warning that the "press must be vigilant against all who would exploit the press for selfish purpose").

The ASNE Statement of Principles also cautions journalists not to give even the impression of impropriety, and includes a mandate that all persons "publicly accused should be given the earliest opportunity to respond." The Statement also urges that pledges of confidentiality be honored "at all costs."

ASSOCIATED PRESS MANAGING EDITORS ASSOCIATION

The Associated Press Managing Editors Association Code of Ethics is roughly the same length as the ASNE code, and is similar in focus. There are four major headings: Responsibility, Accuracy, Integrity and Conflicts of Interests. The code is similar to others examined so far, but has an admonishment found in the ASNE code but not RTNDA or SPJ that news sources should be disclosed unless there is a "clear reason not to do so." (In other words, don't use unidentified sources if you can possibly avoid it.) When it is necessary to protect the confidentiality of a source, the code instructs, "the reason should be explained."

The AP code concludes with this observation, unstated and not implied in the three other codes: "No code of ethics," it reads, "can prejudge every situation. Common sense and good judgment are required in applying ethical principles to newspaper realities." Individual newspapers are encouraged to augment these guidelines with locally produced codes that apply more specifically to their own situations.

COMPARING THE CODES

After examination of the codes, it becomes obvious that certain principles are commonly stressed among most or all of the documents:

1. *Conflict of interest.* All four of the major codes admonish newspeople not to put themselves in positions that compromise their integrity or *appear* to compromise their integrity. "Gifts" are directly prohibited in three of the codes (SPJ, RTNDA, AP Managing Editors) and indirectly in the ASNE Statement, which prohibits accepting "anything of value." The codes also make reference to other compromising activities at various levels of specificity.

2. *Accuracy.* The words *accurate* and *truth* are mentioned in all four major national codes. *Objectivity* and similar concepts appear throughout the codes, also.

3. *Constitutional privilege* is mentioned directly by SPJ ("our constitutional role to seek the truth") and the ASNE. An extensional privilege, the "public's right to know," is mentioned by the SPJ code, the AP code and indirectly ("guarantees to the people through their press a constitutional right") by the ASNE code.

4. *Protecting confidential sources of information* is mentioned explicitly in all four codes. The AP and ASNE codes mention that anonymity of sources should be avoided if possible; SPJ and RTNDA make no such mention.

5. *Recognition and correction of errors* is explicitly mandated by all four codes.

6. *Issues of context* are recognized in all codes. The RTNDA and the SPJ codes get into specifics about the use of video (for RTNDA and SPJ) and headlines and photos (SPJ); the codes mandate that such elements be used in a way that does not mislead.

7. *Separation of news and commentary* is mandated by all four major codes. Interestingly, some codes indicate an *obligation* to provide commentary, or at least some type of advocacy journalism. The AP code goes as far as to claim, "The newspaper should serve as a constructive critic of all segments of society. Editorially, it should advocate needed reform or innovations in the public interest. It should expose wrongdoing or misuse of power, public or private."

8. All codes have various allusions to broad principles of respect for the truth, the reading/viewing/listening public, and all prominently mention the word *responsibility*. All codes explicitly or implicitly recognize an individual's right to privacy.

Of particular interest in this analysis is point 6, the context issue. The AP code gives the strongest recognition of the role of complete context in presenting a fair picture—and invents a verb in the process—when it advocates that "the newspaper should background, with the facts, public statements that it knows to be inaccurate or misleading." (In other words, don't print a statement out of context when you know that simply printing the statement will mislead; use background material to paint a full picture.)

RTNDA advises that the viewer must not be misled by video, an interesting sidelight to the current "news simulation" controversy. Some critics and practitioners feel that simulation, having actors portray news events within the context of a news-type report, is a harmless practice. Others believe it oversteps the boundaries of news coverage.

What adds further interest to the issue is the fact that the trade journals published by RTNDA and SPJ recently have been rife with debate over not just news simulation per se, but the new technologies that could take simulation to previously unheard-of levels. For example, a recently perfected video device allows the televised image of a person to be placed within a scene that might be thousands of miles away; this technology could allow a reporter in Iowa to be electronically "placed" on a street in Moscow.

When in doubt, it's safe to say that anything that is created or prompted by the person holding the camera, or supervising the person holding the camera, is out of bounds. And anything that is *dramatized* and represented as *news* footage is clearly beyond the ethical journalism limit.

This discussion may seem to be veering off the track of an examination of codes of ethics, but it is a good example of the way in which any sort of written regulation—code, statute or law—has difficulty keeping pace with technology.

We should note in closing that not all journalists are comfortable with written codes of ethics. Some maintain that written codes make a news organization an easier target for a libel action. An attorney can cite chapter and verse from the station's code of ethics, for example, in an attempt to show that those procedures were somehow violated.

Others claim that no written code of ethics will actually *make* people ethical, that those with evil intentions will always find a way to circumvent policy.

That notion returns us full circle to the thoughts of ancient philosophers. Many great thinkers maintained that ethics must arise from within and cannot be imposed externally. Aristotle phrased this idea more colorfully when he noted that a person of evil character is not likely to be reformed by lectures.

SUMMARY

1. Standards are imposed from inside and outside organizations. Most of those internally imposed standards and restrictions are ethical in nature.

2. There are several definitions of ethics, but most commonly we think of ethics as the branch of philosophy dealing with questions of right and wrong, or, more informally, we equate ethical behavior with good behavior.

3. The fields of ethics and journalism are becoming increasingly interwoven. It is not unusual for journalists and those who study journalism to evaluate situations using methods of analysis taken directly from classical ethics.

4. Many different categories of ethical analysis exist, but a fundamental way to evaluate ethics is by dividing ethical thought into consequentialist, non-consequentialist and golden mean thinking.

5. Journalists face a variety of ethical problems, including invasion of privacy, evaluating truth, maintaining objectivity, avoiding conflict of interest, dampening sensationalism and judging the appropriateness of misrepresentation.

6. There are many codes of ethics promulgated by national organizations and local news departments. Among the more prominent ethical codes are those of the Society of Professional Journalists, the Radio-Television News Directors Association, the American Society of Newspaper Editors and the Associated Press Managing Editors Association.

7. The four codes emphasized in this chapter stress avoidance of conflict of interest and urge fairness and accuracy, among many other items.

EXERCISES

1. Review the discussion of consequentialist versus non-consequentialist ethical reasoning. Now, assume that you are the news director of a medium-market television station, and a reporter is beseeching you to run grisly footage of an auto accident; the footage shows a portion of the victim's body. Your station's policy holds that you do not show any representation of the victim in auto fatalities.

 But your reporter maintains that you should make an exception in this case. This is high school prom season, and the driver of the auto had been drunk when he ran off the road, killing himself and his date. The reporter maintains that running the photo will create a powerful deterrent to such drinking and driving during the next week of high school proms.

Argue the case from both a consequentialist and non-consequentialist point of view. Since there is an existing policy not to run such footage, your case for using the pictures should be a non-consequentialist one. Use consequentialist ethical reasoning to support making an exception. (You may use this as an example for discussion, or your instructor may assign a paper based on this question.)

2. Review the basic tenets of ethics codes described in this chapter. Now, monitor at least two local newscasts, pencil in hand.

 Do you find anything in the newscasts that appears to be in conflict with the principles put forth in the codes? Pay particular attention to issues of context; can you make a case that a particular item or video shot was taken out of context? From your knowledge of local issues, is there anything in the newscasts that you feel is unfairly presented or inaccurate?

 Explain your reasoning in a brief paper or in a class discussion section. This exercise will be more useful—and most provocative—if your class, or small groups from within the class, watch the same newscast.

3. Choose one *issue* mentioned in this chapter's discussion of ethics and write an approximately five-page paper (about 1,200 words) describing how the issue has surfaced on at least three recent occasions. You are free to use any issue—misrepresentation, conflict of interest, sensationalism or whatever. Just be sure to document that the issue has caused controversy and why it has caused that controversy.

 You will find this assignment much easier if you have access to publications such as the *Washington Journalism Review,* the *Columbia Journalism Review,* and the trade publications of the Society of Professional Journalists (*The Quill*) or the RTNDA (the *Communicator*). If these are not in your library, the "press" and "media" sections of popular magazines such as *Time* and *Newsweek* will prove helpful.

CHAPTER

13

LAWS

L et's pose a question. Here is a quotation you are certain to recognize:

> Congress shall make no law respecting an establishment of religion, or prohibiting the free exercise thereof; or abridging the freedom of speech, or of the press; or the right of the people peaceably to assemble, and to petition the government for a redress of grievances.

That, of course, is the First Amendment to the United States Constitution, part of the Bill of Rights ratified in 1791. The clause dealing with freedom of speech and of the press, commonly known as the press clause, underpins our entire concept of the American free press.

But although our Constitution guarantees that Congress shall enact no law infringing on press freedom, and later court decisions tied that prohibition to the due process amendment (14th Amendment) to guarantee that states could not inhibit freedom of the press, *there are hundreds of laws and regulations that prohibit certain expressions of speech and of the press.*

How can this seeming contradiction exist? That's an initial consideration in this chapter's examination of laws relating to journalism—an important consideration, because it offers insight into the underlying legal theory that guides press law.

We'll then examine those specific restrictions: *libel, invasion of privacy,* and *government regulations affecting the news media and specifically broadcast journalism.*

This chapter is brief and broad-brush. Its intent is to trace the threads of the laws that govern journalism, but *not* to offer specific legal guidance. Many laws relating to journalism vary from state to state, and the law is continually evolving. Legal fine points change according to decisions of a variety of courts, and even the nation's most distinguished jurists can't always come to a unanimous decision on the ramifications of applying law to journalism.

Overly broad legal advice is often worse than no advice at all. Should you, in your journalism

career, confront specific questions relating to libel, privacy or government regulations, direct them to your station's lawyer. Don't rely on a basic understanding of legal issues because the principles of journalism law cannot be applied at face value in all cases; the dockets of state and federal courts are filled with cases where highly experienced reporters learned that lesson the hard way.

With that disclaimer in mind, let's first look at the First Amendment, our so-called First Freedom. The First Amendment was the first article of a Bill of Rights appended to the Constitution by American founders who had witnessed at close proximity the painful history of government control of the press. Among the more troubling aspects were licensing regulations that permitted Colonial newspapers to be printed only "by authority," and "seditious libel," a criminal act that could put journalists who criticized the government behind bars.

The First Amendment, however, became a rule destined to be broken. At various points throughout American history, we have seen the imposition of laws that punish (after the fact) journalists who defame individuals or invade their privacy, government regulations that control what can and cannot be said over the broadcast air waves, and in extreme circumstances, court actions that forbade publication of items that were deemed to be a threat to national security.

How, precisely, can we have a provision in our Constitution that protects freedom of speech, and have linked that provision to another amendment that guarantees due process in every state, when we also have a galaxy of laws that restrict expression?

The answer is that the U.S. Supreme Court has divided expression into two camps: protected speech and unprotected speech. (For the sake of this oversimplified discussion, we'll use freedom of "expression," "speech" and "press" synonymously, although there are subtle distinctions among the concepts.)

As an example, some court decisions have held that *speech* (the word we're using in a non-technical sense to cover all aspects of news and expression) is not really speech under some conditions. If I follow you down the street shouting threats, my utterances are not really speech; my words more closely resemble weapons. They are meant to hurt, not to express. And as a result, I could be charged with a variety of crimes, including harassment and assault.

If I falsely shouted "Fire!" in a crowded theater, my speech would not be protected by the First Amendment either, since—in the reasoning of legal scholars—my words are not a form of speech or expression. Oliver Wendell Holmes used this argument in citing "clear and present danger" as a determining factor in what is speech and what is, for lack of a better term, not-really-speech.

Confused? You're not alone. Even Supreme Court justices fall into sharp disagreement over the cleavage between writings and utterances that are speech and not-really-speech. Harvard Law Professor Arthur Miller has offered one of the more cogent explanations of this distinction, and it is well worth reading and rereading because he offers a clear explanation of a murky issue. Here, he uses the "Fire!" in a crowded theater example as the centerpiece of his examination.

> The Supreme Court has defined unprotected speech very narrowly in order to give First Amendment coverage to the widest possible variety of messages . . . [concerning falsely shouting "Fire!" in a crowded theater] . . . At least three factors go into pushing the word *fire* in this context into the area of unprotected speech. The first is that the speaker does not intend the word to communicate any idea. Rather, it is said in order to cause a panic; it is more a weapon than speech. (It is like sneaking up and screaming "Boo!" at someone you know has a weak heart.) . . .
>
> The second factor is that shouting "Fire!" is quite likely to lead to serious harm as the audience rushes for the exits. If there is a fire, we'll take that chance rather than leave the audience to

burn in their seats. But if there isn't a fire, the risk of people being crushed or trampled as a result of yelling "Fire!" is unacceptable. . . .

The immediacy and unavoidability of the speech's harm is the third factor. There is no time to debate the question of whether or not there is a fire before the panic starts. If there was, then the spirit of the First Amendment calls on us to discuss the matter freely. Since shouting "Fire!" cuts off the discussion, it is contrary to the spirit and the freedom so the shout can itself be cut off.[1]

Other freedoms can and are cut off by the law, and as such—for the reasons explained above—the freedom of speech is not absolute. Communications law, which has evolved from the debate over protected and unprotected speech (meaning just about all of that body of law), was born in the gray areas left undefined by the ten words, one comma and one semi-colon of the free speech and press clause of the First Amendment.

L*ibel*

Of most immediate concern to the student of journalism and the practicing journalist is libel law. Libel suits are not uncommon, and *threats* of libel action are routine occurrences in major newsrooms. It is very easy for someone who feels he or she has been wronged to threaten, "I'm going to sue you for libel." It is not quite so easy to actually get a case to court, but many cases do make it to the docket, and many other cases are settled before trial in order to avoid litigation, even in cases where the particular news medium believes itself to be in the right.

Why would a news organization offer such a settlement? First, the price of litigation can be crippling. A law firm charging upward of $150

per hour (and that's a bargain for communications lawyers) can eat up your station's budget pretty quickly. Second, a libel trial is a miserable affair: Your professionalism is called into question, your private thoughts, memos and actions are brought into the public record, and you generally have little time to devote to journalism if you are defending yourself against a libel charge. Mike Wallace, in an article in *Parade* magazine, noted that his experience in a libel suit—in which he was vindicated—left him severely fatigued and depressed.

Given those considerations, it would seem that libel is a good thing to avoid, and it is. But a large portion of the news business involves reporting things about people that they may not find flattering. As a result, it's difficult to report the news without encountering some danger of a libel threat.

How does one avoid libel? Again, I cannot offer a foolproof prescription. Neither can the top communications lawyers in the nation. If they could, there would be no libel suits. But I can outline the basic elements of libel and the primary defenses. This understanding can help you avoid the most clumsy steps into the mine field. Experienced counsel at your station can help you tiptoe through the rest of the territory.

ELEMENTS OF LIBEL

Just what is *libel?* Although definitions vary, a libelous story is one that in some fashion falsely holds a person up to public scorn or ridicule, damages that person's standing in the community and/or damages that person in his or her occupation.

In legal jargon, there are "elements" of a story that make it libelous. To expand on the definition, the elements that must be present in a valid libel action are: *publication, damage, identification* and *fault.*

Publication A news item cannot be deemed libelous unless it's published. In legal lexicon,

[1] Arthur Miller, *Miller's Court* (Boston: Houghton Mifflin, 1982), pp. 31, 32.

published means being spoken over the air as well as being put into print. The essential meaning of this element is that at least one other party besides the instigator and receiver of the statement must be involved. If I write a scandalous newsletter making a false, heinous accusation against you but mail it *only to you,* that's not libel. If I mail it to at least one other person, however, I will probably be seeing you in court.

Damage Some harm must come from the false statement. If I report that you are 5-feet-10-inches tall when you are really 5-feet-8, the statement is clearly false but you would be hard-pressed to prove damage. But if I falsely report that you are an escaped prisoner, you will certainly suffer damage to your reputation and—if you are in business—your pocketbook.

Identification A libel litigant must prove that he or she is recognizable. In practice, this usually means recognized as an individual. Organizations or groups rarely sue for libel, but individuals do. For example, a published statement to the effect that all neurosurgeons are incompetent would be a difficult statement with which to prove libel. For one thing, it would be hard to prove that all neurosurgeons suffered because of the sweeping generality, or that any individual surgeon suffered. But a published statement that called a neurosurgeon with a large practice on Delancey Hill (hypothetical example) an incompetent is bringing you into dangerous territory, since there are probably few neurosurgeons on Delancey Hill, and the one or two that have a practice there may argue successfully that they are recognizable to the listeners or viewers, and suffered financially, personally and professionally as a result.

Fault Implicit in the definition of libel is the assumption that the journalist is at fault; that is, he or she is wrong. *Private* persons, people who have made no attempt to garner fame or have not had it thrust upon them by public circum-stances, need only to prove that the reporter was wrong. Public persons, especially public officials, must prove libel to a greater degree of fault. Public persons usually claim that the reporter was wrong, and *knew* the information was wrong, and went ahead and published it with the intent of causing damage. We'll discuss the ramifications of the "public figure" rule in the following section.

DEFENSES AGAINST LIBEL

Let's assume that a libel action has been brought against you. What are your defenses? You can argue *provable truth, privilege, fair comment* or that the subject of the story was a *public figure.*

Provable Truth Although truth is a defense against libel, there's a hitch: Can you *prove* that what you wrote was true? Calling a neurosurgeon an incompetent is a tough statement to back up, because how, exactly, does one prove that Dr. Hypothetical is incompetent?

Does the fact that her last ten patients died prove that Dr. Hypothetical is incompetent? Not necessarily. To stretch a point, 100 percent of *any* doctor's patients will die—eventually—and those requiring the services of a brain surgeon are already a bit closer to that final milestone.

Some other factors come into play: Perhaps Dr. Hypothetical is a humane woman who specializes in desperate cases no other surgeon will touch. Does that make her incompetent because her last ten patients died? No. We're still on shaky ground—which is why reporters interested in avoiding litigation are well-advised to avoid broad condemnations such as "incompetent" or "mobster." They are both obviously damaging, and given their vagueness, very difficult to prove.

Now, the situation changes if you can truthfully report that "Dr. Mary Hypothetical, who has 40 pending malpractice suits, has seen her last ten patients die on the operating table.

Three anesthesiologists have reported, on separate occasions, that they believed her to be noticeably intoxicated during surgery." Each portion of the statement is a *verifiable* fact, and if you can verify it, you're in the clear. Either she has 40 pending malpractice suits, or she doesn't. Either her last ten patients died on the table, or they didn't. Either the anesthesiologists told you that she appeared drunk, or they didn't. (This last contention is a little shaky, however: You'd want explicit detail on what, exactly, led them to believe she was drunk.)

Privilege Statements made on the floor of a legislative body when that body is in session, or in court when court is in session, are given absolute protection against libel judgments. In other words, a senator can say anything he or she wishes without fear of legal repercussions; a judge can call a defendant every name in the book and be immune from prosecution.

The American system of government values robust public debate, which is why legislative and judicial remarks are exempt from libel actions. Technically, this is known as *absolute privilege*. When you report these remarks, that privilege is passed along to you in the form of *qualified privilege*, meaning that you are immune from a libel action as long as you give a fair and accurate recounting of the debate or action.

Fair Comment Libel law holds that Americans have a right to an opinion. If you are a restaurant reviewer, you are well within your rights to call the food at a certain restaurant tasteless, badly prepared and overpriced. That's a fair comment.

But you can't embellish the story with misrepresentations. If you say the restaurant is "crawling with roaches"—when it's not—you've crossed the fair comment boundary. Any provably false statement removes you from the safety of the protected speech umbrella.

Recently, the concept of opinion as constitutionally protected speech has been eroded some-

what. A Supreme Court opinion rendered in June 1990 held that what was basically an opinion column did fall into the realm of legally actionable publication because it dealt with a serious issue (an implication that a local high school wrestling coach committed perjury). In delivering the majority opinion, Chief Justice William Rehnquist expressed the notion that separate constitutionally based privilege for opinion may not be necessary to ensure freedom of expression under the First Amendment.

Public Figure When a person actively courts fame or public office, he or she sacrifices some legal protections against libel. This stems from one of the most important cases in communications law, *The New York Times v. Sullivan*. Sullivan was a Southern police commissioner who sued *The New York Times* over an advertisement carried but not written by the *Times*. The advertisement contained some allegedly libelous remarks about the commissioner's treatment of blacks. The advertisement also included several factual errors, although they were relatively minor.

In 1964, the U.S. Supreme Court reversed an Alabama State Supreme Court ruling in favor of Sullivan (which had awarded him $500,000), holding that since our society so greatly values robust political discourse, a public official *exposes* him- or herself to public criticism. In order to collect damages after the *Times v. Sullivan* ruling, a public official must prove that "a defamatory . . . statement was made with 'actual malice,'—that is, with knowledge that it was false or with reckless disregard of whether it was false or not."

Decisions in the immediate wake of *Times v. Sullivan* extended the definition of public figures to include persons in the limelight as well as elected or appointed public officials. But recently, the pendulum has begun to swing in the opposite direction, affording more protection for well-known people who are not public officials. (A *public official* is someone elected or

appointed to a tax-funded office. We generally use the term *public figure* to refer to someone who has no official government role but who has attained widespread recognition.)

Ironically, *Times v. Sullivan* is not universally regarded as a boon for the press, because the ruling rewards ignorance. If a reporter can claim that he or she did not know the facts, that is a defense under *Times v. Sullivan*. That was an unpredicted outcome that offered the potential for abuse.

THE EFFECT OF LIBEL LAW ON PRESS COVERAGE

Does libel law have a "chilling effect," as some reporters claim? If chilling effect means dissuading journalists from carelessly or flagrantly publishing information they know to be false, then such an effect is to be applauded.

But that's not the real issue. What concerns members of the press and many news analysts is that reporters are scared away from covering legitimate stories because of fear of litigation. There's no definitive answer on this, but these points do illustrate some of the dangers perceived by the journalistic community:

■ Libel laws are different in all 50 states, and plaintiffs (the parties who initiate the suit) are increasingly shopping for the most favorable site to wage their battle—in some cases, a conservative Southern state.

■ A survey of a group known as Investigative Reporters and Editors (IRE) found that more than half of the respondents claimed that concern over litigation affected journalistic decision making.[2]

■ Even jurists are confused, and some do believe that the hodgepodge of libel laws interferes with reporters in the performance of their jobs. Former Philadelphia Court Judge Lois Forer noted:

No one really knows what the law of libel is today. . . . The law is different in all fifty states, and plaintiffs are jurisdiction-shopping all over the country to find the jurisdiction that is most favorable. What has happened is this chilling effect on the media. . . . Now, almost every major publisher and electronic media has a lawyer sitting in the offices—editorial offices—vetting the news. There is this cautiousness that is preventing the public from getting the information it needs.[3]

AVOIDING LIBEL ACTIONS

We cannot settle the debate over the so-called chilling effect in these pages, but we can examine some basic guidelines for avoiding libel actions.

First of all, get the facts straight. Be aware that a slight juggling of the facts can result in a libel suit given the right (or, more accurately, *wrong*) circumstances.

The classic example is when 18 people are arrested in a drug bust. Seventeen are charged with drug possession charges, but one—naturally, one of the people you name in your story—is booked on a lesser charge, such as disorderly conduct. If you fail to nail down every fact in the case, and report that so-and-so was arrested on drug charges, be prepared for a subpoena.

Second, step carefully when you do stories about businesses. A very large percentage of libel cases evolve from charges made against businesses, probably for two reasons. First, people's

[2] R. E. Labunski and J. V. Pavlik, "The Legal Environment of Investigative Reporters: A Pilot Study," *Media Asia* 13, no. 1 (1986): 43–45.

[3] Remarks transcribed from interview on CNN television network, Dec. 14, 1987. Comments previously cited in Carl Hausman, *The Decision-Making Process in Journalism* (Chicago: Nelson-Hall, 1989), p. 87.

pocketbooks seem to be less resilient than their egos. And second, it is easier to prove actual damages when a business is involved, since the owner can show hard figures on a profit-and-loss sheet.

In addition, don't accidentally make associations. "Wallpaper video" is very dangerous. If you're doing a story about street criminals, don't paper it over with shots of tough-looking folks hanging out on the street corners. Just because someone leans against a lamppost doesn't mean he's a criminal. But if you use that video, it may mean that he'll be a plaintiff.

A final suggestion: Don't leave a paper trail that implicates yourself. A reporter's state of mind became a valid issue in the wake of *Times v. Sullivan.*

This issue came to a head in a case involving a former Army colonel who sued a "60 Minutes" producer (*Herbert v. Lando*). A federal district court ruled that since a public figure—the colonel who brought the suit had actively sought publicity—could recover damages only if it could be proved that the reporter acted with reckless disregard of the facts, it was entirely appropriate for the plaintiff to inquire into the reporter's frame of mind. In this case, that included pretrial examination ("discovery") of notes, memoranda and unused footage of interviews.

In general, journalists were horrified by this ruling, but some, including CBS' Mike Wallace, felt that it was reasonable to investigate a reporter's intentions and state of mind since *intent* was the only ground on which a public figure could win a libel case.

Although you should never go into a story with the intent of "we're going to get this guy regardless of the facts," you should *definitely* never write a memo to this effect. And you are well advised not to orally announce your intentions to "get" someone to other members of the news department, your acquaintances or your bartender. Those remarks may come back to haunt you during the discovery process.

Privacy

If you thought libel law was murky, the waters swirling around privacy are virtually opaque to the non-lawyer. Privacy actions are much less common than libel suits, but are infinitely more complicated.

THE RIGHT TO PRIVACY

We have no clear heritage of law relating to privacy. Libel law dates back many centuries, but privacy has only surfaced as a legal right in the past century, and it is an ill-defined right at best.

What many legal scholars regard as the first sustained discussion of the right to privacy was an article of that title written by Samuel Warren and his young partner, Louis Brandeis, who would later become a justice of the U.S. Supreme Court. The article, published in 1890, was inspired by intrusive reporters who crashed a party at Warren's house.

Since then, a body of law has evolved around privacy, but the law has had a difficult time keeping up with technology. In Brandeis' day, the mass media were in their infancy, at least in their ability to shred someone's privacy. And to illustrate the continuing problem, courts are still attempting to play catch-up with new technologies that can mix and match computer records. Other technological/legal dilemmas include the use of lie detector tests, drug tests or psychological questionnaires given to job applicants.

PRIVACY AND THE JOURNALIST

Many applications of privacy law do not directly affect newsroom operations. For example, one tenet of privacy law involves appropriation of someone's image for advertising purposes without consent and payment.

But an area that should concern you is the problem involving revealing embarrassing details of an essentially private person's life. The legal and philosophical reasoning involves two points:

1. A person actively seeking publicity loses some of his or her right to privacy. That is part of the transaction of fame.

2. A public person has access to the media (that is almost a definition of a public person) and can reply and seek public redress in the media.

But *private* people are entitled to some redress if details of their private lives are spread before the public in *a way that embarrasses that person* or *portrays that person in a false light.*

The definition of a *private* versus a *public* person can be quite unclear. Does a person who was *once* a public figure remain a public figure even if he or she has retreated to a private life? In many cases, the courts have ruled that they do *not* remain public figures, and therefore a large number of successful privacy suits involve "Where are they now?" stories.

Could you be held liable if you were preparing a "Twenty Years Ago Today" piece and brought up a crime committed by someone who is now a private person toiling away at an honest job? Possibly; some cases have reaffirmed that it is not fair to dredge up events of the past—even legitimate news items *of the time*— when they embarrass people who lead private lives *today.*

Aside from legal issues, there are standards of decency involved in privacy issues. Intrusions into people's personal lives for less-than-compelling reasons are gratuitous and best avoided.

Defenses against invasion of privacy suits rest on the same complex set of laws and precedents as do the elements of privacy, but as a guideline, consent of the subject is a reasonably reliable defense. If someone willingly becomes involved in an interview, or better (from your standpoint), instigates the press relationship, he or she sacrifices some right to privacy. But be very careful when dealing with minors. Even if a minor offers you information, you may be in jeopardy of a privacy invasion suit if the minor changes his or her mind about disclosure of the information and/or the parents object to the story. Also, be cautious when dealing with people whose capabilities might be diminished, such as victims of mental or physical illness.

Sometimes, subjects lose some of their right to privacy through no fault of their own; they are simply thrust into the public spotlight because of random happenstance. This is unavoidable. As long as you do not actively or tacitly portray this person in a false light, or intrude unreasonably onto his or her property, the news value generally overrides that vaguely defined right to privacy.

This is not always the case with certain events, such as sexual crimes, where the names of the victims are sometimes protected by statute. (Florida is one such state; there is a criminal statute against publishing the name of a sex-crime victim, and a recent civil case resulted in a major damage award against the newspaper that published a victim's name; the verdict, however, was eventually overturned.)

In fact, at the time of this writing in 1991, Florida officials were considering taking action against national news organizations that reported the name of the alleged rape victim in the William Kennedy Smith case. The issue is a thorny one, but those organizations that used the name, including NBC, claimed that all facts relevant to a case should be disclosed, and publication of a rape victim's name would eventually ease the stigma associated with being a victim of a crime.

After NBC used the name, other organizations, including *The New York Times*, also repeated the name, reasoning in part that the name was now common knowledge. The question of whether national news organizations

face substantial risk from state law of this sort is currently quite unclear.

In sum, when someone courts publicity or is the subject of a legitimate news story, you are on safe ground when dealing with privacy legalities. But privacy is an ethical as well as a legal matter; attempt to view the situation from your subject's perspective before portraying his or her story before thousands of people.

Government Regulation

Government plays two major roles in the working life of a journalist. First, the government is the ultimate mediator of rights that come into conflict. Second, an agency of the government, the Federal Communications Commission, issues (and can revoke) licenses of broadcast stations, and also exercises some control over the way broadcast journalists perform their duties.

Volumes could be (and have been) written about the relationship of government to journalism. Here, we can only scratch the surface and list a few of the categories of government regulation you may encounter. The suggested readings at the end of this book contain several sources that will help you pursue further information on the topics involved.

FREE PRESS/FAIR TRIAL

Here is a classic case where rights come into conflict. The Sixth Amendment to the Bill of Rights guarantees a defendant the right to a trial by an impartial jury, but the First Amendment guarantees a free press. History has shown that the two cannot always peaceably co-exist.

Free press/fair trial came to a head in a notorious case involving Sam Sheppard, a Cleveland osteopathic physician accused of murdering his wife. Press coverage of the case was sensational and bordered on the hysterical. Cleveland newspapers ran editorials that cried out for Shep-

pard's arrest and conviction ("Why Isn't Sam Sheppard in Jail?"). That crusade may indeed have resulted in Sheppard's arrest and conviction—as well as the overturning of his conviction 12 years later on the grounds that the jurors could not possibly have been impartial given the intense publicity to which they were exposed.

When the U.S. Supreme Court overturned the Sheppard conviction, the court held that the judge in any case has the responsibility of ensuring that publicity does not hinder the process of a fair trial, and in the words of the majority opinion, avoid the "carnival atmosphere" that pervaded the Sheppard trial.

The press took its lumps, too, in the court decision. And partly as a result of the Sheppard case (and partly because of the Warren Commission probe into the press coverage of Lee Harvey Oswald, the likely assassin of President Kennedy), an American Bar Association committee developed a series of guidelines for the press and the court. These recommendations, which dealt with press coverage, venue of the trial and related issues, were instrumental in establishing dialog between state bar associations and local news organizations.

As a result, states have codified various sets of guidelines concerning what information about defendants and witnesses should be released, and what information—such as statements about the credibility of witnesses or the texts of confessions made to police—should be withheld.

If you are planning to cover court cases, it would be wise to check with your state bar and ascertain what voluntary guidelines exist and what *legal* constraints are in place concerning press coverage, such as whether videocameras are permitted in the courtroom.

THE EQUAL TIME REQUIREMENT

The Federal Communications Act of 1934 and its later amendments govern broadcasting today. One provision that is still in effect—and still the subject of some controversy—is under

Section 315, titled "Candidates for Public Office; Facilities; Rules." Section 315 is called the equal time provision, although "equal opportunity" is more accurate since it more closely mirrors the wording of Section 315; the term "equal access" is also utilized.

The ruling states that "if any licensee [meaning a television or radio station licensed by the government] shall permit any person who is a legally qualified candidate for any public office to use a broadcasting station, he shall afford equal opportunities to all other such candidates."

This law primarily applies to sale of commercial airtime; a station cannot sell political commercials to one qualified candidate and not another, and must make the same amount of time available. Section 315 also requires that the station cannot charge excessive rates. In fact, in a roundabout way it insists that the station charge its lowest rates when selling airtime to any and all qualified candidates.

A broadcast journalist, however, is not particularly concerned about the equal opportunity clause of Section 315 because it specifically excludes, in the words of the act, any:

1. Bona fide newscast

2. Bona fide news interview

3. Bona fide news documentary (if the appearance of the candidate is incidental to the presentation of the subject or subjects covered by the news documentary)

4. On-the-spot coverage of bona fide news events (including but not limited to political conventions and activities incidental thereto)

But you *do* have to pay attention to the equal opportunity provision of Section 315 if you are producing a public affairs program or a news-related documentary specifically about the election (and not, as the FCC puts it, "incidental").

This means that your "Meet the Candidates" program or series of programs must include everyone legally qualified to be on the ballot for

the particular office in question. (Generally, a candidate is legally placed on the ballot when his or her party obtains a specific number of signatures and files a variety of disclosure statements and several pounds of other paperwork.)

Public affairs shows *do* cause problems. A news director of a local radio station would normally jump at the chance to snag the governor for the station's regular public affairs interview program. But can the governor be interviewed about non-partisan issues during the election period? And if so—or if not—what constitutes the *beginning* of the election period? The National Association of Broadcasters regularly issues advisories on this, but the issue is far from clear-cut, and station managers are unsure because individual situations vary so greatly.

Again, as a daily journalist you probably won't confront problems dealing with political candidates' airtime as long as you make a reasonable effort to balance your coverage (Section 315 points out that the bona fide newscast provision is not an invitation to stack your coverage). However, it is advisable to check with station management about their interpretation of what constitutes programming falling under the aegis of Section 315.

THE FAIRNESS DOCTRINE

In 1949, the Federal Communications Commission adopted a doctrine that required broadcasters to present a wide, representative range of viewpoints in coverage of important and controversial issues.

During the 1980s, an atmosphere of deregulation swept the nation and with it went the Fairness Doctrine. Although Congress in 1987 legislated that the FCC enforce the doctrine, President Reagan vetoed the measure and the FCC then rescinded the Fairness Doctrine altogether.

At the time of this writing, congressional efforts to reinstate the Fairness Doctrine continue, but President Bush has affirmed his op-

position to the measure. Many news organizations persevere in their battle against the Fairness Doctrine, too. Larry Scharff, counsel for the Radio-Television News Directors Association, is adamant in his opposition.

> The term "Fairness Doctrine" is a great propaganda advantage for its advocates. But it's really just semantic camouflage for something that's not fair at all. The real issue is: Who should judge what is fair—the government.or the people?[4]

Whether the Fairness Doctrine is an attempt to ensure a reasonable presentation of views or an attempt to impose government regulation into news coverage, it is an issue bound to resurface, especially as constituencies in the executive and legislative branches of government change over the years.

PRIOR RESTRAINT

A fundamental tenet of American journalism is that the government cannot, except under dire circumstances, prohibit the dissemination of news. Punishments can be meted out after the fact, usually in the form of civil damages, but *prior restraint* runs contrary to our national heritage, and is an option rarely exercised by the government. (The noted cases of prior restraint were brought against print media, so they are used below for illustration; but the principles apply to all media, print and electronic. Note also that prior restraint is not particularly unusual in *copyright* cases, where a firm is enjoined from publishing material to which another person or firm lays claim.)

When prior restraint does occur, it is generally done so under the exigencies of national security. It was this reasoning that led President Richard Nixon in 1971 to seek an injunction to prevent *The New York Times* from printing a collection of classified documents known as the Pentagon Papers. These documents painted a highly unflattering picture of American involvement in the Vietnam War—and Nixon was successful in obtaining the restraining order. But another paper, the *Washington Post,* began printing the Pentagon Papers immediately after the *Times* was enjoined, and by the time a second restraining order was sought and denied and the case brought to the Supreme Court, the cats were out of the bag, anyway.

Later cases involved injunctions prohibiting a magazine from printing plans for a hydrogen bomb and the Central Intelligence Agency's attempts to censor books dealing with American intelligence efforts. One recent case involving prior restraint of which I am aware dealt with an injunction against an Atlanta newsletter, preventing it from publishing confidential accounting information. The injunction was later overturned.[5]

Strictly speaking, this was not a freedom of the press case; neither is the current controversy surrounding the release, and eventual court injunction, of tapes obtained by the Cable News Network. The tapes allegedly contain confidential communications between exiled Panamanian leader Manuel Noriega. Again, the legal theory behind this case deals more with a defendant's rights to a fair trial than with First Amendment issues.

BROADCAST OF RADIO TRANSMISSIONS AND TAPE RECORDINGS

You cannot rebroadcast radio signals from police, fire or other agencies. In fact, you cannot use them verbatim as accounts of news coverage even if you transcribe them. But you *can* use what you hear on the scanner as a news tip.

[4]Quoted by Bruce Sanford, "The Politics of Fairness," *The Quill* (February 1989): 7.

[5]See "Judge Lifts Prior Restraint," *Editor and Publisher* (Feb. 17, 1990): 20.

You can broadcast an interview taped over the phone, but depending on your individual state laws, one or all parties may need to be informed. Irrespective, it's just good judgment to seek permission from an interviewee. The best way to do this and ensure that you'll stay out of hot water is to *get that agreement on tape.*

SHIELD LAWS

On occasion, a court will order a reporter to reveal the identity of a secret source. Up until 1972, many reporters were able to cite First Amendment justifications for protecting their sources: Without confidentiality, freedom of the press would be encumbered.

But reporters do not enjoy the same sanctity of privilege enjoyed by priests, lawyers and doctors, and a decision titled *Branzburg v. Hayes* drove that point home when the court decreed that journalists, just like any other citizens, are compelled to give information when so requested by a court.

Some states responded by passing so-called shield laws, which ostensibly prohibit courts from compelling newspeople to reveal their sources. I say "ostensibly" because shield laws have been regularly circumvented by inventive court interpretations, so even if you work in a state with a shield law, or some combination of statutory or common law that effectively constitutes a shield law, don't count on staying out of jail if a judge adamantly wants to discover the name of your source.

The best solution is not to offer anonymity to a source. That won't always work; some reporters claim that many of their stories would be impossible to gather without anonymous sources. But many journalists have surprised their colleagues—and perhaps themselves—by showing that they can get virtually *anything* stated on the record.

FREEDOM OF INFORMATION ACT AND SUNSHINE LAWS

Enacted in 1966, the Freedom of Information Act allows reporters (in fact, all citizens) to request information that the federal government has kept classified. The government must either release the information or come up with an explanation of why it must be kept secret.

About ten years later, the federal government passed the Government-in-Sunshine Act, which required many federal agencies and commissions to open regular business meetings to the public. In addition, all states and the District of Columbia have open meeting laws pertaining to local government bodies.

From the journalist's perspective, these provisions are laudatory, but they have their problems. FOI requests can take a while to wend their way through the government bureaucracy. Government-in-Sunshine and local open meeting laws have a variety of exceptions, many of which apply to cases under litigation or personnel matters.

SUMMARY

1. Although the Bill of Rights to the U.S. Constitution guarantees freedom of speech and press, some expression is protected while some is not.

2. The general characterization of unprotected speech is that it is more of a weapon than an expression—that it poses a "clear and present danger" or causes harm to someone.

3. Libel is false statement that harms someone's reputation, holds that person up to scorn or ridicule or causes financial damage to a person's business.

4. In addition to falsity, the elements of libel (as defined for our purposes) are publication, identification, damage and fault.

5. The primary defenses against libel are provable truth, privilege, fair comment or demonstrating that the subject is a public figure.

6. If the subject is a public figure, the libel must be proved to a higher degree of fault. In addition to the journalist being wrong, the plaintiff must prove that the journalist knew the information to be wrong but used it recklessly.

7. Some journalists argue that libel laws, which are complex and vary from state to state, have a "chilling effect"—causing journalists to back off from coverage of legitimate stories.

8. The best defense against libel is to get your facts straight. It's important to double-check names, ensure that accidental associations are not made, and avoid leaving a paper trail or a record of statements that can be used against you.

9. The right to privacy is a vague right, and has a very short history in law. In general, journalists are subject to invasion of privacy actions if they disseminate embarrassing information about essentially private people or cast persons in a false light. If the person involved is a public figure, or if he or she has consented to the coverage, you have some measure of protection against a privacy action.

10. The government has a role in journalism, particularly in broadcast journalism, since the Federal Communications Commission grants broadcast licenses and has authority over certain aspects of broadcast news.

11. One area in which government rights come into conflict is the friction between the constitutional rights to freedom of the press and a fair trial. Various compromises have been worked out on a national and state-by-state basis.

12. Other federal regulations include requirements of equal opportunities for airtime for political candidates, and the now-defunct but always-ready-to-be-revived Fairness Doctrine.

13. Prior restraint is very rare, but courts do sometimes exercise this option.

14. The FCC prohibits rebroadcast of two-way radio transmissions of fire, police and other agencies. You can replay taped telephone interviews, but usually only after you have notified the party. The latter statement applies only to some states.

15. Shield laws offer some degree of protection to journalists who wish to protect their sources, but shield laws can be circumvented so they are far from foolproof.

16. Various acts, including the Freedom of Information Act and federal and local open meeting laws, offer the public and reporters some degree of access to the workings of government.

EXERCISE

1. Write a paper analyzing one of the following libel cases:

 ■ *Burnett v. National Enquirer, Inc.* This case involved entertainer Carol Burnett and was decided in 1981; appeals were filed in 1983 and 1984.

 ■ *Herbert v. Lando* (1977 and 1979). This case involved Colonel Anthony Herbert and Producer Barry Lando. It was described briefly earlier in this chapter.

 ■ *Falwell v. Flynt* (1987 and 1988). This case involved Reverend Jerry Falwell and *Hustler* publisher Larry Flynt.

 I have provided the first names of the plaintiffs and defendants along with the years of the appeals in case you do not have access to a law library; you can also find adequate details in newsmagazines. Look up the cases in *The Readers' Guide to Periodical Literature* and other periodical indexes and databases.
 In your paper, be sure to:

 a. Identify the elements of libel cited by the plaintiff.
 b. Identify the defenses cited by the defendant.
 c. Discuss the way the case modified libel law, and identify its impact on media coverage and practices.

 Note that although two of the cases are drawn from the print media, the principles affect broadcast news as well. For all intents and purposes, libel law for print and broadcast is identical.

14

BROAD- CASTING AND THE BUSINESS BEHIND THE BUSINESS

Broadcast news is a business. Commercial operations are expected to make money, and non-commercial news organizations are at the very least expected to generate a sufficient audience to keep the program viable and audience interest high.

That's common knowledge, although many of the facts and figures we'll present later in this chapter may surprise you. But there is a deeper layer to this issue; we'll devote a few pages to exploring what broadcast journalists know about their audience and, conversely, what we know about the impact of broadcast journalism on that audience.

Those three topics are inextricably intertwined, and therefore seem a suitable theme for this final chapter. We'll examine *the business of broadcast journalism, how the broadcast news industry researches its audience*, and *how we*—as consumers, scholars and journalists who investigate journalism—*research the business itself.*

The Business of Broadcasting

Throughout this book, I've attempted to keep an objective, neutral tone—as a journalist and textbook writer must—but the subject of careers in broadcast news requires a blunt approach.

CAREERS IN BROADCAST JOURNALISM

A simple strategy will help decide if a career in broadcast news is for you. If you value a reliable and predictably good income and regular working hours, find another career.

Income But don't top TV anchors make a great deal of money? Yes, they do. So do generals in the Army—but that's not a particularly valid reason to rush down to your local recruiting office. The odds are decidedly against you or

anyone you know reaching the top ranks of television broadcast news.

Let's look at the facts: There are only about 1,300 television stations in the country (of which about a thousand are commercial stations). I counted 370 colleges and universities that have *specific programs* dedicated to mass communications listed in a recent directory of the Association for Education in Journalism and Mass Communications; and that number does not include many colleges that have not submitted information to the directory, or colleges that offer programs in fields peripherally related to media industries. Remember, too, that all reporters do not enter the business from a journalism curriculum.

Assuming that even relatively small departments of journalism and mass communications often have 50 to 100 majors, some simple arithmetic will give you an idea of the competition—and your odds of winding up as a television anchorperson, a job that seemingly *everyone* studying the field of broadcast journalism wants.

Radio offers more opportunity in terms of numbers of stations, but radio news pay is often *abysmal.* And now that I've brought up the subject, it's time to get down to figures.

The average entry-level salaries in radio and television are in the $14,000 a year range.[1] Of course, salaries can increase rapidly *if* you advance into larger markets.

What is probably the most easily grasped layout of salary structure in the industry was prepared by Dr. Vernon Stone, a professor in the School of Journalism at the University of Missouri, Columbia, and director of research for the Radio-Television News Directors Association. His statistics, prepared for a 1989 booklet entitled *Careers in Broadcast News,* were gathered in 1988, so they require some adjustment for fluctuation in the industry and economy. If you

adapt them for current trends, you can probably assume a slight increase for television salaries and a marginal *decrease* for radio salaries.

Here's the story:

■ Television general assignment reporters nationwide earned an average of $18,200 per year. In the top 25 markets the salary is $40,000, an income comparable to that of a worker in a good civil service job. (The listing of the top 25 markets begins with New York, Los Angeles, Chicago and Philadelphia and works its way down to cities such as Hartford, Indianapolis and Phoenix.)

In the smallest markets, general assignment reporters earned, as a mean salary, a little more than $14,000 per year. (The smallest markets as defined in this study ranged from cities such as Utica, N.Y., down to very small markets like Selma, Ala.)

■ TV anchors nationwide earned a mean salary of $30,000. In large markets, the mean was more than $88,000 per year; in small markets, $20,000.

■ Radio reporters earned a national average of $14,100. In large markets (areas with a population of a million or more in the coverage area) they garnered the handsome mean salary of $18,300. In small markets, areas with 50,000 people or less, *radio reporters earned a mean salary of $11,400.*

Let me repeat that in case it didn't register. In small markets, radio reporters earned a mean salary—not a mean starting salary, but an average salary for all employees regardless of tenure—of $11,400.[2] If anything, that figure is creeping downward.

[1] See Vernon A. Stone, *Careers in Broadcast News* (Washington, D.C.: Radio-Television News Directors Association, 1989), p. 9.

[2] All figures taken from the Stone study cited above. The statement indicating that salaries are probably higher in television and lower in radio was concluded from an examination of later figures (the categories of which were not directly comparable) reported by Stone in "Salaries Go Up in TV, Take Setback in Radio News," *Communicator* (February 1990): 26–30.

Most of you will have no choice but to start in small markets. Or, if you immediately secure work in a large market, it almost certainly will be off-air work, and will most likely involve menial duties.

On-air work is highly coveted; even small markets receive dozens of resumes a week. Large markets are inundated with tapes and resumes from job seekers. A news director in the sixth largest television market once showed me a table he reserved specifically for applicants' tapes: It was stacked with at least 300 tapes, all from men and women with considerable experience in medium markets.

This illustrates that there is an undeniable matter of luck involved in reaching a major market. There may be no clear superiority between the applications of 300 experienced professionals, who have already progressed in their careers, and the applications of most aspirants. Finishing second doesn't count; and if you finish second several times, you'll wind up staying where you are.

I do not intend to belittle reporters in medium and small markets. They are often talented people who elect to stay where they are because of the quality of life offered by a small city. In my opinion, I have seen better reporters working in medium markets than many of those who work in major markets.

I also do not intend to slight off-air work. Producers, writers and other staffers form the iceberg of which the on-air staff is only the tip. But since on-air work seems to be the aspiration of so many who enter the field, I want to deal with the situation thoroughly and forthrightly.

Please do not enter the job search with unrealistic expectations or—worse—unfounded arrogance. I recently spoke with a student who informed me that he wanted to *start* his career as a TV anchor, but "not in Buffalo, or someplace like that." At this student's present state of development—he's pretty good, for someone

with limited experience—he would not stand the *slightest* chance of competing with the on-air talent in what is, at the time you read this, the nation's 35th largest market.

I suggested he try a stint in radio. He "doesn't want" radio, but admitted he might try for a radio job with the understanding that it would only be temporary, until he could move into television. Such an attitude is offensive to radio news directors, who do not like to see their operations regarded as a stepping-stone.

Realistically, radio *is* often a stepping-stone into television, but there is no guarantee that you will make it from radio into TV no matter how badly you want to make the switch. (There's no guarantee you'll find a job in radio, either.)

The point of this sermon is that you'll almost always start small and work your way up. Starting small is good. It gives you an opportunity to experiment and make some mistakes that—while they won't win you any friends in a small market—would get you fired in a large market.

But don't expect to make a lot of money at first, and don't assume that a high income will follow later. And don't go into broadcast news for the wrong reasons. Go into broadcast news because *you love it.*

REQUIREMENTS FOR THE JOB

"That's what we look for here," said Dan Rather (Figure 14.1), who offered his thoughts during an interview relating to the points presented in this chapter. "We look for people who love news—not TV, not broadcasting, but *news.*

"The people who make it in broadcast news are also highly motivated," Rather said. "They come in early and stay late. Around here, it is considered extremely bad form not to work a 10-hour day. Someone who doesn't probably won't last. In fact, it's not uncommon for people here to put in 12- or 13-hour days."

What are the other hallmarks of a promising journalist? According to Rather, they include

Figure 14.1 *Dan Rather, who in this chapter offers advice to students interested in a broadcast journalism career, prepares to go on-air.*

news judgment—in his words, "knowing what news is"—and *the ability to write.*

The latter sentiment is echoed unanimously by every broadcast executive whom I have known. You *must* be able to write well. It is one of the first criteria on which you will be judged.

GETTING THE JOB

The following is a compendium of suggestions I have gathered from various sources: interviews with those in media hiring positions, seminars on the subject and my own experiences—good and bad—in the job market as a working journalist.

1. Know how to type.

2. Get a broad-based education. All the technical journalistic skill in the world won't make you a good reporter if you cannot put events into perspective and explain their meanings adequately. Learn about law, government, history, science—just about anything and everything.

3. Get experience. Paid experience is best. An internship or work at the college radio station, television facility or newspaper is also very valuable.

4. Make contacts. Attend symposia that feature local journalists. Join professional organizations.

In regard to this last point, your college may have a chapter of the Society of Professional Journalists and/or the Radio-Television News Directors Association. Join both if you can. (You don't have to have a chapter at your college in order to join.) For information, write The Society of Professional Journalists, P.O. Box 77, Greencastle, Ind. 46135, and The Radio-Television News Directors Association, 1717 K St., N.W., Washington, D.C. 20006.

The Society of Professional Journalists has a "jobs for journalists" program that matches members with prospective employers, and plays host to many events throughout the year, events that are invaluable ways to cultivate contacts. RTNDA also hosts events and publishes a twice-monthly bulletin of currently available jobs.

You might also consider a subscription to *Broadcasting Magazine*, which has an extensive help-wanted section.

Some further tips on the job application procedure follow:

■ When you are ready to start applying, have many copies of tapes and resumes ready to fire off, as well as samples of your best writing. If you are applying for radio, you'll want a sample newscast and, if you have one available, a roser.

TV audition tapes should include a standup report if possible, and an anchor segment. If you are applying for a non-air position, such as a producer's job, it will be enormously helpful to have a tape that you produced or directed; make sure your name is on the credits. Send a rundown sheet you generated if one is available.

It is increasingly common for those who advertise jobs to specify that they will not be able to return tapes. This can get expensive for the applicant. In a pinch, you can send out standard VHS consumer-grade tapes, but there remains a definite preference for tapes in the ¾-inch professional format. You might try sending a stamped, self-addressed envelope for the return of the tape, but that is no guarantee.

■ Keep the tape brief. Ten minutes is about right, and put your strongest material up front. News directors sometimes view only a few seconds of the tape before making their initial decisions.

■ An inflated resume will cause more harm than good. Don't list that you have extensive experience in a particular area when that's not the case. News directors, people who *do* have extensive experience, won't be fooled.

■ Write a personal cover letter. Attempt to show that you have done some research into the market. For example, you might note that you have experience covering some issues that are currently hot topics in that market (crime, urban development and so on).

Make sure that the name of the news director is correct. The *Broadcast/Cablecast Yearbook*, which lists station personnel, is up to date when printed, but jobs change rapidly in the broadcast industry. Invest in a phone call to verify that the news director listed is still at the station. (Hint: Call the switchboard and ask for the news director's office. When that phone is answered, say that you are applying for a job and wanted to verify the name and spelling of the news director. The payoff is that the person who answers the phone just might *be* the news director, in which case you've made an initial, positive contact.)

■ Do you send out resumes cold or do you only apply to stations that have an opening? Both approaches are appropriate. If you have identified a certain area in which you want to live, or if you are already located in a certain region, there's no reason not to send resumes and/or tapes to stations in that area.

Some argue that this is not a particularly effective method of job hunting. But answering ads for existing vacancies has its drawbacks, too. When stations spend the money to advertise in a national publication, they are generally looking for experienced people, and they will receive a flood of applications.

Remember, the main criterion for choosing news personnel is primarily a business decision:

Can this person represent the station as a reporter, reinforce the news department's image and—in the process—help the station turn a profit by pleasing the audience?

Up until this point, we have been discussing the rudiments of finding a job in broadcasting, but it's important to now take an overall look at the industry to see where you might fit in. Getting into the business is an easier proposition once you clearly know what exactly that business is. The following sections on how broadcast news researches its audience and how researchers research broadcast news will provide some insight.

It is impossible to discuss one end of the business—the individual job—without at least a cursory examination of what that business expects of the job-holder and, secondarily, how industry observers view the broadcast journalist's role in society.

B roadcast News and Its Audience

News is a profit center for most TV and radio stations, although its money-making potential is most fully realized in network-affiliated TV stations.

The name of the game is ratings. The number of people watching determines how much a television or radio station can charge for its advertising. To a lesser degree, the *type* of people viewing or listening can influence rates, too. If the station can demonstrate that it reaches an affluent audience or a highly specialized audience, then premium rates can be charged.

News ratings are a larger factor in television revenue than in radio because the radio station defines and segments its audience with its entire programming schedule. Network-affiliated TV stations, however, carry much the same type of programming (except for newly emerging specialized cable networks) and need to dif-

ferentiate their news product *via* the content of the news product.

DEFINITION OF TERMS

Because there are some technical differences between audience measurement for radio and TV, we will define them in general terms that apply to both. A *rating* is the percentage of all potential viewers or listeners tuned in to a program. A *share* is the percentage of those viewers or listeners *actually tuned in* who are tuned in to a particular program.

Demographics refer to the type of listeners or viewers: their incomes, occupations and so forth. The literal meaning of demographic data is statistical representations of a population, but in broadcasting we typically use the word informally to refer to audience characteristics.

BUILDING AN AUDIENCE

While details may differ, it stands to reason that a station wants a big audience and a loyal audience. Building this audience often involves catering to the expressed desires of the listeners and viewers and furnishing on-air talent who project the image the station feels will most effectively captivate the audience.

Audience Research A station's initial data come from the straightforward reporting of the various ratings services. The workings of the ratings services are too detailed to describe in a book of this nature, but it's sufficient simply to know that they measure the audience and the age ranges of the audience. For a premium, some ratings services will furnish more specific data about other demographic characteristics.

But numbers alone don't provide answers. Knowing that the station is in third place is bad news indeed, but the more immediate question

is *what are we going to do about it?* That's where individualized audience research plays a role.

Station management will sometimes form *focus groups* to determine if, for instance, there is a lack of identification of the station's principal anchor, or if the anchorpeople don't project the right image—the image that makes viewers comfortable and loyal.

Here's where the consultants and coaches do their jobs. Before discussing exactly what they do, it's worthwhile to examine who, exactly, is involved in advising broadcast news directors about their product and their people. The vocabulary is not universal. Talent agent Bill Slatter, a former executive producer for WMAQ in Chicago, offers these definitions:

Consultants Consultants, according to Slatter, advise news directors on all aspects of the show—talent, set, even lighting. Consultants often have in-house research staffs.

Talent Agents Agents represent talent in dealings with their superiors. They are hired by talent and receive a percentage of the performer's income.

Headhunters Headhunters maintain a vast bank of tapes and help news directors screen likely candidates from other markets.

Talent Coaches Talent coaches mainly advise on-air people about appearance, delivery and writing.[3]

Criticism of Audience Research Consultants can and do help a station improve its product. Many news directors note that the consultant's broad exposure to markets throughout the coun-

try offers a perspective not available to the local news director. Consultants also are able to view station operations more objectively since they are not so close to the problems. Some news executives feel that consultants have made valuable contributions to the station's news effort.

And some think that's total trash. One executive who has worked as a news director in two of the nation's largest cities maintains that consultants frequently serve as cosmetic scapegoats to camouflage top management's lack of commitment or expertise. If ratings go up after the consultant has been on the job for a year, top management can claim credit. If ratings go down, management can blame the consultant for impeding the ideas that management knew would work all along.

A more serious allegation is that consultants often stray beyond the boundaries of cosmetics and affect the substance of news. A news director may find him- or herself advised that there are too many local meetings making air—so those stories should be cut and "people" stories emphasized. Or it may be suggested that writers insert the word *you* into almost every sentence of copy ("You're going to be paying more at the gas pumps this month . . .").

Although many newspeople bristle about the presence of audience research in news decision making, others vehemently reject the entire concept. "It's a nightmare," said John Katz, former executive producer of the "CBS Morning News."[4] "It has become the Bible, the dominant ethic in television news programming . . . [some performers] are almost total creations of Q-research. . . . [Audience research] is error-prone and a distortion of the news process."[5]

[3] From Karen Frankola, "Who Uses Consultants and Why," *Communicator* (August 1990): 15.

[4] Interview, Nov. 19, 1990.

[5] By Q-research, Katz means a *q*uotient of popularity, determined by weighing and combining factors such as likability, recognition and appeal.

There is no easy compromise in sight, because newspeople frequently adamantly oppose suggestions to pretty up the set, include more "people" stories or force the news crew to engage in "happy talk." Fred Graham, a former reporter for *The New York Times* and correspondent for CBS, pulled no punches in his book *Happy Talk: Confessions of a TV Newsman*.

In 1987, Graham returned to his hometown of Nashville to become principal anchor of WKRN-TV. As he tells it, his tenure was not a happy one because of his inability to engage in "meaningful happy talk."

> The plan had been to weave some of my knowledge and experience into the conversation at the anchor desk. The results suggested that either I was not adroit at doing it or that "meaningful happy talk" was a contradiction in terms.
>
> During my anchor training in Iowa, the Frank N. Magid Company[6] handlers had come up with a technique for injecting my own thoughts and personality into the format. The voice coach suggested that when a scripted news item caught my attention, I could add a "dollop" of my own insights as I tossed the conversation to . . . [his co-anchor] for her next story.

Graham concluded acidly that the only real result of this strategy would be his discovery that his co-anchor knew six different ways to say "that's interesting."[7]

Graham's comments, whether you agree or disagree, are a form of reporting *about* reporting, a trend that seems to be gaining steam as we look around us and view the effects of the news media. So, as a concluding section of this book, let's reverse our perspective and examine what critics and researchers have to say about the news media.

[6] The nation's pre-eminent news consulting firm.

[7] From an excerpt by Fred Graham reprinted as "Tom Paine Strikes Out," *The Quill* (April 1990): 14–15.

Research About the News Media

When we say "research," we're extending the meaning beyond the type of criticism offered by Graham. In general usage, research (as opposed to criticism) about journalism is an attempt to break new ground, uncover new facts and relationships among facts, and verify or cast doubt upon existing theories.

Much research about journalism is published in what are known as refereed journals. In order for an article to be published in a refereed journal, it must be submitted to several referees who will judge the merits of the research document. The referees do not know the name of the author, hence the refereeing is done "blindly."

Often, extended works of research are written as books. Usually, book-length research involves large-scale studies of current issues or extensive examinations and applications of theoretical frameworks.

Although research comes in many forms, research into journalism and media falls into the categories of *experimental research*, *qualitative research*, *survey research* and *content analysis*.

EXPERIMENTAL RESEARCH

Experimental research is pretty much what the name implies. A group of people is usually divided into subgroups, exposed to the experimental variable (the item we are changing to see if it has any effect) and the results measured.

For example, a researcher might want to assess, under laboratory conditions, whether a certain style of news presentation (such as inclusion of actualities in radio news) will increase or decrease retention of fact. Such a study would involve creating two or more groups, playing different tapes for them, and assessing any statistically significant difference in the amount of

news information retained. (A result is statistically significant once it can be mathematically shown to be highly unlikely to be produced by chance.)

Experimental research rarely proves anything. Flaws are often discovered in the research process. Another researcher may note that the groups being contrasted were not exactly comparable. Perhaps one group had a higher level of education, or was younger on the average and possessed better hearing.

But that's the point of research: to put results before the investigative community and see if they are reliable and can be replicated.

QUALITATIVE RESEARCH

Qualitative refers to anything not counted and tested for statistical validity. Qualitative studies include a range of research projects, including focus groups and field observations. Many studies of journalism involve independent observers in the field watching the activities of newsrooms and newsroom personnel; they make assessments about how events are routinely handled or the attitudes typically held by journalists.

Interviews can be a form of research. In the academic community, interview material is often gathered from highly structured conversations that are designed to dig deeply into people's attitudes and perceptions.

Case studies are another form of qualitative research in which the workings or histories of various news organizations might be compared to see if they fit a common theory or reinforce a common idea.

Qualitative research rarely proves anything, either. By its very nature, it deals with unpredictable elements. For example, an interview can be distorted by the fact that the person being interviewed tells you what he or she believes you *want* to hear.

SURVEYS

The survey is a common tool of journalism researchers. Researchers ask—either in person, by phone or by questionnaire—a variety of questions dealing with, perhaps, people's opinions of news coverage. Or, the questions may be put to news directors and deal with standard newsroom practices: How many news organizations have ethics codes? How are those ethics codes enforced? Dozens of studies have been done on those very questions, and most likely dozens more will follow.

Survey research is also useful within the industry; the salaries reported earlier in this chapter were garnered from a questionnaire. Members of the industry frequently conduct surveys to gather information about, for example, the number of women and minorities employed in news and news supervisory positions.

Again, survey research is not foolproof. Numbers can appear to be accurate, but if the base from which they are extracted is skewed, the survey is meaningless. For example, if you wanted to determine if advertiser pressure is a major consideration in selecting news stories, your survey would not be conclusive if you sampled only major-market stations. Perhaps advertiser pressure is greater in smaller markets. Perhaps not. But you'll never know unless you use a representative sample to begin with.

A British scholar named Sir Arthur Eddington summed it up perfectly: If you cast a net with a 6-inch mesh into the water and sample the size of the fish you catch, you'll assume that all fish in the sea are larger than 6 inches—since you'll never see the ones that got away.

CONTENT ANALYSIS

Content analysis involves counting the number of messages in a particular sample and making an inference regarding what those numbers

mean. One of the earliest known examples of content analysis was developed during World War II, when Allied intelligence agents counted the number of German popular songs being played on European radio stations. Since popular music was favored by German troops, and radio stations were more than happy to oblige their audience, the Allies were able to chart with some reliability the movement of German soldiers.

Today, countless content analysis studies are undertaken to determine, for example, how often stories are duplicated by competing news organizations, or how often lead stories are duplicated by various stations.

Again, we must be wary of implying that content analysis proves something. It is reflective of what is happening in a certain case or series of cases, but there are limits to the inferences that can be made by analyzing and comparing messages within the mass media. Content analysis, like all research tools, is a method of gathering information and attempting to explain what that information might mean.

Conclusion

I would like to conclude with some observations about the nature of the news business, how it affects us and how we affect it.

More than a half-century ago, journalist and political scientist Walter Lippmann proposed

that we really have no way of knowing our environment directly. We form pictures in our heads based upon the accounts that we come to believe as representing fact.

But just as we have no way of directly observing the environment, we have no infallible method of determining fact and truth. The best we can do is rely on a variety of sources and hope that those sources are providing us with information that is as accurate, fair and unbiased as possible.

Providing that information is a tremendous responsibility. And that is the responsibility of the broadcast journalist. Throughout your career, you'll be responsible for reporting information that will change people's lives—for better and for worse—and will affect the way the public views the world outside and the pictures in their heads.

It is an enormously rewarding job, but one that requires an intense sense of duty. CBS Evening News Anchor and Managing Editor Dan Rather commented on the shortcomings of journalism education in the United States.

> Some people think this is a glamorous business. And in a way, it is. But don't be seduced by that. It doesn't come without a price. I think that those who teach journalism need to do a better job of letting students know that this line of work requires an extraordinary commitment, and has its share of hardships.

Those who succeed, he noted, are the people who "burn with a hot flame."

SUMMARY

1. Despite its glamorous reputation, commercial broadcast news is a business, and operates on the basic premise of all business: turning a profit.

2. If you opt for a career in broadcast journalism, it is best to realize right from the start that working conditions may be rugged and the pay may be mediocre. Some reporters in major markets do make a great deal of money, but they also work very hard. Most reporters in medium and small markets do not make particularly high incomes, and they still work very hard.

3. The bare minimum qualifications are knowing how to type, having a broad-based education, and being able to write and communicate. Experience—and experience in the field—is valuable.

4. A tape and resume are important marketing tools. Your tape should be brief and demonstrate your best work right up front. News directors often just review a few seconds of the tape before making a decision. Don't inflate your resume.

5. A rating is a percentage of all possible viewers or listeners who have the potential to watch or listen. A share is the percentage of those actually tuned in who are watching or listening to a particular station. Either way, both figures translate to money; they are essential tools for those who sell commercial time on the station.

6. A variety of people—including talent coaches, consultants and headhunters—have entered the business of news, and some observers contend that they have a negative effect on the news.

7. Other types of research involve news and mass communications, too. Those types of research include experimental research, qualitative research and surveys.

8. Remember that research is not foolproof nor does it usually prove anything. It is simply information, information that can be used or misused depending on the knowledge and expertise of the person who gathers the information.

DECODING AP WIRE COPY HEADINGS

The heading on a piece of AP wire copy is routing information designed from standardized guidelines provided by the Radio-Television News Directors Association and the American Newspaper Publishers Association. An AP header contains a *service level designator*, a *selector code*, a *priority code* and a *category code*.

The service level designator (SLD) is an abbreviation telling what kind of story follows. For example, the letter *v* is the SLD meaning this is state and national broadcast copy. A folio number follows, which is an arbitrary number used to identify the story; the number has no intrinsic meaning.

The selector code begins with a number that identifies the source of the story (1, as a case in point, indicates that the story is from the national desk) and then a series of letters in the selector code describes the type of the copy; *alb-* means all-points bulletin.

Next, a single letter indicates the priority of the item. An *f* means a critically important flash story, but a *d* means that what follows is lowly spot news, which does not merit very high priority.

A category code then gives an indication of the nature of the story; *i* means international news. The heading will also contain a slug—a brief description of the story.

You won't need to know how an AP wire story is coded unless you are in charge of newsroom operations and are in a position to decide what you want sorted where. But now, at least, the gibberish won't be a mystery.

SUGGESTED READINGS

While some texts attempt to provide an exhaustive list of every book ever written on a particular subject, I would like to propose a limited and practical reading list of books and periodicals that will complement this text. In addition, I have chosen only works that are widely available in most libraries.

GENERAL REPORTING AND WRITING TEXTS

Block, Mervin. *Rewriting Network News: Tips from 345 TV and Radio Scripts.* Chicago: Bonus Books, 1990. A former network writer and writing consultant, Block dissects scripts mercilessly. A great tool that helps you learn from others' mistakes, rather than your own.

Cohler, David K. *Broadcast Journalism.* Englewood Cliffs, N.J.: Prentice-Hall, 1985. Conversational and engaging text, with heavy emphasis on writing technique.

Cohler, David K. *Broadcast Newswriting.* Englewood Cliffs, N.J.: Prentice-Hall, 1990. Thorough, detailed and readable.

Hausman, Carl. *The Decision-Making Process in Journalism.* Chicago: Nelson-Hall, 1990. A study of news judgment: How experienced reporters have handled questions of newsworthiness, fairness, objectivity and accuracy.

Stephens, Mitchell. *Broadcast News.* New York: Holt, Rinehart & Winston, 1986. Thorough, well-written examination of broadcast news practices and techniques.

White, Ted, Meppen, Adrian, and Young, Stephen. *Broadcast News Writing, Reporting and Production.* New York: Macmillan, 1984. Especially useful because material can be accessed easily; written in quickly grasped units. A good addition to any reporter's bookshelf.

GENERAL NEWS AND BROADCAST NEWS

Bagdikian, Ben. *The Media Monopoly,* 3rd rev. ed. New York: Beacon, 1990. Veteran journalist Bagdikian's impassioned argument against corporate mergers and takeovers in the news business, a trend that he claims accounts for a shrinking marketplace of ideas.

Biagi, Shirley. *NewsTalk II: State-of-the-Art Conversations with Today's Broadcast Journalists.* Belmont, Calif.: Wadsworth, 1987. Interviews with such luminaries as David Brinkley, Charles Osgood, Susan Spencer and Judy Woodruff. Specific, pointed advice from the pros.

Chancellor, John, and Mears, Walter R. *The News Business.* New York: Harper & Row, 1984. Superb inside story on how news works. As informative as any text, but reads like a novel. Combines discussion of history, practice and technique.

Ellerbee, Linda. *And So It Goes.* New York: Putnam, 1986. Warts-and-all anecdotal examination of the way the TV news business operates.

Matusow, Barbara. *The Evening Stars.* New York: Ballantine, 1983. The rise of the star anchors and the resulting changes in news operations examined in close detail.

Siebert, Fred S., Peterson, Theodore, and Schramm, Wilbur. *Four Theories of the Press.* Urbana: University of Illinois Press, 1963. Don't be misled by the date or the esoteric title: provides a thoughtful overview of what news is and how it reflects and shapes society.

Wallace, Mike, and Gates, Gary Paul. *Close Encounters.* New York: Berkley, 1985. Although written as a memoir, the book offers a step-by-step breakdown of how news becomes news. Included are brief transcripts of Wallace's most penetrating interviews.

HISTORY

Barnouw, Erik. *History of Broadcasting in the United States*, 3 vols.: *A Tower in Babel* (1966); *The Golden Web* (1968); *The Image Empire* (1970). All published in New York by Oxford University Press. Classic three-volume history of broadcasting. Must reading for anyone interested in the development of broadcasting and broadcast news.

Sperber, Ann. *Murrow: His Life and Times.* New York: Freundlich, 1986. Readable bio of a man who helped shape the structure of broadcast news.

NEWS ANNOUNCING

Hyde, Stuart. *Television and Radio Announcing*, 6th ed. Boston: Houghton Mifflin, 1990. Wide-ranging work about on-air skills.

O'Donnell, Lewis B., Hausman, Carl, and Benoit, Philip. *Announcing: Broadcast Communicating Today*, 2nd ed. Belmont, Calif.: Wadsworth, 1992. Covers wide range of announcing techniques, but places special emphasis on news work.

RESEARCH

Rubin, Rebecca B., Rubin, Alan M., and Piele, Linda. *Communication Research: Strategies and Sources*, 2nd ed. Belmont, Calif.: Wadsworth, 1990. A reference guide that will point you in the right direction should you decide to further investigate research methods.

Wimmer, Roger D., and Dominick, Joseph R. *Mass Media Research*, 3rd ed. Belmont, Calif.: Wadsworth, 1991. Understandable guide. Many parts are quite useful for newspeople interested in ratings and other types of audience research.

REFERENCE

Kessler, Lauren, and McDonald, Duncan. *The Search: Information Gathering for the Mass Media.* Belmont, Calif.: Wadsworth, 1992. A unique work that goes beyond the standard news research techniques and includes good practical advice on using the computer to uncover information.

MacDonald, R. H. *A Broadcast News Manual of Style.* New York: Longman, 1987. A useful, quick-reference guide regarding word usage and scripting and writing techniques.

ETHICS

Fink, Conrad C. *Media Ethics in the Newsroom and Beyond.* New York: McGraw-Hill, 1988. Good anecdotal and analytical study of real problems and possible solutions.

Goldstein, Tom. *The News at Any Cost: How Journalists Compromise Their Ethics to Shape the News.* New York: Simon & Schuster, 1985. Vitriolic study that, while not making a pretense of balance, raises legitimate questions about the news industry. Goldstein, a reporter who has testified as an expert witness in court cases involving journalism ethics, takes on both print and broadcast media.

Hausman, Carl. *Crisis of Conscience: Perspectives on Journalism Ethics.* New York: HarperCollins, 1992. Wide-ranging study examining the roots of ethical issues. Attempts to provide a broad framework for discussion and analysis.

PRODUCTION

O'Donnell, Lewis B., Benoit, Philip, and Hausman, Carl. *Modern Radio Production*, 2nd ed. Belmont, Calif.: Wadsworth, 1990. General text on radio production, but many sections dealing with techniques relevant to news operations. In fact, several chapters address news specifics.

Yoakam, Richard, and Cremer, Charles. *ENG: Television News and the New Technologies*, 2nd ed. New York: Random House, 1989. Well-organized work, integrating technology and news coverage techniques. Authoritative and well-written.

Zettl, Herbert. *Television Production Handbook*, 5th ed. Belmont, Calif.: Wadsworth, 1992. General overview, excellent reference. Useful for

all involved in production, including news personnel.

━━━

PERIODICALS

Broadcasting. Broadcasting Publications, Inc. 1705 DeSales Ave., Washington, DC 20036. Magazine aimed mostly at management, but good discussions of issues affecting entire industry.

College Broadcaster. National Association of College Broadcasters. Box 1955, Brown University, Providence, RI 02912. Much more than the title implies: An in-depth view of all aspects of broadcasting, with exceptionally informative articles about technologies, station operations and programming.

Columbia Journalism Review. 700A Journalism Building, Columbia University, New York, NY 10027. Thoughtful analyses of journalistic trends and dilemmas. "Darts and Laurels" column alternately scolds and praises journalistic practices, naming names in the process.

The Communicator. Published by the Radio–Television News Directors Association, Suite 615, 1000 Connecticut Ave., N.W., Washington, DC 20036. Inside, hands-on advice for all broadcast and cable journalists. Features a wide range of articles, from discussions on technologies to debates on ethics.

FineLine: The Newsletter of Journalism Ethics. 600 East Main St., #103, Louisville, KY 40202. Gritty, down-to-earth discussions of real-life ethical issues: privacy, objectivity, and the "fine line" between news and propaganda.

The Quill. Published by the Society of Professional Journalists, P.O. Box 77, Greencastle, IN 46135. For both print and broadcast journalists. Offers valuable career advice in frequent job-related articles.

Washington Journalism Review. 2233 Wisconsin Ave, N.W., Ste. 442, Washington, DC 20007. Highly readable articles and analysis about news, the news business and the audience.

INDEX